Italian Paintings

FLORENTINE SCHOOL

Italian Paintings

A Catalogue of the Collection of The Metropolitan Museum of Art

FLORENTINE SCHOOL

Federico Zeri

WITH THE ASSISTANCE OF

Elizabeth E. Gardner

The Metropolitan Museum of Art

Distributed by New York Graphic Society

Designed by Peter Oldenburg
Printed in Great Britain by Lund Humphries, Bradford and London
Published by The Metropolitan Museum of Art, 1971

Library of Congress catalog card number 71–127080
Cloth binding, Standard Book Number 87099–019–5
Paperbound, Standard Book Number 87099–020–9

Contents

Preface

IN 1940 The Metropolitan Museum of Art published the first systematic catalogue of its European paintings. Written by Harry B. Wehle, the catalogue presented the Museum's Byzantine, Spanish, and Italian paintings, the latter group numbering two hundred and eighty-six. Since that time the Museum's holdings in this field have increased appreciably. The number of Italian paintings in the collection today is well over four hundred.

The growth of the Italian collection since 1940 is due largely to the generosity of several individuals. In 1941 George Blumenthal, the Museum's seventh President, gave and bequeathed forty-seven Italian paintings, many of outstanding importance. These were followed in 1943 by the bequest of thirteen trecento and quattrocento panels from Maitland F. Griggs, and in 1949 seventeen more paintings of the Italian school were added from the collection of Jules S. Bache. In addition there have been notable gifts from such generous donors as Adele L. Lehman, Robert Lehman, Grace Rainey Rogers, Edward S. and Mary Stillman Harkness, Mrs. Jesse Isidor Straus, George R. Hann, and Mr. and Mrs. Ralph Friedman. The Museum has also purchased important works by Lorenzo Monaco, Francesco Granacci, Lorenzo Lotto, and Giambattista Tiepolo, to mention but a few.

In order to publish all of these additions, Theodore Rousseau, at that time Curator of European Paintings, invited Dr. Federico Zeri to compile a new catalogue of the Italian paintings. An internationally known specialist, Dr. Zeri began work in 1961. He catalogued the one hundred and forty or so paintings acquired since 1940; for those pictures already published in the 1940 catalogue he revised the existing entries, occasionally changing the attributions, often adding new biographical information, and wherever possible bringing the bibliographical references up to date.

Because of the number of paintings involved, it was decided to publish Dr. Zeri's new catalogue in four volumes. Thus the present volume deals only with pictures by Florentine artists. It will be followed by a volume on the Venetian school, another on the North Italian school, and a volume including the Sienese, Central, and South Italian schools.

Following the example of the Museum's previously published catalogues of European paintings, the painters in each volume have been arranged in approximately chronological order. There is a brief biography for each one, outlining his career

and artistic significance. His works owned by the Museum are then catalogued in the order of their production, if this can be determined by factual or stylistic evidence. Each picture is illustrated and its attribution, history, and relation to other works is discussed. There follows a selective listing of references, including both published and verbal comments about the picture. The exhibitions in which the picture was shown and the former owners of the picture are also enumerated. The last line in the entry names the donor or the purchase fund that made its acquisition by the Museum possible.

In preparing the manuscript of the catalogue for publication, Dr. Zeri was assisted by Elizabeth E. Gardner, Associate Curator in the Department of European Paintings. Besides contributing many details to each entry and adding new information about the collections to which many of the paintings once belonged, she supervised the production of this first volume of the catalogue. Claus Virch, Curator of European Paintings from 1968 to 1970, lent his support and enthusiasm to the project. The editing of this volume was done by Jean Leonard, who worked on most of the Museum's previous catalogues of European paintings. Able assistance was also provided by Margaretta M. Salinger, Claire W. Bracaglia, and Toby Volkman. The scholars and museum officials who have helped directly or indirectly are named in the individual entries.

In securing Dr. Zeri's authorship the Museum is indeed fortunate. His connoisseurship of Italian paintings is unique in the world today. Not unexpectedly the catalogue contains many original discoveries and stimulating observations. What Dr. Zeri has written is a remarkable contribution not only to our knowledge of the Museum's collection but also to the study of Italian painting in general.

EVERETT FAHY
Curator in Charge, Department of European Paintings

Italian Paintings

FLORENTINE SCHOOL

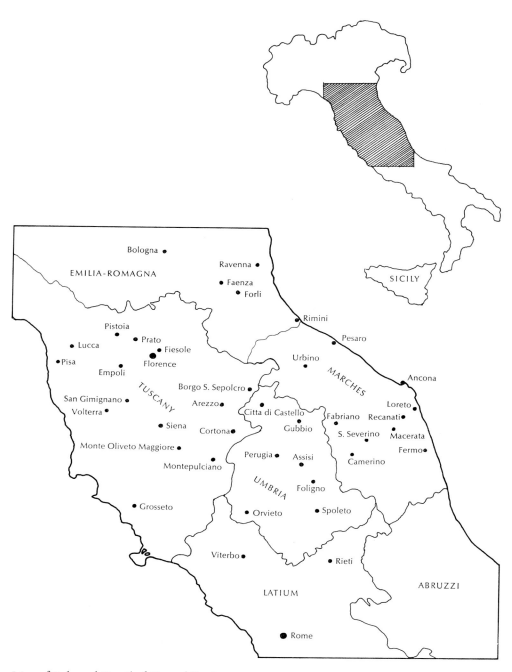

Map of Italy and Detail of Central Portion

Berlinghiero

Often wrongly called Berlinghiero Berlinghieri. Active by 1228; dead by 1242. Because of a misinterpretation of a Latin document of 1228, known only through seventeenth-century transcriptions, it was once erroneously supposed that this artist came from Milan. He was active in Lucca, which was from the eleventh century on the most important city in Tuscany before the rise of Pisa, Florence, and Siena. Berlinghiero was the founder of a school that supplanted the Romanesque style in Lucca and strongly influenced painters in Pisa and Florence during the first half of the thirteenth century. His art shows a union of Romanesque and Byzantine elements, and his profound knowledge of Byzantine painting can be accounted for by the wave of Neo-Hellenism that penetrated deeply into Italy after the fall of Constantinople in 1204. The basis for our knowledge of his style is a signed crucifix in the Lucca Gallery (no. 39). By comparison with this crucifix our Madonna and Child and a Madonna and Child in the cathedral of Pisa can be accepted as his, and a few other works may be attributed to his immediate followers. Among Berlinghiero's followers were his three sons, Bonaventura, Marco, and Barone.

The Madonna and Child 60.173

This painting, one of the three works surely by Berlinghiero, appears to be of a much later date than the crucifix in Lucca and the Madonna and Child in Pisa and was probably painted at the end of Berlinghiero's career, about 1240. The modeling, especially in the draperies, has been slightly strengthened by old restorations. The iconographic scheme is of Byzantine origin and belongs to the type known as Hodegetria.

Inscribed in Greek (on each side of the Virgin's halo): "Mother of God."

Tempera on wood; gold ground. Over-all size, h. 31⅝, w. 21⅛ in. (80.3 × 53.6 cm.); painted surface, h. 30, w. 19½ in. (76.2 × 49.5 cm.).

REFERENCES: V. N. Lazarev, *Burl. Mag.*, LI (1927), pp. 56 ff., ill. opp. p. 56, attributes this painting to Berlinghiero or to one of his immediate followers, dates it in the first quarter of the XIII century, and notes that the iconography of the Madonna belongs to the type of Hodegetria; and *La Pittura bizantina* (1967), pp. 323, 336, note 60, accepts the attribution to Berlinghiero and notes that the iconographic scheme of the half-length Hodegetria is derived from Byzantine art // E. Sandberg-Vavalà, *La Croce dipinta italiana* (1929), pp. 548, 568, note 5, accepts the attribution to Berlinghiero; and *L'Iconografia della Madonna col Bambino nella pittura italiana del dugento* (1934), p. 39, pl. XIV A, places this painting under the Hodegetria type // L. Venturi, *Pitture italiane in America* (1931), pl. II, tentatively ascribes it to Jacopo Torriti; *Ital. Ptgs. in Amer.* (1933), pl. 2, rejects the attribution to Berlinghiero and tentatively suggests ascribing it to Jacopo Torriti // R. van Marle, *Le Scuole della pittura italiana*, I (1932), p. 315, note 1, judging this painting from reproductions only, observes that it is more Byzantine than the works surely by Berlinghiero but rejects the attribution to Jacopo

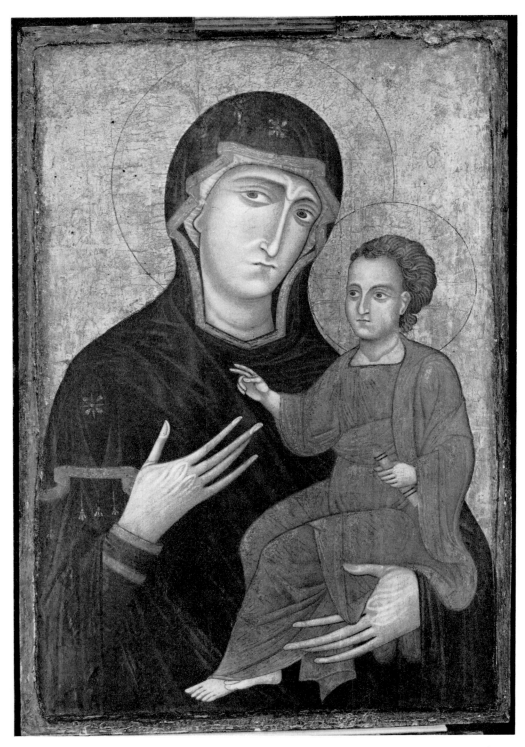

60.173

Torriti // P. D'Ancona, *Les Primitifs italiens du XI au XIII siècle* (1935), p. 66, accepts with some reservation the attribution to Berlinghiero // G. Sinibaldi and G. Brunetti, *Pittura italiana del duecento e trecento* (1943), p. 11, fig. 3, hesitantly accept the attribution to Berlinghiero // E. B. Garrison, Jr., *Art Bull.*, XXVIII (1946), pp. 213 f., fig. 8, accepts with some doubts the attribution to Berlinghiero, suggests that this panel was painted considerably later than Berlinghiero's signed cross in Lucca, and places it towards the end of his life; *Burl. Mag.*, LXXXIX (1947), pp. 278 f., pl. I A, accepts the attribution to Berlinghiero and compares the painting with the Madonna and Child in the cathedral of Pisa; *Italian Romanesque Panel Painting* (1949), pp. 12, 59, no. 96, ill., attributes it to Berlinghiero and dates it between 1230 and 1240; *Art Bull.*, XXXIII (1951), p. 15; *Boll. d'arte*, XLI (1956), p. 309 // R. Longhi, *Proporzioni*, II (1948), p. 30, rejects the attribution to Jacopo Torriti and calls it a work by Berlinghiero // R. Oertel, *Mitteil. des Ksthist. Inst. in Florenz*, VII (1953), p. 24, note 43, calls it a work of the school of Berlinghiero // R. Offner, in D. C. Shorr, *The Christ Child* (1954), p. 14, ill. p. 18, attributes it to Berlinghiero and dates it about 1240 // W. R. Valentiner, *North Carolina Museum of Art Bulletin*, I (1957), no. 2, p. 3, compares it with a Madonna and Child attributed to Berlinghiero in the North Carolina Museum of Art in Raleigh // J. H. Stubblebine, *Guido da Siena* (1964), p. 78, fig. 104, calls it a work by Berlinghiero, comparing it with Guido da Siena's Madonna in the Art Museum of Princeton University.

EXHIBITED: Uffizi, Florence, 1937, *Mostra giottesca*, no. 3 (as Attributed to Berlinghiero, lent by the Straus collection).

EX COLL.: Italo, Florence (?); [Elia Volpi, Florence; sale, New York, American Art Association, March 31, 1927, no. 376]; Jesse Isidor Straus, New York (1927–1936); Mrs. Jesse Isidor Straus, New York (1936–1960).

GIFT OF IRMA N. STRAUS, 1960.

The Master of the Magdalen

The Master of the Magdalen is the name given by O. Sirén to the painter of a panel in the Accademia in Florence (no. 8466) representing Saint Mary Magdalen and eight episodes of her life and of a group of Florentine paintings of the second half of the thirteenth century related to this picture. More recently a large number of works has been ascribed to this unknown painter, and, although the entire group of more than twenty panels goes provisionally under his name, it is possible that it includes the products of a number of painters working in the same shop under his direction. The quality of the paintings varies, but they are in general crude and weak, suggesting that they were made for patrons who were not very exacting and were perhaps from the country and villages near Florence. Although none is a genuine artistic creation, they have great historical importance because they record in imitations the forms and the compositional and iconographic motives of the major Florentine painters of the second half of the thirteenth century. The works of the Master of the Magdalen and his circle fall into three main periods: the first between 1265 and 1270, when he was under the influence of Coppo di Marcovaldo; the second about 1275, when his works were based on borrowings from Meliore Toscano; and the third, from about 1280 to 1295, when he imitated Cimabue and some of his pupils. The panels by the Master of the Magdalen are of great help in dating the prototypes on which they depend and also in postulating the existence of paintings by the greater Florentine artists of the period that are lost today. It has been suggested that the Magdalen Master took part in the execution of the mosaics in

the Baptistry in Florence. This seems to be supported by certain areas in the mosaics themselves that recall his style and by the fact that his panels, with their broad technique, intense colors, and marked outlines, give the effect of mosaic work.

The Madonna and Child Enthroned (triptych) 41.100.8

Central panel: the Madonna and Child enthroned, with Saint Paul and Saint Peter; above, the Annunciation
Left wing: Christ in Glory; the Last Supper; the Betrayal of Christ
Right wing: the Crucifixion; the Way to Calvary; the Flagellation

This altarpiece is one of the early works by the Master of the Magdalen, painted between 1265 and 1270. The types resemble those of Coppo di Marcovaldo, and Byzantine motives are reflected in the composition and the drapery folds of the Madonna and Child. The scenes begin with the Last Supper in the left wing and proceed chronologically counterclockwise to the Crucifixion at the top of the right wing,

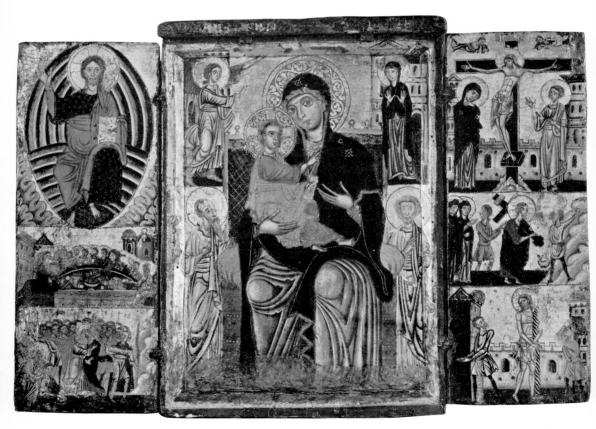

terminating with the Christ in Glory at the top of the left wing. In the scene of the Last Supper there is an iconographic peculiarity in the distinction made between Judas and the other apostles by his halo, which is blue instead of gold.

Formerly attributed by the Museum to an unknown Florentine painter of the middle of the XIII century.

Inscribed (illegibly) along the top of the central panel.

Tempera on wood; gold ground. Central panel, h. 16, w. 11⅛ in. (40.6×28.3 cm.); left wing, h. 15, w. 5⅝ in. (38.1×14.3 cm.); right wing, h. 15, w. 5½ in. (38.1×14 cm.).

REFERENCES: R. van Marle, *Ital. Schools*, I (1923), p. 355, fig. 191, attributes this painting to the Florentine school, dating it about the middle of the XIII century; and *Le Scuole della pittura italiana*, I (1932), pp. 347, note 3, 359, 361, fig. 230, rejects the attribution to the Master of the Magdalen // G. Vitzthum and W. F. Volbach, *Die Malerei und Plastik des Mittelalters in Italien* (*Hdbuch. der Kstwiss.*) (1924), pp. 245 f., attribute it to the circle of the Master of the Magdalen // R. Offner, *Ital. Primitives at Yale Univ.* (1927), pp. 12 f., fig. 4 B, attributes it to the Master of the Magdalen, placing it towards the beginning of his career; and *Corpus*, sect. III, vol. V (1947), pp. 48, note 1, 208, note 1, 259, attributes it to the Magdalen Master and dates it in the third quarter of the XIII century // E. Sandberg-Vavalà, *La Croce dipinta italiana* (1929), pp. 425, 440, mentions it among references for the iconography of the Betrayal and the Crucifixion; and *L'Iconografia della Madonna col Bambino nella pittura italiana del dugento* (1934), p. 40, no. 103, lists the Madonna and Child under the Hodegetria type, observing that the group appears in this painting reversed, and notes the close dependence of the draperies on the scheme of the Madonna and Child in the mosaics in Monreale, Sicily // G. M. Richter, *Burl. Mag.*, LVII (1930), p. 230, note 13, attributes this painting to the Master of the Magdalen // B. Rowland, Jr., *Art in Amer.*, XIX (1931), pp. 127, 133, attributes it to the circle of the Master of the Magdalen // P. D'Ancona, *Les Primitifs italiens du XI au XIII siècle* (1935), p. 104, attributes it to the Master of the Magdalen // R. Jacques, *Mitteil. des Ksthist. Inst. in Florenz*, V (1937), p. 24, discusses the

iconography and dates it in the middle of the century // G. Sinibaldi and G. Brunetti, *Pittura italiana del duecento e trecento* (1943), pp. 229 f., call it one of the earliest works of the Master of the Magdalen // G. Coor-Achenbach, *Burl. Mag.*, LXXXIX (1947), p. 120, note 12, attributes it to the shop of the Master of the Magdalen, notes its links with the early group, and suggests that the now obliterated inscription must have been related to the representation rather than to the painter of the picture; and *Burl. Mag.*, XCIII (1951), pp. 73, 77, attributes it to the Master of the Magdalen himself, dating it among the earliest known works by him, observes that it is the earliest known Italian painted altarpiece showing the Madonna and Child in full length, and notes the iconography of Judas in the scene of the Last Supper, comparing it with that in a panel from the shop of the Master of the Magdalen now in the Museum at Chambéry, France // E. B. Garrison, Jr., *Italian Romanesque Panel Painting* (1949), pp. 22, 111, no. 282, ill., and *Boll. d'arte*, XLI (1956), p. 308, attributes it to the Master of the Magdalen and dates it about 1265 // Thieme-Becker, XXXVII (1950), p. 210, lists it among the works of the Master of the Magdalen.

EX COLL. George and Florence Blumenthal, New York (by 1926; until 1941; Cat., I, 1926, pl. I).

GIFT OF GEORGE BLUMENTHAL, 1941.

The Madonna and Child (fragment)

64.189.1

This painting is apparently a fragment cut out of a very large damaged altarpiece representing the Madonna and Child enthroned and possibly accompanied by saints and angels. All that remains of the Child is a forearm and hand raised in blessing and one of his knees. The circular pattern between the Madonna's shoulders and her halo is probably part of the ornamentation of the throne. Damaged Italian pictures from the Romanesque period were sometimes given decorative metal covers like those on many icons, with openings revealing the undamaged sections, and it is possible that this painting may at one time have had such a

64.189.1

cover. At some point two pieces of new wood were added at the right to give the fragment symmetry and the whole enclosed in a simple molding. Even from this fragment it is clear that the painting was by the Master of the Magdalen himself, for the quality is such that helpers in his shop could not have done it. It was probably painted about 1280, towards the end of the period when he depended greatly on compositions by Meliore Toscano. A clue to its original appearance is provided by a small painting with a closely similar main group, the Madonna and Child enthroned with saints and angels in the Acton collection in Florence, a product of the Magdalen Master's shop.

Tempera on wood. H. 29½, w. (at bottom) 18¼ in. (74.9×46.3 cm.).

REFERENCES: O. Sirén, *Toskanische Maler im XIII Jahrhundert* (1922), p. 271, mentions this painting as a fragment of a large Madonna picture, attributed to the Magdalen Master // R. Offner (unpublished opinion, 1928) attributes it to the Magdalen Master // B. Rowland, Jr. *Art in Amer.*, XIX (1930–1931), pp. 127 ff., fig. 5, attributes it to the Magdalen Master, compares it to a panel in the Acton collection, Florence, a Madonna and Child in the Fogg Museum, and a frontal in the Blumenthal collection // R. van Marle, *Le Scuole della pittura italiana*, I, (1932), p. 347, accepts the attribution to the Magdalen Master // G. Sinibaldi and G. Brunetti, *Pittura italiana del duecento e trecento* (1943), pp. 237, no. 73, 236, ill., attribute it to the workshop of the Magdalen Master // R. Longhi, *Proporzioni*, II (1948), p. 44, quotes Sinibaldi and Brunetti (above) as attributing it to the workshop of the Magdalen Master // E. B. Garrison, Jr. *Italian Romanesque Panel Painting* (1949), p. 231, no. 640, attributes it to the Magdalen Master, dating it about 1270–1280 // D. C. Shorr, *The Christ Child* (1954), p. 111, attributes it to the Magdalen Master // C. L. Ragghianti, *Pittura del dugento a Firenze* (1955), p. 102, accepts the attribution to the Magdalen Master and calls it an early work.

EXHIBITED: Uffizi, Florence, 1937, *Mostra giottesca*, no. 74 (as Attributed to the Magdalen Master, lent by the Straus collection).

EX COLL.: possibly Jean Dollfus, Paris; Alphonse Kann, Paris (in 1920; until 1927; sale, American Art Association, New York, January 7, 1927, no. 45, as the Virgin by Cimabue); Jesse Isidor Straus, New York (1927–1936); Mrs. Jesse Isidor Straus, New York (1936–1964).

GIFT OF IRMA N. STRAUS, 1964.

Unknown Florentine Painter, Last Quarter of the XIII Century

The Madonna and Child Enthroned
69.280.4

An extensive restoration of the entire surface of this picture has weakened the forms and made it more difficult to identify the painter. Although the iconography is similar to that of groups common in Siena and Pisa during the thirteenth century, the execution of our painting and some elements of the composition suggest that it was made in Florence. In the rendering of the Madonna's face and hands, and in the folds of the draperies, there are significant resemblances to works by the Master of the Magdalen, especially the later ones. The attempted perspective of the throne and of the step below the Madonna's feet, which occurs also in

69.280.4

Duccio's so-called Rucellai Madonna in Santa Maria Novella in Florence, is probably derived from works by Cimabue and his immediate followers. The same influence could account for the placing of the Madonna's knees and feet.

Tempera on wood. H. 32¾, w. 21⅞ in. (83.2 ×55.5 cm.).

REFERENCE: E. B. Garrison, Jr., *Italian Romanesque Panel Painting* (1949), p. 44, no. 22, ill.,

attributes this painting to the Florentine school, dates it about 1280–1290, and observes considerable damage and repainting.

EX COLL.: [Elia Volpi, Florence; sale, New York, American Art Association, March 31, 1927, no. 374, as by Margaritone d'Arezzo]; [Ercole Canessa, New York; sale, New York, American Art Association, March 29, 1930, no. 90, as by Margaritone d'Arezzo]; Mrs. W. Murray Crane, New York (about 1930–1969).

GIFT OF MRS. W. MURRAY CRANE, 1969.

Unknown Florentine Painter, Late XIII Century

The Madonna and Child 41.100.21

This painting is representative of a group of artists of the late thirteenth-century Florentine school who were conservative and repeated in a crude and insensitive way the works of the great masters of preceding generations. Though our panel is related in composition to the circle of Coppo di Marcovaldo and is perhaps derived from a prototype by him, the figure of the Virgin shows a knowledge of Cimabue's Maestà, painted for the church of Santa Trinità and now in the Uffizi (no. 8343), which suggests a date about 1290, later than Coppo's known activity. The picture was at one time extensively repainted and has also suffered from early overcleanings, especially in the Virgin's face, where the modeling is partly lost and the greenish underpaint can be seen.

Inscribed in Greek (on each side of the Virgin's halo): "Mother of God."

Formerly attributed by the Museum to an unknown Tuscan painter of the XIII century.

Tempera on wood; gold ground. H. 60½, w. 36 in. (153.7×91.5 cm.).

REFERENCES: W. Suida, *Monats. für Kstwiss.*, II (1909), pp. 65 ff., fig. 2, calls this picture a work painted outside Tuscany, perhaps in the Marches or in Bologna, and dates it about 1300 // O. Sirén, *Art in Amer.*, III (1915), p. 283, attributes it to the anonymous artist who painted a panel in the Jarves collection in the Yale University Art Gallery, New Haven, and a panel with the Magdalen in the Accademia in Florence // R. van Marle, *Ital. Schools*, I (1923), p. 304, attributes it to the Florentine school, dating it about 1300 // E. B. Garrison, Jr., *Italian Romanesque Panel Painting* (1949), p. 82, no. 193, ill., attributes it to the Florentine school and dates it between 1285 and 1290.

EXHIBITED: Metropolitan Museum, New York, 1943, *Masterpieces of the Collection of George Blumenthal*, no. 18.

EX COLL.: [H. O. Miethke, Vienna, 1909]; private collection, Florence (about 1927); George and Florence Blumenthal, New York (about 1927; until 1941).

GIFT OF GEORGE BLUMENTHAL, 1941.

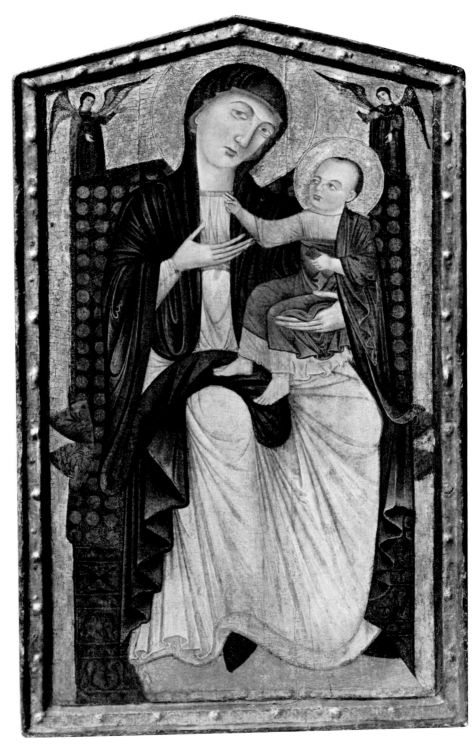

41.100.21

The Master of Varlungo

Active from about 1285 to the first decade of the fourteenth century. The Master of Varlungo is the name given by Offner to the painter of about nine panels, which he was the first to relate to a Madonna and Child in the church of San Pietro in Varlungo, a village near Florence. The paintings reveal a talented Florentine artist, strongly influenced by Cimabue. His earliest works are somewhat similar to the work of Coppo di Marcovaldo, while a few of the later ones show a knowledge of Duccio's Rucellai Madonna, painted for the church of Santa Maria Novella in Florence about 1285 (now in the Uffizi).

The Madonna and Child Enthroned with Angels 49.39

This painting, dating from about 1290, is characteristic of the Master of Varlungo and shows clearly his dependence on Cimabue. The composition, including the type of the throne, the angels, and the Child's position, was directly inspired by a prototype similar to the altarpiece in the church of Santa Maria dei Servi in Bologna, usually attributed to Cimabue or to one of his immediate followers. The Virgin's expressive face in our painting shows how some of the more progressive Florentine artists of the period, perhaps under the spell of the young Giotto, broke away from late Byzantine conventions. The base of the throne, cut at the lower edge, suggests that a strip has been lost from the bottom of the panel.

Formerly attributed by the Museum to an unknown Florentine painter of the XIII century.

Tempera on wood; silver ground. Over-all size, h. $51\frac{1}{4}$, w. $32\frac{5}{8}$ in. (130.1×82.6 cm.); painted surface, h. $50\frac{1}{4}$, w. 28 in. (127.6×72.3 cm.).

REFERENCES: R. Lehman, *The Philip Lehman Collection* (1928), no. II, ill., attributes this painting to the Florentine school of about 1285 // E. Sandberg-Vavalà, *L'Iconografia della Madonna col Bambino nella pittura italiana del dugento* (1934), p. 66, attributes it to an anonymous Florentine painter of the late XIII century and observes its close relationship to Cimabue's altarpiece in the church of Santa Maria dei Servi in Bologna // R. Offner (verbally, 1940) and in D. C. Shorr, *The Christ Child* (1954), p. 118, ill., p. 124, attributes it to the Master of Varlungo // R. Longhi, *Proporzioni*, II (1948), p. 48, pl. 35, attributes it to the Master of Varlungo // E. B. Garrison, Jr., *Italian Romanesque Panel Painting* (1949), pp. 32, 44, no. 24, ill., attributes it to the Master of Varlungo and dates it between 1285 and 1290 // C. L. Ragghianti, *Pittura del dugento a Firenze* (1955), p. 127, accepts the attribution to the Master of Varlungo, dating his activity between 1290 and 1310 // F. Bologna, *La Pittura italiana delle origini* (1962), p. 130, attributes it to the Master of Varlungo, observing the combined influence of Cimabue and Duccio // G. Previtali, *Giotto e la sua bottega* (1967), pp. 30, 136, note 104, calls it a work by the Master of Varlungo, rejects E. B. Garrison's dating, notes a similarity in the Child to a Madonna and Child in the Contini Bonacossi collection, Florence.

PROVENANCE: possibly from the convent of Santa Croce, Florence.

EX COLL.: [Paolo Paolini, Rome]; Philip Lehman, New York (by 1928; until 1947; Cat., 1928, no. II); Robert Lehman, New York (1947–1949).

GIFT OF ROBERT LEHMAN, 1949.

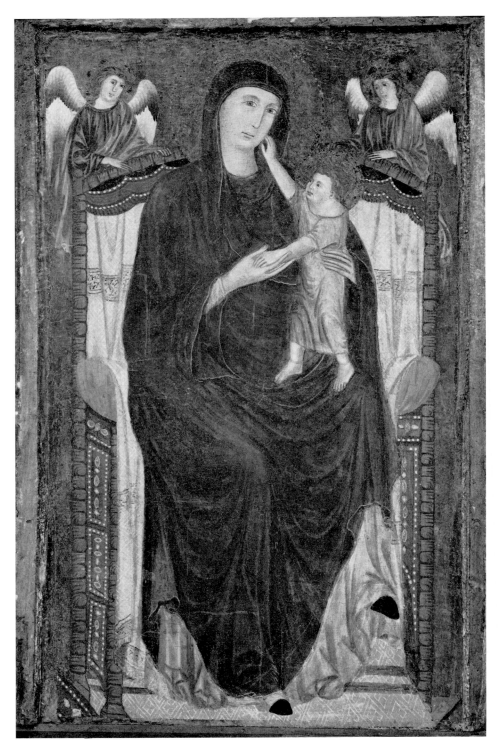

49·39

Giotto

Giotto di Bondone. Born 1266 or 1276; died 1337. For centuries Giotto has been considered the founder of the Florentine school and the originator of the new conception of painting that gradually spread through Europe and survived as an influence until the advent of non-representational painting in the twentieth century. According to tradition he was the pupil of Cimabue, but his style was evidently affected by the sculpture of Arnolfo di Cambio and by the Roman school of painting of the second half of the thirteenth century. It was Giotto's genius above all others that made the decisive break with the Byzantine tradition dominating Italian painting. In his works the expression of human feeling and character is combined with an entirely new attitude towards form in relation to the surrounding space. Giotto's most important extant works are the frescoes in the Arena Chapel in Padua (about 1304–1305) and in Santa Croce in Florence and the large panel of the Madonna and Child with angels now in the Uffizi Gallery. The attribution to him of the cycle of frescoes in the upper church of San Francesco in Assisi remains doubtful, although it has been accepted by a large number of prominent scholars. Giotto was employed by Cardinal Stefaneschi in Rome, by King Robert of Naples, by Azzo Visconti in Milan, and by the lords of Rimini. His followers and pupils were many, and his influence not only overshadowed the artists of the immediately succeeding generations in Florence but also shaped the creators of the Florentine Renaissance, such as Masaccio and the young Michelangelo Buonarroti.

The Epiphany 11.126.1

This is one of a series of scenes of the life of Christ, seven of which are known today. The other scenes are: the Presentation in the Temple in the Gardner Museum in Boston, the Entombment in the Berenson collection in Settignano, the Pentecost in the National Gallery in London (no. 5360), and, in the Alte Pinakothek in Munich, the Last Supper, the Crucifixion with Saint Francis, and the Christ in Limbo (nos. 643, 667, 5295). It is not known how many panels there originally were in the series, but it is likely that some are still missing. Nor is it known exactly how the panels were arranged or where they were placed. They could have ornamented the cupboard doors of a sacristy, but they were more probably part of an altarpiece. The presence of Saint Francis kneeling at the foot of the cross in the Munich Crucifixion suggests that they were made for a Franciscan church. Judging from their style, the seven panels seem to belong to Giotto's mature period, and they must have been painted about the time of the frescoes in the Peruzzi chapel in Santa Croce, which were possibly done about 1320. Some areas are poorly executed, probably by assistants, but the admirably high quality of many compositional and spatial ideas, as well as a large part of the actual painting must be ascribed to Giotto himself. In iconography and composition the scenes

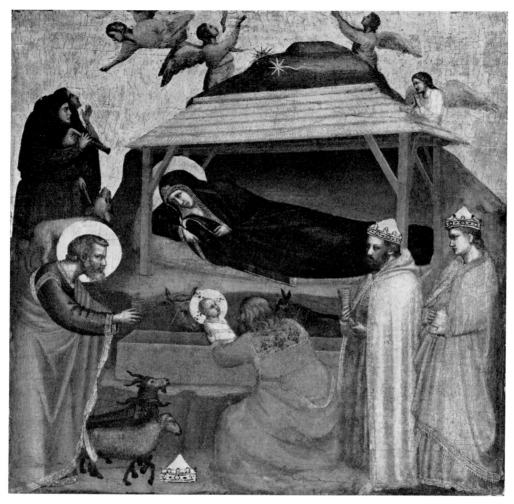

11.126.1

differ a good deal from Giotto's correspond-
ing frescoes in Padua. Our panel is unusual
in the daring gesture of the kneeling king,
who lifts the child from the manger, and in
combining the Annunciation to the Shep-
herds and the Nativity with the Adoration
of the Magi (see Refs., M. Meiss, 1936).

Formerly attributed by the Museum to the
workshop of Giotto (Cat., 1940).

Tempera on wood; gold ground. H. 17¾,
w. 17¼ in. (44.9 × 43.7 cm.).

REFERENCES: G. F. Waagen, *Galleries and Cabinets*,
IV (1857), p. 234, possibly refers to this picture in
mentioning two good pictures of the school of
Giotto in the Fox collection but assumes errone-
ously that they came from the Sandford (*sic*)
collection // B. B[urroughs] *Met. Mus. Bull.*, VI
(1911), p. 216, ill. p. 215, attributes it to a pupil of
Giotto, dates it before Giotto's death, and observes
that it resembles in composition the Nativity in the
Arena Chapel at Padua // F. J. Mather, Jr., in a
letter, 1911, and *Amer. Journal of Archeol.*, XVI
(1912), p. 102, considers it designed and partly
executed by Giotto but painted in the main by
Taddeo Gaddi, dates it about 1320–1325, and
connects it with the Gardner panel, considering

them door panels rather than predella panels; *Hist. of Ital. Ptg.* (1923), p. 475, lists the series as from the workshop of Giotto, dating it after 1330; and *Art Studies*, III (1925), p. 31, calls the series a product of the school of Giotto rather than his workshop // J. P. Richter (in a letter, 1911) attributes this panel to Giotto and connects it with the Gardner panel // O. Sirén, *Giotto and Some of His Followers* (1917), I, pp. 79 f., pl. 60, no. 1, considers it painted either by Giotto or under his direct supervision, connects it with the five other panels then known, and suggests that they all belonged to a larger series probably commissioned for a Franciscan church // I. B. Supino, *Giotto* (1920), pp. 270 f., pl. CCXLII, attributes it to Giotto's workshop // R. van Marle, *Recherches sur l'iconographie de Giotto et de Duccio* (1920), p. 9, note 5, and *Ital. Schools*, III (1924), pp. 186 ff., fig. 108, attributes it to an assistant of Giotto and dates it about the time of the frescoes in the chapel of the Magdalen in the lower church of San Francesco at Assisi // W. Hausenstein, *Giotto* [1923], pp. 15, 189, 191, states that even if the series is by Giotto it is unimportant in his work // G. Vitzthum and W. F. Volbach, *Die Malerei und Plastik des Mittelalters in Italien (Hdbuch. der Kstwiss.)* (1924), p. 265, attribute it to the workshop of Giotto // C. H. Weigelt, *Giotto (Kl. der Kst.)* (1925), p. 242, attributes it to the school of Giotto and suggests that it was part of the predella of an altarpiece or of the decoration of a door or a sacristy chest // W. Rankin (in a letter, 1926) attributes it tentatively to Giotto // P. Hendy, *Burl. Mag.*, LIII (1928), p. 23, pl. II B, and *The Isabella Stewart Gardner Museum, Catalogue of the Exhibited Paintings and Drawings* (1931), p. 171, attributes it to Giotto // P. Toesca, *Florentine Painting of the Trecento* (1929), p. 66, attributes it to a follower of Giotto; and *Il Trecento* (1951), p. 610, attributes it to a pupil of Giotto who collaborated with him in the frescoes of the Arena chapel // R. Fry, *Burl. Mag.*, LVI (1930), p. 83, observes the strong Giottesque character of the panels, and hesitantly suggests attributing them to a close follower // R. Longhi, *Dedalo*, XI (1930), p. 290, attributes our panel to Giotto, tentatively suggesting that it formed part of an altarpiece for the church of Santa Croce in Florence; and *Proporzioni*, II (1948), p. 51, dates the series at the same time as Giotto's frescoes in the Peruzzi chapel in Santa Croce; and *Paragone*, III (1952), no. 25, p. 8, suggests that it belonged to one of the four altarpieces by Giotto that Ghiberti mentioned as in the church of Santa Croce in Florence, probably the one in the Peruzzi chapel there // P. G. Konody, *Works of Art in the Collection of Viscount Rothermere* (1932), text for pl. 3, attributes the series to Giotto // B. Berenson, *Ital.*

Pictures (1932), p. 235, lists it as a product of Giotto's workshop; and *Flor. School* (1963), p. 82, lists the series among the works of Giotto's assistants // L. Venturi, *Ital. Ptgs. in Amer.* (1933), pl. 30, attributes it to Giotto // R. Offner (verbally, 1935) attributes it to a follower of Giotto; and *Corpus*, sect. III, vol. V (1957), p. 212, note 1, calls it Giottesque, discusses its iconography, and observes that it is the earliest Florentine instance of combining different episodes related to the Nativity // M. Meiss, *Art Bull.*, XVIII (1936), p. 456, note 74, calls it a work of the school of Giotto and discusses its iconography; and *Painting in Florence and Siena after the Black Death* (1951), p. 149, note 70, attributes it to the school of Giotto // C. Gamba, *Riv. d'arte*, XIX (1937), p. 274, attributes the series to Giotto, assisted by pupils // W. Suida, *Pantheon*, XX (1937), p. 350, calls our panel a product of Giotto's workshop // L. Coletti, *Boll. d'arte*, XXXI (1937), p. 57, considers the series perhaps executed under Giotto's direction // M. Salmi, *Emporium*, LXXXVI (1937), pp. 358 ff., ill., attributes the series to the workshop of Giotto and suggests that the scenes were originally disposed in two rows, forming a small altarpiece for a Franciscan church, perhaps in upper Italy, where this type of altarpiece was rather common // E. Cecchi, *Giotto* (1937), pp. 124, 174, pl. 173, assigns it to Giotto's workshop // C. Brandi, *Le Arti*, I (1938), p. 125 f., pl. L, attributes it to a follower of Giotto // T. Borenius, *Burl. Mag.*, LXXXI (1942), p. 277, adds to the six known panels the newly discovered Pentecost in the National Gallery, London, and ascribes them all to the workshop of Giotto but very near to Giotto himself // G. Sinibaldi and G. Brunetti, *Pittura italiana del duecento e trecento* (1943), p. 343, no. 105, attribute our panel to the workshop of Giotto, dating the series at about the same time as the frescoes in the Florentine chapels (Santa Croce) // M. Davies, *The Earlier Italian Schools (National Gallery Catalogue)* (1951), pp. 180 f., 304, attributes the series to the workshop of Giotto rather than to Giotto himself, suggesting that the panels ornamented the cupboard doors of some sacristy, and notes the rare detail of Saint Joseph holding the first king's gift // R. Salvini, *Tutta la pittura di Giotto* (1952), p. 50, pl. 95, attributes our panel and the others to the workshop of Giotto and observes that they reflect Giotto's late style // *Art Treasures of the Metropolitan* (1952), p. 223, no. 70, pl. 70 (in color) // T. Rousseau, Jr., *Met. Mus. Bull.*, n.s., XII (1954), p. 8, ill. // F. Zeri, *Paragone*, VIII (1957), no. 85, p. 78, attributes the series to Giotto // C. Gnudi, *Giotto* (1958), pp. 220 f., 248, pl. 160, attributes our panel and the other six to Giotto and dates them at the same time as the frescoes in the

Peruzzi chapel in Santa Croce / / D. Gioseffi, *Giotto architetto* (1963), p. 66, fig. 64 B, calls the entire series the product of the workshop, reflecting Giotto's late style / / G. Previtali, *Giotto e la sua bottega* (1967), pp. 112, 346, and passim, pl. LXXXI (in color), calls our picture a work by Giotto, dates it after 1305 and before 1319, possibly between 1310 and 1315, relates it to the other pictures in the series and calls it a fragment of a Franciscan "paliotto" (altar frontal), noting that the figure of the kneeling Magus is very similar to that of an apostle in the Berlin Dormition of the Virgin / / F. Bologna, *Novità su Giotto* (1969), pp. 97 f., gives the series to Giotto, rejects the connection with the Peruzzi chapel, and suggests that the seven panels may belong to an altarpiece painted by Giotto for Borgo San Sepolcro that Vasari mentions as having had small figures and as later having been split and taken first to Arezzo and then to Florence, where it was in the collection of Baccio Gondi; and *I Pittori alla Corte Angioina di Napoli* (1969),

pp. 190 ff., 229, notes 79–81, dates it about 1327, calling it a fragment from the altarpiece for San Francesco at Borgo San Sepolcro.

EXHIBITED: Uffizi, Florence, 1937, *Mostra giottesca*, no. 105 (as Attributed to Giotto); Metropolitan Museum, New York, 1952–1953, *Art Treasures of the Metropolitan*, no. 70.

EX COLL.: Prince Stanislas Poniatowski, Palazzo Poniatowski, Florence (sale, Christie's, London, Feb. 9, 1839, no. 101, as Giotto); Hall, London (?); General Charles Richard Fox, London (by 1857; sale, Christie's, London, July 4, 1874, no. 37, with the Entombment, as Early Italian School); Daniell, London (?); William Fuller-Maitland, Stansted House, Essex (by 1893; until about 1911; Cat. of Pictures, 1893, p. 12, no. 37, as Giotto); [R. Langton Douglas, London, 1911].

PURCHASE, KENNEDY FUND, 1911.

Unknown Florentine Painter, Second Quarter of the XIV Century

The Madonna and Child 47.143

It is probable that this panel was originally the center of a large altarpiece. Its style is clearly that of a Florentine painter working in the second quarter of the fourteenth century. The facial type of the Madonna, as well as the psychological relationship between the figures, recalls the Master of Santa Cecilia and is closely connected with the so-called Lippus di Benivieni. The Madonna's face, though much finer, foreshadows the types that the Florentine Jacopo del Casentino painted in the next generation. Although certainty is impossible, this Madonna could almost be attributed to the Master of the Fogg Pietà, on the basis of its great similarities to his fresco in the sacristy of the lower church of San Francesco in Assisi,

representing the enthroned Madonna and Child with two Saints and angels (see A. Graziani, *Proporzioni*, I, 1943, figs. 86, 88–90, and R. Offner, *Corpus*, sect. III, vol. VI, 1956, pl. XXXII). But if by the same painter it would belong to a slightly earlier stage in his development. An earlier dating is also suggested by the motive of the Child standing on his mother's lap, used by the older painters in Giotto's following, especially those, both from Florence and from the Umbro-Romagnole region, who knew the paintings at Assisi. This picture may have been painted for the Franciscan order, as the Child's pink robe is tied with what would appear to be a Franciscan girdle, once painted in gold but now partly effaced. Another example of the Infant Christ in a pink robe standing on the Madonna's lap is to be found in a Riminese Maestà of about 1320, which

seems also to have been painted for the Franciscan order because of the presence of the kneeling figures of Saint Francis and Saint Clare (formerly in the Prince Galitzine collection, London, now in the Vittorio Cini collection, Venice). The present shape of the panel is the result of at least two cuttings, one which removed the pointed top and cut off part of the rich tooling of the Madonna's halo and one, on the left side, which removed a tooled border like the one remaining on the right.

Formerly attributed by the Museum to an unknown Florentine painter, about 1290.

Tempera on wood; gold ground. H. 24¼, w. 16½ in. (63 × 42 cm.).

REFERENCES: R. Lehman, *The Philip Lehman Collection* (1928), no. III, ill., attributes this painting to the Florentine school of about 1290 // E. Sandberg-Vavalà (verbally, 1939) attributes it to a Florentine artist of the early XIV century, with resemblances to the Master of Santa Cecilia and Pacino di Bonaguida // F. Bologna, *I Pittori alla Corte Angioina di Napoli* (1969), pp. 224, 233, note 265, attributes it to an artist active around 1330 who painted a Coronation of the Virgin in the Museum at Valencia, a Saint John the Baptist in the gallery of Christ Church College at Oxford, a crucifix at Oberlin College, and the Crucifixion in the Thyssen collection at Lugano (no. 137).

EX COLL.: [Paolo Paolini, Rome, about 1923];

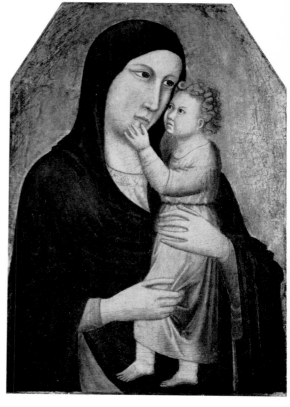

47.143

Philip Lehman, New York (by 1928; until 1947; Cat., 1928, no. III); Robert Lehman, New York (1947).

GIFT OF ROBERT LEHMAN, 1947.

Pacino di Bonaguida

Active by 1303; still active after 1320. The only work certainly by Pacino is a signed polyptych in the Accademia in Florence, which bears a partly effaced date that has been tentatively read as 1315. The large number of panel paintings and illuminations that can be convincingly connected with this altarpiece show that Pacino headed a very productive workshop. His style is related to that of Giotto in his early period and to that of such early Giottesque painters as the Master of Santa Cecilia.

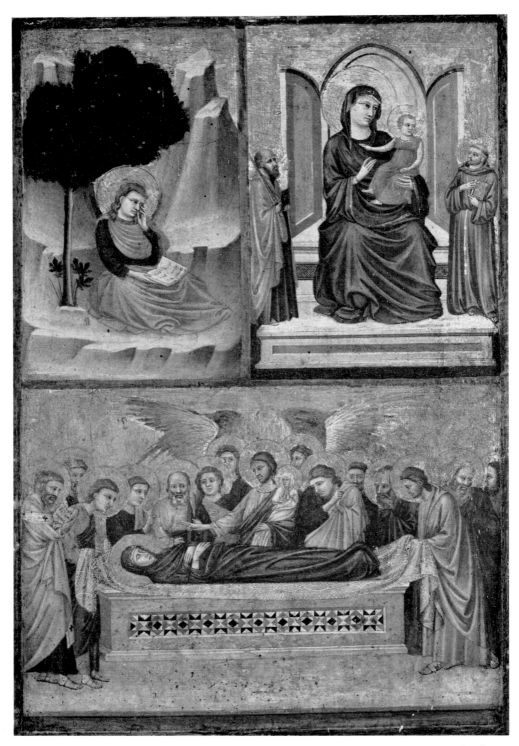

64.189.3 A

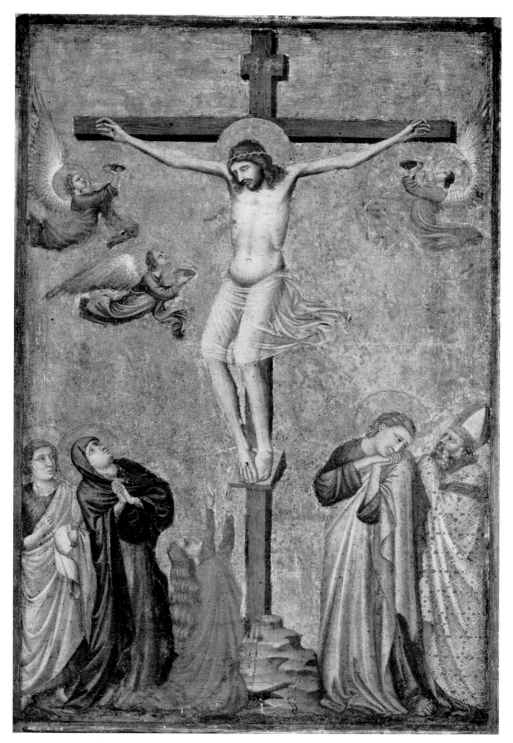

Diptych 64.189.3 A, B

Left wing: Saint John on Patmos; the Madonna and Child enthroned with Saint Paul and Saint Francis; the Death of the Virgin

Right wing: the Crucifixion with Saint John the Baptist, the Virgin, Saint Mary Magdalen, Saint John the Evangelist, and a bishop saint

It is difficult to decide whether the Crucifixion was originally at the left or at the right. In chronological sequence it should follow the Madonna and Child but precede the Death of the Virgin and the scene showing Saint John on Patmos. By placing the Crucifixion at the right the sequence would begin with the Madonna and Child in the left panel and move clockwise through the other three scenes. There are examples of painted panels dating from the early fourteenth century in which the episodes were arranged in a clockwise sequence. The Crucifixion, however, is an event of such importance that it could be placed at either side, without regard to its place in the historical sequence of events. The style of this painting is apparently based upon early Giottesque themes and forms. Its date would seem to be about 1310. There is a close affinity between this diptych and similar paintings made in Rimini during the first quarter of the fourteenth century which also reflect Giotto's early work.

Tempera on wood. Left wing, h. 24¾, w. 16 in. (61.9×40.6 cm.); right wing, h. 24¾, w. 15¾ in. (61.9×40 cm.).

REFERENCES: The authorities cited below agree in attributing this diptych to Pacino di Bonaguida. R. Offner, *Studies in Florentine Painting* (1927), pp. 8 ff., fig. 11, opp. p. 3 (the Crucifixion); and *Corpus*, sect. III, vol. II, part I (1930), pp. II, VII, VIII, 5, pl. VI, VI¹, VI², VI³, VI⁴, vol. II, part II, p. 201 (listed), pp. 221, 225 // M. Salmi, *Riv. d'arte*, series II, I (1929), p. 134; and *Atti della Società Colombaria* (1931–1932), p. 8 // G. Sinibaldi and G. Brunetti, *Pittura italiana del duecento e trecento* (1943), p. 405, ill. pp. 404, no. 125 a (left wing), 405, no. 125 c (detail, Saint John on Patmos), 406, no. 125 b (right wing) // M. Boskovits, *Zeitschr. für Kstgesch.*, 29 (1966), pp. 61 f., fig. 14 (Crucifixion).

EXHIBITED: Uffizi, Florence, 1937, *Mostra giottesca*, no. 131 (lent by the Straus collection).

EX COLL.: a private collection, Impruneta; [Bellini, Florence, 1924]; Jesse Isidor Straus, New York (1924–1936); Mrs. Jesse Isidor Straus, New York (1936–1964).

GIFT OF IRMA N. STRAUS, 1964.

Maso di Banco

Known activity 1320–1346. Maso was a painter highly praised by the late fourteenth-century Florentine writer Filippo Villani. Although no signed work by him has survived, a homogeneous group of paintings has been convincingly attributed to him by Offner. This group includes a cycle of frescoes in the chapel of Saint Sylvester in the church of Santa Croce in Florence, four panels of a polyptych, including our panel, and a polyptych in the church of Santo Spirito in Florence. The frescoes in Santa Croce were ascribed to Maso by Lorenzo Ghiberti towards the middle of the fifteenth century, and about a hundred years later by the

Codice Magliabechiano. Vasari attributed them to Tommaso di Stefano called Giottino, mistakenly combining three names, Stefano, Giottino, and the real Maso (Tommaso) di Banco. The frescoes, probably painted soon after 1336, were commissioned by a member of the Bardi family, powerful Florentine bankers. A document of 1341 mentions Maso di Banco as involved in a legal controversy with the Bardi. Maso's noble and solemn style, with types derived from Giotto's middle period, shows that he truly understood the contemporary problems of space and perspective. The small group of works attributed to him make it plain that he was one of the greatest painters of the fourteenth century in Florence. The work of some of his contemporaries, such as Bernardo Daddi in Florence and the Lorenzetti in Siena, echoes his painting. His influence extended to the Orcagna brothers, and later artists, as long as the Giottesque tradition survived, used his themes, but sometimes without understanding them.

Saint Anthony of Padua 43.98.13

This panel originally belonged to a polyptych, as did a Madonna and Child, which was its center, in the Berlin Museum (no. 1040) and two panels formerly there but destroyed in the war, a Saint Anthony Abbot (no. 1529) and a Saint John the Baptist (no. 1530). There must have been a fifth panel, perhaps representing Saint John the Evangelist. The four known panels were acquired by the Berlin Museum in 1821, possibly as a complete polyptych with the lost panel, which may now be unrecognized in some provincial German museum. Soon afterwards the Madonna was exhibited in the Berlin Museum, first as a work of the school of Giotto and later as a work by Bernardo Daddi, while our painting was kept in storage, and the paintings of Saint Anthony Abbot and John the Baptist were lent, under the name of Gherardo Starnina, to the Stadt Museum in Königsberg, East Prussia, where they remained until 1934 (they were destroyed in 1945). These panels show a close affinity to Maso's frescoes in the Bardi chapel in the church of Santa Croce in Florence, suggesting that they were painted at about the same time in the painter's

career. As the frescoes are believed to have been begun soon after 1336, a dating towards the end of the 1330's is most likely for the panels. In our painting the placing of the figure and the halo at one side of the central axis of the panel and the extension of the painted sleeves over the tooled border emphasize the solid, three-dimensional structure of the forms and their freedom from the flat traditional gold ground.

Tempera on wood; gold ground. H. $29\frac{1}{4}$, w. 16 in. (74.3 × 40.2 cm.).

REFERENCES: G. F. Waagen, *Verzeichn. aer Gemäldesmlg. des Königl. Museum zu Berlin* (1837), p. 284, calls this painting a work of the school of Giotto // M. Logan Berenson (in a letter, 1927) calls it a work close to Giotto // R. Offner, *Burl. Mag.*, LIV (1929), pp. 224 f., ill. p. 228, reconstructs the polyptych to which our saint belonged, except for the fifth panel, relating it to the polyptych in Santo Spirito and to the frescoes in Santa Croce; identifies the painter of this group as Maso di Banco // W. Suida, in Thieme-Becker, XXIV (1930), p. 209, accepts Offner's reconstruction and mentions the four panels among works attributed to Maso // B. Berenson, *Dedalo*, XI (1930–1931), pp. 986, 988, note 3, and 1073, note 5, calls it a Franciscan saint by Maso and accepts the reconstruction; *Ital. Pictures* (1932), p. 337, lists it as a Franciscan saint by Maso; and *Flor. School* (1963), p. 136, lists it as Saint Anthony by Maso, part of the same polyptych as the Berlin panels // L. Venturi,

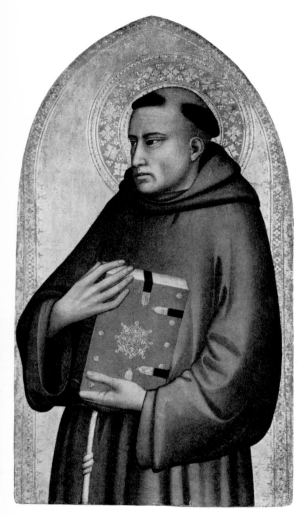

43.98.13

Ital. Ptgs. in Amer. (1933), pl. 35, attributes it to Maso, accepting the reconstruction // H. D.

Gronau, *Andrea Orcagna und Nardo di Cione* (1937), pp. 81, note 82, and 83, note 118, accepts the attribution to Maso and the reconstruction, suggesting a date about 1340 // L. Coletti, *Boll. d'arte*, XXXI (1937), p. 67, fig. 20; and *I Senesi e i giotteschi* (*I Primitivi*, II) (1946), p. 36, pl. XLI, accepts the attribution to Maso and the reconstruction // E. Cecchi, *Giotto* (1937), p. 121, mentions it as a Franciscan saint by Maso // G. Sinibaldi and G. Brunetti, *Pittura italiana del duecento e trecento* (1943), pp. 481ff., ill., no. 152, accept the attribution to Maso and the reconstruction // *Met. Mus. Bull.*, n.s., II (1944), p. 158, ill. // P. Toesca, *Il Trecento* (1951), p. 628, accepts the attribution to Maso and the reconstruction, dating it at the same time as the Santa Croce frescoes or somewhat later // R. Longhi, *Paragone*, X (1959), no. 109, p. 34, and no. 111, p. 6, accepts the attribution to Maso and the reconstruction // V. N. Lazarev, *The Origins of the Italian Renaissance*, Russian ed., II (1959), p. 101, pl. 138, accepts the attribution to Maso and the reconstruction.

EXHIBITED: New York, 1930, Century Association, *Exhibition of Italian Primitive Paintings*, no. 22 (as Maso di Banco, lent by M. F. Griggs); Uffizi, Florence, 1937, *Mostra giottesca*, no. 152 (as attributed to Maso di Banco, lent by M. F. Griggs); New York, World's Fair, 1939, *Masterpieces of Art*, no. 240 (as Maso di Banco, lent by M. F. Griggs); New York, Metropolitan Museum, 1944, *The Maitland F. Griggs Collection*; Hartford, 1965, Wadsworth Atheneum, *Exhibition of Italian Panels and Manuscripts . . .*, no. 4.

EX COLL.: Edward Solly, London (until 1821); Kaiser Friedrich Museum Berlin (1821–1926; Cat., 1921, p. 601, no. III, 62, as school of Giotto); [Edward Hutton, London, 1926]; Maitland Fuller Griggs, New York (1926–1943).

BEQUEST OF MAITLAND FULLER GRIGGS, 1943.

Taddeo Gaddi

Active by 1334; died 1366. Taddeo's earliest dated work is the small triptych of 1334 in the Berlin Museum, which is almost identical to the one by Bernardo Daddi (1333) now in the Museum of the Bigallo in Florence. He later (1341–1342) worked in San Miniato al Monte in Florence, in San Francesco, and in the Camposanto in Pisa, and in 1353 he completed the altarpiece for the church of San Giovanni Fuorcivitas in Pistoia. His style is closely

connected with that of Giotto's late works, and it is very likely that he collaborated in some of them. He was also influenced by Maso di Banco. Taddeo's frescoes in the Baroncelli chapel in Santa Croce in Florence (1332–1338) and those in the Camposanto in Pisa show his profound understanding of the problems of space and perspective and are among the most remarkable achievements of fourteenth-century Florentine painting. His late work declined sharply in quality, revealing the participation of a number of pupils and assistants.

The Madonna and Child Enthroned with Saints 10.97

Left: Saint Lawrence, Saint John the Baptist

Right: Saint James, Saint Stephen

This altarpiece is in the style of Taddeo's work of about 1340. The structure of the figures and their relation to the gold ground and to the shape of the panels may be in part due to the influence of Maso di Banco. It was originally a polyptych composed of five panels with pointed tops, but in the late fifteenth century it was remodeled and reframed in the style then current in Florence. The tops of the panels were cut, pilasters were painted in between, the Virgin's garments were greatly enriched, and the four Evangelists were added in the spandrels. The figures of the Evangelists reveal the hand of an artist trained in the Ghirlandaio workshop, recalling paintings from the workshops of Bastiano Mainardi and Bartolomeo di Giovanni. (For similarly remodeled polyptychs, see R. Offner, *Corpus*, sect. III, vol. V, 1957, p. 88, note 10.) Our painting has been tentatively identified with an altarpiece which Vasari mentions as a work by Taddeo Gaddi on the high altar of the church of Santo Stefano al Ponte Vecchio. Vasari first attributed the predella of the altarpiece to Taddeo as well but elsewhere said that it was by Antonio Veneziano (G. Vasari, *Vite*, 1568, Milanesi ed., I, 1878, pp. 574, 663). The predella probably represented stories of

Saint Stephen, and some scholars have identified it as the predella with eight scenes from the lives of Saint Stephen and Saint Lawrence by Bernardo Daddi that is now in the Vatican Gallery (nos. 30–37; see M. Salmi, *Boll. d'arte*, VIII, 1928, p. 452, note 17). There is no documentary evidence connecting the Vatican predella with our painting, but its width over all (each panel 12 in., 30.5 cm.) matches roughly the width of our painting. Another series of six scenes from the lives of Stephen and Lawrence attributed to Taddeo Gaddi, in the Brooklyn Museum (nos. 03.74–79), has also been thought to be the predella mentioned by Vasari, but it seems rather to come from the circle of Niccolò di Pietro Gerini and Lorenzo di Niccolò, and a connection with our painting is unlikely.

Inscribed (on XV century frame under the corresponding XIV century panels): S. LAVRENTIVS S. IOHANES S. MARIA: MATER DEI S. IACOBVS S. STEFANVS.

Tempera on wood; gold ground. Over-all size, h. 43¼, w. 90⅛ in. (109.8×228.9 cm.); Saint Lawrence, h. 43¼, w. 15½ in. (109.8× 39.4 cm.); Saint John, h. 43¼, w. 13½ in. (109.8×34.3 cm.); Madonna and Child, h. 43¼, w. 28½ in. (109.8×72.4 cm.); Saint James, h. 43¼, w. 15¾ in. (109.8×40 cm.); Saint Stephen, h. 43¼, w. 16¾ in. (109.8× 42.5 cm.).

REFERENCES: F. Mason Perkins, *Rass. d'arte*, IV (1904), p. 153, and *Burl. Mag.*, V (1904), part II, p. 584, mentions this altarpiece as a Gaddesque

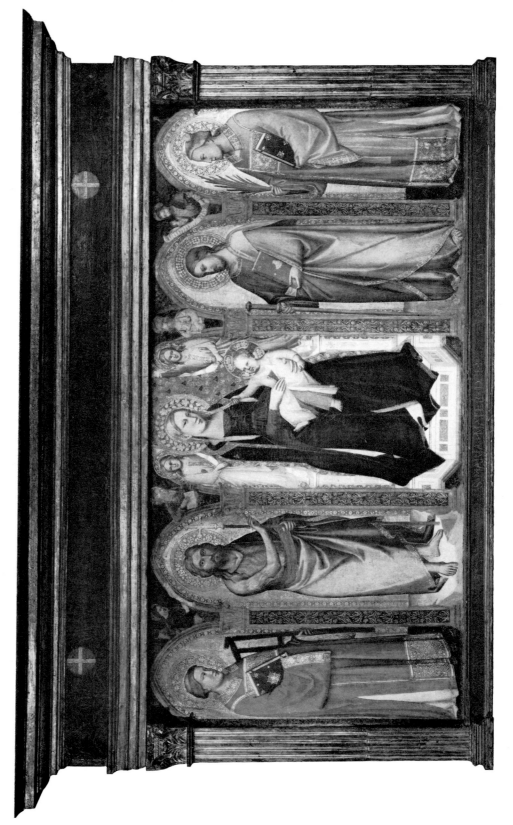

work // C. Ricci, *Il Palazzo Pubblico di Siena e la mostra d'antica arte senese* (1904), p. 69, attributes it to Taddeo Gaddi but considers the pilasters and the figures of the Evangelists the addition of a follower of Ghirlandaio // F. J. Mather, Jr., *Met. Mus. Bull.*, V (1910), pp. 252 ff., ill., attributes it to Taddeo, dates it towards the end of his life, ascribes the figures of the Evangelists to a follower of Ghirlandaio, suggests its possible identity with an altarpiece in the church of Santo Stefano al Ponte Vecchio mentioned by Vasari, and tentatively relates to it a predella of six panels showing scenes from the life of Saint Lawrence in the Brooklyn Museum, which he attributes to Taddeo // O. Sirén, *Giottino* (1908), p. 88, lists it among the works by Taddeo Gaddi; *Giotto and Some of His Followers* (1917), I, p. 154, pl. 132, no. II, attributes it to Taddeo // B. C. Kreplin, in Thieme–Becker, XIII (1920), p. 32, lists it as a work by Taddeo with later additions // R. van Marle, *Ital. Schools*, III (1924), p. 341, fig. 200, attributes it to Taddeo and suggests that it was contemporary with the Madonna of 1355 in the Uffizi in Florence // B. Berenson, *Ital. Pictures* (1932), p. 215, lists it as a work by Taddeo; and *Flor. School* (1963), p. 71 // L. Venturi, *Ital. Ptgs. in Amer.* (1933), pl. 49, attributes it to Taddeo, finds it similar to a polyptych in San Martino a Mensola, near Florence, and notes the late XV century additions // R. Offner (verbally, 1935) attributes it to Taddeo, dates it about 1340, and dates the frame about 1500; and *Corpus*, sect. III, vol. VIII (1958), p. 202, rejects as arbitrary the suggestion of W. and E. Paatz (1953,

below) that its predella was the one by Bernardo Daddi now in the Vatican Gallery, even if there were proof that our painting was the altarpiece in Santo Stefano // W. and E. Paatz, *Die Kirchen von Florenz* (1953), V, p. 223, attribute our painting to Taddeo, tentatively accepting it as the altarpiece once in Santo Stefano, and follows Salmi in suggesting that the predella mentioned by Vasari may be the one by Bernardo Daddi now in the Vatican Gallery // T. Rousseau, *Met. Mus. Bull.*, n.s., XII (1954), p. 9, ill. // D. Covi, *Met. Mus. Bull.*, n.s., XVI (1958), p. 155, ill. p. 153 (detail) // R. Longhi, *Paragone*, X (1959), no. 111, pp. 4, 8, attributes it to Taddeo, dates it about the time of the frescoes in the Camposanto at Pisa, perhaps 1342, and questions whether the predella is the one by Daddi in the Vatican Gallery // E. Fahy (in a letter, 1967) attributes the spandrels to Davide Ghirlandaio, comparing them with the Crucifixion in the Musée Dobrée, Nantes // B. Klesse, *Seidenstoffe in der italienischen Malerei des vierzehnten Jahrhunderts* (1967), p. 454, no. 471d, dates this altarpiece 1360–1370, on the basis of the pattern of the textile behind the Virgin.

EXHIBITED: Palazzo Pubblico, Siena, 1904, *Antica Arte senese*, no. 5 (as Taddeo Gaddi, lent by Marcello Galli-Dunn).

EX COLL. Cav. Marcello Galli-Dunn, Castello di Badia, Poggibonsi, Tuscany (by 1904; until 1910).

PURCHASE, ROGERS FUND, 1910.

Bernardo Daddi

Active by 1327; probably died in 1348. Daddi belongs to the generation immediately following Giotto, on whose style his own depends. His earliest works also show a close link with such Giottesque painters as the Master of Santa Cecilia and other Florentines of the first quarter of the fourteenth century. Later he developed a highly refined manner, influenced to some extent by Maso di Banco. He was apparently the head of a very active workshop, and a great number of paintings in his style have come to light during recent decades, in which the various hands of his pupils and assistants can be distinguished. Daddi is the best-known painter of Florence between the death of Giotto in 1337 and the Black Death (1348). Although the quality of his craftsmanship is often very high, his lyrical elegance is somewhat diminished by a certain academic and mechanical hardness.

Saint Reparata before the Emperor Decius 43.98.3

This painting and the two following belonged to the same predella. They represent scenes of the judgment and martyrdom of Saint Reparata, the patron saint of Florence, to whom the original cathedral there was dedicated. The predella also included three other scenes: Saint Reparata in Prison, in the collection of Madame Paul Pechère in Brussels (formerly in the Wauters collection); Saint Reparata in a Furnace, in the Weischer collection in Cologne; and the Beheading of Saint Reparata (formerly in the collection of Prince Borghese, Rome; present whereabouts unknown). Our panel, representing the saint being questioned by the Roman emperor Decius, must have been at the extreme left of the predella. The six scenes are in the style of Daddi's late period,

around the middle of the 1340's. Their quality seems to indicate that the predella was painted entirely by Daddi, with no visible evidence of the participation of pupils or assistants. The altarpiece to which the predella belonged has not been identified.

Formerly called by the Museum Saint Catherine of Alexandria before the Emperor.

Tempera on wood. H. 12$\frac{5}{8}$, w. 15$\frac{7}{8}$ in. (32.1 × 40.3 cm.).

REFERENCES: G. F. Waagen, *Treasures – Gr. Brit.* (1854), III, p. 2, attributes this painting to Spinello Aretino, calling it the legend of Saint Catherine and mentioning a companion scene with the saint in prison // R. Offner (in a letter, 1926) attributes it to Bernardo Daddi; *Corpus*, sect. III, vol. III (1930), pp. 10, 60, 66, pl. xv (with two other panels of the predella), pl. xv^3, attributes it to Daddi, calling it Saint Catherine before the Emperor and connecting it and the other panel then in the Griggs collection (43.98.4) with the Saint Reparata in

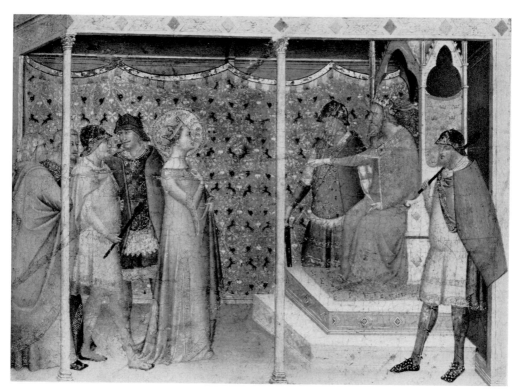

43.98.3

Prison in the Wauters collection in Brussels; *Corpus* sect. III, vol. VIII (1958), pp. x, xiv ff., 29 f., 202, pl. VI (all six panels), accepts the reconstruction suggested by Steinweg and dates the predella about 1345 // B. Berenson, *Ital. Pictures* (1932), p. 167, lists it as a work by Daddi, calling it Saint Catherine before the Emperor; and *Flor. School* (1963), p. 56 lists the Museum's three panels of Saint Reparata as by Daddi, connecting them with the other panels of the predella // L. Venturi, *Ital. Ptgs. in Amer.* (1933), pl. 47, attributes it to Daddi, calls it the story of Saint Barbara, and dates it in the fourth decade of the XIV century // M. Salmi, *Emporium* LXXXVI (1937), p. 363, ill. p. 364, calls it a story of Saint Catherine by Daddi // G. Sinibaldi and G. Brunetti, *Pittura italiana del duecento e trecento* (1943), p. 505, fig. 160, call it Saint Catherine before the Emperor by Daddi, connecting it with the panel in the Wauters collection // *Met. Mus. Bull.*, n.s., II (1944), p. 155, ill. // K. Steinweg, *Riv. d'arte*, XXXI (1956), pp. 37 ff., ill. pp. 38–39 (all six panels), attributes it to Daddi, identifying the saint as Reparata and including with it in the same predella the two other panels in this Museum, those in the Pechère collection in Brussels and a private collection in Cologne, and a sixth scene, of unknown whereabouts, representing the beheading of the saint; suggests that this predella belonged to a five-panel polyptych very probably painted for the church of Saint Reparata in Florence, demolished in 1375 // E. K. Waterhouse in *Italian Studies Presented to E. R. Vincent* (1962), pp. 277, 279, no. 38, identifies two paintings in the collection of William Young Ottley as by Daddi, mistakenly lists our painting as at Yale, quotes Offner, *Corpus* (1930), pl. XV // B. Klesse, *Seidenstoffe in der italienischen Malerei des vierzehnten Jahrhunderts* (1967), pp. 79, 81, 124, 356, 479, nos. 305, 513, fig. 95 (detail of textile), dates this painting about 1345, on the basis of the textiles in it, and discusses the symbolism in the pattern of one of them // F. Bologna, *Novità su Giotto* (1969), p. 15, note 7, attributes it to Daddi, accepting the connection with the Wauters panel, and doubts that the subject is Saint Catherine or Saint Barbara.

EXHIBITED: Century Association, New York, 1930, *Exhibition of Italian Primitive Paintings*, no. 7 (as Bernardo Daddi, lent by M. F. Griggs); Uffizi, Florence, 1937, *Mostra giottesca*, no. 163 (as Bernardo Daddi, lent by M. F. Griggs).

EX COLL.: William Young Ottley, London (until 1836); Warner Ottley, London (1836–1847; sale, Foster's, London, June 30, 1847, no. 38, as Spinello Aretino); William Fuller Maitland, Stansted Hall, Stansted, Essex (1847–1876; Cat. 1872, p. 9, as Florentine School); William Fuller Maitland, Stansted Hall, Stansted, Essex (1876–1922; Cat., 1893, p. 9, no. 20, as Florentine School; sale, Christie's, London, July 14, 1922, no. 52, as Spinello Aretino); [Shoebridge, 1922]; [Wildenstein and Co., New York, 1924–1927]; Maitland Fuller Griggs, New York (1927–1943).

BEQUEST OF MAITLAND FULLER GRIGGS, 1943.

Saint Reparata Tortured with Red-hot Irons
41.190.15

In this painting Christ appears to bless Saint Reparata while she is being tortured in the presence of the emperor Decius. It belonged to the same predella as the preceding and following panels, and in the sequence of the saint's history it must have occupied the third place from the left, after the questioning and prison scenes. See also comment above under Saint Reparata before the Emperor Decius.

Formerly called by the Museum the Martyrdom of Saint Agatha and attributed to a follower of Bernardo Daddi.

Tempera on wood; gold ground; tooled pattern added, possibly in the late XIX century. H. 13, w. $16\frac{1}{2}$ in. (33×41.9 cm.).

REFERENCES: O. Sirén, *Art in Amer.*, II (1913–1914), p. 264, attributes this painting to Bernardo Daddi; (in a letter, 1916) changes the attribution, calling it the work of a Giottesque painter in the Romagna, possibly Giovanni Baronzio da Rimini, and dating it about the middle of the XIV century; *Burl. Mag.*, XXIX (1916), p. 281, tentatively suggests an attribution to Pietro da Rimini // R. van Marle, *Ital. Schools*, III (1924), p. 408, note 1, attributes it to the school of Daddi // R. Offner, *Corpus*, sect. III, vol. III (1930), p. 9, lists it among the works attributed to Daddi; *Corpus*, sect. III, vol. IV (1934), pp. 165 f., pl. LXII, attributes it to a remote follower of Daddi, observing its similarities to paintings in the Griggs and Wauters collections and identifying the subject as the Martyrdom of Saint Agatha; *Corpus*, sect. III, vol. VIII (1958), pp. x, xiv ff., 29, 202, pl. VI (all six panels), attributes the entire predella to Daddi, accepts the

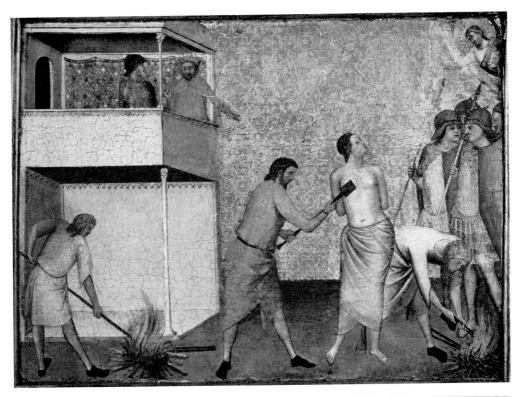

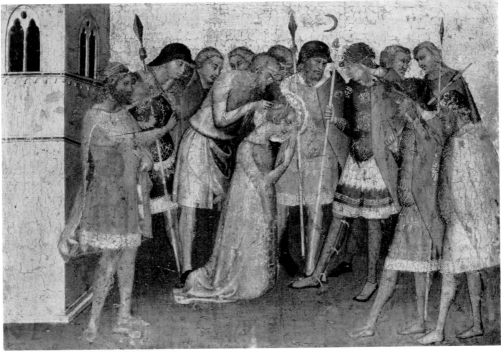

reconstruction suggested by Steinweg, and dates the predella about 1345 // L. Serra, in Thieme-Becker, XXVII (1933), p. 27, lists it among works attributed to Pietro da Rimini // M. Salmi, *Dedalo*, XIII (1933), p. 17, note 8, calls it a Florentine work derived from Daddi // G. Kaftal, *Iconography of Saints in Tuscan Painting* (1952), col. 892, fig. 1001, identifies the subject as the martyrdom of Saint Reparata and attributes it to a remote follower of Daddi // K. Steinweg, *Riv. d'arte*, XXXI (1956), pp. 37 ff., ill. pp. 38–39 (all six panels), attributes it to Daddi, identifying the saint as Reparata and including with it in the same predella the two other panels in this Museum, those in the Pechère collection in Brussels and a private collection in Cologne, and a sixth scene of unknown whereabouts representing the beheading of the saint; suggests that this predella belonged to a five-panel polyptych very probably painted for the church of Saint Reparata in Florence, demolished in 1375 // B. Berenson, *Flor. School* (1963), p. 56, lists the Museum's three panels of Saint Reparata as by Daddi, connecting them with the other panels of the predella // B. Klesse, *Seidenstoffe in der italien-ischen Malerei des vierzehnten Jahrhunderts* (1967), p. 356, no. 305 a, dates this painting about 1345 on the basis of the patterned textile hanging from the loggia.

EX COLL.: Léon de Somzée, Brussels (by 1904; sale, J. Fievez, Brussels, May 24, 1904, cat., II, no. 295, as Taddeo Gaddi); Mme Léon de Somzée, Brussels (sale, J. Fievez, Brussels, May 27–29, 1907, no. 266, as Taddeo Gaddi); George and Florence Blumenthal, New York (by 1913; until 1941; Cat., I, 1926, pl. II, as school of Giotto).

GIFT OF GEORGE BLUMENTHAL, 1941.

Saint Reparata Being Prepared for Execution 43.98.4

This painting represents Saint Reparata having her head shaved before her martyrdom. It belonged to the same predella as the two preceding panels and must have been placed second from the right, with the Beheading at the extreme right. See also comment above under Saint Reparata before the Emperor Decius.

Formerly called by the Museum the Martyrdom of Saint Catherine.

Tempera on wood; gold ground. H. 9⅝, w. 13⅝ in. (24.4 × 34.6 cm.).

REFERENCES: R. Offner (in a letter, 1926) attributes this panel to Bernardo Daddi; *Corpus*, sect. III, vol. III (1930), pp. 10, 62, 66, pls. XV (with two other panels of the predella), XV¹, calls it an Episode from the Martyrdom of a Female Saint and attributes it to Daddi, connecting it and the other panel in the Griggs collection (43.98.3) with the saint in prison in the Wauters collection in Brussels; *Corpus*, sect. III, vol. VIII (1958), pp. x, xiv, 29 f., 202, pl. VI (all six panels), accepts the reconstruction suggested by Steinweg and dates the predella about 1345 // B. Berenson, *Ital. Pictures* (1932), p. 239, lists it as a Scene from the Legend of Saint Barbara, attributing it to an anonymous Florentine working after 1350, a close follower of Giovanni da Milano; and *Flor. School* (1963), p. 56, lists the Museum's three panels of Saint Reparata as by Daddi, connecting them with the other panels of the predella // L. Venturi, *Ital. Ptgs. in Amer.* (1933), pl. 47, attributes it to Daddi, calls it the story of Saint Barbara and dates it in the fourth decade of the XIV century // M. Salmi, *Emporium*, LXXXVI (1937), p. 363, calls it a story of Saint Catherine by Daddi // G. Sinibaldi and G. Brunetti, *Pittura italiana del duecento e trecento* (1943), p. 507, fig. 161, call it a story of Saint Catherine by Daddi, connecting it with the panel in the Wauters collection // K. Steinweg, *Riv. d'arte*, XXXI (1956), pp. 37 ff., ill. pp. 38–39 (all six panels), attributes it to Daddi, identifying the saint as Reparata and including in the same predella the two other panels in this Museum, those in the Pechère collection in Brussels and a private collection in Cologne, and a sixth scene, representing the beheading of the saint, of unknown whereabouts; suggests that this predella belonged to a five-panel polyptych very probably painted for the church of Saint Reparata in Florence, demolished in 1375 // F. Bologna, *Novità su Giotto* (1969), p. 15, note 7, attributes it to Daddi, accepting the connection with the Wauters panel, and doubts that the subject is Saint Catherine or Saint Barbara.

EXHIBITED: Uffizi, Florence, 1937, *Mostra giottesca*, no. 163 a (as Bernardo Daddi, lent by M. F. Griggs).

EX COLL.: [Colnaghi, London, 1926]; [Galerie Caspari, Munich, 1927]; Maitland Fuller Griggs, New York (1927–1943).

BEQUEST OF MAITLAND FULLER GRIGGS, 1943.

Workshop of Daddi

The Crucifixion 41.190.12

This painting was originally the central panel of a small portable altarpiece; the shutters are lost or still unidentified. Although parts of it may have been painted by Daddi the execution is mostly that of pupils and assistants.

Inscribed (on cross): HIC EST IHS / [NA] SARENVS / REX [JV]DEO[RVM].

Tempera on wood; gold ground. H. 18¾, w. 10¼ in. (43 × 21 cm.).

REFERENCES: The authorities cited below, with the exception of R. Offner in 1934, attribute this painting to Bernardo Daddi. O. Sirén, *Art in Amer.*, II (1913–1914), p. 264; (in a letter 1916); and *Giotto and Some of His Followers* (1917), I, pp. 168, 271, pl. 148 // M. Gilman, *Art in Amer.*, VI (1918), pp. 213 f. // R. van Marle, *Ital. Schools*, III (1924), pp. 365, 368 // R. Offner, *Corpus*, sect. III, vol. III (1930), p. 9; *Corpus*, sect. III, vol. IV (1934), pp. ix, 13, 18, pl. VIII, attributes it to a close follower of Daddi, grouping it with several paintings derived from Daddi's signed panel in the Accademia in Florence; *Corpus*, sect. III, vol. VIII (1958), pp. 81, 203 // B. Berenson, *Ital. Pictures* (1932), p. 167; and *Flor. School* (1963), p. 56.

EX COLL.: [Herbert P. Horne, Florence]; George and Florence Blumenthal, New York (by 1913; until 1941; Cat., I, 1926, pl. III, as Bernardo Daddi).

BEQUEST OF GEORGE BLUMENTHAL, 1941.

The Madonna and Child Enthroned with Saints (triptych) 32.100.70

Central panel: Madonna and Child enthroned with angels, Saint Nicholas (?) and Saint Bartholomew, and donors, one of them a Franciscan monk

Left wing: Saint Francis receiving the stigmata (above, the Angel of the Annunciation)

Right wing: the Crucifixion (above, the Virgin of the Annunciation)

This triptych is a good example of the type of work produced in Daddi's shop. The

41.190.12

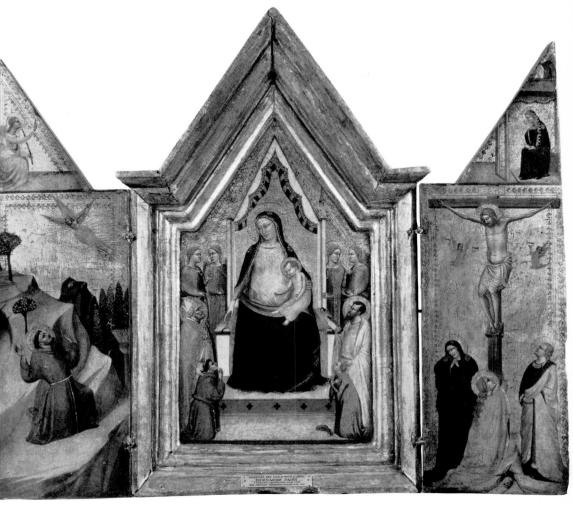

composition and motives were invented and designed by the master himself, but the rather stiff execution was entirely carried out by assistants. The altarpiece must have been painted towards the end of the fourth decade of the fourteenth century.

Tempera on wood; gold ground. Central panel, over–all size, h. 19½, w. 11¼ in. (49.5 × 28.5 cm.), painted surface, h. 13¼, w. 7¾ in. (33.6 × 19.7 cm.); left wing, h. 18⅛, w. 5½ in. (46 × 14 cm.); right wing, h. 18¼, w. 5⅝ in. (46.4 × 14.3 cm.).

REFERENCES: O. Sirén (in a letter, 1917) attributes this painting to Bernardo Daddi and dates it around 1335 or a little earlier; *Giotto and Some of His Followers* (1917), I, p. 166, pl. 143, attributes it to Daddi // M. Gilman, *Art in Amer.*, VI (1918), p. 213, attributes it to Daddi // B. Berenson, in Cat. of Friedsam Coll. (unpublished, n.d.), pp. 49 f., dates it in Daddi's middle period; *Ital. Pictures* (1932), p. 167, lists it as a work by Daddi; and *Flor. School* (1963), p. 56 // R. van Marle, *Ital. Schools*, III (1924), pp. 365 f., attributes it to Daddi and dates it about 1333 to 1336, when Daddi's style was more Sienese than Florentine // R. Offner, *Corpus*, sect. III, vol. III (1930), p. 10, includes it among the pictures attributed to Daddi; *Corpus*, sect. III, vol. IV (1934), p. 20, pl. IX, attributes it to an artist

in the close following of Daddi; in D. C. Shorr, *The Christ Child* (1954), p. 33, ill. p. 36 (detail), attributes it to a follower of Daddi; and *Corpus*, sect. III, vol. VIII (1958), p. 79 // B. Burroughs and H. B. Wehle, *Met. Mus. Bull.*, XXVII (1932), Nov., sect. II, p. 31 // H. D. Gronau, *Andrea Orcagna und Nardo di Cione* (1937), p. 71, ascribes it to a follower of Daddi // E. B. Garrison, Jr., *Marsyas*, III (1946), pp. 37, 65, note 84, fig. 19, attributes it to a follower of Daddi about 1330–1335 and discusses the iconography // B. Klesse, *Seidenstoffe in der italienischen Malerei des vierzehnten Jahrhunderts* (1967), p. 454, no. 471 a, dates it between 1330 and 1340 on the basis of the textile above the Virgin's throne.

The Madonna and Child Enthroned with Saints 41.100.15

This painting is the left shutter of a small diptych. The right shutter, the Crucifixion, was sold at Sotheby's on June 30, 1965 (no. 32). The saints surrounding the Madonna and Child are: in the left foreground, John the Baptist and Francis; behind them Louis of Toulouse and Catherine of Alexandria; in the right foreground, Anthony of Padua and an Evangelist; and in the background Agnes and Elizabeth of Hungary. The panel was executed under Daddi's supervision, after his designs, but he took no part in the actual painting. Compared with similar works made in his shop, it is unusual in its rectangular shape and in the pose of the Christ Child, which goes back to prototypes invented by Giotto and his assistants. It seems to have been painted about the middle of the 1330's.

Formerly attributed by the Museum to a follower of Daddi.

41.100.1

Tempera on wood; gold ground. Over-all size, h. 13¼, w. 8½ in. (33.7×21.6 cm.); painted surface, h. 13, w. 8⅛ in. (33×20.6 cm.).

REFERENCES: O. Sirén, *Burl. Mag.*, XIV (1908), p. 188, attributes this painting to Bernardo Daddi, dating it towards the end of the 1320's or at the beginning of the 1330's; *Giotto and some of His Followers* (1917), I, p. 271, pl. 154, attributes it to Daddi // R. van Marle, *Ital. Schools*, III (1924), p. 378, attributes it to Daddi, dating it after 1338 // R. Offner, *Corpus*, sect. III, vol. III (1930), p. 9, lists it among the works attributed to Daddi; *Corpus*, sect. III, vol. IV (1934), p. xii, attributes it to a close follower of Daddi; *Corpus*, sect. III, vol. V (1947), p. 8, calls it Daddesque; in D. C. Shorr, *The Christ Child* (1954), p. 105, ill. p. 107 (detail), attributes it

to a close follower of Daddi; *Corpus*, sect. III, vol. VIII (1958), pp. 69 f., pl. XIII, attributes it to a follower of Daddi, calls it the left shutter of a diptych, and comments on its unusual shape and the position of the Child, dating it about the middle 1330's, about the time of the altarpiece of 1333 in the Bigallo in Florence and of a central panel in the Uffizi dated 1334 // B. Berenson, *Flor. School* (1963), p. 56, lists it as a product of Daddi's workshop // B. Klesse, *Seidenstoffe in der italienischen Malerei des vierzehnten Jahrhunderts* (1967), p. 185, note 40 a, dates it about the middle of the fourteenth century, on the basis of the textile on the Virgin's throne.

EX COLL.: Baron Sulzbach, Paris (by 1908; until 1924); [Arnold Seligmann, New York, after 1924; until 1926]; George and Florence Blumenthal, New York (1926–1941).

GIFT OF GEORGE BLUMENTHAL, 1941.

Giovanni da Milano

Real name Giovanni di Jacopo di Guido da Caversaio; also called Giovanni da Como. Known activity about 1350–1369. Giovanni da Milano is first recorded in 1346 as a foreigner serving his painter's apprenticeship in Florence. He did not become a citizen of Florence, however, until 1366, when he was painting his most important work, the frescoes of scenes from the lives of the Virgin and the Magdalen in the Rinuccini chapel in the sacristy of Santa Croce. Nothing remains of the frescoes he is known to have executed in 1369 in two chapels in the Vatican, where he worked with Giottino and with Agnolo and Giovanni Gaddi. Giovanni da Milano is the greatest Lombard painter of the fourteenth century. His style was certainly formed by that of the followers of Giotto who were active in Milan, but it seems likely that he also knew the works of Vitale da Bologna and Tommaso da Modena. Giovanni da Milano harmonized the naturalistic tendencies of Lombard art with a sense of space derived from Giotto. His forms are modeled with a subtle and delicate treatment of shading that recalls the Paduan painter Giusto dei Menabuoi.

The Madonna and Child with Donors (lunette) 07.200

This painting must belong to a late period in Giovanni da Milano's career since it shows the influence, not otherwise evident in his works, of the Sienese school, especially Simone Martini and his immediate followers, who are recalled in the type of the Child and the pronounced Gothic rhythm of the Virgin's draperies. It is unusual for a panel with a half-length Madonna and donors to have the shape of a lunette; it is unlikely that it was the uppermost section of an altarpiece. It may have been placed above a tomb or set into a wall as an overdoor.

Once attributed by the Museum to Gherardo Starnina.

Tempera on wood; gold ground; donors' robes considerably repainted. H. $27\frac{1}{8}$, w. $56\frac{3}{4}$ in. (68.9 × 144.1 cm.).

REFERENCES: R. E. F[ry], *Met. Mus. Bull.*, III (1908), p. 11 // O. Sirén, *Burl. Mag.*, XIV (1908), p. 194, pl. IV, and *Giottino* (1908), p. 91, attributes this painting to Giovanni da Milano // P. Toesca, *La Pittura e la miniatura in Lombardia* (1912), p. 226, doubts the attribution to Giovanni da Milano; and *Il Trecento* (1951), p. 766, attributes it to Giovanni

07.200

da Milano, dating it shortly before 1365 and about the time of his polyptych in the Prato Gallery // W. Suida, in Thieme-Becker, XIV (1921), p. 129, lists it among the controversial attributions to Giovanni da Milano // R. van Marle, *Ital. Schools*, IV (1924), p. 240, note, calls it a work of the school of Giovanni da Milano // B. Berenson, *Ital. Pictures* (1932), p. 244, lists it as a work by Giovanni da Milano; and *Flor. School* (1963), p. 89, pl. 278 // L. Venturi, *Ital. Ptgs. in Amer.* (1933), pl. 123, attributes it to Giovanni da Milano // R. Offner (verbally, 1935) attributes it to Giovanni da Milano // A. Marabottini, *Giovanni da Milano* (1950), pp. 71, 122, pl. XI, attributes it to Giovanni da Milano, suggests that it was painted in Florence, and dates it between 1365 and 1369 // D. C. Shorr, *The Christ Child* (1954), p. 84, note 2,

observes that the figure of the Child is similar to that in Simone Martini's Maestà in the Palazzo Pubblico in Siena // M. Boskovits, *Giovanni da Milano* (1966), pp. 17, 33, dates it close to the Prato polyptych (1363) and notes the close similarity between our Madonna and the Saint Catherine of the Prato polyptych.

EXHIBITED: Palazzo Reale, Milan, 1958, *Arte lombarda dai Visconti agli Sforza*, no. 53.

EX COLL.: Gen. Charles Richard Fox, London; William Fuller-Maitland, Stansted House, Essex; [Georges B. Brauer, Florence, 1907].

PURCHASE, ROGERS FUND, 1907.

Niccolò di Tommaso

Known activity 1343–1376. Our knowledge of the work and career of Niccolò di Tommaso is based on a triptych, signed by him and dated 1371, in the church of Saint Anthony Abbot in Naples. His style is closely related to that of Nardo di Cione, with some influence from Giovanni da Milano. Niccolò has also been called the Master of the Convent of the T, from the cycle of frescoes ascribed to him in the former convent of the T (or convent of Saint Anthony Abbot) in Pistoia.

The Man of Sorrows 25.120.241

This impressive figure, perhaps painted for a niche over a tomb, is surely by Niccolò di Tommaso. It shows his close relationship to Nardo di Cione.

Once called by the Museum a work of the Tuscan school of the XIV century and later attributed to a follower of Nardo di Cione (Cat., 1940).

Fresco, transferred to canvas. H. 65, w. 70 in. (165.1 × 177.8 cm.).

REFERENCES: R. Offner, *Studies in Florentine Painting* (1927), p. 101, fig. 8, says this fresco was found in a niche in Florence, attributes it to an assistant of Nardo di Cione; verbally, 1940, and *Mitteil. des Ksthistorisch. Instituts in Florenz*, VII (1956), p. 191, attributes it to Niccolò di Tommaso; and *Corpus*, sect. III, vol. VIII (1958), p. 166, note 2, attributes it to Niccolò di Tommaso and discusses its iconography, observing that this type of Man of Sorrows with the palms of his hands turned outward displaying his wounds was borrowed from contemporary representations of the Last Judgment // J. J. Rorimer, *The Cloisters* (1938), p. 46, fig. 23 // M. Meiss, *Ptg. in Florence and Siena after the Black Death* (1951), p. 124, note 76, pl. 125, accepts the attribution to Niccolò di Tommaso // F. Bologna, *I Pittori alla Corte Angioina di Napoli* (1969), pp. 327, 330; fig. VII, 83, 111 (detail), attributes it to Niccolò di Tommaso.

EX COLL. George Grey Barnard, New York (about 1912; until about 1925).

At the Cloisters.

GIFT OF JOHN D. ROCKEFELLER, JR., 1925.

25.120.241

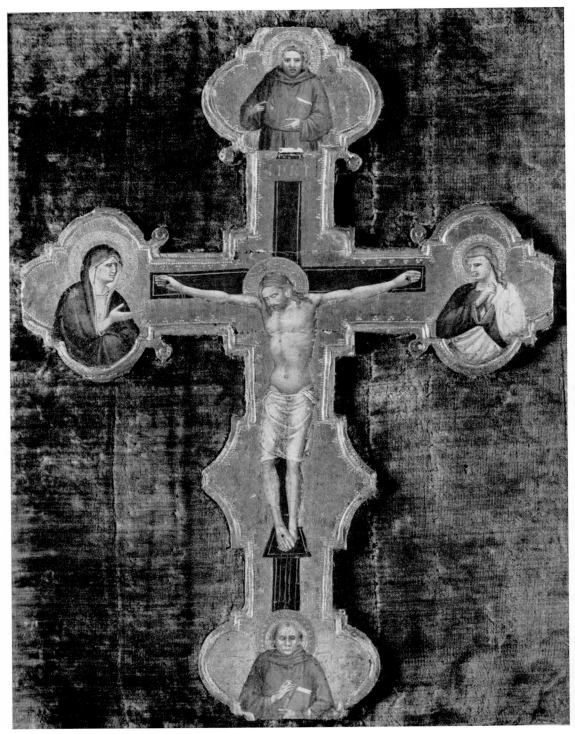

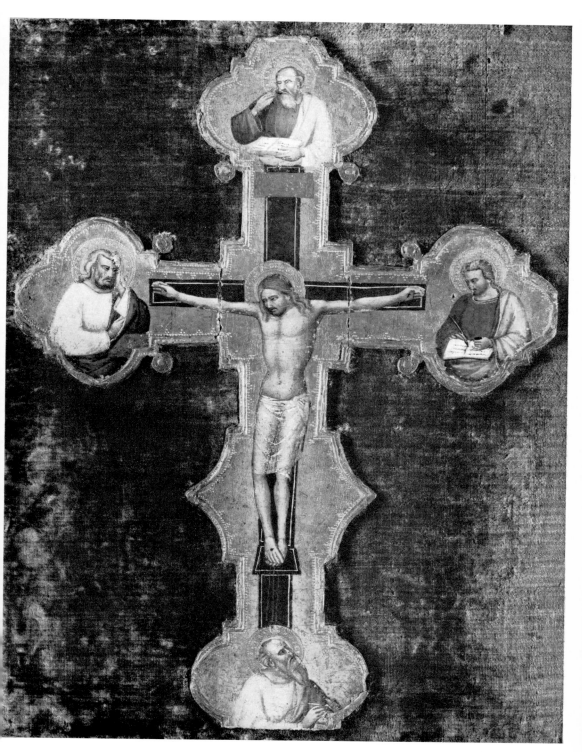

27.231

The Master of the Orcagnesque Misericordia

The Master of the Orcagnesque Misericordia is the name given by Offner to the painter of a group of Florentine works of the late fourteenth century that includes a Madonna della Misericordia (Madonna of Mercy) now in the Accademia in Florence (no. 8562). This unknown painter was strongly influenced by Jacopo di Cione, in whose workshop he may have served his apprenticeship, and his style is similar but superior to that of Niccolò di Pietro Gerini. Some of his paintings are slightly influenced by Agnolo Gaddi. His most personal characteristic is his deliberate archaism in imitating the compositions of several Florentine painters of the first half of the fourteenth century, especially Bernardo Daddi and his immediate circle. He has sometimes been confused with Daddi.

Crucifix 27.231

Terminals (obverse): the Virgin, Saint John, Saint Francis, and Saint Bonaventura

Terminals (reverse): the four Evangelists

As this crucifix was made to be carried in processions the crucified Christ is painted on both sides. He is represented as alive on one side and dead on the other, according to an old tradition followed in a number of other crosses dating from the thirteenth century onwards. This cross is typical of the Master of the Orcagnesque Misericordia, showing in the terminal figures his usual facial types and in the treatment of forms the peculiar background of his style, in which the influences of Maso di Banco and the earlier followers of Giotto blend with those of Andrea Orcagna and Jacopo di Cione. It may be one of the earliest of the known works of this artist, possibly painted about 1380.

Formerly attributed by the Museum to an unknown Florentine painter of the second half of the XIV century (Cat. 1940).

Tempera on wood; gold ground. The obverse and reverse have been separated for exhibition. H. 18, w. $13\frac{1}{4}$ in. (45.7 × 33.7 cm.).

REFERENCES: R. Longhi (unpublished opinion, 1926) considers this cross Florentine, close in style to Maso di Banco and Giottino and dates it 1340–1350 // J. M. L[ansing], *Met. Mus. Bull.*, XXIII (1928), pp. 91 f., ill. // R. Offner (verbally, 1935) and *Corpus*, sect. III, vol. VI (1956), p. 166, note 1, attributes it to the Master of the Orcagnesque Misericordia // G. Fiocco (unpublished opinion, 1936) calls it Florentine and dates it about 1300 // W. Suida (unpublished opinion, 1936) suggests attributing it to Maso and dates it about 1330–1340 // A. Venturi (unpublished opinion, 1936) attributes it to a follower of Giotto // F. Mason Perkins (unpublished opinion, 1936) attributes it to an anonymous Florentine and dates it after 1350 // B. Berenson, *Flor. School* (1963), p. 216, lists it as by an unidentified Florentine painter, about 1350–1420 // F. R. Shapley, *Paintings from the Samuel H. Kress Collection* (1966), p. 38, figs. 89. 90, dates it about 1390, agreeing with the attribution to the Master of the Orcagnesque Misericordia // F. Zeri, *Gaz. des B.-A.*, LXXI (1968), pp. 74, 78, note 16, accepts the attribution to the Master of the Orcagnesque Misericordia suggested by Offner and lists it among other works by the artist.

EX COLL.: [Count Alessandro Contini Bonacossi, Rome, 1926]; Samuel H. Kress, New York (1926–1927).

GIFT OF SAMUEL H. KRESS, 1927.

Cristiani

Giovanni di Bartolomeo Cristiani. Known activity 1367–1398. Little remains of the work of Cristiani, who was born in Pistoia and was active there and in Florence. Our knowledge of his style is based on three signed pictures, the Saint John altarpiece, dated 1370, in the church of San Giovanni Fuorcivitas in Pistoia, a Madonna in the Pistoia Gallery (no. 27), and a triptych in the Rivetti collection in Biella, dated 1390. These paintings and the few that have been attributed to him on the basis of style show that Cristiani was strongly influenced by Andrea Orcagna's brother, Nardo di Cione. His rigorously balanced and often symmetrical compositions, along with the sharp outlines of his figures, show that he knew the paintings of Maso di Banco, who is known to have worked in Pistoia.

Saint Lucy and Her Mother at the Shrine of Saint Agatha 12.41.4

This painting and the three following illustrate episodes in the life of Saint Lucy, as related in the *Golden Legend*. The four pictures were part of a larger series, of which another panel, the Last Communion and Martyrdom of Saint Lucy, is in the collection of Heinz Kisters, Kreuzlingen, Switzerland (9¾ × 15 in.; sold at Sotheby's, London, June 24, 1964, no. 48). The series may have been the predella of an altarpiece, but it is more likely that the scenes were arranged along the sides of a central panel, as in Cristiani's Saint John altarpiece, and, if so, there must have been a sixth scene. It is possible that a larger painting by Cristiani now in the Yale University Art Gallery, New Haven (no. 1943.215; formerly in the M. F. Griggs collection) was the central panel. It shows a frontal figure of Saint Lucy enthroned with six angels and is very similar in composition to the central panel of the Saint John altarpiece. Saint Lucy holds a dagger almost identical to the one in the

small scene of her martyrdom. The height of the Yale picture (31¾ × 29½ in.) would equal the combined heights, with frames, of three of the small panels.

In this first episode, Lucy is shown with her sick mother, Eutychia, at the shrine of Saint Agatha, who is appearing to her in a vision and telling her that her mother will be cured.

Once attributed by the Museum to an unknown Tuscan painter of the XIV century and later to Lorenzo di Niccolò Gerini.

Tempera on wood; gold ground. H. 9¾, w. 15⅛ in. (24.7 × 38.4 cm.).

REFERENCES: B. B[urroughs], *Met. Mus. Bull.*, VII (1912), pp. 92 f., ill., considers these paintings Tuscan and dates them in the late XIV century // B. Berenson, *Dedalo*, XI (1931), p. 1314, ill. p. 1317, attributes them hesitantly to Cristiani, and notes their similarity to the works of Lorenzo di Niccolò and Mariotto di Nardo; *Ital. Pictures* (1932), p. 238, lists them as works by Cristiani; and *Flor. School* (1963), p. 51, pls. 329 (12.41.3) and 330 (12.41.2) // R. Offner (verbally, 1935) and *Mitteil. des Ksthist. Instit. in Florenz*, VII (1956), p. 192, attributes them to Cristiani // R. Longhi (unpublished opinion,

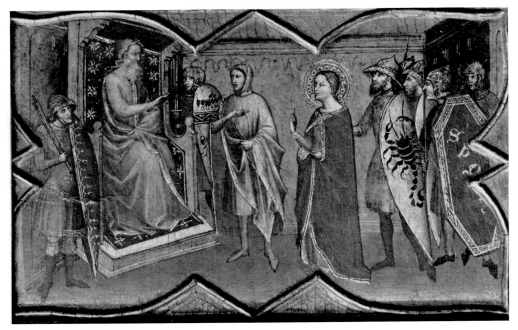

12.41.1

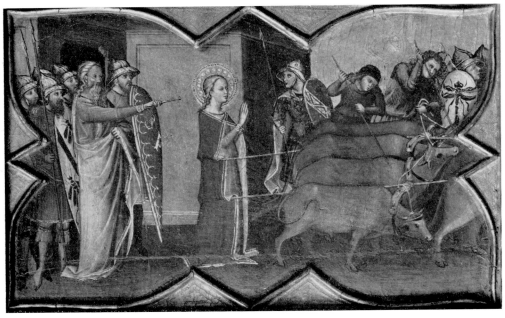

12.41.2

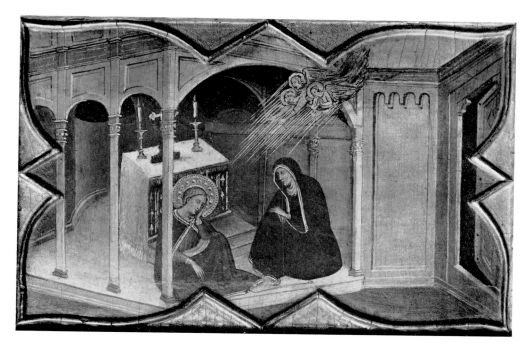

12.41.4

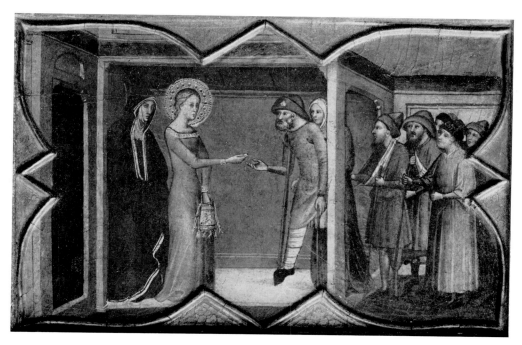

12.41.3

1937), attributes them to Cristiani // G. Kaftal, *Iconography of Saints in Tuscan Painting* (1952), col. 645, figs. 741–744, attributes them to Cristiani // M. Boskovits, *Acta historiae artium Academiae Scientiarum Hungaricae*, XI (1965), pp. 69 f., figs. 4, 5, attributes them to Cristiani, dating them after the altarpiece of 1370.

EX COLL. [J. P. Richter, Florence, 1912].

PURCHASE, ROGERS FUND, 1912.

Saint Lucy Giving Alms 12.41.3

In this painting Saint Lucy is shown with her mother giving away their inheritance. See also comment above under Saint Lucy and Her Mother at the Shrine of Saint Agatha.

Formerly attributed by the Museum to a Tuscan painter of the XIV century and later to Lorenzo di Niccolò Gerini.

Tempera on wood; gold ground. H. $9\frac{3}{4}$, w. $15\frac{1}{8}$ in. (24.7×38.4 cm.).

REFERENCES: See above under Saint Lucy and Her Mother at the Shrine of Saint Agatha.

EX COLL. [J. P. Richter, Florence, 1912].

PURCHASE, ROGERS FUND, 1912.

Saint Lucy before Paschasius 12.41.1

In this painting Saint Lucy is shown before the heathen prefect Paschasius, who commands her to sacrifice to idols. The grasshoppers and the scorpion that decorate the shields of the soldiers are symbols of pagan religion and evil. See also comment above under Saint Lucy and Her Mother at the Shrine of Saint Agatha.

Formerly attributed by the Museum to a Tuscan painter of the XIV century and later to Lorenzo di Niccolò Gerini.

Tempera on wood; gold ground. H. $9\frac{1}{2}$, w. $15\frac{1}{4}$ in. (24.1×38.7 cm.).

REFERENCES: See above under Saint Lucy and Her Mother at the Shrine of Saint Agatha.

EX COLL. [J. P. Richter, Florence, 1912].

PURCHASE, ROGERS FUND, 1912.

Saint Lucy Resisting Efforts to Move Her 12.41.2

This painting shows how even oxen could not drag Saint Lucy to the brothel to which Paschasius wanted to send her. See also comment above under Saint Lucy and Her Mother at the Shrine of Saint Agatha.

Formerly attributed by the Museum to a Tuscan painter of the XIV century and later to Lorenzo di Niccolò Gerini.

Tempera on wood; gold ground. H. 10, w. 15 in. (25.4×38.1 cm.).

REFERENCES: See above under Saint Lucy and Her Mother at the Shrine of Saint Agatha.

EX COLL. [J. P. Richter, Florence, 1912].

PURCHASE, ROGERS FUND, 1912.

Spinello Aretino

Real name Spinello di Luca Spinelli. Active by 1373; died 1410 or 1411. Spinello was trained in his native town of Arezzo. He worked in Pisa in the Camposanto, in Siena in the Palazzo Pubblico, and in Florence, where by 1386 (or possibly later) he had become a member of the

Physicians' Guild. He painted a large number of works, including extensive cycles of frescoes, among them the scenes from the life of Saint Benedict in the sacristy of San Miniato al Monte in Florence. Spinello was influenced by the Florentine painters Orcagna and Agnolo Gaddi, and he is one of the artists who began working in the Giottesque tradition and later moved towards the late Gothic or international manner.

Processional Banner 13.175

Obverse: Saint Mary Magdalen with a Crucifix

Reverse: the Flagellation of Christ

This banner was painted for a brotherhood in Borgo San Sepolcro, apparently a flagellant order. Members of the order are shown kneeling in the foreground of the scene with Saint Mary Magdalen. Such banners were carried in processions, especially during Holy Week. The style is apparently that of Spinello around 1375. The Flagellation is similar in composition to some other examples of late fourteenth-century Florentine painting. A section of an altarpiece by Agnolo Gaddi in the church of San Miniato al Monte shows a similar scene, as does a fresco by an unknown painter in the church of the Carmine, both in Florence. It is likely that all of them were derived from a single prototype. Sometime after 1888 the Flagellation was covered by relining. When the relining was removed in 1950 the picture was in satisfactory condition except for the absence of the head and the upper part of the torso of Christ and the surrounding gold ground. The empty rectangular area is about $19\frac{3}{8} \times 15\frac{3}{4}$ inches (49.8×40 cm.). A fragmentary half-length figure of Christ in the collection of the Camposanto Teutonico in Vatican City in Rome has now been identified as the missing part of our painting (see F. Zeri, 1958, in Refs.). It is painted in tempera and gold and measures about $19\frac{1}{2} \times 15\frac{1}{8}$ inches (49.4×38.4 cm.). It was evidently transferred to a new canvas, now glued to a panel. X-ray shadowgraphs show a part of the column behind the figure of Christ and the right hand of the torturer at the left, both covered over by repaint to conceal their fragmentary state. The banner was painted on the two sides of a single canvas. In the area of the missing section there are many traces of gold and tempera, indicating that the upper part of the figure of Christ was removed by gluing a facing on the painted surface and pulling the paint from the canvas. The banner was originally framed by a painted architectural border with medallions of saints.

Tempera on canvas; gold ground. H. 69, w. 47 in. (175.2×119.4 cm.).

REFERENCES: The authorities cited below, with the exception of Lucarelli, attribute this banner to Spinello Aretino. G. B. Cavalcaselle (ms., n.d., Biblioteca Marciana, Venice) notes that it came from a confraternity in San Sepolcro; and, with J. A. Crowe, *Ptg. in Italy*, II (1864), pp. 17 f., describes both sides of the banner (then in the Ranghiasci collection in Gubbio) and the painted border, stating (apparently in error) that it was made for the brotherhood of San Sepolcro in Gubbio // O. Lucarelli, *Memorie e Guida storica di Gubbio* (1888), p. 537, no. 212, attributes it to Parri Spinelli and notes that it was still in the Ranghiasci collection and not sold in the sale of 1882 // F. J. Mather, Jr., *Met. Mus. Bull.*, IX (1914), pp. 43 ff., ill., tentatively dates it in the 1360's // F. Mason Perkins, *Rass. d'arte*, XVIII (1918), p. 6, ill. p. 4, dates it between the two Madonnas by Spinello in the Fogg Art Museum, that is, shortly after 1385; and in Thieme-Becker, XXXI (1937), p. 386 // R. L. Douglas, ed., in Crowe and Cavalcaselle, *Ptg. in Italy*, II (1923), p. 263 // R. van Marle, *Ital. Schools*, III (1924), p. 603, considers it a late work // G. Gombosi, *Spinello Aretino* (1926), pp.

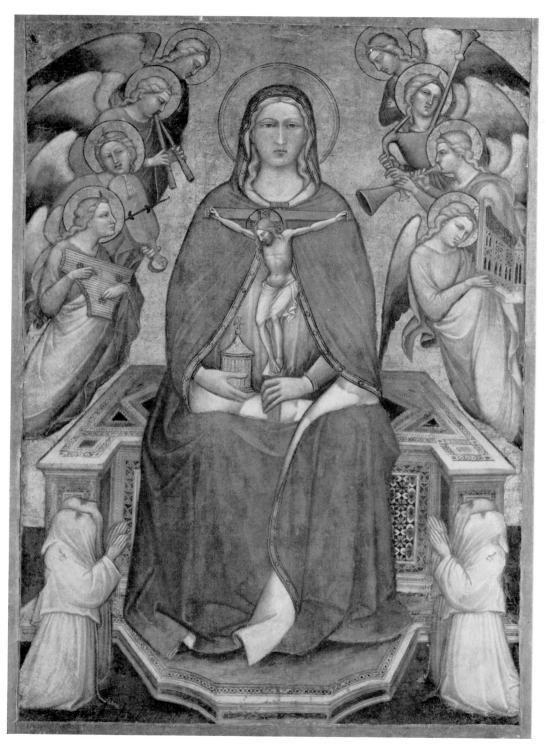

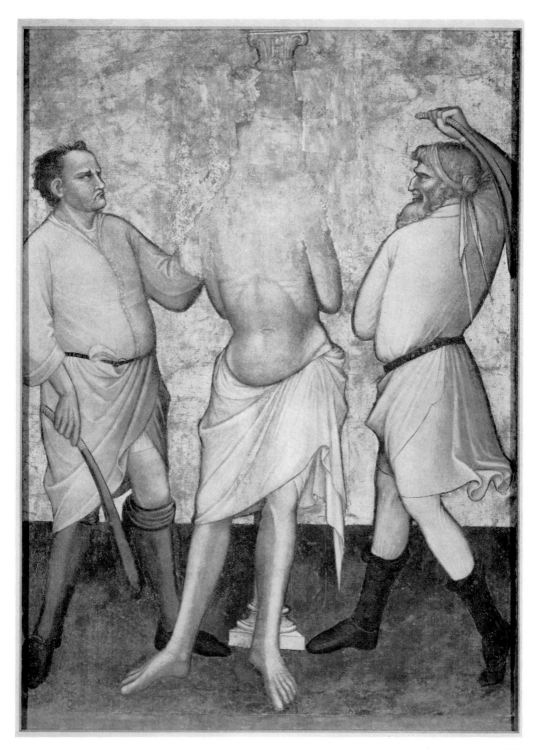

37 ff., 117, 135, dates it about 1370–1379, comments on its likeness to works from the circle of Orcagna, and points out its great similarity to a Madonna by Spinello in the Museum in Copenhagen // A. Burroughs, *Met. Mus. Bull.*, XXIII (1928), pp. 274 ff., ill., notes the discovery, made with X-rays, of the Flagellation under the relining // B. Berenson, *Ital. Pictures* (1932), p. 548; and *Flor. School* (1963), p. 205, pls. 404 (obverse), 405 (reverse, reconstruction) // M. Salmi, *L'Arte italiana* (1942), fig. 200 // G. Kaftal, *Icon. of Saints in Tuscan Ptg.* (1952), p. xxvii, note 5, and col. 717 // M. Schapiro in *Scritti . . . in onore di Lionello Venturi* (1956), I, p. 34, mentions this banner as painted for a confraternity of "battuti" in Gubbio // F. Zeri, *Paragone*, IX (1958), no. 105, pp. 63 ff., figs. 40, 41, 43 (reconstruction of reverse), publishes the fragment in the Camposanto Teutonico // *Frühchristliche Kunst aus Rom* (Cat., Essen, 1962), p. 206, no. 428 (fragment from Camposanto

Teutonico), fig. 428 (reconstruction of reverse), dates it about 1390 // F. Bologna, *I Pittori alla Corte Angioina di Napoli* (1969), pp. 239 f., discusses processional banners of the XIV century.

PROVENANCE: a confraternity at Borgo San Sepolcro.

EX COLL.: Marchese Francesco Ranghiasci-Brancaleoni, Gubbio (before 1864–1877; sale, Gubbio, April 12 ff., 1882, no. 341, as P. Spinello); Ranghiasci-Brancaleoni heirs, Gubbio (1877; until after 1888); Francis M. Bacon, New York (sale, Metropolitan Art Association, Anderson Galleries, New York, Oct. 24, 1913, no. 476 A, as Unknown Italian Painter, Madonna Holding a Crucifix).

GIFT OF THE ESTATE OF FRANCIS MCNEIL BACON, THROUGH HIS SON ROGERS H. BACON, 1914.

Agnolo Gaddi

Active by 1369; died 1396. Agnolo, the son of Taddeo Gaddi, almost certainly received his early training in his father's workshop until Taddeo died in 1366. Then, according to Vasari, he became the pupil of Giovanni da Milano. In 1369 Agnolo was in Rome, working as an assistant in the Vatican, perhaps under his brother Giovanni. His most important extant paintings are the frescoes representing the story of the True Cross in the choir of the church of Santa Croce in Florence. Other frescoes, in the cathedral of Prato, are of 1392–1395, and an altarpiece documented as his in the church of San Miniato al Monte in Florence was worked on from 1393 to 1396 but was left unfinished at his death and was completed by his pupils. Agnolo was the head of a very large and active workshop, and a good many of the paintings which are in his style but uneven in quality must be assigned to his assistants. Several unconvincing attempts have been made by critics to identify his individual collaborators. Some of the frescoes and panels from the workshop have been attributed to Gherardo Starnina, but not on solid grounds. Agnolo Gaddi's earlier work is in the tradition of Giotto. Later, perhaps with some influence from the art of North Italy, he began painting in the sinuous international, late Gothic style. His influence was strongly felt in Florence, and all the late Gothic painters who worked there during the first decade of the fifteenth century, including Lorenzo Monaco and the Master of the Straus Madonna, were more or less affected by him.

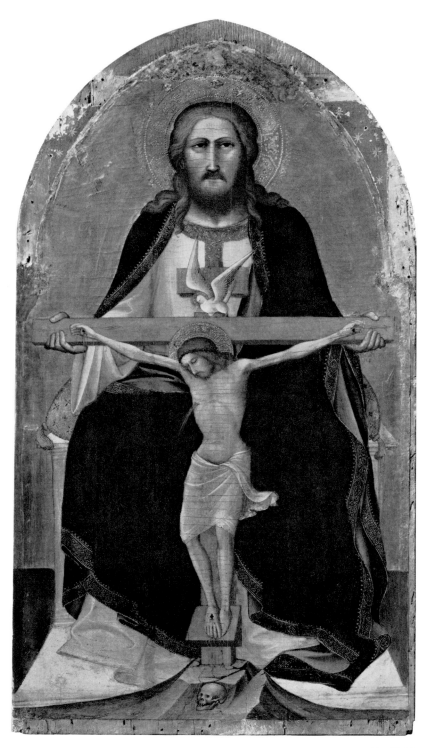

The Trinity 41.100.33

It is not certain whether this painting was conceived as a single unit or, as is more likely from its size and proportions, as part of a triptych. It shows all the characteristics of Agnolo Gaddi's mature period, in the vivid range of colors, the Gothic linear movement of the borders of the draperies, and the modeling, which emphasizes a two-dimensional rendering of space, in spite of the hints of perspective in certain details, as in the dove, which represents the Holy Ghost. The faces are typical of Gaddi's work, suggesting a date about 1390. It is quite possible that the execution of this panel is partly by pupils and assistants working from Agnolo's design.

Tempera on wood; gold ground. Over-all size, h. $53\frac{1}{2}$, w. $28\frac{3}{4}$ in. (135.9×73 cm.);

painted surface, h. $51\frac{1}{8}$, w. $27\frac{7}{8}$ in. (129.8×78 cm.).

REFERENCES: O. Sirén, Burl. Mag., XXVI (1914), p. 113, attributes this painting to a follower of Agnolo Gaddi whom he calls Compagno di Agnolo // R. van Marle, Ital. Schools, III (1924), pp. 573 f., note, lists it among the works of Gherardo Starnina // B. Berenson, Ital. Pictures (1932), p. 214, lists it among the works of Agnolo Gaddi; and Flor. School (1963), p. 68 // R. Salvini, Boll. d'arte, XXIX (1935–1936), p. 294, note 11, attributes it to Compagno di Agnolo.

EXHIBITED: Metropolitan Museum, New York, 1943, Masterpieces of the Collection of George Blumenthal, no. 20.

EX COLL.: [Alfredo Barsanti, Rome]; [Arnoldo Corsi, Florence, 1914]; George and Florence Blumenthal, New York (by 1924; until 1941; Cat., I, 1926, pl. VI).

GIFT OF GEORGE BLUMENTHAL, 1941.

Workshop of Agnolo Gaddi

Saint Margaret and the Dragon
 41.190.23

Saint Margaret, who usually has the vanquished dragon at her feet, is shown here in his wide-open jaw, in illustration of a version of her legend that tells how he swallowed her alive. She holds a cross (now partly effaced) and the martyr's palm. This panel has hitherto been attributed to Spinello Aretino, but the characteristics of the style, especially the formal treatment of the hands and the gay color scheme, suggest rather the

workshop of Agnolo Gaddi. Two other panels, representing a Franciscan saint (possibly Francis) and Saint Elizabeth of Hungary, which were on the art market in Amsterdam and Paris about 1955 and which may at one time have been in the Charles Loeser collection in Florence, are very similar in style. They were the same size as ours and showed the same tooled pattern in the haloes, and it is very probable that all three paintings came originally from the predella of the same altarpiece. Additional tooling along the borders of the panels showing the

Franciscan and Saint Elizabeth might be due only to a different position in the predella, on the base of the pilasters or at the ends.

Formerly attributed by the Museum to Spinello Aretino.

Tempera on wood; gold ground. H. 19⅛, w. 8 in. (23.2 × 20.3 cm.).

REFERENCES: The authorities cited below, with the exception of Bellosi, attribute this painting to Spinello Aretino. B. Berenson, *Ital. Pictures* (1932), p. 548; and *Flor. School* (1963), p. 205 // F. Mason Perkins, in Thieme-Becker, XXXI (1937), p. 386 // L. Bellosi, *Paragone*, XVI (1965), no. 187, p. 42, note 16, attributes it to Mariotto di Nardo.

EX COLL.: Harold Mellor, Florence; F. Mason Perkins, Lastra a Signa; George and Florence Blumenthal, New York (by 1926; until 1941; Cat., I, 1926, pl. v, as Spinello Aretino).

BEQUEST OF GEORGE BLUMENTHAL, 1941.

41.190.23

Unknown Florentine Painter, 1394

The Coronation of the Virgin and Saints (triptych) 50.229.2

Central panel: Christ crowning the Virgin, with angel musicians (above, bust of Christ)

Left panel: Saint Bernard and Saint Sylvester (above, bust of a prophet)

Right panel: Saint Nicholas and Saint Julian the Hospitaller (above, bust of a prophet)

Predella panels: the emperor Constantine's dream of Saint Peter and Saint Paul and Saint Sylvester baptizing Constantine; Saint Sylvester raising the bull; Saint Sylvester binding the dragon's mouth and resuscitating the magicians; between the panels, kneeling donors

This altarpiece was painted in 1394 for the altar of the Brunelleschi chapel in the small parish church of San Leo in Florence, which was suppressed and converted to a residence in 1785 and demolished in 1901. Alderotto Brunelleschi, who commissioned the altarpiece, and his uncle Silvestro are portrayed kneeling in profile on the pilaster sections between the predella scenes, and the family coat of arms (or, a fess azure) appears four times on the colonette bases. The composition of the central panel is derived from the center of a polyptych by Giotto and his pupils in the Baroncelli chapel in the church of Santa Croce in Florence. In the predella panels, especially the one at the right, there is a faint reminder of Maso di Banco's frescoes

50.229.2

in the Bardi chapel in Santa Croce, also representing the legend of Saint Sylvester. Other details, such as the head of Christ in the Coronation, indicate a knowledge of Taddeo Gaddi's work. The prophets in the medallions recall those on the frame of Jacopo di Cione's Coronation of 1372–1373 in the Accademia in Florence. Although the style of the painting as a whole is in the Orcagnesque tradition, it is more closely related to the school of Agnolo Gaddi, showing many similarities to the work of an

unknown follower of Gaddi, active between 1385 and 1395, who painted the polyptych in the church of San Martino a Mensola, near Settignano (see B. Klesse, in *Mitteil. des Ksthist. Inst. in Florenz*, VIII, 1957, pp. 247 ff.). Our painting is even closer in style and detail to a group of panels, all dating from the 1390's, apparently by an unknown artist who worked in Florence and the surrounding regions under the strong influence of Gaddi. This group includes a dismembered triptych with the Coronation of the Virgin in the central panel (formerly in the collection of Alfredo Barsanti, Rome) and two standing saints in each wing (Wengraf Gallery, London, about 1948), a Madonna and Child with two angels in the Bestagini collection in Milan, another triptych of the Madonna and Child with four saints in the Baptistry of the Collegiata of Impruneta, near Florence, and a number of other works. The painter may have been a Florentine, but aspects of his style suggest that he was Spanish or Portuguese. The musical instrument held by the angel at the left of the throne is of a type hardly known in Tuscan painting, but something like it appears in Byzantine art, in an ivory panel on a chest of about the tenth century in the Carrand collection in the Bargello in Florence.

Inscribed (on frame at base of central panel): HANC TABVLAM FIERI [FECIT] ALDEROT[T]VS DE BRVNEL[L]ESCHIS QVE DIMISSIT / SILVESTER PATRVVS SVVS P[RO] REMEDIO ANIME SVE E[T] SVORVM A D M CCC L XXXX IIII ("Alderottus Brunelleschi had this altarpiece made with what his paternal uncle Silvester left for the redemption of his soul and the souls of his family in the year of our Lord 1394"); (at bottom of central panel): DIE VIIII MENSIS NOVENBRIS; (on frame at base of left panel): S[AN]C[TV]S BERNAR-DVS ABB[AS] / S[AN]C[TV]S SILVESTER P[A]P[A]; (on frame at base of right panel): S[AN]CTV]S NICCHOLAVS EP[ISCO]P[VS] / S[AN]C[TV]S IVLIANVS M[ARTY]R; (on open book held by Christ): A U U (Alpha and Omega).

Formerly attributed by the Museum to an unknown Pisan painter.

Tempera on wood; gold ground. Central panel, h. 48, w. 26½ in. (122×67.2 cm.); side panels, each h. 37, w. 23¼ in. (94×59 cm.).

REFERENCES: G. Richa, *Notizie istoriche delle chiese fiorentine*, IV (1756), pp. 151 f., reports an altarpiece of "Mary and Saints" in the Brunelleschi chapel in the church of San Leo in Florence, quoting an inscription corresponding with ours, with the same date and names of donors and in the same position // M. Chaumelin, *Trésors d'art de la Provence* (1862), pp. 8 ff., mentions this painting (then in Avignon) as an *ex-voto* of the Brunelleschi family and attributes it to Taddeo di Bartolo, comparing it with an altarpiece attributed to him in the Louvre // E. Parrocel, *Annales de la peinture* (1862), pp. 92 f., notes analogies with the Giottesque frescoes in Avignon and tentatively suggests the names of Giotto and Simone Martini, without attributing it to either of them // G. Carocci, *Il Mercato Vecchio di Firenze* (1884), p. 173, lists it among the works that disappeared from the church of San Leo and quotes the inscription // A. Cocchi, *Le Chiese di Firenze*, I (1903), pp. 123 ff., confuses it with another altarpiece, also mentioned by Richa, in the church of San Leo, but quotes the correct inscription // R. Lehman, *The Philip Lehman Collection* (1928), pl. 58, attributes it to a Pisan painter and identifies the Saint Julian as Saint Philip // B. Berenson, *Dedalo*, XI (1930–1931), pp. 986 ff., ill., observes analogies with Niccolò di Pietro Gerini in the faces of Christ and the Virgin but considers it, in general, faithful to Orcagnesque canons; and *Flor. School* (1963), p. 105, attributes it to Jacopo di Cione // M. Salmi, *Rivista d'arte*, XVI (1934), pp. 73 ff., figs. 5, 6, tentatively attributes it to Francesco di Michele and observes reminiscences of Agnolo Gaddi and Gerini within an Orcagnesque tradition // W. and E. Paatz, *Die Kirchen von Florenz*, II (1941), p. 460, lists it among works that disappeared from the church of San Leo and quotes the inscription from Richa and Carocci //

Met. Mus. Bull., n.s., x (1952), p. 188, ill. / / D. Covi *Marsyas*, vi (1950–1953), pp. 58 ff., pl. xix, and *Met. Mus. Bull.*, n.s., xvi (1958), pp. 147 ff., ill., identifies it with the painting in San Leo, quotes contemporary documents, Richa, and other writers before the suppression of the church, gives an account of the lives of the donors, explains the inscription, notes similarities to works in Taddeo Gaddi's tradition, and quotes R. Offner, attributing the altarpiece to an unknown Florentine painter / / G. Kaftal, *Icon. of Saints in Tuscan Ptg.* (1952), col. 929, fig. 1051 *bis* (detail of Saint Sylvester) attributes it tentatively to the Florentine school / / F. Zeri, *Boll. d'arte*, xlix (1964), p. 50, attributes it to the unknown artist who painted works in the Princeton University Museum, the Bestagini collection in Milan, the Sanctuary of the Impruneta near Florence, and elsewhere, calls it an early work, notes echoes of Agnolo Gaddi and the Orcagnesque tradition, and suggests that the painter might have been of Spanish or Portuguese origin, judging from his non-Florentine and non-Italian characteristics.

EXHIBITED: Marseilles, 1861, *Trésors d'art de la Provence*, no. 1190 (lent by Count de Cambis-Alais).

PROVENANCE: Brunelleschi chapel, church of San Leo, Florence (removed 1785).

EX COLL.: a private collection, Florence (until about 1825); Vicomte de Cambis-Alais, Avignon (by 1861); [Ercole Canessa, New York, before 1928]; Philip Lehman, New York (by 1928; until 1947); Robert Lehman, New York (1947–1950).

GIFT OF ROBERT LEHMAN, 1950.

Lorenzo di Niccolò

Lorenzo di Niccolò Gerini. Known activity 1392–1411. Lorenzo was the son of the painter Niccolò di Pietro Gerini, in whose workshop he was trained. His early works can hardly be distinguished from those of his father and the shop assistants; in his later work he was deeply influenced by Spinello Aretino, with whom he collaborated, and by Lorenzo Monaco. Lorenzo di Niccolò was chiefly active in Florence and in San Gimignano. His style shows the final remnants of the Giottesque and Orcagnesque tradition, combined with the forms and rhythms of the late Gothic Florentine painters. He was probably still working long after the last mention made of him in contemporary documents.

An Episode from the Life of Saint Giovanni Gualberto
58.135

Giovanni Gualberto was a Florentine nobleman and the founder of the Vallombrosans, a branch of the Benedictine order. He died in 1073. According to a legend, he was asked by his father to avenge the death of his brother Hugo, but when he met the murderer in a narrow street, instead of exacting blood for blood, he forgave him and spared his life. He then went into the church of San Miniato al Monte in Florence, and as he prayed a painted crucifix leaned towards him as if to thank him for pardoning his enemy. Although the legend says that Giovanni parted from the murderer before he entered San Miniato, both are shown in this painting before the altar. The two swords under his feet seem to be symbolic rather than real, for Giovanni still wears his hanging at his side. The miraculous crucifix is supposed to be

the painted one now in the church of Santa
Trinità in Florence, formerly a Vallom-
brosan church, but it does not seem to be
earlier than the thirteenth century. This
painting is very closely related to one of the
same scene by Giovanni del Biondo, which
is part of a triptych dedicated to Saint Gio-
vanni Gualberto in the Bardi di Vernio
chapel in the church of Santa Croce in
Florence. The similarities are so close that it
seems probable either that Lorenzo di
Niccolò used the picture by Giovanni del
Biondo as a model or that they were both
derived from a common prototype. The
style of our painting is typical of Lorenzo di
Niccolò while he was still under the influ-
ence of his father and before his collabora-
tion with Spinello Aretino in 1401. A dating
in the last years of the fourteenth century
seems the most convincing.

Tempera on wood; gold ground. H. 57¾,
w. 28½ in. (146.7 × 72.4 cm.).

58.135

REFERENCES: The authorities cited below attribute
this painting to Lorenzo di Niccolò. O. Sirén, *Burl.
Mag.*, XXXVI (1920), pp. 72 ff., ill., dates it probably
before 1400 // B. Berenson, *Flor. School* (1963),
p. 123, pl. 389.

EXHIBITED: Museum of Fine Arts, Boston, 1940,
The Arts of the Middle Ages, no. 60 (as Lorenzo di
Niccolò, lent by Eugene L. Garbáty).

EX COLL.: Gen. Sir Edward Kerrison, Oakley Hall,
Eye, Suffolk (until 1853); Lady Bateman (Agnes
Burrell Kerrison), Oakley Hall, Eye, Suffolk (1853–
1919; sale, Christie's, London, July 25, 1919, no.
126, without attribution); Martin (1919); Raymond
Wyer, Worcester, Mass. (1920); Eugene L.
Garbáty, Schloss Alt-Doebern, Nieder-Lausitz, and
Scarsdale, New York (1940–1956; sale, Sotheby's,
London, April 25, 1956, no. 81); [Rudolf Fenouil,
Paris, 1956]; [Arthur Kauffman, London, 1958].

PURCHASE, GWYNNE M. ANDREWS FUND,
1958.

Workshop of Lorenzo di Niccolò

A Rustic Concert (reverse of a
marriage salver) 26.287.1

Salvers (deschi) are pictures painted on pre-
pared panels which were used as trays for
carrying gifts or food on the occasion of a
birth or a marriage. It is very likely that this
painting and the following one were origin-

ally the two sides of one salver, now split
apart. The rarity of such salvers may no
doubt be partly explained by injuries result-
ing from the utilitarian purpose which they
served. Like cassone panels, they usually have
secular subjects – figures in contemporary
interiors or idyllic landscapes. This pair of
scenes illustrates country pastimes in the

26.287.1

mood of the *novelle* of Sacchetti and Boccaccio and is among the earliest known examples. The style resembles that of Lorenzo di Niccolò about the end of the first decade of the fifteenth century, as shown by comparison with his polyptych of 1408 in the Medici chapel in Santa Croce in Florence, but the execution seems to be mostly by his workshop. The Rustic Concert must be the reverse, since it bears coats of arms, which, according to Florentine custom, appear on the reverse. These arms (left, gules a greyhound rampant argent, collared vert, holding in the dexter paw a sword argent,

and, right, sable, on a mound of six rocks vert [azure?], a wolf proper statant) are surely those of the two people for whose marriage the salver was made.

Formerly attributed by the Museum to an unknown Florentine painter of the early XV century (Cat., 1940).

Tempera on wood. H. $21\frac{1}{8}$, w. $22\frac{1}{8}$ in. (53.9×56.2 cm.), twelve-sided.

REFERENCES: W. Bode (unpublished opinion, about 1926) calls these paintings probably Florentine and dates them about 1425 // G. Gronau (unpublished opinion, 1926) considers them Florentine

and dates them in the first part of the fifteenth century // P. Schubring (unpublished opinion, 1926) suggests that the arms are those of the Canigiani and Monte di Pietà families; and *Apollo*, VI (1927), pp. 105 ff., ill., ascribes them tentatively to the school of Agnolo Gaddi and dates them about 1420 // B. Burroughs, *Met. Mus. Bull.*, XXII (1927), pp. 120 ff., ill., dates them 1410–1425 // *International Studio*, 87 (July, 1927), p. 76, ill., notes that the painter also did a salver in the Liechtenstein collection // R. van Marle, *Iconographie de l'art profane* (1931), p. 461, discusses the iconography of the Rustic Concert // B. Berenson, *Ital. Pictures* (1932), p. 9, lists them hesitantly as late works of the Sienese artist Andrea di Bartolo; and *Central and North Italian Schools* (1968), I, p. 7 // R. Offner (verbally, 1935) calls them close to Lorenzo di Niccolò Gerini // L. Venturi, *The Rabinowitz Collection* (1945), pp. 19 f., mentions them as Florentine, early fifteenth century, discusses the iconography of A Hunting Scene // F. Antal, *Florentine Painting and Its Social Background* (1947), pp. 365, 372, pl. 155 (Rustic Concert only), attributes them hesitantly to Mariotto di Nardo, discusses the iconography, and notes that the music-making shepherds are a motive of religious origin, which here is first translated into a secular scene, suggesting that the listeners at the concert are a woman and the bridal pair and the man in the hunting scene is the bridegroom // A. Spychalska-Boczkowska, *Bulletin du Musée National de Varsovie*, IX (1968), no. 2, pp. 29 ff., figs. 2 (reverse), 3 (obverse), considers them as two separate paintings, attributing the reverse to Mariotto di Nardo and the obverse to his circle, and compares them to a cassone frontal in the National Museum in Warsaw depicting the story of Diana with Meleager and Actaeon.

EX COLL.: a private collection, Florence; C. Fairfax Murray, London; [Bottenwieser, Berlin, in 1926].

PURCHASE, ROGERS FUND, 1926.

A Hunting Scene (obverse of a marriage salver) 26.287.2

See comment above under A Rustic Concert.

Formerly attributed by the Museum to an unknown Florentine painter of the early XV century (Cat., 1940).

Tempera on wood. H. $21\frac{1}{8}$, w. $22\frac{1}{8}$ in. (53.6×56.1 cm.), twelve-sided.

REFERENCES: P. Schubring, *Apollo*, VI (1927), p. 106, ill., suggests that the subject of this scene is Atalanta and Milanion. See also above under A Rustic Concert.

EX COLL.: a private collection, Florence; C. Fairfax Murray, London; [Bottenwieser, Berlin, in 1926].

PURCHASE, ROGERS FUND, 1926.

Unknown Florentine Painter, Early XV Century

The Intercession of Christ and the Virgin 53.37

This painting, for a long time wrongly considered a processional banner, is the main part of an altarpiece painted for the cathedral of Florence and known variously as: the altarpiece of the Trinity; the altarpiece of the Annunciation, because of two statues of this subject that stood on the altar table; and the altarpiece of the Pietà, because of the subject of the central part of the predella. According to M. Meiss, who has made an extensive study of the problem, this altarpiece stood against the west wall of the church between the main portal and the smaller northern portal, that is, immediately on the left as one entered the church through the main door. In its complete form it included, in bands at the sides, the figures of

53·37

David, Moses, Isaiah, and Jacob, each bear-
ing an inscription from the Bible alluding to
the Incarnation. Below, in a predella, Christ
was represented as the Man of Sorrows,
between Saint John the Evangelist and the
Magdalen. The entire altarpiece was sur-
mounted by a huge wooden baldachin, the
ceiling of which was decorated with five
wooden quatrefoils, painted by Mariotto di
Nardo and representing Christ surrounded
by the Doctors of the Church. These five
panels are still preserved in the sacristy of the
cathedral of Florence, while the four lateral
prophets and the predella of the altarpiece,
as well as the wooden baldachin, are lost.
Both the side portions and the predella,
according to ancient sources, were, like our
picture, painted on canvas, making this the
earliest known altarpiece not painted on
wood.

Our picture shows an unusual representa-
tion of the Trinity, in which the second
person, exhibiting his wounds, is a sort of
Man of Sorrows. The subject of the picture,
in which the Virgin shows Christ her breast
while Christ shows God the Father his
wounds, is derived from a book devoted to
the praise of the Virgin Mary written by
Ernaldus of Chartres, who died in 1156.[1] In
a passage of this book, which was soon attri-
buted to the better-known Bernard of Clair-
vaux, one reads the following lines: "O man,
you have sure access to God when the
Mother is before her Son, and the Son before
his Father. The Mother showed her breast to
her Son, the Son showed his wounds to
his Father: there where the proofs of love
are so many no one can be denied." The
same theme was further expounded in the
so-called *Speculum humanae salvationis* (Mir-

ror of Human Salvation) in which the double
intercession is the argument of chapter 39.
Our painting seems to be the first known
instance of combining the two intercessions
in one scene, since earlier illustrations of that
book show in one picture Christ exhibiting
his wounds to God and in a second vignette
the Virgin exhibiting her breast to the Son.
The painting, which occupied such a promi-
nent place in the cathedral of Florence,
became very popular during the fifteenth
century, and a number of derivations from
it are known.[2] The painter has not only
established a sort of hierarchy of intercession
but has symbolized in the colors of the gar-
ments the kinds of proof offered by the two
lower figures, representing the Virgin in
white, suggesting her milk, and Christ in a
reddish mantle, symbolizing the blood and
the wine.

The date of the execution of the altarpiece
is not known, but it can be conjectured from
contemporary documents. The baldachin
above the altar was completed in 1402, and
it is almost certain that our painting stood
on the altar by that time. It seems that
Mariotto di Nardo's quatrefoils in the ceil-
ing of the baldachin were paid for in 1402
and that further payments to the same artist

[1] Ernaldus of Chartres, Libellus de laudibus B.
Mariae Virginis, in J. P. Migne, ed., *Patrologia
latina*, 189 (1854), col. 1726.

[2] The seven known versions of the subject are:
1. Master of the Sherman Predella, Florence, priv-
ate collection (R. Longhi, *Proporzioni*, II, 1948,
pl. 182). 2. Follower of D. Ghirlandaio, Museum
of Fine Arts, Montreal (L. Cust, *Les Arts*, October
1907, pp. 5, 28). 3. Follower of Domenico Ghir-
landaio, Florence, in the former monastery of San
Giorgio alla Costa (M. Salmi, *Riv. d'arte*, XV, 1933,
pp. 260 ff., fig. 5, wrongly as by Bartolomeo
Caporali). 4. Filippino Lippi and assistants, Munich,
Alte Pinakothek (K. Neilson, *Filippino Lippi*, 1938,
p. 109, fig. 48). 5. Andrea della Robbia, Foiano,
church of San Francesco (Marquand, *Andrea della
Robbia*, 1922, II, p. 215, fig. 269). 6. Follower of
Piero di Cosimo, Potsdam, Neues Palais (in stor-
age). 7. Florentine school, early XVI century, Pisa
Museum, lunette (*Dedalo*, V, 1924–1925, p. 22).

for other works on the same altar were made in 1404. The statues of the Annunciation, possibly the famous ones now in the Museo dell'Opera del Duomo often attributed to Nanni di Banco, were placed upon the altar by 1409, but they had been made for the Porta della Mandorla and in 1409 and again in 1414 it was resolved that they had to be removed to that part of the church.

It is not known who commissioned the painting, which used to be thought a processional banner made for a confraternity. The people between Christ and the Virgin may, however, represent a family group rather than a confraternity, since two women and a young boy are included among them. It is possible that the foremost man wears the costume of a Gonfaloniere di Giustizia, an important officer in the government of Florence. The artist is also unknown. The style shows the characteristics of a late follower of Andrea Orcagna, far superior to Niccolò di Pietro Gerini and Mariotto di Nardo, and in its linear rhythms is strongly reminiscent of that of the early Lorenzo Monaco. In spite of the importance of this commission no other work by the same hand is at present known.

Inscribed (in center): PADRE MIO SIENO SALVI CHOSTORO PEQUALI TU / VOLESTI CHIO PATISSI PASSIONE ("My Father, let those be saved for whom you wished me to suffer the passion"); DOLCIXIMO FIGLIUOLO PELLAC: / TE CHIO TIDIE. ABBI MĪA [MISERICORDIA] DI CHOSTORO ("Dearest Son, because of the milk that I gave you have mercy on them").

Tempera on canvas. H. $94\frac{1}{4}$, w. $60\frac{1}{4}$ in. (239.4 × 153 cm.).

REFERENCES: G. Richa, *Notizie istoriche delle chiese fiorentine*, VI (1757), pp. 115 f., describes this painting in its original place, says it was painted in oil,

and suggests that the foremost man in the group of people is a Gonfaloniere di Giustizia // G. Cambiagi, *Guida al forestiero* . . . (1790), p. 28, describes it in its original place // V. Follini, *Firenze antica e moderna illustrata* (1790), II, pp. 195 f., says that the group of people represents the Signoria of Florence // F. Fantozzi, *Nuova Guida della città di Firenze* (1846), p. 352, describes it in its original place, and calls the medium oil // C. J. Cavallucci, *Santa Maria del Fiore* (1887), pp. 239, 241, describes it in its original place and rejects the description of the medium given by Richa, and part II, p. 151, publishes the documents of 1402 related to the altar // G. Poggi, *Il Duomo di Firenze* (1909), pp. cix ff., documents nos. 371, 372, 1006–1016, 1019, 1036, 1056, 1061 // T. Borenius, *Burl. Mag.*, XII (1922), pp. 156 ff., ill. opp. p. 155, calls it hesitantly a processional banner and attributes it to the late period of Niccolò di Pietro Gerini // R. van Marle, *Ital. Schools*, III (1924), p. 624, note 1, calls it a panel, attributes it to Niccolò di Pietro Gerini; and V (1925), p. 480, observes that there are many reminiscences of Agnolo Gaddi's art and, although confirming the attribution to Niccolò di Pietro Gerini, denies that it could belong to his late period // E. Panofsky, in *Festschrift für Max Friedländer* (1927), pp. 293 f., 305 f., note 106, fig. 38, discusses the iconography, calls it the earliest known example of this theme, and attributes it to Niccolò di Pietro Gerini; and *Early Netherlandish Painting* (1954), p. 214 // R. Offner, *Studies in Florentine Painting* (1927), p. 94, attributes it tentatively to an assistant of Niccolò di Pietro Gerini // A. Scharf, *Filippino Lippi* (1935), pp. 46, note 95, 47, attributes it to Niccolò di Pietro Gerini, calls it a processional banner, and discusses it in connection with Filippino Lippi's altarpiece in Munich, along with other derivations // B. Berenson, *Pitture italiane* (1936), p. 295, lists it as a work of Mariotto di Nardo and calls it a processional banner; and *Flor. School* (1963), p. 132, attributes it tentatively to Mariotto di Nardo // F. Antal, *Florentine Painting and Its Social Background* (1947), p. 329, fig. 121, attributes it to the late period of Niccolò di Pietro Gerini, calls it a panel, and discusses the iconography // W. and E. Paatz, *Die Kirchen von Florenz*, III (1952), pp. 400 f., attribute it to Niccolò di Pietro Gerini and believe that it was placed on the altar in 1414 // M. Meiss, *Met. Mus. Bull.*, n.s., XII (1954), pp. 302 ff., ill. (with details), fully discusses the history and the iconography of the painting and attributes it to an unknown Florentine painter, dating it possibly in 1402 // H. S. Merritt (in a letter, 1954) compares it with Andrea della Robbia's altarpiece in the church of San Francesco at Foiano // F. Bologna, *I Pittori alla Corte Angioina di Napoli*

(1969), pp. 240, 282, note 10, calls it a Florentine banner of the early XV century.

PROVENANCE: the chapel of the Santissima Trinità, cathedral of Florence (Santa Maria del Fiore); removed sometime after 1846.

EX COLL.: the Earls of Crawford and Balcarres, Haigh Hall, Wigan, Lancashire (by 1856; until 1940); David Alexander Robert Lindsay, twenty-eighth Earl of Crawford and eleventh Earl of Balcarres, Haigh Hall, Wigan (until 1946; sale, London, Christie's, October 11, 1946, no. 18, attributed to Taddeo di Bartolo); [Arthur Kauffman, London, 1946–1953].

At The Cloisters.

THE CLOISTERS COLLECTION, PURCHASE 1953.

Unknown Florentine Painter, First Quarter of the XV Century

Scenes from a Legend (cassone panel)
32.75.2 A

No satisfactory explanation has yet been suggested for the episodes represented in this panel. It was at one time supposed to represent various examples of female virtue, but it is more probable that it illustrates some classical or medieval tale. The surface has suffered greatly from rubbing and restoration. The style is that of late Gothic Florentine painting, recalling particularly the late followers of Agnolo Gaddi and the Gerini. It was probably painted about 1410.

A companion to this cassone panel, decorated with the same embossed ornament but still preserving the original frame at the sides as well and showing two undecipherable coats of arms, is now in the collection of Count Leonardo Vitetti in Rome. The series of scenes illustrated on it is almost certainly related to the legend of Aeneas and to his arrival at the court of Queen Dido (Virgil, *Aeneid* XIV, 78 f.).

Formerly called by the Museum Three

Scenes of Female Virtue and attributed to an unknown Florentine painter of the first half of the XV century (Cat., 1940).

Tempera on wood; gilt and silver embossed ornaments. H. 15½, w. 46 in. (39.4 × 116.8 cm.).

REFERENCES: H. B. Wehle, *Met. Mus. Bull.*, XXXIV

(1939), pp. 19 f. // M. Boskovits (in a letter, 1968) suggests that this panel was probably painted by the "Master of the Cracow Cassone."

EX COLL.: Giovanni P. Morosini, Riverdale-on-Hudson, New York (until 1908); Giulia Morosini, Riverdale-on-Hudson, New York (1908–1932).

THE COLLECTION OF GIOVANNI P. MOROSINI, PRESENTED BY HIS DAUGHTER GIULIA, 1932.

Unknown Florentine Painter, Early XV Century

The Coronation of the Virgin 88.3.77

In the arrangement of the figures, the shape of the crown, and the drapery background this painting accords with the type of Coronation painted in Florence during the last quarter of the fourteenth century and in the first three decades of the following. It is close in style to the work of the Gothic followers of Agnolo Gaddi and may perhaps come from the workshop of the anonymous artist who painted a triptych in the church of San Jacopo at Mucciana, near Florence. This painting and the Museum's Coronation adopt the types of Agnolo Gaddi in a very similar way.

Once attributed by the Museum to Gherardo Starnina.

Tempera on wood; gold ground; evidently the panel originally had an arched top. H. 13½, w. 10⅞ in. (34.3 × 27.6 cm.).

REFERENCE. C. Brandi (verbally, 1940) tentatively calls this painting a Bolognese work, close to Pietro dei Lianori.

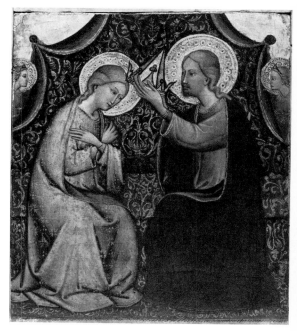

88.3.77

EX COLL. Mme d'Oliviera, Florence.

GIFT OF COUDERT BROTHERS, 1888.

Lorenzo Monaco

Real name Piero di Giovanni. Born in Siena about 1370; died 1425. Lorenzo Monaco left Siena in his youth and settled in Florence, where in 1391 he entered the Camaldolese monastery of Santa Maria degli Angeli. In this monastery he was much occupied with the illumination of manuscripts, an art for which the foundation was famous. His style, influenced by the flexible line of the miniaturists, is evidently derived from both Sienese and Florentine sources, showing particular analogies to Agnolo Gaddi. In 1413 he painted for his monastery his most resplendent work, the elaborate altarpiece of the Coronation of the Virgin now in the Uffizi in Florence. In spite of some concessions to the newer forms of the Renaissance, especially apparent in his late frescoes in the Bartolini chapel in Santa Trinità in Florence, Lorenzo continued to cling to the methods of a miniaturist and remained essentially a fourteenth-century painter. A number of conservative minor artists active in Florence during the first half of the fifteenth century who were unaffected by the great founders of the Renaissance were deeply influenced by his style.

Abraham 65.14.1

Abraham is pictured here holding in his right hand the silver knife for the sacrifice commanded by the Lord and the symbol of the altar's flame; his left hand rests upon the head of his young son Isaac, kneeling before him in respectful obedience. This panel and the three following are similar in composition and must once have belonged to the same ensemble. All four show Old Testament figures, seated on marble benches. A fifth painting, also arched at the top and with many similarities to the Museum's four, represents Saint Peter, seated on a marble bench, holding in his right hand a key and in his left an open book; it belongs to the Lotzbeck collection at Schloss Nannhofen, not far from Munich.

The style of the Museum's panels and the high quality of their execution proclaim that they were painted by Lorenzo Monaco himself, without help from his workshop. They must be from his middle period, around 1410 or perhaps a little earlier, judging from the strong plasticity of the figures and their close relationship to other Florentine paintings of the late fourteenth century.

Although Sirén believed (see Refs., below) that the panel with David was part of an altarpiece that Lorenzo Monaco painted for the Cappella Fioravanti in the church of San Pier Maggiore in Florence, such a hypothesis for the provenance of the panels is unacceptable. It is difficult to imagine the work of art that these figures helped to compose. They are in any case too large to have been the uppermost sections of a many-paneled ensemble. Certain differences in the Museum's four divide them into two pairs and suggest that they were arranged not in a single row but in two ranks of balancing figures, possibly on either side of a central missing part. The angles of perspective at

the corners of the marble benches on which the figures are seated are the same in the panels showing Moses and Abraham and somewhat less acute in those showing Noah and David. The same pairing is also suggested by the colors of the pavement beneath the benches; the Noah and David panels show pink marble paving with a strip of green below along the edge, while the same colors are used in the opposite arrangement in the panels showing Moses and Abraham. The source of light, furthermore, which can best be determined in the faces of the figures, is at the left of David and Abraham and at the right of Moses and Noah, confirming the supposition that Abraham and Moses were on the same level and David and Noah below on another. One curious difference remains inexplicable, the fact that the halo of Moses is decorated with a motive of dots and circles while the haloes of the other three prophets and of the little Isaac as well are adorned with six-petaled floral forms and dots.

The halo of the Lotzbeck panel is one of a number of differences that the painting exhibits in connection with the Museum's four. It is tooled but less rich and elaborate than either of the types of haloes to be found on the Museum's works. Although this fifth panel shows all the characteristics of the same period of development in Lorenzo Monaco's career as the other four, it appears to be slightly inferior to them in quality. This could be due to the participation of the workshop in its execution, but it is difficult to be precise about the quality of a picture in such a rubbed and repainted state as that of the Saint Peter today. It has been deeply altered by very extensive restoration, which has not only affected its style but has changed certain details of the composition, especially the right part of the marble bench

and the bottom of the saint's robe. Nevertheless, combining the present appearance of the panel with the evidence afforded by photographs taken before the restoration leads to the conclusion that the Lotzbeck panel is closely connected in style with the Museum's four panels. It is slightly smaller than they, measuring 20½ by 15 inches, as compared with their 23 by 17 inches. The difference in height is due to the absence of the marble step at the bottom, probably the result of the loss of a strip of the painted surface. A final major difference between the Lotzbeck panel and the Museum's pictures is the fact that the light does not fall upon the figure from either side, but is apparently centralized and evenly distributed. This suggests that Saint Peter appeared somewhere in the middle of the ensemble, rather than at the sides, where our figures must have been.

Such an arrangement of the figures fits well with what can be supposed about the iconography of the original ensemble. As Millard Meiss has already pointed out (see Refs., below), though patriarchs, kings, and prophets are represented in the art of the Renaissance as playing a role in the scheme of salvation, they are nevertheless not permitted independent existence on an altarpiece but are customarily represented in connection with the New Testament persons or themes which they prefigure. Since Noah here holds the ark, which usually signifies the Church, and Abraham, in sacrificing Isaac, is a parallel to God in his sacrifice of Christ, it is reasonable to assume that the complex to which the five panels belonged had a Christian subject, dedicated to the New Testament and the Church, flanked at the sides by important representatives of the Old Law. The presence of Saint Peter is to be expected in such a scheme as he

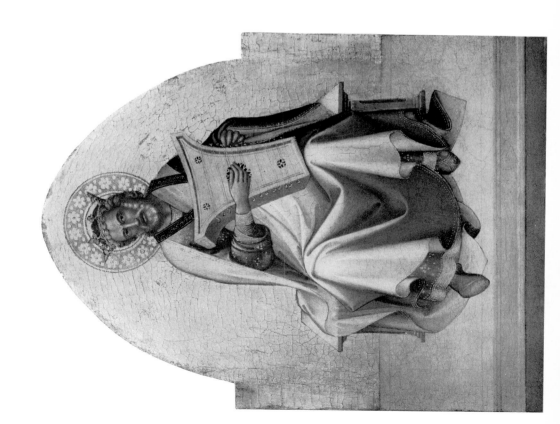

is usually regarded as the first and chief symbol of the New Law. A contrast between the characters in the lettering on Moses' tablets and in Saint Peter's book is perhaps significant as an allusion to the two different traditions.

Tempera on wood; gold ground. Over-all size, h. 26, w. 17 in. (66 × 43.1 cm.); painted surface, h. 23, w. 16⅝ in. (58.4 × 42.2 cm.).

REFERENCES: The authorities cited below attribute the paintings of Abraham, Moses, and Noah to Lorenzo Monaco. B. Berenson, *Flor. Ptrs.* (1909), p. 154; *Flor. School* (1963), I, p. 120, pl. 441 (Noah) calls them companions to the painting of David // R. van Marle, *Ital. Schools*, IX (1927), p. 168, note 3, quotes Berenson's attribution // W. Suida, in Thieme-Becker, XXIII (1929), p. 392 // M. Meiss, *Burl. Mag.*, C (1958), pp. 191 ff., figs. 1 (detail of Moses), 5 (Moses), 4 (Abraham), 7 (Noah), relates them to the panel of David from the Cassel Gallery, suggesting a date around 1406–1410, fully discusses their possible origin and their iconographic significance, tentatively indicates the possible influence of Donatello's Saint John the Evangelist in the strong formal treatment, mentions a drawing from the workshop of Fra Angelico in the British Museum that surely is derived from the figure of David, and ascribes the Saint Peter in the Lotzbeck collection to a follower of Lorenzo Monaco, rejecting the idea that it was part of our series; and in a letter (1964) notes that the Vallombrosan order venerated Old Testament prophets, which are represented several times in their church of Santa Trinità in Florence // *Sele arte*, XVII (1959), no. 41, p. 17, quotes Meiss's attribution of the panels to Lorenzo Monaco before 1410 // P. de Montebello, *Met. Mus. Bull.*, n.s., XXV (1966), pp. 152, ff. ill. (including details and cover in color), dates them about 1406.

EX COLL.: Vincenzo Biondi, Florence (sale, George, Paris, March 12–13, 1841, no. 8, as attributed to Beato Angelico); Albin (?) Chalandon, La Grange Blanche, Trévoux; Henri Chalandon, La Grange Blanche (by 1909); Georges (?) Chalandon, La Grange Blanche, (until about 1958); [Wildenstein, New York, after 1958–1965].

PURCHASE, GWYNNE M. ANDREWS FUND AND EXCHANGE, GIFT OF G. LOUISE ROBINSON, 1965.

Noah 65.14.2

The patriarch is represented holding in his left hand the ark, symbol of his salvation, while with his right hand he points upward indicating divine help. See above under Abraham.

Tempera on wood; gold ground. Over-all size, h. 26⅛, w. 17½ in. (66.3 × 44.4 cm.); painted surface, h. 23, w. 17 in. (58.4 × 43.1 cm.).

REFERENCES: See above under Abraham.

EX COLL.: Vincenzo Biondi, Florence (sale, George, Paris, March 12–13, 1841, no. 9, as attributed to Beato Angelico); Albin (?) Chalandon, La Grange Blanche, Trévoux; Henri Chalandon, La Grange Blanche (by 1909); Georges(?) Chalandon, La Grange Blanche (until about 1958); [Wildenstein, New York, after 1958–1965].

PURCHASE, GWYNNE M. ANDREWS FUND AND EXCHANGE, GIFT OF PAUL PERALTA RAMOS, 1965.

Moses 65.14.3

Moses is represented with rays of light issuing from his head and holding in his hands the tablets of the law. See also above under Abraham.

Tempera on wood; gold ground. Over-all size, h. 24¾, w. 17¾ in. (62.8 × 45.1 cm.); painted surface, h. 22¾, w. 17¾ in. (57.8 × 45.1 cm.).

REFERENCES: See above under Abraham.

EX COLL.: Vincenzo Biondi, Florence (sale, George, Paris, March 12–13, 1841, no. 7, as attributed to Beato Angelico); Albin (?) Chalandon, La Grange Blanche, Trévoux; Henri Chalandon, La Grange Blanche (by 1909); Georges(?) Chalandon, La Grange Blanche (until about 1958); [Wildenstein, New York, after 1958–1965].

PURCHASE, GWYNNE M. ANDREWS FUND AND EXCHANGE, BEQUEST OF MABEL CHOATE IN MEMORY OF HER FATHER, JOSEPH H. CHOATE, 1965.

David 65.14.4

King David is represented singing his Psalms and accompanying himself with a harp. See also above under Abraham.

Tempera on wood; gold ground. H. $22\frac{1}{4}$, w. 17 in. (56.5×43.1 cm.).

REFERENCES: The authorities cited below attribute this painting to Lorenzo Monaco. *Kurzes Verzeichnis der Gemälde in der königlichen Galerie zu Cassel* (1903), no. 477 a; *Katalog der königlichen Gemäldegalerie zu Cassel* (1913), p. 38, no. 478, calls it a fragment of a large altarpiece; (ed. 1929) p. 44, calls the painting in the Lotzbeck collection in Munich a companion piece // O. Sirén, *Don Lorenzo Monaco* (1905), pp. 43 f., pl. x, asserts that this painting and the panel in the Lotzbeck collection are the same size and format and are pendants from the same altarpiece by Lorenzo Monaco, probably an early work, perhaps that supposedly painted for the Cappella Fioravanti in San Pier Maggiore, Florence // B. Berenson, *Flor. Ptrs.* (1909), p. 152, lists it; *Dedalo*, XII (1932), pp. 30 f., pl. opp. p. 5, dates it between 1405 and 1410; *Flor. School* (1963), I, p. 120, pl. 440, calls it a companion to the three paintings of Noah, Abraham, and Moses // R. van Marle, *Ital. Schools*, IX (1927), p. 165 // W. Suida, in Thieme-Becker, XXIII (1929), p. 392 // V. Golzio, *Lorenzo Monaco* (1931), p. 34, pl. 23, notes that Lorenzo Monaco has treated this figure like a manuscript illumination and with the plasticity found also in his larger paintings // G. Pudelko, *Burl. Mag.*, LXXIII (1938), p. 238, note 13, dates this painting and the Saint Peter in the Lotzbeck Gallery later than 1405 // M. Meiss, *Burl. Mag.*, C (1958), pp. 191 f., 195 f., 359, fig. 8, relates it to the three panels of Noah, Abraham, and Moses, dates them around 1406–1410, and discusses their possible origin; in a letter (1964) notes that the Vallombrosan order venerated Old Testament prophets, which are represented several times in their church of Santa Trinità in Florence // *Sele arte*, XVII (1959), no. 41, p. 17, quotes Meiss's attribution to Lorenzo Monaco before 1410 // P. de Montebello, *Met. Mus. Bull.*, n.s., XXV (1966), pp. 152 ff., ill. (including cover in color and details), dates the panels about 1406.

EX COLL.: George Augustus Wallis, Florence (until 1847; sale, Heberle, Berlin, May 24, 1895, no. 61); Königliche Gemäldegalerie, Cassel (by 1903; until 1929); [A. S. Drey, Munich and New York, 1929]; Solomon R. Guggenheim, New York (1929–1949); Solomon R. Guggenheim Foundation, New York (1949; sale, Sotheby's, London, June 27, 1962, no. 14); [Wildenstein, New York, 1962–1965].

PURCHASE, GWYNNE M. ANDREWS AND HENRY G. MARQUAND FUNDS AND EXCHANGE, GIFT OF MRS. RALPH J. HINES, 1965.

Workshop of Lorenzo Monaco

The Madonna and Child with Angels 09.91

This picture belongs to the type known as the Madonna of Humility, in which the Virgin is shown seated low upon the ground, usually upon a cushion. The style is very close to that of Lorenzo Monaco, making it likely that the design at least is his. The execution, however, betrays the hand of an assistant working in his shop, apparently the same artist who was responsible for a triptych representing Saint Lawrence Enthroned between Saint Agnes and Saint Margaret in the Louvre (no. 1348; predella in the Vatican Gallery, nos. 215–217). The date is surely between 1405 and 1410, about the time of a

09.91

Crucifixion in the Seattle Art Museum
(Kress collection, no. 1654), which is dated
1408.

Formerly attributed by the Museum to
Lorenzo Monaco (Cat., 1940).

Tempera on wood; gold ground; the original arched top of the panel has been
slightly truncated. H. $35\frac{1}{4}$, w. $22\frac{1}{8}$ in.
(89.6 × 56.2 cm.).

REFERENCES: The authorities cited below, with
the exception of R. Offner, attribute this painting
to Lorenzo Monaco. O. Sirén, *Don Lorenzo
Monaco* (1905), pp. 36 f., pl. v, notes its similarity to
the Madonna of 1400 in Berlin and dates it shortly
before 1403 // B. Berenson, *Flor. Ptrs.* (1909), p. 154;
Ital. Pictures (1932), p. 300, lists it as an early work;
and *Flor. School* (1963), p. 120 // B. B[urroughs],
Met. Mus. Bull., IV (1909), pp. 141 ff., ill. // M.
Bernath, *New York und Boston* (1912), p. 68 // V.
N. Lazarev, *L'Arte*, XXVII (1924), p. 124, agrees with
Sirén's dating and compares it with a Madonna in
the Rumiantzeff Museum in Moscow // R. van
Marle, *Ital. Schools*, IX (1927), p. 134, fig. 87, dates
it between the Madonna of 1405 in the Berenson
collection and the polyptych of 1406–1410 in the
Uffizi // R. Offner (verbally, 1937) calls it a work
from the shop of Lorenzo // G. Pudelko, *Burl.
Mag.*, LXXIII (1938), p. 238, note 13, relates this
picture stylistically to the Virgin of Humility of
1405 in the Berenson collection and the Madonna
in the Rumiantzeff Museum in Moscow and dates
it shortly before 1405.

EX COLL.: [dealer, Dover, England]; [Victor G.
Fischer, Washington, D.C., 1909].

PURCHASE, ROGERS FUND, 1909.

Bicci di Lorenzo

Born 1373; died 1452. Bicci di Lorenzo was the son of Lorenzo di Bicci and the father of
Neri di Bicci. His early work is in the fourteenth-century tradition and recalls the style of
Agnolo Gaddi and the later followers of Giotto. Subsequently he was influenced by Lorenzo
Monaco, and his later works reflect the taste of the late Gothic Florentine style. His manner
also shows a knowledge of Gentile da Fabriano, who was in Florence between 1422 and
1425. Towards the end of his career he was influenced by Domenico Veneziano, with whom
he collaborated in the decoration of the main chapel of the church of Sant'Egidio in Florence,
now lost. He was commissioned to paint the frescoes of the choir of the church of San

Francesco at Arezzo, but he only began this work, which after his death was taken over by Piero della Francesca. Bicci di Lorenzo was the director of a very active shop, and only a few of his paintings are free from the collaboration of assistants and pupils.

Saint Nicholas Providing Dowries

88.3.89

This painting and the following one be-longed to the five-part predella of an altar-piece painted by Bicci di Lorenzo and his partner Stefano di Antonio in 1433 for the monastery of San Niccolò in Cafaggio in Florence. In the corners of our rectangular panels unfinished areas can still be seen which indicate the shape of the original frame of the predella. The predella included three other panels, Saint Nicholas Rebuking the Tempest in the Ashmolean Museum in Oxford (no. 60), Pilgrims at Saint Nicholas's Tomb in the Museum of the Castle of Wawel in Cracow, and the Birth of Saint Nicholas, lately on the art market in France. The altarpiece was appraised on January 14, 1435, by Fra Angelico and Rossello di Jacopo Franchi. It was dismembered during the eighteenth century. The central panel, showing a Madonna and Child with four angels, is now in the Parma Gallery (no. 456). The wings, at one time wrongly identified with two panels each showing two saints in the Pinacoteca Stuard in Parma, have been traced through an eighteenth-century description by Richa[1] of the main panels of the altarpiece. They are a Saint Benedict and Saint Nicholas in the Museum of the Badia at Grottaferrata, near Rome, and a Saint John the Baptist with Saint John the Evangelist (called Saint Matthew by Richa) in the collection of Robert Lehman

in New York. The central panel and four of the five sections of the predella are free copies from an altarpiece that Gentile da Fabriano painted in 1425 for the Quaratesi family, which was once in the church of San Niccolò Oltrarno in Florence and is now dispersed through various collections (cen-tral panel in Buckingham Palace, London; wings in the Uffizi, Florence; four predella panels in the Vatican Gallery, Rome, and one in the National Gallery of Art, Wash-ington.)

In this panel, which was derived from one of the panels by Gentile in the Vatican Gallery, Saint Nicholas of Bari is shown throwing through the window three bags (or balls) of gold into the chamber of three girls, whose father, a nobleman of Panthera, was so destitute that he was considering giving them up to prostitution. The three bags of gold, usually represented as golden balls, have become the familiar attribute of Saint Nicholas.

According to a document, the altarpiece was painted by Bicci di Lorenzo with the collaboration of Stefano di Antonio, a minor figure of Florentine painting (1405–1483), who began his career in Bicci's shop and from 1430 onwards was his partner. This panel shows no sign of collaboration and must thus be considered entirely painted by Bicci di Lorenzo.

Once attributed by the Museum to Gher-ardo Starnina and later called a work of the Florentine school.

Tempera on wood. H. 12, w. 22¼ in. (30.5 × 56.5 cm.).

[1] G. Richa, *Notizie istoriche delle chiese fiorentine,* VII (1758), p. 35, describes the altarpiece and calls it a work by Lorenzo di Bicci in San Niccolò.

88.3.89

REFERENCES: A. H. Schmarsow, *Masaccio Studien*, IV (1898), pp. 88 f., ascribes the Quaratesi predella in the Vatican to Masaccio and publishes *Saint Nicholas Resuscitating Three Youths* as a copy by a later, less skillful painter // M. L. Berenson, *Rass. d'arte*, XV (1915), pp. 210 f., ills. p. 209 and opp. p. 209, ascribes our panels to Bicci, associating them with the central panel of his altarpiece of 1433 from the monastery of San Niccolò (now in Parma) and noting Bicci's dependence on Gentile da Fabriano's Quaratesi altarpiece // B. B[urroughs], *Met. Mus. Bull.*, XI (1916), pp. 237 f., ill. (*Saint Nicholas Resuscitating Three Youths*), considers our two panels the predella to the Madonna and Child of 1433 in Parma, wrongly recording the provenance as a monastery church of San Niccolò at Parma // R. van Marle, *Ital. Schools*, IX (1927), pp. 16 ff., figs. 9, 10, associates our panels with the predella panel in Oxford and with the Madonna in Parma // M. Salmi, *Enciclopedia italiana*, VI (1930), p. 973, reconstructs the altarpiece, identifying the two paintings in the Pinacoteca Stuard as the side panels once with the Madonna in Parma, mentioning our two paintings and the one in Oxford as predella panels and observing the dependence on Gentile's Quaratesi altarpiece // B. Berenson, *Ital. Pictures* (1932), p. 85, lists our panels as works by Bicci; and, *Flor. School* (1963), p. 30, pl. 507 (*Saint Nicholas Resuscitating Three Youths*) // A. Santangelo,

Inventario degli oggetti d'arte d'Italia, Provincia di Parma (1934), p. 119, considers the two Stuard panels the wings of the altarpiece of 1433 by Bicci, but observes that the saints represented do not correspond to Richa's description // A. O. Quintavalle, *La Regia Galleria di Parma* (1939), p. 168, accepts a reconstruction of the altarpiece that includes the Stuard panels // W. and E. Paatz, *Die Kirchen von Florenz*, IV (1952), pp. 389, 391, note 19, examine the reconstruction of the original 1433 altarpiece, tentatively accepting the Stuard paintings as side panels and identifying our two pictures and the Oxford one as predella panels // R. Krautheimer, *Lorenzo Ghiberti* (1956), p. 259, note 12, refers to the panels as by Bicci // F. Zeri, *Paragone*, IX (1958), no. 105, pp. 67 ff., figs. 45, 46, rejects the Stuard paintings as part of the altarpiece of 1433 by Bicci, considers that the wings are the panels now in Grottaferrata and in the collection of Robert Lehman, adds to the predella a panel in a private collection in New York // M. Michalska, *Studye do Dziejów Wawelu*, II (1959), pp. 39 ff., accepts the reconstruction of the altarpiece suggested by Zeri and adds to the predella the panel in the Wawel Museum in Cracow // W. Cohn, *Boll. d'arte*, XLIV (1959), pp. 61 f., 68, note 2, accepts the reconstruction of the altarpiece suggested by Zeri, identifies the so-called Saint Matthew in the Lehman picture as Saint John the Evangelist, publishes the

documents related to the appraisal of the altarpiece (Florence, Archivio di Stato, Convento di San Niccolò Maggiore, vol. IV, c. 1ᵛ), and suggests that the panel in Grottaferrata and our Saint Nicholas Resuscitating Three Youths, which he considers inferior in quality to the other parts of the altarpiece, are mainly by Stefano di Antonio.

EXHIBITED: Corning Museum of Glass, Corning, New York, *A Century of Toys*, 1956–1957.

PROVENANCE: the monastery of San Niccolò in Cafaggio, Florence (removed about 1783).

EX COLL.: Marchese Alfonso Tacoli Canacci, Florence and Parma (about 1787); Foresse; Mme d'Oliviera, Florence.

GIFT OF COUDERT BROTHERS, 1888.

Saint Nicholas Resuscitating Three Youths 16.121

Saint Nicholas of Bari, during a famine, chanced to stop at an inn where three youths had been butchered by the innkeeper and salted in vats to be sold for food. Here the saint is shown restoring them to life by making the sign of the cross. The tablets on the wall are inscribed with marks which are probably alchemists' symbols, related to various kinds of substances, rather than mystic symbols as formerly thought. This panel, with its stiff execution, slightly inferior to that of the other predella panels, was probably painted, at least in part, with the collaboration of Stefano di Antonio. See also comment above under Saint Nicholas Providing Dowries.

Tempera on wood. H. 12, w. 22¼ in. (30.4 × 56.5 cm.).

REFERENCES: See above under Saint Nicholas Providing Dowries.

EXHIBITED: Royal Academy, London, 1884, *Old Masters*, no. 217 (as Florentine School, lent by Charles Butler); New Gallery, London, 1893–1894, *Early Italian Art*, no. 37 (as Florentine School, lent by Charles Butler).

16.121

PROVENANCE: the monastery of San Niccolò in Cafaggio, Florence (removed about 1783).

EX COLL.: Marchese Alfonso Tacoli Canacci, Florence and Parma (about 1787); Charles Butler, London (by 1884; sale, Christie's, London, May 25 and 26, 1911, no. 91, as School of Zanobi Strozzi); [Dowdeswell and Dowdeswell, London, 1911]; [Stephen Bourgeois, Cologne, 1916]; [Kleinberger Galleries, New York, 1916].

GIFT OF FRANCIS KLEINBERGER, 1916.

The Madonna and Child with Saint Matthew and Saint Francis
41.100.16

This panel is typical of Bicci di Lorenzo's work and ranks with a number of similarly conceived representations where certain motives and details from his large altarpieces are repeated with slight changes and in various combinations. Among the paintings of this type, often partly by his workshop, are those in the Accademia in Florence (no. 8611), the Gallery in Montepulciano, and the Ca' d'Oro in Venice. Although in Bicci's long career, especially in his mature period, there are no stylistic changes marked enough to postulate a precise order of development, comparison with dated works by him seems to place our panel in the 1430's.

The embossed and gilded frame, in large part original, contains, in the quatrefoil in the apex, traces of a painted God the Father and in the seven quatrefoils at the bottom seraphs painted alternately in red and blue.

Inscribed (on haloes): AVE MARIA GRATIA PLE[NA]; SCS MATTEVS AP[OSTOLVS]; SCS FRANCISCHV[S].

Tempera on wood; gold ground, embossed haloes. Over-all size, h. 44⅝, w. 22¼ in. (113.4 × 56.6 cm.); painted surface, h. 32¾, w. 18¾ in. (83.2 × 47.6 cm.).

REFERENCES: The authorities cited below attribute this painting to Bicci di Lorenzo. M. L. Berenson,

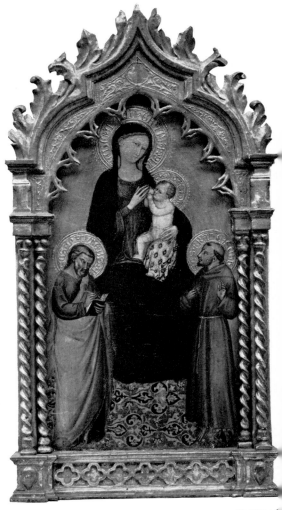

41.100.16

Rass. d'arte, XV (1915), pp. 212 f., ill. // R. van Marle, Ital. Schools, IX (1927), p. 8, calls it the most typically fourteenth-century of Bicci's works; p. 33, note 1, lists it, wrongly identifying the saint on the left as John the Evangelist // B. Berenson, Ital. Pictures (1932), p. 85, lists it; and Flor. School (1963), p. 30 // B. Klesse, Seidenstoffe in der italienischen Malerei des vierzehnten Jahrhunderts (1967), p. 241, no. 131 b, dates our painting approximately 1425–1450 on the basis of the textile in the foreground.

EX COLL.: Prince Corsini, Florence; [Pedulli, Florence, about 1915]; George and Florence Blumenthal, New York (by 1926; until 1941; Cat. I, 1926, pl. VII).

GIFT OF GEORGE BLUMENTHAL, 1941.

Unknown Painter, Possibly Florentine, Second Quarter of the XV Century

The Story of Actaeon
(cassone panel) 41.190.129

This panel, like the following, is the decoration of the front of a large cassone, or marriage chest. On the ends of each chest are shields bearing the same unidentified coat of arms, which indicates that the two chests once belonged to the same family. In this panel the myth of Actaeon is represented in three episodes: on the left he is shown hunting with his companions; in the center he is being turned into a stag by the goddess Diana, whom he had angered by spying on her and her nymphs while they were bathing; on the right his friends are shown looking for him in vain. The style of this painting and its companion shows an unusual and rather puzzling mixture of Florentine and non-Florentine late Gothic elements. Although certain figures, especially those of the hunters, recall late Gothic painting in

Florence around 1420–1430, the rendering of certain forms, for instance the marble fountain in the central episode, and the coloring suggest a North Italian, possibly Veronese artist. The type of the gilded gesso ornaments, especially those on the frames, is also not characteristically Florentine. The paintings cannot be ascribed as yet to any painter, but their combination of Florentine and North Italian late Gothic traits is reminiscent of the work of Cecchino da Verona, a Veronese artist, who, according to documents, was in Tuscany in the 1430's. There is a signed painting by him in the Diocesan Museum in Trent, which seems to be later than these panels.

Inscribed: (on cartouche in left scene) *Como Anteon andava alla caccia / Con [su]a compagnia;* (on cartouche in central scene) *Como Diana deve diventare / Cervio Antheon;* (on cartouche in right scene) *Como licōpagni de antheo . . . / Andauano Cercñdo e no[n] / Lu*

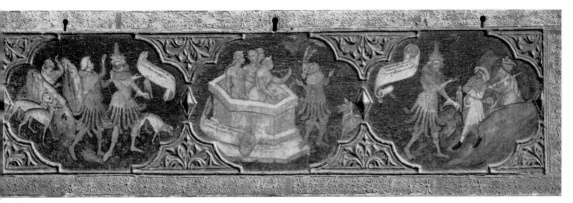

poteano retrouar[e] ("How Actaeon went hunting with his companions; how Diana turned Actaeon into a stag; how Actaeon's companions were looking for him and could not find him").

Tempera on wood; embossed and gilt ornaments. Over-all size, h. 29½, w. 62¼ in. (75 × 158.1 cm.).

REFERENCES: E. Bertaux, *La Revue de l'art ancien et moderne*, XXXIV (1913), pp. 7 f., ill. p. 5, attributes the two panels to a Florentine painter at the beginning of the fifteenth century, identifies the coats of arms as those of the Portinari, states that they came from the Ospedale di Santa Maria Nuova // P. Schubring, *Cassoni* (1915), p. 224, nos. 22, 23, pls. III, VII (no. 23, end), considers them painted in the style of Spinello Aretino and states that they came from Santa Croce in Florence.

EXHIBITED: Hôtel Sagan, Paris, 1913, *Exposition . . . du Moyen-Age et de la Renaissance*, no. 318 *bis* (lent anonymously).

EX COLL.: possibly the Ospedale di Santa Maria Nuova, Florence (until 1904?); [Paul Drey, Munich]; George and Florence Blumenthal, New York (by 1913; until 1941; Cat., IV, 1927, pl. XXXVI, as style of Spinello Aretino).

BEQUEST OF GEORGE BLUMENTHAL, 1941.

Three Allegorical Scenes (cassone panel) 41.190.130

Although this cassone is the companion to the preceding one, its subjects seem to bear no relation to the story of Actaeon. The inscriptions are no longer legible. The three scenes seem to represent three different themes, possibly allegorical. On the left a bearded man in fancy dress is talking to a seated lady who holds a child in her lap; in the center two young men on horseback are shaking hands; and on the right a crowned female figure is seated on a marble bench surrounded by a multicolored glory in the shape of a mandorla. Like that of the Actaeon episodes the style of these pictures shows an unusual mixture of Tuscan and Northern elements. The child in the left scene is curiously similar to a type often repeated by the Sienese artist Sano di Pietro. See also comment above under The Story of Actaeon.

Illegibly inscribed on cartouches in each scene.

Tempera on wood; embossed and gilt ornaments. Over-all size, h. 29½, w. 62¼ in. (75 × 158.1 cm.).

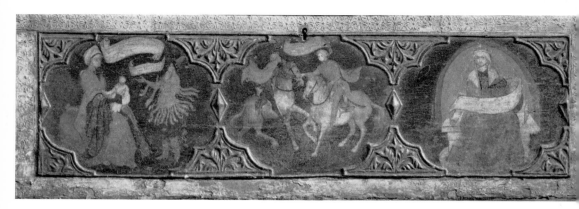

REFERENCES: See above under The Story of Actaeon.

EXHIBITED: Hôtel Sagan, Paris, 1913, *Exposition . . . du Moyen-Age et de la Renaissance*, no. 318 (lent anonymously).

EX COLL.: possibly the Ospedale di Santa Maria Nuova, Florence (until 1904?); [Paul Drey, Munich]; George and Florence Blumenthal, New York (by 1913; until 1941; Cat., IV, 1927, pl. XXXVI, as style of Spinello Aretino).

BEQUEST OF GEORGE BLUMENTHAL, 1941.

Giovanni Toscani

Giovanni di Francesco Toscani. Active perhaps by 1420; died 1430. A large group of Florentine paintings, obviously by a single artist, has long been ascribed by scholars to the Master of the Griggs Crucifixion, a name derived from the painting now in this Museum. It has recently been observed that a pair of frescoes in the Ardinghelli chapel in the church of Santa Trinità in Florence is painted in the same style and apparently by the same hand. This observation has led to the discovery of the real name of the Master of the Griggs Crucifixion, since the frescoes are documented works by Giovanni di Francesco Toscani, who was paid for one of them in 1423 and for the other at the end of the following year. The chief influence on the style of Toscani appears to have been that of the sculptor Ghiberti. Some of his paintings are based upon compositions borrowed from works of the early fourteenth century in Florence, but many are interpretations of the International Gothic style, and in these he very closely resembles Arcangelo di Cola da Camerino and Rossello di Jacopo Franchi. He was also affected by the painting of Gentile da Fabriano. Giovanni had a brother, Domenico di Francesco Toscani, recorded as dead by 1427, who was also a painter, but no work by him is known.

The Crucifixion 43.98.5

The various influences that combined to form the style of Giovanni Toscani are all evident in this panel. The general composition is fairly common for Florentine paintings of the Crucifixion in the fourteenth century, but the figures are grouped around the cross in a semi-circle intended to suggest spatial depth, revealing the artist's timid effort to deal with the scientific representation of perspective that obsessed the major artists of the early Renaissance in Florence. The subtly modeled body of Christ and such figures as that of the man next to the cross holding up the sponge of vinegar show the influence of Masolino's style around 1425, when he was most closely following Masaccio. The figure of Saint John, with its echoes of Lorenzo Monaco and the sculptors working in the late Gothic manner, best illustrates Toscani's attachment to the International style. Similar faces of soldiers, with gleaming eyes that somehow recall orientals, appear frequently in other works by Toscani.

Inscribed (on breast strap of the horse in lower right corner): . . . LHONE.

Formerly attributed by the Museum to the workshop of Masolino.

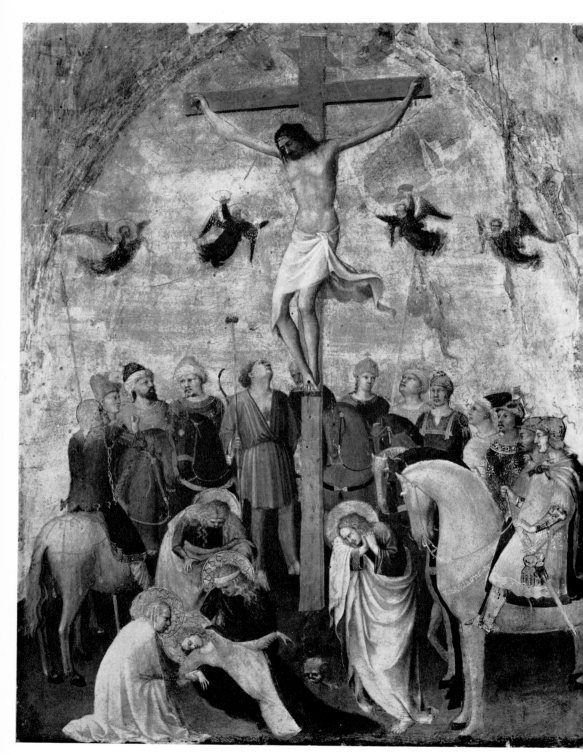

43.9

Tempera on wood; gold ground. H. 25⅛, w. 19 in. (63.8 × 48.3 cm.).

REFERENCES: A. Muñoz, *Pièces de choix de la collection Stroganoff*, Rome, II (1911), p. 15, pl. VIII, ascribes this painting to Giottino // B. Berenson (unpublished opinion, about 1911) calls it a Florentine work of the early XV century, close to Lorenzo Monaco; and *Dedalo*, XII (1932), p. 192, ill. p. 191 (detail), tentatively suggests an attribution to Rossello di Jacopo Franchi; *Ital. Pictures* (1932), p. 494, lists it as a work by Rossello di Jacopo Franchi; and *Flor. School* (1963), p. 193, pl. 547, lists it tentatively as a work by Rossello di Jacopo Franchi // R. van Marle, *Ital. Schools*, III (1924), p. 421, note 1, does not ascribe it to the artist whom Sirén called Maso-Giottino; and (in a letter, 1926), tentatively suggests an attribution to Pietro Lorenzetti or to Ambrogio Lorenzetti under Pietro's influence // R. Offner (verbally, 1926) tentatively suggests an attribution to Arcangelo di Cola da Camerino; and *Burl. Mag.*, LXIII (1933), pp. 170 f., ill. p. 171, fig. C, attributes this painting to an anonymous Florentine painter, calling him the Master of the Griggs Crucifixion and reconstructing his oeuvre and activity // L. Venturi, *L'Arte*, XXXIII (1930), pp. 165 ff., fig. 1; and *Ital. Ptgs. in Amer.* (1933), pl. 185, attributes it to the early period of Masolino under Lorenzo Monaco's influence // M. Salmi, *Masaccio* (1932), p. 134, rejects the attribution to Masolino and attributes it to an anonymous Florentine painter close to Masolino and Arcangelo di Cola, to whom he ascribes other works in the museums of Pescia and Bergen; and *Riv. d'arte*, XVI (1934), pp. 178 ff., accepts Offner's grouping of it with other works under the name Master of the Griggs Crucifixion // H.

Tietze, *Meisterwerke Europ. Mal. in Amer.* (1935), p. 326, pl. 41, attributes it to Masolino // G. Pudelko, *Art in Amer.*, XXVI (1938), p. 63, accepts Offner's grouping of pictures ascribed to the Master of the Griggs Crucifixion // C. Sterling, *La Peinture française; Les Primitifs* (1938), p. 151, note 50, observes its relationship to the work of the Limbourg brothers // R. Longhi, *La Critica d'arte*, XXV–XXVI (1940), p. 185, note 22, accepts the group of works by the Master of the Griggs Crucifixion as proposed by Offner // M. Boskovits, M. Mojzer, and A. Mucsi, *Das Christliche Museum von Esztergom* (1965), p. 28, note the relationship with the style of Rossello di Jacopo Franchi, with whom the Master of the Griggs Crucifixion may have worked in the same workshop, and the influence of Masolino // L. Bellosi, *Paragone*, XVII (1966), no. 193, pp. 44, 57, identifies the Master of the Griggs Crucifixion with Giovanni Toscani and dates this painting in his late period, observing the influence of both Gentile da Fabriano and Fra Angelico.

EXHIBITED: Century Association, New York, 1930, *Exhibition of Italian Primitive Paintings*, no. 21 (as Masolino or a close follower, lent by M. F. Griggs); Art Institute, Chicago, 1933, *Century of Progress Exhibition*, no. 89 (as Masolino, lent by M. F. Griggs; cat. pl. 11).

EX COLL.: Charles A. Loeser, Florence; Count Gregory Stroganoff, Rome (until 1911); Princess Scerbàtov, Rome (1911–about 1914); private collection, Rome (about 1914–about 1925); [Edward Hutton, London (?)]; Maitland Fuller Griggs, New York (about 1925–1943).

BEQUEST OF MAITLAND FULLER GRIGGS, 1943.

Fra Angelico

Real name Guido di Pietro; also called Giovanni da Fiesole and Beato Angelico. Born probably 1387; died 1455. Fra Angelico joined the Dominican order at Fiesole, near Florence, when he was twenty years old and throughout his life painted for Dominican convents and churches. In 1436 the Medici gave the monks of Fra Angelico's congregation the old convent of San Marco in Florence, and during the renovation of this building Angelico devoted several years to decorating with sacred subjects the walls of the cells and common rooms. His fame soon spread, and in 1447 he was called to execute important frescoes in the Vatican and in the cathedral of Orvieto. In 1449 he was elected prior of the

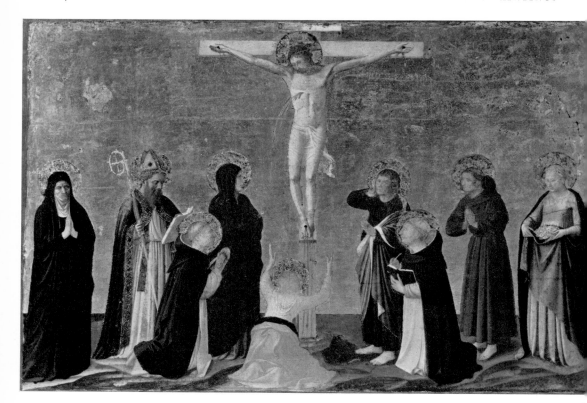

14.40.6

monastery of San Domenico at Fiesole. His last years, 1452–1455, were spent in Rome, where he painted in the chapel of Pope Nicholas V in the Vatican frescoes with scenes from the lives of Saint Stephen and Saint Lawrence. The early works of Angelico suggest the training of a miniature painter, and his forms reveal a close link with Lorenzo Monaco. Later the structure of his figures and the rational use of perspective put him among the first and most significant artists of the early Renaissance, along with Masaccio and Domenico Veneziano. His intense and mystical religious spirit, springing from the purest medieval tradition, shows how the culture of the early Renaissance was likewise strongly pervaded with Christian thought and feeling. Angelico had a very active workshop, and it is often difficult to distinguish between his own works and those of his pupils. His best-known follower was Benozzo di Lese, known as Benozzo Gozzoli.

The Crucifixion 14.40.628

The figures are (left to right), Saints Monica, Augustine, Dominic (kneeling), the Virgin, Mary Magdalen, John the Evangelist, Thomas Aquinas (kneeling), Francis, and

Elizabeth of Hungary. When the Museum acquired this painting it had as background a blue sky and two palm trees, which were found to be later additions and were subsequently removed. The figures also had been repainted, and cleaning revealed

them in a rather poor condition except for Saint Augustine and the Magdalen. This painting is surely by Fra Angelico and seems to have been executed as an independent work and not as part of the predella of an altarpiece.

Tempera and gold on wood. H. 13¾, w. 19¾ in. (33.9 × 50.1 cm.), set in panel, h. 15¾, w. 21¼ in. (40 × 54 cm.).

REFERENCES: B. Berenson (in a letter, 1910) considers this painting a work by Fra Angelico; *Ital. Pictures* (1932), p. 22, lists it as a ruined work by Fra Angelico; and *Flor. School* (1963), p. 14 // R. Langton Douglas, ed., in Crowe and Cavalcaselle, *Ptg. in Italy*, IV (1911), p. 97, notes that it was once a good example of Angelico but is now retouched and repainted // F. Monod, *Gaz. des B.-A.*, LXV (1923), II, p. 180, attributes it to Angelico and calls it a fragment of a predella // F. Schottmüller, *Fra Angelico (Kl. der Kst.)* (1924), p. 268, ill. p. 243, considers it either repainted or not by Angelico //

R. van Marle, *Ital. Schools*, X (1928), p. 160, fig. 99, calls it a work of Angelico's shop and suggests that it may be by the same hand as the Nativity in the von Nemes collection // F. Mason Perkins (in a letter, 1938) calls it a genuine but much repainted work by Fra Angelico // *Art Treasures of the Metropolitan* (1952), p. 223, pl. 73 (color) // J. Pope-Hennessy, *Fra Angelico* (1952), p. 201, fig. XLV, attributes it to Angelico's shop, connecting it with the pupil he calls the Master of Cell 36.

EXHIBITED: Louvre, Paris, 1885, *Tableaux ... Orphelins d'Alsace-Lorrains*, no. 186, (lent by the Marquis de Gouvello de Kériaval); Metropolitan Museum, New York, *Art Treasures of the Metropolitan*, 1952–1953, no. 73.

EX COLL.: Marquis de Gouvello de Kériaval, Paris (by 1885); [Wildenstein and Co., New York, by 1909; until 1910]; Benjamin Altman, New York (1910–1913).

In the Altman galleries.

BEQUEST OF BENJAMIN ALTMAN, 1913.

Workshop of Fra Angelico

The Nativity 24.22

This picture was apparently the left wing of a diptych; the right wing may have represented the Crucifixion or the Madonna and Child enthroned. The back of the panel is painted to imitate porphyry. Judging from the quality of the painting it is possible that Fra Angelico designed it in his middle period and supervised the execution, but many details show the hand of an assistant. In the figure of the Madonna and especially in that of the Child there is a close similarity to the work of the so-called Pseudo-Domenico di Michelino, sometimes identified with Zanobi Strozzi, who was an assistant of Fra Angelico's.

Formerly attributed by the Museum to Fra Angelico (Cat., 1940).

Inscribed (at top of panel): [TER]RA PAX HO[MIN]ĪB[US] BON[A]E [VOLUNTA-TI]S ("... on earth peace to men of good will." Luke 2:14).

Tempera on wood. Over-all size, h. 15¼, w. 11½ in. (38.7 × 29.1 cm.); painted surface, h. 13, w. 9⅛ in. (33 × 23.3 cm.).

REFERENCES: G. de Nicola (verbally, 1923) attributes this painting to Fra Angelico // F. Mason Perkins (verbally, 1923) attributes it to Fra Angelico // T. Borenius (verbally, 1923) attributes it to Fra Angelico // L. Venturi (verbally, 1923) attributes it to Fra Angelico; *Ital. Ptgs. in Amer.* (1933), pl. 183, ascribes it to Domenico di Michelino and compares it to the Annunciation in the

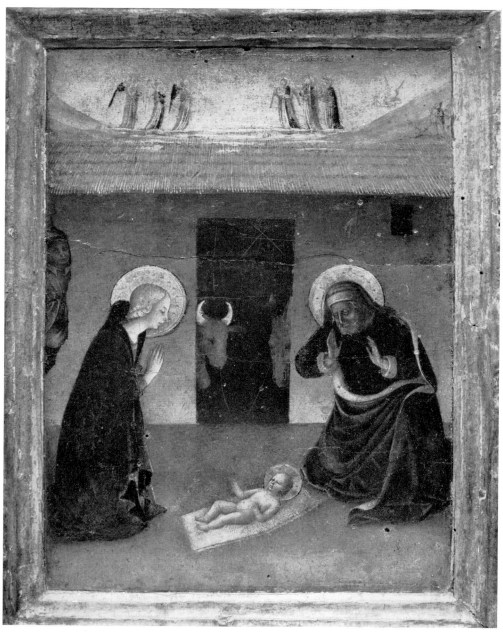

24.22

Johnson collection in the Philadelphia Museum //
B. B[urroughs], *Met. Mus. Bull.*, XIX (1924),
pp. 66 f., ill. // F. Schottmüller, *Fra Angelico (Kl.
der Kst.)* (1924), p. 266, ill. p. 179, dates it between
the fresco in the fifth cell of San Marco and the

Nativity from Santissima Annunziata, now in the
Museo San Marco // R. van Marle, *Ital. Schools*, X
(1928), pp. 160 f., calls it a work of Angelico's shop
and compares it to the von Nemes Nativity //
B. Berenson, *Ital. Pictures* (1932), p. 22, lists it as a

work by Fra Angelico; and *Flor. School* (1963), p. 14, lists it as a product of Fra Angelico's workshop.

EX COLL.: Antonio Nardi (until about 1923); [Ugo Jandolo, Rome, about 1923–1924]; [Thomas Agnew and Sons, London, 1924].

PURCHASE, ROGERS FUND, 1924.

The Annunciation 41.190.8

The Annunciation was the subject of a number of paintings by Fra Angelico that are among his most popular works. This painting, by an artist in his workshop, incorporates elements from several of his representations of the Annunciation and is very much like another such version in the Prado (no. 15) that many scholars ascribe to an assistant of Fra Angelico's frequently identified with Zanobi Strozzi. It differs, however, from the Prado picture in a number of details, as, for instance, the figure of the Virgin, which here repeats that in the fresco of the Annunciation in one of the cells in the convent of San Marco in Florence. In the left background is seen the Expulsion from Paradise, a symbolic allusion to original sin, from which humanity was redeemed by the birth of Christ. This panel may have been at the extreme left of a predella; but severe damage, especially in the

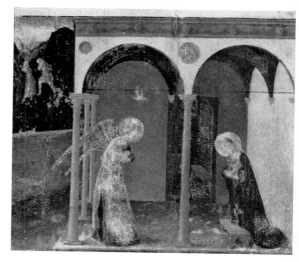

41.190.8

figure of the angel and in the Madonna's face, so obscures the style that it is difficult to identify other possible parts of the series.

Formerly attributed by the Museum to a follower of Fra Angelico.

Tempera and gold on wood. H. 14¾, w. 16¼ in. (37.4 × 41.3 cm.).

REFERENCE: R. van Marle, *Ital. Schools*, X (1928), p. 158, fig. 98, attributes this painting to the school of Fra Angelico and calls it a copy after a composition by Angelico.

EX COLL.: a private collection, Florence; George and Florence Blumenthal, New York (by 1926; until 1941; Cat., 1926, I, pl. VIII, as School of Fra Angelico).

BEQUEST OF GEORGE BLUMENTHAL, 1941.

Follower of Fra Angelico

The Annunciation 41.190.25

This picture is a rather feeble late adaptation of motives originated by Fra Angelico. The figure of the Madonna recalls many of his

Virgins Annunciate, particularly the one in the altarpiece in the church of San Francesco at Monte Carlo in the Valdarno; the figure of the angel is especially reminiscent of the Angel of the Annunciation in the polyptych

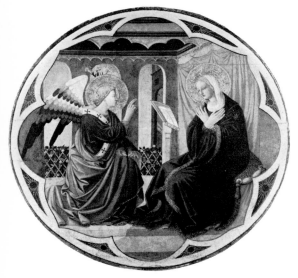

co's paintings reveals that this is the work of a minor artist who was active about 1455–1465, more probably from the countryside around Florence than from the city itself. It is not clear what was the original destination of this panel. The circular shape and the simulated frame seem to suggest that it might have been hung on or inserted high in a wall, possibly one of the end walls of a church. No other paintings showing a similar border are known, and it does not seem possible that our panel formed part of a series.

Tempera on wood. Diameter $37\frac{1}{4}$ in. (94.6 cm.).

41.190.25

PROVENANCE: the neighbourhood of Siena.

in the Gallery at Perugia. The way these two figures, as well as the architectural setting and some minor details, like the hands of the angel, have been adapted from Fra Angeli-

EX COLL. George and Florence Blumenthal, New York (by 1926; until 1941; Cat., I, 1926, pl. IX).

BEQUEST OF GEORGE BLUMENTHAL, 1941.

Fra Filippo Lippi

Born about 1406; died 1469. Filippo Lippi took monastic vows at the monastery of the Carmine in Florence in 1421. Ten years later his name disappeared from the registers of the order, and it is assumed that he had left the monastery to paint independently in Florence. He was active in Padua in 1434, and there he painted a number of works, now lost, that were of great importance for the formation of the Paduan style during the 1440's. Among his frescoes are those in the cathedral of Prato (1452–1464) and in the cathedral of Spoleto, where he was employed during the last two years of his life. Although Lorenzo Monaco has been named as his first teacher, his style was strongly influenced by Masaccio, who was at work in the Brancacci chapel and in the cloister of the church of the Carmine while Fra Filippo was still with the Carmelites. Later he was also affected by Fra Angelico. In his paintings he shows concern, as did Masaccio, for the exact representation of space and volume, but he also interprets form in a linear way, depending more on design than on light and shadow. Filippo Lippi had a large number of pupils and assistants, including Pesellino, Botticelli, and his own son, Filippino Lippi.

The Madonna and Child Enthroned with Two Angels 49.7.9

This panel was originally the central part of a triptych. The wings, representing the four Fathers of the Church, are now in the Accademia Albertina in Turin (nos. 140, 141). The style clearly indicates that this work was painted not long after Lippi's stay in Padua, very likely between the Madonna dated 1437 in the Museum of Tarquinia and the altarpiece painted for the church of Santo Spirito in Florence, now in the Louvre in Paris, which was commissioned in 1437 and finished the following year. The rose held by the Virgin may be an allusion to the verse "I am the rose of Sharon" from the Song of Solomon (2:1).

Inscribed (on scroll held by angel on left): VENI/TE. AD/ME.O/MNE/S. Q[VI]/CON-CVPI/SCIT/ [I]S.ME/.X. AG/ENE/RAT/ION [IBVS MEII IMPLEMINI] ("Come over to me, all ye that desire me, and be filled with my fruits." Apocrypha, Ecclesiasticus 24:19).

Tempera, with gold haloes, on wood, transferred from the original panel. H. 48¼, w. 24¾ in. (122.6×62.8 cm.).

REFERENCES: The authorities cited below, with the exception of M. J. Friedländer, attribute this painting to Fra Filippo Lippi. F. Kugler, *Kleine Schriften* . . . , II (1854), p. 321 // G. Parthey, *Deutscher Bildersaal* (1864), II, p. 45, no. 9 // M. J. Friedländer, *Repert. für Kstwiss.*, XVII (1894), p. 328, rejects the attribution to Fra Filippo Lippi and calls it a good painting from his workshop // *A Collection of Ancient Pictures* . . . (1925), section I, no. 6, ill. // G. Gronau, in Thieme-Becker, XXIII (1929), pp. 272 f., dates it after 1435 and mentions it in close connection with the two panels in the Accademia Albertina in Turin // A. L. Mayer, *Pantheon*, VI (1930), p. 541, ill., dates it about 1440 // B. Berenson, *Ital. Pictures* (1932), p. 288; and *Boll. d'arte*, XXVI (1932), p. 21, fig. 16, dates it very near

the Madonna of 1437 in Tarquinia, observes the late Gothic and Byzantine type of the throne but dates the panels in Turin somewhat later; and *Flor. School* (1963), p. 113 // L. Venturi, *Ital. Ptgs. in Amer.* (1933), pl. 208, dates it about the time of the altarpiece of 1437–1438 from Santo Spirito, now in the Louvre // G. Castelfranco, *Riv. d'arte*, XV (1933), p. 88 // M. Salmi, *Riv. d'arte*, XVIII (1936), p. 21, note 1, calls it the central part of a triptych that had the Turin panels as wings and dates it about 1440 // G. Pudelko, *Riv. d'arte*, XVIII (1936), p. 58, connects it with the Turin panels and dates it between 1437 and 1441, about the time of the altarpiece of 1437–1438 // *Duveen Pictures* (1941), no. 46 // R. Oertel, *Fra Filippo Lippi* (1942), pp. 22, 66, pl. 54, connects it with the Turin panels and dates it about the time of the Tarquinia Madonna of 1437 and the Annunciation in the church of San Lorenzo in Florence // M. Pittaluga, *Filippo Lippi* (1949), pp. 47, 210, pl. 17, connects it with the Turin panels and dates it about the time of the Tarquinia Madonna of 1437 // *Art Treasures of the Metropolitan Museum* (1952), p. 224, no. 276, pl. 76 (in color) // A. Griseri, *Boll. d'arte*, XLIII (1958), p. 69, connects it with the Turin panels // E. Trautscholdt in *Mouseion, Studien aus Kunst und Geschichte für Otto H. Förster* (1960), pp. 303, 305, notes 18, 34, 35, 36, fig. 115, traces the history of the Zanoli collection.

EXHIBITED: Cologne, 1840, *Ausstellung von Gemälden der Meister älterer Zeit aus den Sammlungen kölnischer Kunstfreunde*, no. 27, (lent by Franz Zanoli); Cologne, 1854, *Ausstellung altdeutscher und altitalienischer Gemälde*, no. 67 (lent by Max Clavé von Bouhaben); Knoedler and Co., New York, 1929, *Loan Exhibition of Primitives*, no. 8 (lent by Jules S. Bache); Petit Palais, Paris, 1935, *Exposition de l'art italien de Cimabue à Tiepolo*, no. 239 (lent by Jules S. Bache); World's Fair, New York, 1939, *Masterpieces of Art*, no. 218 (lent by Jules S. Bache); Metropolitan Museum, New York, 1943, *The Bache Collection*, no. 9 (lent by Jules S. Bache); Metropolitan Museum, New York, 1952, *Art Treasures of the Metropolitan*, no. 76.

EX COLL.: Johann Baptist Ciolina-Zanoli, Cologne (until 1837); Franz Anton Zanoli, Cologne (until 1850); Max Clavé von Bouhaben, Cologne (by 1854; Katalog der Gemäldesammlung des verstorbenen Herrn Franz Anton Zanoli, jetzt im Besitz dessen Schwiegersohnes Max Clavé von Bouhaben, 1858, ms. cat., apparently lost, quoted by Parthey, 1864; see Refs.); Franziska Clavé von Bouhaben, Cologne (sale, Cologne, J. M. Heberle, June 4–5,

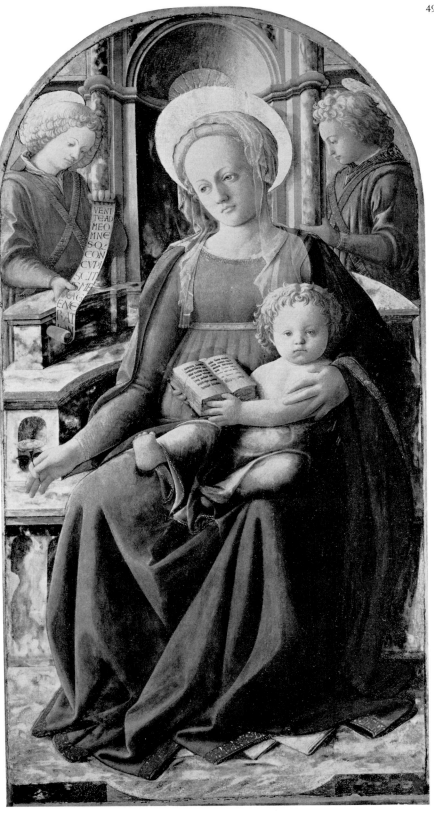

1894, no. 67); Dr. Ludwig Mond, London; Dr. Adolphe Schaeffer, Frankfurt-am-Main (until 1921); [Duveen Brothers, New York, 1921–1928]; Jules S. Bache, New York (1928–1943).

THE JULES S. BACHE COLLECTION, 1949.

Portrait of a Man and Woman at a Casement 89.15.19

This picture may be dated by the costume shortly after the beginning of the 1440's; the style, which is that of Fra Filippo Lippi about 1440–1445, confirms this dating. The two figures and their arrangement suggest that the picture was made as an engagement or marriage portrait. The sitters have been variously identified, but it is fairly certain that the man belonged to the Scolari family, whose coat of arms is prominently shown under his hands. Along the edge of the woman's sleeve there are letters embroidered in gold, enriched with pearls, which can be tentatively read as LEALTA . . ., in all probability part of the motto on the device of the woman's family.

Once called by the Museum a work of the school of Masaccio, subsequently the work of an unknown Florentine painter of the middle of the XV century, and later attributed to the workshop of Fra Filippo Lippi (Cat., 1940).

Tempera on wood. H. 25¼, w. 16½ in. (64.1 × 41.9 cm.).

REFERENCES: G. B. Cavalcaselle (unpublished opinion, 1883) calls this painting a youthful work by Piero della Francesca // W. Bode, *Zeitschr. für bild. Kst.*, VI (1895), p. 17, attributes it to Cosimo Rosselli; and *Art in Amer.*, II (1914), p. 322, agrees with Breck's attribution and dating (see below) // B. Berenson, *Gaz. des B.-A.*, XV (1896), p. 200, and *Flor. Ptrs.* (1896), p. 129, attributes it tentatively to Uccello; (in a letter, 1908) calls it an early work by Uccello; *Flor. Ptrs.* (1909), p. 186, calls it Profiles of

a Woman and Man of the Portinari Family by Uccello; *Ital. Pictures* (1932), p. 288, considers it in great part the work of Filippo Lippi and calls it a portrait of a Portinari with a Medici (?) bride; *Boll. d'arte*, XXVI (1932), pp. 53, 66, fig. 36, attributes it to Lippi, possibly assisted by a helper, and dates it about 1448; *Pitt. ital.* (1936), p. 247, considers it in great part by Lippi, assigns it to his late period, and calls it a portrait of a Portinari with a Medici bride; and *Flor. School* (1963), p. 113, considers it in great part by Lippi // J. Breck, *Art in Amer.*, II (1914), pp. 44 ff., attributes it to Lippi, dates it about 1440, and calls it a portrait of Lorenzo di Ranieri Scolari (1407–1478) and his wife, and pp. 170 ff., ill., dates it 1436 // F. J. Mather, Jr., *Art in Amer.*, II (1914), pp. 169 f., 379, rejects the attribution to Lippi and considers it more like the work of Domenico Veneziano, dates it 1444, and agrees with Breck's identification of the sitters // A. Schmarsow, *Sandro del Botticelli* (1923), pp. 54 ff., attributes it to Botticelli, regarding it as the earliest of a group of portraits executed when he was still studying with Fra Filippo Lippi // R. van Marle, *Ital. Schools*, X (1928), pp. 237 f., 459, fig. 156, attributes it tentatively to Uccello and also lists it under works that might be attributed to Lippi // G. Gronau, in Thieme-Becker, XXIII (1929), p. 273, lists it as a work by Lippi // P. Soupault, *Paolo Uccello* (1929), p. 26, pl. VIII, attributes it to Uccello // R. Offner (verbally, 1935) considers it close in style to Lippi; and in *Medieval Studies in Memory of A. Kingsley Porter* (1939), I, p. 220, fig. 12, ascribes it to an artist in Lippi's shop, comparing the lady to one in Fra Carnevale's Birth of the Virgin // G. Pudelko, *Pantheon*, XV (1935), p. 96, ill. p. 95, attributes it to Lippi and dates it about 1440; and *Riv. d'arte*, XVIII (1936), p. 67, considers it similar to and contemporaneous with the Annunciation in the Palazzo Venezia in Rome and calls it probably a portrait of Scolari and his wife // J. Lipman, *Art Bull.*, XVIII (1936), p. 68, note 23, calls it a work from the shop of Lippi and discusses it in connection with a number of Florentine profile portraits, and pp. 88, 101, fig. 10, lists it as a work from Lippi's shop, painted in the period 1450–1475, and compares the landscape with those of Uccello // R. Longhi (unpublished opinion, 1937) attributes it definitely to Lippi and dates it about 1440; *Paragone*, III (1952), no. 33, pp. 42 f., attributes it to Lippi, dates it before the profile portrait of a woman in Berlin, which he places about 1450, and notes the Flemish flavor of the view in the background // F. Mason Perkins (in a letter, 1938) attributes it to an artist closely connected with Uccello // R. Oertel, *Fra Filippo Lippi* (1942), pp. 48, 76, fig. 119, attributes it to Lippi, dates it not later than 1440, and calls it a

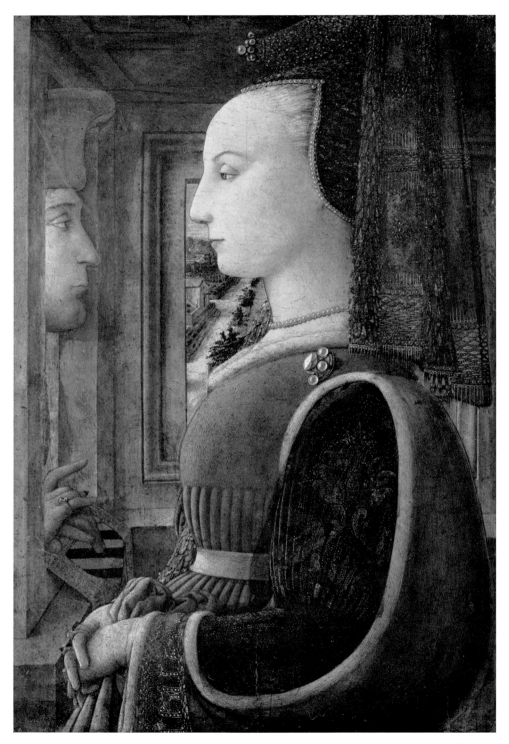

89.15.19

marriage portrait showing probably the Scolari coat of arms // M. Pittaluga, *Filippo Lippi* (1949), p. 209, fig. 73, lists it among works by Filippo Lippi, dating it towards the end of the 1450's // L. Coletti (in a letter, 1949) tentatively suggests attributing it to the very early period of Domenico Veneziano // L. Goldscheider (in a letter, 1954) tentatively accepts the attribution to Botticelli suggested by Schmarsow, groups it with other paintings, including a Madonna in the Naples Gallery and a portrait in the Filangieri Museum, Naples, dates it about 1459–1460, when Botticelli was the assistant of Fra Filippo at Prato, and identifies the arms as those of Francesco di Marco Datini, indicating that the man might be one of Francesco's grandsons // B. Nicolson, *Burl. Mag.*, XCVII (1955), pp. 208 f., 213, no. 29, attributes it to Lippi, quotes manuscript catalogues of the Sanford collection, in which it was attributed to Masaccio // J. Pope-Hennessy, *The Portrait in the Renaissance* (1966), pp. 41 f., ill., 44, 48, 59, 309, note 63, calls it the earliest female profile portrait and attributes it to Lippi, dating it about 1440.

EXHIBITED: Royal Academy, London, 1877, *Old Masters*, no. 181 (as Masaccio, lent by Lord Methuen).

EX COLL.: a private collection, Florence (until about 1829); Rev. John Sanford, Nynehead Court, Wellington, Somerset, and London (about 1829–1855; *Catalogue raisonné . . .*, 1847, no. 1, as by Masaccio); Lord Methuen, Corsham Court, Chippenham, Wilts. (1855–1883); Henry G. Marquand, New York (1883–1889).

GIFT OF HENRY G. MARQUAND, 1889.

The Annunciation 43.98.2

The style of this small picture is typical of Fra Filippo Lippi's work in the middle of the 1440's. He probably painted it after he began the large Coronation of the Virgin in the Uffizi (no. 8352) in 1441 and before he completed the Annunciation in the Alte Pinakothek in Munich. The color scheme and certain passages, such as the figure of the angel, recall the work of Pesellino, who was developing his own style under the influence of Lippi's at this time. The unusual way in which the Corinthian column divides the scene in half is a spatial device which Lippi had previously used in the large Annunciation in the church of San Lorenzo in Florence. This method of defining space and perspective was also employed by Piero della Francesca and recurs frequently in his later works. In our Annunciation and the Munich one Lippi may have been reflecting some ideas from the murals Domenico Veneziano and Piero della Francesca painted in the first half of the 1440's in the church of Sant'Egidio (in the hospital of Santa Maria Nuova) in Florence. The Museum's Annunciation with its symmetrical division, was evidently the central section of the predella of an altarpiece. The main panel or panels above it probably represented the Madonna and Child with saints and the altarpiece may have been the one with scenes from the legends of Saints Benedict and Bernard that Lippi painted, according to Vasari, for the nuns of the convent of the Murate in Florence, about 1443 (Milanesi ed., II, p. 617). This altarpiece, commissioned by Giovanni di Amerigo Benci, has been dismembered[1] and neither the main panel nor any fragment of it has been identified. A predella panel in the National Gallery in Washington (Kress collection, no. 804) representing a scene from the life of Saint Benedict is strikingly similar to our picture in many ways, except for the haloes, which are not represented in perspective as in our painting. This panel, corresponding with ours in size ($16\frac{3}{8} \times 28$ inches), range of color, type of craquelure, and style, has been identified by R. Oertel[2] as part of the predella of the altarpiece made

[1] See Repertorio strozziano di memorie ecclesiastiche, Florence, Archivio di Stato, F. 34.

[2] *Fra Filippo Lippi* (1942), p. 66, no. 51; see also M. Pittaluga, *Filippo Lippi* (1949), p. 194, fig. 53.

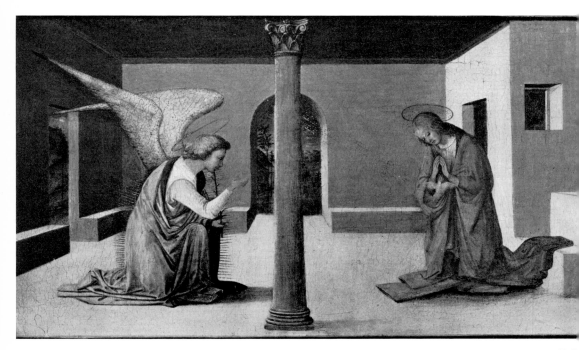

43.9

for the church of the Murate. It is entirely possible that both it and our Annunciation were part of this predella.

Formerly attributed by the Museum to the workshop of Fra Filippo Lippi.

Tempera on wood. H. 15⅞, w. 27½ in. (40.3 × 69.8 cm.).

REFERENCES: G. Gronau (unpublished opinion, 1930) attributes this painting to Pesellino // *Met. Mus. Bull.*, n.s., II (1944), p. 154, ill., ascribes it to the workshop of Fra Filippo Lippi // B. Berenson, *Flor. School* (1963), p. 219, attributes it to an artist between Fra Filippo Lippi and Pesellino // F. Zeri, *Boll. d'arte*, XLVIII (1963), p. 249, attributes it to Fra Filippo Lippi, notes its similarity to a Madonna and Child in the church at Bottinaccio, and dates it about 1448–1450 // F. R. Shapley, *Paintings from the Samuel H. Kress Collection* (1966), pp. 107 f., after studying the manuscript of this catalogue, accepts F. Zeri's attribution of it to Fra Filippo Lippi and his association of it with the Kress panel and suggests that both may be the only remnants now known of the altarpiece with scenes from the legends of Saint Benedict and Saint Bernard re-corded by Vasari as in the church of the Murate; but also suggests that they may possibly be part of the predella of the altarpiece of the Coronation painted by Lippi for the chapel of Saint Bernard at Monte Oliveto, Arezzo, now in the Vatican; accepts Zeri's dating.

EXHIBITED: New York, Metropolitan Museum, 1944, *The Maitland F. Griggs Collection*.

EX COLL.: [Tomas Harris, London]; [Vitale Bloch, Berlin, 1936–1937]; Maitland Fuller Griggs, New York (1937–1943, as Francesco Pesellino).

BEQUEST OF MAITLAND FULLER GRIGGS, 1943.

Saint Lawrence Enthroned with Saints and Donors 35.31.1 A,B,C

Central panel: Saint Lawrence enthroned, with Saint Cosmo, Saint Damian, and Alessandro Alessandri and two of his sons
Left panel: Saint Benedict

Right panel: Saint Anthony Abbot

These panels were part of an altarpiece which, according to Vasari, was painted for Lippi's friend the patrician Alessandro Alessandri (1391–1460) and originally ornamented the church in the villa of the Alessandri at Vincigliata on the hill of Fiesole. The patron is represented kneeling before Saint Lawrence's throne at the right, while at the left are his two sons, Jacopo (1422–1494) and Antonio (1423–1473). The style of the picture indicates a date possibly around the middle of the 1440's. When the altarpiece was moved to the house of the Alessandri in the Borgo degli Albizzi in Florence, its central panel was separated from the rest and was for a time framed as a tondo, to match another tondo by (or attributed to) Botticelli. The two side panels are incomplete and are in rather poor condition. Judging from the position of the saints in them, it seems that at least two figures are missing. Saint Anthony's raised knee and slanting staff (the lower end seen in the central panel) indicate that he knelt at the right of the throne, probably balanced by a second kneeling saint at the left of the central panel, between it and the standing figure of Saint Benedict; and Saint Benedict must have been balanced by another standing saint at the extreme right.

Tempera on wood, gold ground; some of the gold renewed; the green of the robes of Saint Lawrence and Saint Benedict has been restored; new strips added around the edge. Central panel, h. 47⅝, w. 40 in. (at top), 41⅛ in. (at bottom); with added strips at sides, h. 47⅝, w. 45⅝ in. (120.9 × 105.9 cm.); left panel, h. 27¼, w. 12 in.; with added strips at bottom and sides, h. 28½, w. 15 in. (72.4 × 38.1 cm.); right panel, h. 28½, w. 13 in.; with added strips at sides, h. 28½, w. 15 in. (72.4 × 38.1 cm.).

REFERENCES: The authorities cited below, with the exception of Pudelko, attribute this altarpiece to Filippo Lippo. G. Vasari, *Vite* (1568), Milanesi ed., II (1878), pp. 626 f. // Crowe and Cavalcaselle, *Ptg. in Italy*, II (1864), p. 348 // B. Berenson, *Flor. Ptrs.* (1896), p. 118; *Boll. d'arte*, XXVI (1932), pp. 12 ff., fig. 6, groups it with the pictures showing the influence of Fra Angelico and dates it not before 1442; *Ital. Pictures* (1932), p. 288, lists it as in great part the work of Lippi; *Pitture italiane* (1936), p. 247; and *Flor. School* (1963), p. 113 // E. C. Strutt, *Fra Filippo Lippi* (1901), pp. 83, 197, assigns it to Lippi's "second Florentine period" (1441–1452) // *Der Cicerone* (Bode and Fabriczy ed., 1904), part II, sect. III, p. 651, dates it soon after 1440 // I. B. Supino, *Fra Filippo Lippi* (1902), p. 71, dates it soon after 1440 and illustrates the central panel framed as a tondo // H. Mendelsohn, *Fra Filippo Lippi* (1909), pp. 74 ff., ill. p. 258, dates it 1435–1440 // A. Venturi, *Storia*, VII, part I (1911), pp. 368 ff., calls it an early work // B. B[urroughs], *Met. Mus. Bull.*, VIII (1913), p. 34, ill. p. 33, dates it about 1440–1445 // R. Offner, *The Arts*, V (1924), p. 257, dates it a few years before the Louvre altarpiece of 1437 and about the time of the two lunettes in the National Gallery, London; and *Corpus*, sect. III, vol. V (1957), p. 198, note 2, mentions other examples of the same type of altarpiece in which the central part shows an enthroned saint instead of the Madonna and Child // W. R. Valentiner, *Catalogue of Early Italian Paintings, Duveen Galleries* (1926), nos. 5 (center), 6 (two saints) // R. van Marle, *Ital. Schools*, X (1928), pp. 406 ff., fig. 247, notes in it the influence of Fra Angelico and a connection in style with two panels in the National Gallery in London, nos. 666, 667 // G. Gronau, in Thieme-Becker, XXIII (1929), p. 272, dates it about 1433–1435 // L. Venturi, *Ital. Ptgs. in Amer.* (1933), pls. 206 (center), 207 (side panels); and *L'Arte*, XXXVI (1933), pp. 39 ff., ill., dates it about 1435 // H. B. Wehle, *Met. Mus. Bull.*, XXX (1935), pp. 239 ff., ill., dates it about 1435 // G. Pudelko, *Riv. d'arte*, XVIII (1936), pp. 46 ff., accepts Berenson's date, p. 56, note 1, no. 12, attributes it to "Scolaro di Prato" // *Duveen Pictures* (1941), no. 45, ill., dates it about 1435 // R. Oertel, *Fra Filippo Lippi* (1942), p. 69, no. 68, fig. 68 (center only), dates it not before 1445, judging it close to the Madonna del Ceppo in the Prato Gallery, which was paid for in 1453, observes that Alessandri, being a partisan of the Medici, dedicated the central part of the altarpiece to their patron saint, Lawrence, and notes that this altarpiece is the prototype for related compositions by Neri di Bicci, who is known to have been in contact with Lippi in 1454 // M. Pittaluga, *Filippo Lippi* (1949), pp. 74, 210, figs.

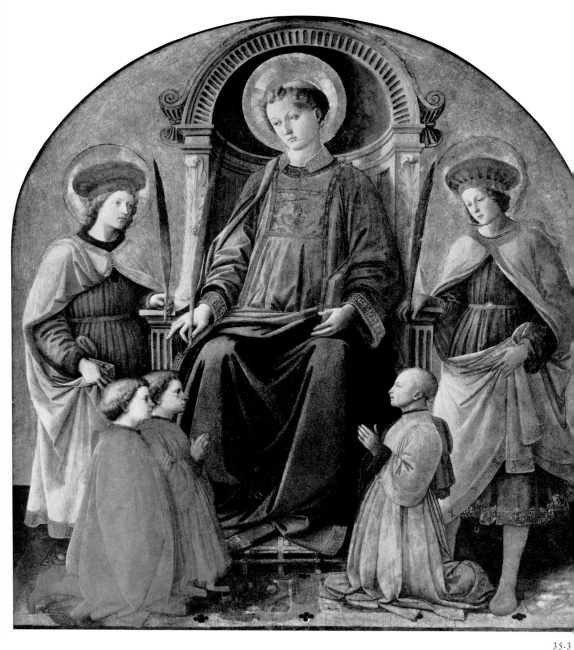

47, 48, accepts the dating suggested by Berenson // G. Kaftal, *Iconography of Saints in Tuscan Painting* (1952), columns 289, 613, fig. 333 (center only, as a tondo) // J. Pope-Hennessy, *The Portrait in the Renaissance* (1966), p. 258, notes the greatly reduced scale of the portraits of the donors.

EXHIBITED: Metropolitan Museum, New York, 1912–1915, *Loan Exhibition of Mr. Morgan's Paintings* (lent by J. P. Morgan); Duveen Galleries, New York, 1924, *Early Italian Paintings*, nos. 12, 36, 37 (lent by J. P. Morgan); Virginia Museum of Art, Richmond, 1961, *Treasures in America* (center only; Cat. p. 53.).

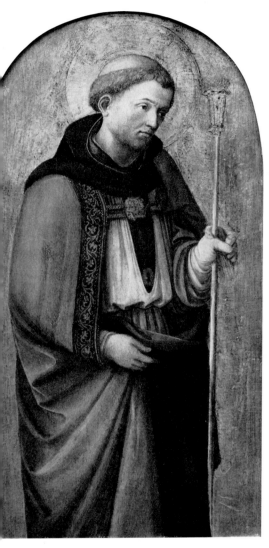

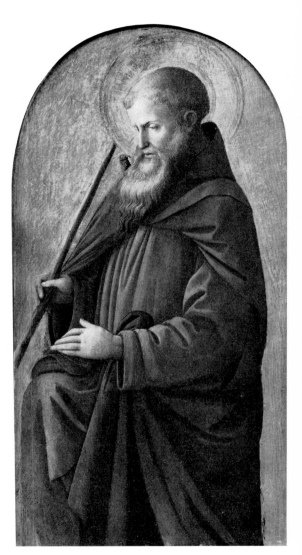

35.31.1 B 35.31.1 C

PROVENANCE: the church of the Villa Alessandri, Vincigliata, Fiesole (removed about 1790).

EX COLL.: the Alessandri family, Palazzo Alessandri, Borgo degli Albizzi, Florence; Count Cosimo degli Alessandri, Florence (1912); [Luigi Grassi, Florence, 1912 (?)]; [Sulley and Co., London, 1912]; [Duveen Bros., New York, 1912]; J. P. Morgan, London and New York (1912–1913); J. Pierpont Morgan, New York (1913–1935); [M. Knoedler and Co., New York, 1935].

PURCHASE, ROGERS FUND, 1935.

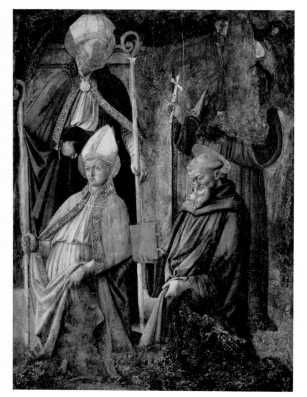

17.89

Saint Augustine, Saint Francis, a Bishop Saint, and Saint Benedict

17.89

This partly ruined picture must have been the right-hand section of a large altarpiece; marks at the top show that at some time it had a frame with two Gothic arches. The conception and possibly the design of the four figures are probably Lippi's, but the execution seems to be mostly the work of pupils and assistants. The date is probably somewhere in the 1450's. The saint at the lower left has often been called Louis of Toulouse, but he does not show any attributes to support this identification.

Tempera on paper, transferred from wood. H. 56, w. 39½ in. (142.2 × 100.3 cm.).

REFERENCES: O. Sirén, *Boston Mus. Bull.*, XIV (1916), p. 14, ill., attributes this painting to Filippo Lippi's middle period, dating it about the time of the frescoes in the cathedral of Prato, and considers it the right wing of an altarpiece which may have had in its predella the panel showing a miracle of Saint Augustine at that time in the Oldenburg collection in Petrograd (later in the Hermitage Museum), as well as the panels now framed as the predella of the Annunciation in San Lorenzo in Florence // B. B[urroughs], *Met. Mus. Bull.*, XIII (1918), pp. 231 f., ill. // R. van Marle, *Ital. Schools*, X (1928), p. 406, dates it in Lippi's early period, before 1437, and notes the influence of Fra Angelico // G. Gronau, in Thieme-Becker, XXIII (1929), p. 273, lists it as a work by Lippi // B. Berenson, *Boll. d'arte*, XXVI (1932), p. 52, calls it a work by Lippi of the period of the Coronation of 1441–1447 now in the Uffizi in Florence; *Ital. Pictures* (1932), p. 288, lists it as a work by Lippi; *Pitt. ital.* (1936), p. 247, calls it an early work by Lippi; and *Flor. School* (1963), p. 113, calls it an early work, in part by Lippi // L. Venturi, *Ital. Ptgs. in Amer.* (1933), pl. 209, attributes it to Lippi and considers it the right wing of a triptych to which the Oldenburg panel also belonged // G. Pudelko, *Riv. d'arte*, XVIII (1936), p. 56, note 1, no. 13, attributes it to a pupil of Lippi whom he names "Scolaro di Prato" and hesitantly describes it as part of the altarpiece to which the Oldenburg panel belonged // R. Oertel, *Fra Filippo Lippi* (1942), p. 68, fig. 67, calls it a weak work by Lippi and dates it about 1445 // M. Pittaluga, *Filippo Lippi* (1949), p. 209, fig. 153, attributes it to Lippi with the collaboration of Fra Diamante and dates it towards the end of the 1450's.

EX COLL.: [Colnaghi, London, 1884]; Newell, Cambridge, Mass. (1884); Mrs. Jane Newell Moore, Cambridge, Mass. (by about 1907; until 1912); Museum of Fine Arts, Boston (1912–1917); Mrs. Jane Newell Moore, Cambridge, Mass. (1917).

PURCHASE, ROGERS FUND, 1917.

Follower of Fra Filippo Lippi

The Madonna and Child with Two Angels 29.100.17

This panel is apparently a fragment of a larger composition, which, in general design, follows a painting by Fra Filippo Lippi formerly in the collection of the Medici family and now in the Uffizi Gallery in Florence (no. 1598). In the Uffizi picture, which is generally dated in the second half of the 1450's, the figures of the Madonna and Child are in a slightly different position, and one of the angels is almost completely concealed. A number of closely similar versions depending on this prototype are known. Some of these are attributed by critics to the early period of Botticelli, as for instance the panel in the National Gallery in Washington (Kress coll., K 714) and the one in the gallery of the Ospedale degli Innocenti in Florence (no. 107). Another example was in the Von Nemes collection in Munich, and there are others in the Musée Jacquemart-André in Paris and the National Gallery in Naples, this last showing the composition in reverse. Our painting has suffered irreparably from ancient overcleanings, and its present condition makes it difficult to reach a definite attribution. The less ruined parts, however, such as the landscape and the head of the angel on the extreme right, are very high in quality, superior by far to the other works of the group. Although many elements might suggest that it is by Botticelli in his early period, the treatment of the paint is not characteristic of him. The head of the angel on the extreme

right shows striking similarities to works from the middle period of Francesco Botticini, especially his altarpiece of the three archangels now in the Uffizi in Florence (no. 8359).

Tempera on wood. Oval, h. 39¼, w. 28 in. (99.7 × 71.1 cm.).

REFERENCES: A. Colasanti, *L'Arte*, VI (1903), pp. 299 ff., ill., attributes this painting to Filippo Lippi, notes its connection with the Uffizi version, but considers it earlier, dating it in the period when the painter was working in the cathedral of Prato;

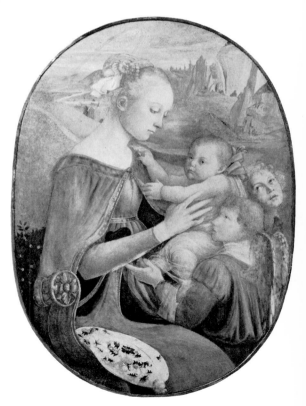

29.100.17

and *Connoisseur*, VII (1903), pp. 232 f., ill. // R. van Marle, *Ital. Schools*, X (1928), pp. 432 ff., ascribes it to Lippi and notes the close relationship to the Uffizi and Munich Madonnas // L. Venturi, (in a letter, 1929) attributes it to Filippo Lippi; and *L'Arte*, XXXIV (1931), pp. 258 ff., discusses the group of pictures following the Uffizi prototype // G. Gronau (in a letter, 1930) attributes it to Lippi // B. Berenson, *Italian Pictures* (1932), p. 104; and *Flor. School* (1963), I, p. 37, lists it as a ruined early work by Botticelli // C. Gamba, *Botticelli* (1936), p. 87, pl. I, calls it one of the earliest surviving works by Botticelli, and notes its dependence on the prototype by Lippi, comparing it with other similar versions // G. Pudelko, *Riv. d'arte*, XVIII (1936), pp. 51 f., discusses the dating of the group of versions of the Lippi prototype, considering them painted in the 1460's and possibly not before 1465 // J. Mesnil, *Botticelli* (1938), pp. 13 f., notes that this painting reproduces almost literally the head of the Madonna and the landscape in the

background of the Uffizi painting // R. Salvini, *Tutta la Pittura del Botticelli* (1958), I, p. 67, pl. 125, includes it among works attributed to Botticelli but leaves the attribution problematic, not having seen the original.

EXHIBITED: Metropolitan Museum of Art, New York, 1930, *The H. O. Havemeyer Collection*, no. 74.

PROVENANCE: the parish church of San Tommaso, Castelfranco di Sopra, near Florence (removed in the late XVIII century).

EX COLL.: the Counts Baglioni, Baglioni Villa, Cerreto (from the late XVIII century until about 1903); Mr. and Mrs. H. O. Havemeyer, New York (about 1903; until 1929; Cat., 1931, no. 7).

THE H. O. HAVEMEYER COLLECTION. BEQUEST OF MRS. H. O. HAVEMEYER, 1929.

Unknown Florentine Painter, Second quarter of the XV Century

The Madonna and Child 30.95.254

This picture appears to have been painted towards the end of the 1430's by an artist under the influence of Masolino, Angelico, and Domenico Veneziano. The same hand, with its peculiarities in the treatment of the hair, the types of the faces, and the folds of the robes, can be recognized in another painting, an Annunciation formerly in the Lanckorónski collection in Vienna and now in the M. H. de Young Memorial Museum in San Francisco. In this picture the artist also shows himself influenced by the early style of Filippo Lippi and by some of the architectural ideas of the earliest phase of the Renaissance in Florence. A third panel, a Madonna and Child between two saints and six angels in the Musée Condé at Chantilly,

is probably by this same painter and shows an even closer relationship to Filippo Lippi's early works. Too little is known about the earliest followers of Filippo Lippi to suggest a definite attribution for the group. It is quite possible that the three panels, so close to each other in time, represent the early work of some Florentine artist among Lippi's followers who may be well known at a more advanced period of his career. In our picture the round gilded haloes of a type used by Angelico are later additions; cleaning has revealed that the original haloes were represented in perspective as they are in the Lanckorónski Annunciation. The flesh painting throughout has lost much of its surface layer from overcleaning.

Formerly exhibited by the Museum as a work by Masolino and later attributed to an

unknown Florentine painter of the middle of the XV century (Cat., 1940).

Tempera on wood. H. 29⅝, w. 22¼ in. (75.2 × 56.5 cm.).

REFERENCES: *Boston Mus. Bull.*, I (1903), p. 30, describes this painting as a work of Tuscan origin // J. Breck, *Rass. d'arte*, XI (1911), p. 114, ill. opp. p. 111, attributes it to Masolino and dates it about the time of the Baptism in Castiglione d'Olona (1435) // R. van Marle, *Ital. Schools*, IX (1927), pp. 274 f., fig. 178, hesitantly accepts the attribution to Masolino and notes the influence of Fra Angelico // M. Salmi, *Dedalo*, IX (1928), p. 13, attributes it to the painter of the Lanckorónski Annunciation // R. Longhi, *Pinacoteca*, I (1928), p. 35, and (unpublished opinion, 1937), calls it a late work by the painter of the tondo of the Judgment of Paris in the Bargello in Florence, notes the influence of Domenico Veneziano, and dates it about 1440 // B. B[urroughs] *Met. Mus. Bull.*, XXVI (1931), Mar., sect. II, p. 14, attributes it to a follower of Fra Angelico and dates it in the second quarter of the XV century // B. Berenson, *Ital. Pictures* (1932), p. 196, attributes it to the Florentine who painted the Lanckorónski Annunciation and notes its similarity to the work of Fra Angelico and Domenico Veneziano; and *Flor. School* (1963), p. 219, pl. 818 // L. Venturi, *Ital. Ptgs. in Amer.* (1933), pl. 229, tentatively attributes it to Pietro di Lorenzo and notes its resemblance to a Madonna in the picture gallery in Dresden (no. 7A, as Pesellino) and to a Madonna in the Pallavicini collection in Rome // G. Pudelko, *Art Bull.*, XVII (1935), p. 76, note 11, is inclined to accept the attribution to the painter of the Lanckorónski Annunciation // A. Neumeyer, *Art Quarterly*, XXVIII (1965), pp. 7 ff., notes the close connection with the Lanckorónski Annunciation, ascribing both paintings to an artist between Fra Angelico and Domenico Veneziano and dating them probably between 1445 and 1450.

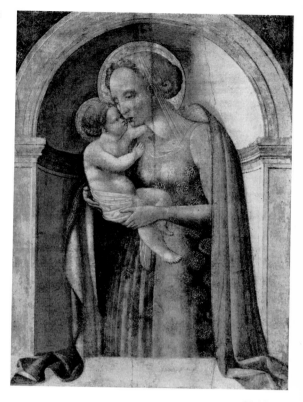

30.95.254

EXHIBITED: Museum of Fine Arts, Boston, 1903 (lent by Theodore M. Davis).

EX COLL.: Countess Fossi, Florence; [D. Costantini, Florence, 1900]; Theodore M. Davis, Newport (1900–1915).

THE THEODORE M. DAVIS COLLECTION. BEQUEST OF THEODORE M. DAVIS, 1915.

Pesellino

Real name Francesco di Stefano. Born about 1422; died 1457. Pesellino's first teacher may have been his grandfather, Giuliano Pesello, a painter well known in his own time, none of whose works, unfortunately, have survived. In 1453 Pesellino became the partner of Piero di Lorenzo and Zanobi di Migliore. According to tradition, he collaborated with Filippo Lippi on Lippi's altarpiece for Santa Croce in Florence, painting the panels of the predella,

which are now in the Uffizi and the Louvre. The only documented work by him is an altarpiece of the Trinity with Saints now in the National Gallery in London, which was commissioned in 1455 for the Company of the Trinity at Pistoia, begun by Pesellino, and completed by Fra Filippo Lippi. Critics have convincingly ascribed to Pesellino a group of panels, mostly small, which show that the determining influence on him was that of Filippo Lippi. The types he painted reveal his knowledge of Fra Angelico's work; his pictures show as well that he was intelligently aware of the values of space and volume in the painting of such basic innovators as Masaccio and Domenico Veneziano.

The Madonna and Child with Six Saints 50.145.30

The saints, from left to right, are Anthony Abbot, Jerome, Cecilia(?), Catherine of Alexandria (?), Augustine, and George. This panel, painted in a miniature-like technique, is one of Pesellino's finest works. It shows the influence of both Fra Angelico and Fra Filippo Lippi and seems to have been done in the second half of the 1440's. A drawing corresponding to the Saint Augustine is in the Louvre in Paris (no. 9886); its quality makes it questionable whether it is for or after our painting. The original gold ground, which had been painted over with green oil paint, possibly in the seventeenth or eighteenth century, was revealed in 1926, when this addition was removed.

Tempera on wood; gold ground. Over-all, including added strips, h. $10\frac{3}{8}$, w. $9\frac{3}{8}$ in. (26.4×23.8 cm.); painted surface, h. $8\frac{7}{8}$, w. 8 in. (22.6×20.3 cm.).

REFERENCES: Crowe and Cavalcaselle, *Geschichte der Italienischen Malerei*, III (1870), p. 103, reject the traditional attribution of this painting to Fra Angelico and call it a work by Pesellino // J. P. Richter, *Repert. für Kstwiss.*, XVII (1894), p. 240, rejects the ascription to Pesellino and calls it an early work by Benozzo Gozzoli // C. J. Ffoulkes, *Arch. stor. dell'arte*, VII (1894), p. 156, rejects the attribution to Pesellino and attributes it to Benozzo Gozzoli // B. Berenson, *Flor. Ptrs.* (1896), p. 124, lists it as a work by Pesellino; *Rev. archéologique*, XL

(1902), p. 194; *Drawings of the Florentine Painters* (1903), I, p. 55, note 2, calls it an early work by Pesellino influenced by Filippo Lippi and Domenico Veneziano and considers the drawing in the Louvre a copy after the figure of Saint Augustine; *Rass. d'arte*, V (1905), p. 43, ill., notes similarities to the Annunciation in the Parry collection; *Dedalo*, XII (1932), p. 669; *Pitture italiane del Rinascimento* (1936), p. 381; *The Drawings of the Florentine Painters* (1938), II, p. 255, no. 1841 A, considers the drawing in the Louvre a preparatory study for our panel; and *Flor. School* (1963), p. 168, pl. 823 // H. Mackowsky, *Zeitschr. für Bild. Kst.*, N.F., X (1898–1899), pp. 82 f., ill., calls it a work by Pesellino and identifies the drawing in the Louvre as a preparatory study for the bishop saint on the right, whom he calls Saint Louis of Toulouse // W. Weisbach, *Francesco Pesellino und die Romantik der Renaissance* (1901), pp. 68, 130, pl. XI, attributes it to Pesellino, calls the drawing in the Louvre a preparatory study, and tentatively identifies the bishop saint as Saint Louis of Toulouse // M. Logan, *Gaz. des B.-A.*, XLIII (1901), pp. 23, 342, note 1, attributes it to Pesellino // E. Hutton, ed., in Crowe and Cavalcaselle, *Ptg. in Italy* (1909), II, p. 362, quotes Berenson's attribution to Pesellino // A. Venturi, *Storia*, VII, part I (1911), pp. 396, 402, calls it a work by Pesellino // C. Phillips, *Burl. Mag.*, XXXIV (1919), p. 215, ill. p. 208, attributes it to Pesellino // J. Meder, *Die Handzeichnung . . .* (1919), pp. 664 f., fig. 324 (detail), calls the Louvre drawing a copy after the painting // T. Borenius, *Apollo*, III (1926), p. 327, ill. (in color), attributes it to Pesellino and describes the removal of the overpaint in the background // R. van Marle, *Ital. Schools*, X (1928), pp. 496 f., fig. 300, and XI (1929), p. 228, note, attributes it to Pesellino // P. Hendy, *Burl. Mag.*, LIII (1928), pp. 68, 74, attributes it to Pesellino // [H. Comstock?], *International Studio*, 90 (1928), pp. 62 f., ill., dates it soon after 1447, noting the relationship between Fra Filippo Lippi and Pesellino, identifying the bishop as either Bonaventura or Louis of Toulouse // A. Scharf, in W. R. Valentiner,

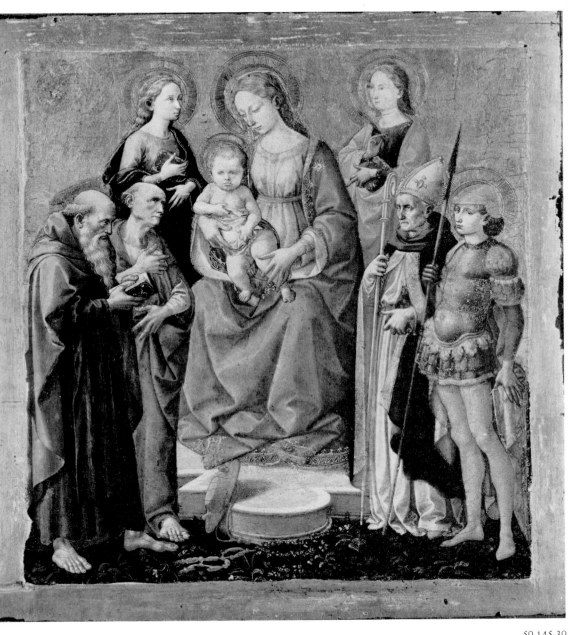

50.145.30

Unknown Masterpieces (1930), I, no. 8, attributes it to Pesellino // O. H. Giglioli, *Riv. d'arte*, XIII (1931), p. 523, attributes it to Pesellino // P. Toesca, *Dedalo*, XII (1932), pp. 86 f., ill., attributes it to Pesellino // G. Gronau, in Thieme-Becker, XXVI (1932), p. 463, lists it as a work by Pesellino, dating it in his late period, near the time of the altarpiece in the National Gallery, London // L. Venturi, *Ital. Ptgs. in Amer.* (1933), pl. 226, attributes it to Pesellino // H. B. W[ehle], *Met. Mus. Bull.*, XXVIII (1933), p. 12, mentions it as by Pesellino // *Met. Mus. Bull.*, n.s., X (1951), p. 62, ill. //

Art Treasures of the Metropolitan (1952), p. 223, pl. 71 (in color) // A. T. Gardner, *Met. Mus. Bull.*, n.s., XIII (1954), p. 48, ill. p. 46 // B. Alexander, *England's Wealthiest Son, a Study of William Beckford* (1962), p. 297, notes it among the paintings Beckford acquired during his residence in Bath; in a letter (1966) suggests that "Praston" in the traditional provenance may be a misprint for Praslin, an XVIII century French collection, from which Beckford acquired many objects // B. Degenhart, *Corpus der italienischen Zeichnungen* (1968), part I, vol. 2, pp. 528, 539, no. 528, fig. 769, dates the painting in Pesellino's late period, noting that certain differences in the miter, mantle, folds, etc. between the Louvre drawing and the painting make it uncertain whether the drawing was a cartoon for the painting or was made from it and that the relationship between painting and drawing is not clear; identifies the saints as Anthony Abbot, Jerome, Zeno, Louis (or Bonaventura), and George.

EXHIBITED: Royal Academy, London, 1887, *Old Masters*, no. 204 (as Pesellino, lent by R. S. Holford); New Gallery, London, 1893–1894, *Early Italian Art*, no. 107 (as Pesellino, lent by Capt. G. L. Holford); Burlington Fine Arts Club, London, 1919, *Exhibition of Florentine Painting before 1500*, no. 19 (as Pesellino, lent by Lt. Col. Sir George Holford); M. Knoedler and Co., New York, 1928, *Loan Exhibition of Twelve Masterpieces of Painting*, no. 7; M. Knoedler and Co., New York, 1929, *Loan Exhibition of Primitives*, no. 14 (lent anonymously); Century Association, New York, 1935, *Exhibition of Italian Paintings of the Renaissance*, no. 12 (lent by Edward S. Harkness); Cleveland Museum of Art, Cleveland, 1936, *20th Anniversary Exhibition*, no. 140, (lent by Edward S. Harkness); M. Knoedler and Co., New York, 1946, *Loan Exhibition of Twenty-Four Masterpieces*, no. 3 (lent by Mrs. Edward S. Harkness); Metropolitan Museum of Art, New York, 1950, *The Harkness Collection*; Metropolitan Museum of Art, New York, 1952–1953, *Art Treasures of the Metropolitan*, no. 71.

EX COLL.: Praston (possibly Praslin, Paris); William Beckford, Lansdown Tower, Bath, Somerset (1839?); Robert Stayner Holford, Dorchester House, London (by 1864(?)–1892); Sir George Lindsay Holford, Dorchester House, London (1892–1927; Cat., 1927, I, no. 14; sale, Christie's, London, July 15, 1927, no. 82); [M. Knoedler and Co., New York, 1927]; Edward S. Harkness, New York (1927–1940); Mrs. Edward S. Harkness, New York (1940–1950).

BEQUEST OF MARY STILLMAN HARKNESS, 1950.

Unknown Florentine Painter, Second Quarter of the XV Century

The Madonna and Child Enthroned with Saint John the Baptist and Another Saint 06.1048

The saint at the right, who holds a covered cup and the palm of martyrdom, has sometimes been tentatively identified as Cosmo or Damian but is more probably Miniato (or Minias). This identification, however, is also doubtful, as Saint Miniato is generally represented wearing a crown. Although the symbol of Christ in the pediment, originated and made known by Saint Bernardino of Siena, is Sienese in origin, the style of the picture shows unmistakable Florentine characteristics, especially in the rendering of perspective and the tooling of the golden haloes and in the strength and simplicity of its design. This painting, which, in spite of its fine quality, cannot be precisely attributed, must be a work by one of the minor, unrecognized artists in the close following of Pesellino. Its date seems to be towards the end of the second quarter of the fifteenth century.

Formerly attributed tentatively by the Museum to Pesellino (Cat., 1940).

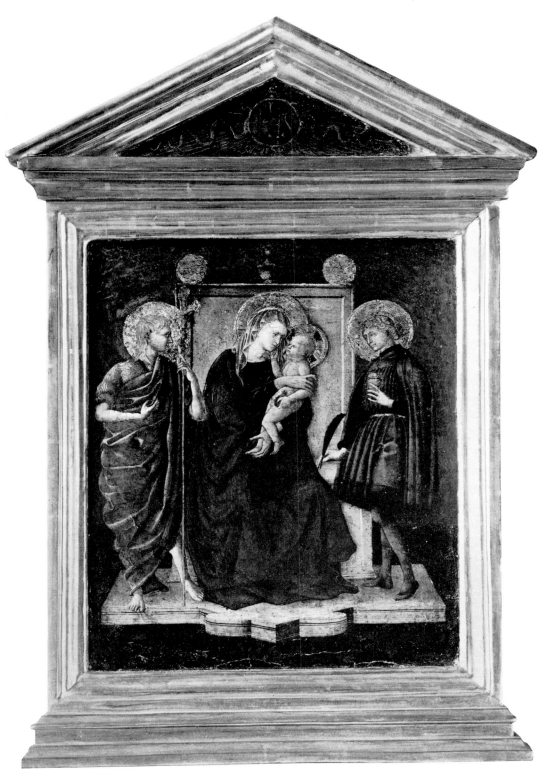

06.1048

Tempera and gold on wood. Over-all size, h. 29¾, w. 17⅛ in. (75.5 × 43.5 cm.); painted surface, h. 17⅛, w. 14¼ in. (43.5 × 36.2 cm.).

REFERENCES: R. Langton Douglas (unpublished opinion, n.d.) calls this painting an early work by Pesellino, of the time of a predella in the Doria Gallery in Rome // R. E. F[ry], Met. Mus. Bull., I (1906), p. 164, ascribes it to Pesellino and notes the influence of Masaccio // W. Rankin, Rass. d'arte, VIII (1908), cronaca no. 3, p. iv, attributes it to Pesellino // R. van Marle, Ital. Schools, X (1928), p. 495, fig. 299, assigns it to Pesellino's transitional period, when he was influenced by Fra Filippo Lippi, and identifies the saint on the right as Saint John the Evangelist // B. Berenson, Ital. Pictures (1932), p. 443, lists it as a work by Pesellino; and Flor. School (1963), p. 168, lists it hesitantly as a

work by Pesellino // R. Offner (verbally, 1937) rejects the attribution to Pesellino and considers it the work of an anonymous painter influenced by Lippi // R. Longhi (unpublished opinion, 1937) dates it about 1430–1440 and attributes it to a Sienese painter working under Florentine influence, perhaps Domenico di Bartolo in his early period; and La Critica d'arte, V (1940), part II, p. 189, note 28, fig. 67, calls it a work much closer to Domenico di Bartolo than to Pesellino and certainly Sienese of about 1430 under Florentine influence // C. Brandi, Quattrocentisti senesi (1949), p. 209, note 72, rejects the attribution to Domenico di Bartolo and calls it Pesellinesque.

EX COLL.: [R. Langton Douglas, London, about 1905]; [Georges Brauer, Florence, 1906].

GIFT OF GEORGES BRAUER, 1906.

Marco del Buono and Apollonio di Giovanni

Marco del Buono Giamberti: born 1402; died 1489. Apollonio di Giovanni di Tomaso: born 1415 or 1417; died 1465. A group of related works ascribed by C. Hülsen and R. Offner to an anonymous Florentine whom they called the Virgil Master is now known to be the product of a shop run by Apollonio di Giovanni and Marco del Buono. They must have employed a large number of assistant painters. The book of the shop, which records transactions between 1446 and 1465, is extant and reveals that it produced marriage chests for many of the chief Florentine families. Similar in style to these cassoni is a series of illuminations adorning a Codex of Virgil in the Riccardiana Library in Florence, which accounts for the provisional name of Virgil Master. Works related in style to those assigned to the Virgil Master had previously been grouped under such other designations as the Dido Master, the Cassone Master, and the Master of the Jarves Cassoni. The older of the two partners, Marco del Buono, was a member of the painters' guild in Florence in 1426. Apollonio di Giovanni, thirteen years younger, is recorded as a member of the guild in 1442. There are no signed or documented works by either of the painters alone. A contemporary Florentine poet, however, cited Apollonio in verse, praising him for his painting of subjects from Virgil, which strongly suggests that it was he and not his partner who illuminated the Riccardiana Codex and painted the two scenes from the Aeneid in the Jarves collection at Yale University. The paintings that proceeded from this popular and productive shop combine the International Gothic with renaissance realism and certain echoes of Domenico Veneziano. The painters who produced these pictures, however, depended essentially on Pesellino, bringing his forms and motives up to date and enriching them and adapting them to their decorative function

with tooling and gilding. (See W. Stechow, *Bulletin of the Allen Memorial Art Museum, Oberlin College*, I, 1944, pp. 5 ff., and E. H. Gombrich, *Journal of the Warburg and Courtauld Institutes*, XVIII, 1955, pp. 16 ff.)

The Story of Esther (cassone panel)

18.117.2

This painting, originally the decoration of a marriage chest, represents episodes from the story of Esther, who is shown standing with Ahasuerus in the marriage scene with her name inscribed beneath her. There probably was a second cassone, now lost, that showed the later and more familiar episodes in Esther's life. This panel shows the arrival of the princes at the king's feast, Esther and her maidens feasting in the house of the women, Mordecai listening at the king's gate, and the marriage of Esther and Ahasuerus (Esther 2). The costumes of the figures, especially the various types of hats, are characteristic of the shop. The style in which the faces are painted reflects Pesellino, but the right side and the architectural background at the left give evidence that the artist was familiar with the work of Domenico Veneziano.

Formerly attributed by the Museum to an unknown Florentine painter of the third quarter of the XV century (Cat., 1940).

Inscribed (beneath the figure of Esther): ESTER.

Tempera on wood. H. 17½, w. 55⅜ in. (44.4 × 140.6 cm.).

REFERENCES: A. Alexandre, *Les Arts*, III (1904), Jan., p. 7, ill. p. 9, attributes this painting to Dello Delli and calls it the Marriage of Esther and Ahasuerus // H. Frantz, *L'Art décoratif*, I (1912), p. 291, calls it a work of the Florentine School and identifies the subject as the marriage of Esther and Ahasuerus // P. Schubring, *Cassoni* (1915), p. 266, no. 191, pl. XLI, attributes it to the Cassone Master and suggests that the subject is Aeneas and Dido //

B. B[urroughs], *Met. Mus. Bull.*, XIV (1919), pp. 6 ff., ill. // R. Offner (verbally, 1937) considers it a product of the shop of the Virgil Master, possibly a work by the master himself.

EXHIBITED: Louvre, Paris, 1885, *Tableaux ... orphelins d'Alsace-Lorraine*, no. 118 (as Dello Delli, lent by Jean Dollfus); Kleinberger Galleries, New York, 1917, *Italian Primitives*, no. 23 (as the Arrival of Aeneas at Dido's Palace (?) by the Cassone Master); Virginia Museum of Art, Richmond, 1947, *Original Works of Art from the Italian Renaissance;* The Jewish Museum, New York, 1963, *The Hebrew Bible in Christian, Jewish, and Muslim Art*, no. 110, as by an unknown Florentine artist.

EX COLL.: Jean Dollfus, Paris (by 1885–1912; sale, Galerie Georges Petit, Paris, Apr. 1 and 2, 1912, no. 53, as Florentine School); [Wildenstein and Company, Paris, 1912–about 1917]; [Kleinberger Galleries, New York, about 1917–1918].

PURCHASE, ROGERS FUND, 1918.

The Conquest of Trebizond (cassone panel)

14.39

This painting is still set in the front of a richly ornamented cassone. On each end panel is a device, or impresa, probably that of the individual for whom the cassone was made: on a red background a belled golden falcon resting on a stock, or perch, of four parts, at the base of which is a banderole (on the left end the falcon is reversed to face in the opposite direction). The front panel represents the conquest of Trebizond by the Ottoman Turks in 1461 under Sultan Mohammed II. Trebizond is shown at the right, and in the background at the left are the buildings of Constantinople, which, though not factual representations, suggest

18.117.2

the way the real ones looked in the fifteenth century. The obelisk can be identified as the one put up by Theodosius the Great in the Hippodrome, while the large column on the left might be one of the two spiral columns erected by Theodosius the Great and Arcadius and later destroyed. The faces are characteristic of the products of this shop, as are the gilt ornament and tooling and the rendering of the architecture, which recalls Pesellino. Although, with its rare subject matter and sumptuous decoration, this panel is one of the best of the extensive group, it was probably in large part executed by the workshop.

Formerly attributed by the Museum to an unknown Florentine painter of the second half of the XV century (Cat., 1940).

Inscribed (on buildings in background): CONSTANTINOPOLI, S. FRA[N]CESCO, S. SOFIA, PERA, CHASTELO NUOVO, LOSCUTERIO (Scutari), TREBIZOND; (on the water): [LO STR]ETTO.

Tempera on wood. Sight size, h. $15\frac{1}{4}$, w. $49\frac{1}{4}$ in. (38.7×125 cm.).

REFERENCES: W. Weisbach, *Zeitschr. für bild. Kst.*, XXIV (1913), pp. 262 ff., fig. 9, calls this painting Florentine, dates it 1450–1460, finds it especially like two cassone panels in the collection of the Earl of Crawford, discusses its topography, and suggests the possibility that it was painted for one of the Strozzi // W. R. V[alentiner], *Met. Mus. Bull.*, IX (1914), pp. 145 ff., ill., calls it Florentine and dates it about 1475 // P. Schubring, *Cassoni* (1915), p. 283, nos. 283–285, pls. LXV, LXVI, LXVII, calls it Florentine // W. M. Odom, *History of Italian Furniture*, I (1918), p. 99, fig. 52, calls it Florentine about 1475 // E. H. Gombrich, *Journal of the Warburg and Courtauld Institutes*, XVIII (1955), pp. 25, note 1, 29, note 2, ascribes it to the Virgil Master, whom he identifies with the documented painters Marco del Buono and Apollonio di Giovanni, and alludes to a possible hidden significance of the subject // E. Callmann (in a letter, 1967) identifies this cassone with the commission recorded in the shop book for the Strozzi-Spini

14.39

marriage of 1465 // *Met. Mus. Bull.*, n.s., XXVI (1968), p. 225, ill.

PROVENANCE: Palazzo Strozzi, Florence.

EX COLL. [Stefano Bardini, Florence, 1913].

PURCHASE, KENNEDY FUND, 1913.

The Story of Paris (cassone panel)

32.75.1 A

This painting originally ornamented the front of a cassone and the two following were set at the ends. The story shown here is a version of the Paris legend current in the romance literature of the day. Paris, instead of taking Helen from the house of Menelaus, his host, as in the usual form of the legend, takes her from the island of Cythera. The Judgment of Paris is shown at the left, and in the distance Menelaus is sailing away with Agamemnon, leaving Helen behind. The boat in the foreground is bringing Helen to the island of Cythera, where she expects to find Paris attending a feast at the temple of Venus. On the shore is Paris with his retinue, and at the far right, beyond the temple, he and Helen are pictured gazing at each other in admiration. That night, according to the legend, Paris stole Helen and carried her, along with treasures from the temple, back to Troy. The types, the costumes, and the composition of this panel declare it a product of the large cassone shop conducted by Marco del Buono and Apollonio di Giovanni. Considerable repainting, however, makes it impossible to tell whether it is by one of the directors of the shop or by one or more of their many helpers. A rather early date is suggested by certain details, such as the Judgment of Paris and the hexagonal building at the right, which is derived from examples of early renaissance architecture in Florence.

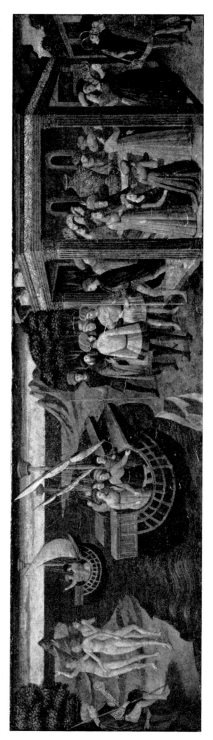

32.75.1 A

Formerly attributed by the Museum to an unknown Florentine painter of the third quarter of the XV century (Cat., 1940).

Tempera on wood. H. $15\frac{3}{4}$, w. $60\frac{1}{2}$ in. (40 × 153.6 cm.).

REFERENCES: H. B. Wehle, *Met. Mus. Bull.*, XXXIV (1939), pp. 19 f., dates this cassone after the middle of the XV century // E. S. King, *Journal of the Walters Art Gallery*, II (1939), pp. 62, 64, fig. 8, 70, note 43, discusses various representations of the legend of Paris and Helen // N. B. Rodney, *Met. Mus. Bull.*, n.s., XI (1952), ill. p. 59.

EX COLL. Giovanni P. Morosini, Riverdale-on-Hudson, New York.

THE COLLECTION OF GIOVANNI P. MOROSINI, PRESENTED BY HIS DAUGHTER GIULIA, 1932.

Campaspe and Aristotle (cassone panel)

32.75.1 B

This painting illustrates the medieval legend about the humiliation of Aristotle, who had reproached Alexander the Great for his love for Campaspe (Phyllis) but was ensnared by her himself and forced to obey her degrading command. This panel, like the story of Paris, has been considerably repainted. See also comment above under the Story of Paris.

Tempera on wood. H. $15\frac{3}{4}$, w. 19 in. (40 × 48.3 cm.).

REFERENCES: see above under the Story of Paris.

EX COLL. Giovanni P. Morosini, Riverdale-on-Hudson, New York.

THE COLLECTION OF GIOVANNI P. MOROSINI, PRESENTED BY HIS DAUGHTER GIULIA, 1932.

Pyramus and Thisbe (cassone panel)

32.75.1 C

This painting shows Thisbe about to kill

herself after finding her lover Pyramus dead. Crouching at a well is the lion which had frightened Thisbe away and stained her cloak with blood, thus causing Pyramus to think her devoured and to kill himself. This panel, like the Story of Paris, has been considerably repainted. See also comment above under the Story of Paris.

Tempera on wood, H. 15¾, w. 19 in. (40×48.3 cm.).

REFERENCES: See above under the Story of Paris.

EX COLL. Giovanni P. Morosini, Riverdale-on-Hudson, New York.

THE COLLECTION OF GIOVANNI P. MOROSINI, PRESENTED BY HIS DAUGHTER GIULIA, 1932.

Domenico di Michelino

Real name Domenico di Francesco. Born 1417; died 1491. Domenico's apprenticeship was spent in the workshop of an ivory-carver, Michelino, from whom he took his surname. Our knowledge of his work is based on a large painting that he executed in 1465 for the cathedral of Florence, after a design by Alesso Baldovinetti, which shows Dante standing beside the city of Florence, in front of a symbolic representation of hell, purgatory, and paradise, and holding an open book, his *Divine Comedy*. The paintings attributed to Domenico di Michelino are closely dependent on Pesellino, with whom he has often been confused, and strongly influenced by Fra Angelico.

The Crucifixion 19.87

Both the figures and the landscape in this picture combine stylistic elements derived from Fra Angelico and Pesellino. The treatment of forms is characteristic of Domenico di Michelino at a relatively early period in his career. The original panel, now cut at the top and inlaid in a larger one, may have been the central section of a small triptych.

Formerly attributed tentatively by the Museum to Pesellino (Cat., 1940).

Tempera on wood. Original panel, h. 16½, w. 11⅝ in. (41×29.5 cm.).

REFERENCES: B. B[urroughs], *Met. Mus. Bull.*, XIV (1919), pp. 155 ff., ill., notes in this painting the influence of Fra Angelico // R. van Marle, *Ital. Schools*, X (1928), pp. 477 f., fig. 285, ascribes it to Pesellino and dates it after the period of Fra

19.87

Angelico's influence // B. Berenson, *Ital. Pictures* (1932), p. 172, attributes it to Domenico Veneziano; and *Flor. School* (1963), p. 62 // M. Salmi, *Riv. d'arte*, XVII (1935), p. 416, considers it close in style to Domenico di Michelino and dates it after Domenico's triptych in the museum at Chambéry and before the paintings in San Piero in Palco in Florence // R. Offner (verbally, 1937) attributes it to Domenico di Michelino // R. Longhi (un-published opinion, 1937) attributes it to Pesellino // F. Mason Perkins (in a letter, 1938) tentatively calls it an early work by Pesellino showing the influence of Fra Angelico.

EX COLL. [R. Langton Douglas, London, 1919].

PURCHASE, MARQUAND FUND, 1919.

The Lippi-Pesellino Imitators

A very extensive and fairly homogeneous group of fifteenth-century Florentine paintings, essentially derivative, was at one time attributed by Berenson to Pier Francesco Fiorentino, a modest painter whose works are dated between 1474 and 1497. He was apparently a follower of Benozzo Gozzoli and was also influenced by some of his Florentine contemporaries. Several other critics recognized a pronounced disparity between signed works by Pier Francesco in San Gimignano and Montefortino and the paintings of this group, which are lacking in genuine individuality and are characterized by a firm, even rude technique, with sharp, definite outlines, flat, bright areas of color, and often embellished with tooled gold in the haloes and rose hedges as backgrounds. These are mechanical products, not the work of one artist but rather of a group of craftsmen in a single, very prolific Florentine workshop. Their compositions were borrowed from a few fifteenth-century Florentine sources, especially Filippo Lippi and Pesellino (hence the appellation used above), and molded into an old-fashioned and popular formula. For a panel formerly in the Steffanoni collection in Bergamo the model was a work by Antonello da Messina; in a tondo in the Gallery of Arezzo, possibly one of the latest products of the group, the main figures are taken from the Benois Madonna by Leonardo in the Hermitage in Leningrad. Very often compositions taken from one model are mixed with details borrowed from another. Painted backgrounds with flower hedges of the type seen in the works of the Lippi-Pesellino followers adorn a few stucco reliefs, mostly from the shop of Desiderio da Settignano. None of the many panels of the group is dated, but the workshop must have been active during the last four decades of the fifteenth century.

In 1932 Berenson withdrew his original attribution from a large part of the group of paintings and listed those of the type to which ours belong under the name Pseudo-Pier Francesco Fiorentino, which he invented to distinguish them from those of the real Pier Francesco.

The Madonna and Child with the Infant Saint John the Baptist and Angels 32.100.79

The chief source of this painting is the Madonna with three angels by Pesellino formerly in the Hainauer and Pratt collections and now in the Toledo Museum of Art, Toledo, Ohio. From it are derived the central group of the Madonna and Child, the two winged angels in the back, and, partially, the figure in the lower right corner. The figure of the little Saint John is from Filippo Lippi's Adoration originally in the chapel of the Palazzo Medici-Riccardi in Florence and now in the Berlin Museum. The dark background, the dove, and the two boy's heads on each side of the Madonna, however, are additions by our anonymous painter. An almost exact replica of this picture was formerly in the Costantini collection in Florence, later in the art market in Paris. A second version, with five figures only and a rose hedge, as in the model by Pesellino, is in the Uffizi in Florence (no. 486), and a third, also with a rose hedge but with three angels only, is in the collection of Lord Rochdale in Lingholm, Keswick. The central group appears also in a panel in the Acton collection, Florence, but in a slightly different context.

Once attributed by the Museum to Pier Francesco Fiorentino.

Tempera and gold on wood; background dotted with gold. H. 33⅜, w. 23¾ in. (84.8×60.3 cm.).

32.100.79

REFERENCES: B. Berenson (in a letter, 1917) ascribes this painting to Pier Francesco Fiorentino; and in Cat. of Friedsam Coll. (unpublished, n.d.), pp. 42 f., and *Ital. Pictures* (1932), p. 451, attributes it to Pseudo-Pier Francesco Fiorentino and considers it a free copy after the Madonna in the Hainauer and Pratt collections (now in Toledo), which he attributes to Pesellino; *Flor. School* (1963), p. 173, lists it as a work by Pseudo-Pier Francesco Fiorentino, noting that it is based on a painting by Pesellino in the Gardner Museum in Boston, erroneously giving its number as 41.116.1 // G. Soulier, *Dedalo*, VII (1926), p. 96, attributes the Costantini replica of our painting to Pier Francesco Fiorentino // R. van Marle, *Ital. Schools*, XIII (1931), p. 447, fig. 298, attributes our panel to Pier Francesco Fiorentino, to whom he ascribes also the Hainauer-Pratt Madonna // M. Mseriantz, *Art in Amer.*, XXIII (1935), pp. 104 ff., attributes it to Pier Francesco Fiorentino, notes the influence of Filippo Lippi, and calls it an early work, about 1480–1485 // R. Offner (verbally, 1937) attributes it to a follower of Pesellino // F. Mason Perkins (in a letter, 1938) attributes it to Pseudo-Pier Francesco Fiorentino // H. Friedmann, *The Symbolic Goldfinch* (1946), p. 149, discusses the iconography of the goldfinch.

EX COLL.: Sir George Donaldson, London and Brighton; [Duveen Brothers, New York, about

1917–1919]; [Kleinberger, New York, 1921]; Michael Friedsam, New York (1921–1931).

THE MICHAEL FRIEDSAM COLLECTION. BE-QUEST OF MICHAEL FRIEDSAM, 1931.

The Madonna adoring the Child, with the Infant Saint John the Baptist and Two Angels 41.100.9

This composition was one of those most frequently employed in the workshop of the Lippi-Pesellino imitators. With differing degrees of variation and enrichment, it re-appears in numerous panels, rectangular, circular, or arched at the top. The figures of the Madonna, the Child, and the little Saint John are taken from the Adoration by

41.100.9

Filippo Lippi from the Palazzo Medici-Riccardi in Florence, now in the Berlin Museum and the two angels from Pesel-lino's Hainauer-Pratt Madonna, now in the Museum in Toledo, Ohio (see preceding entry). The original frame, with a motive of gilt stars and dots on a dark blue ground has, like the painting itself, a mechanical quality that places the artist on the level of a crafts-man.

Tempera on wood; gold ground. Over-all size, h. 41, w. 26⅜ in. (104.2×67 cm.); painted surface, h. 31⅜, w. 17⅜ in. (79.7× 44.2 cm.).

REFERENCES: B. Berenson, *Flor. Ptrs.* (1907), p. 133, lists this painting as a work by Pier Fran-cesco Fiorentino; *Ital. Pictures* (1932), p. 451, lists it as by Pseudo-Pier Francesco Fiorentino; *Flor. School* (1963), p. 173 // R. van Marle, *Ital. Schools*, XIII (1931), p. 435, attributes it to Pier Francesco Fiorentino, wrongly describing the Child as held by two angels.

EX COLL.: John Montague Spencer-Stanhope, Florence (about 1907); George and Florence Blumenthal, New York (by 1926; until 1941; Cat., I, 1926, pl. XII).

GIFT OF GEORGE BLUMENTHAL, 1941.

The Madonna and Child with the Infant Saint John the Baptist and an Angel 65.181.4

This painting, a typical work from the shop of the Lippi-Pesellino Imitators, combines motives from three different prototypes. The Madonna and Child are based on the group in a panel by Pesellino in the Gardner Museum in Boston or a similar version in the Christian Museum in Esztergom, Hun-gary, the Saint John comes from Lippi's Adoration in the Berlin Museum, and the angel is taken from Pesellino's Madonna and

Child with Angels in the Toledo Museum of Art in Ohio. A number of details in the Museum's painting have symbolic significance: the goldfinch held by the Child alludes to the Passion, the angel's lily to virginity, the roses are included as attributes of the Virgin or symbols of love, and the pomegranate on the ledge is symbolic of the church or the Resurrection. The same compositional design was used in a number of versions from the workshop of the Lippi-Pesellino Imitators, of which the closest to ours is one in the National Museum in Budapest (no. 2539), in which, however, the rose hedge has been largely destroyed and the haloes partly repainted. There are many other versions that combine motives appearing in this picture with various other elements not found in it.

Tempera on wood. Over-all size, h. 25¾, w. 20 in. (65.4 × 50.8 cm.); painted surface, h. 24¾, w. 19 in. (62.8 × 48.2 cm.).

REFERENCES: F. Mason Perkins (in a letter, 1925) rejects the traditional attribution to Pier Francesco Fiorentino, calling it one of the better paintings in a group which he attributes to Pseudo-Pier Francesco Fiorentino // R. van Marle, *Ital. Schools*, XIII (1931), p. 447, lists it as by Pier Francesco Fiorentino // C. Virch, *The Adele and Arthur Lehman Collection* (1965), pp. 34 f., ill., attributes it to the Lippi-Pesellino Imitators.

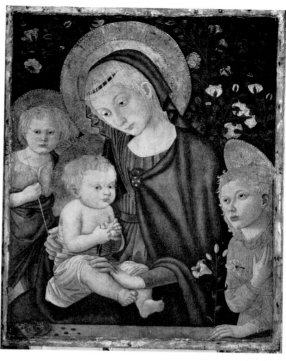

65.181.4

EXHIBITED: New York, Wildenstein and Co., 1962, *Masters of Seven Centuries*, no. 5 (lent by Mrs. Arthur Lehman).

EX COLL.: Charles T. D. Crews, London (sale, Christie's, London, July 2, 1915, no. 153, as by Pier Francesco Fiorentino); [R. Langton Douglas, London, 1915–1916]; Mr. and Mrs. Arthur Lehman, New York (1916–1965).

BEQUEST OF ADELE L. LEHMAN IN MEMORY OF ARTHUR LEHMAN, 1965.

Follower of Castagno

Andrea del Castagno. Real name Andrea di Bartolo di Simone. Born 1419 or slightly earlier; died 1457. Andrea del Castagno took his name from his birthplace, the little village of Castagno in the Mugello valley. His earliest extant works are the frescoes in the church of San Zaccaria in Venice, which he painted with Francesco da Faenza in 1442. He was mainly active in Florence, however, and there are a number of works surely by him, all done for

that city, including the frescoes in the Cenacolo di Sant'Apollonia and an altarpiece painted for the church of San Miniato fra le Torri in 1449–1450, now in the Berlin Museum. Andrea del Castagno's style is based upon the work of the great masters of the Florentine Renaissance, especially the paintings of Domenico Veneziano and the sculptures of Donatello. The power of his works, achieved through vigorous, sculptural modeling and a rather crude treatment of form, initiated a new trend in Florentine painting and greatly influenced artists of the next generation, such as the Pollaiuolos and, even later, Michelangelo.

Saint Sebastian 48.78

This painting was acquired as a work by Castagno, and indeed the head of the saint, in its form and expression, recalls figures in certain important works by that artist, especially the Saint Thomas in the Last Supper in the Cenacolo di Sant'Apollonia in Florence and the Saint Jerome in a fresco in the church of the Santissima Annunziata, also in Florence. The treatment of the light and shadow falling on the saint's body, however, in the Museum's picture, the type of the landscape, and the relation of the figures to this landscape background combine to suggest that the picture was painted after 1457, the year in which Castagno died. The landscape is more detailed and naturalistic than those in paintings by Domenico Veneziano but less so than the backgrounds by Baldovinetti and the Pollaiuolos, who lived and worked for several decades after Castagno's death. The artist indeed appears to have been familiar with the paintings of Antonio and Piero Pollaiuolo and also possibly knew early works by Verrocchio, who was only twenty-two when Castagno died.

Several other paintings very similar in style to this Saint Sebastian form a coherent group, presumably by the same artist. Two of them, a Crucifixion in the National Gallery, London, (no. 1138) and a Resurrection in the Frick Collection in New York, both predella panels, are so close to it in style, technique, and artistic tradition that one must assume the three are by the same artist at almost the same moment in his career. Among the other paintings in the same style are a Madonna adoring the Child in the Museum of Art in Birmingham, Alabama (Kress Coll., K. 1722) and a small altarpiece representing Saint Nicholas enthroned with four female saints, formerly in the collection of W. H. Woodward in London, both closely related to the Museum's picture. Judging from the stylistic development within the group, the earliest works, which include the Saint Sebastian, seem to have been painted about 1465 and the more advanced ones, like the panel with the three saints in the Museum at Bagnères-de-Bigorre in France, about 1470–1475. There are numerous similarities between this group of paintings and the works of Francesco Botticini, especially those of his early period. They cannot, however, be ascribed to him without more evidence and a clearer conception of Botticini's artistic individuality. It is, however, certain that the Saint Sebastian and the pictures related to it were painted by a Florentine deeply influenced by the last phase of Andrea del Castagno and also impressed, though later, by the work of Antonio and Piero del Pollaiuolo and Andrea del Verrocchio.

Although such a representation of Saint Sebastian standing against the trunk of a tree, his feet resting on sawed-off stumps, appears to be derived from a North

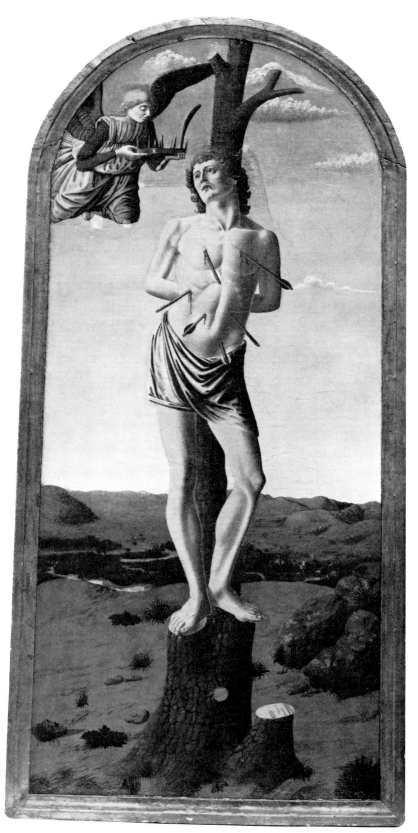

48.78

European prototype, the motive had already been used in Florence in the late fourteenth century by Giovanni del Biondo and others (Opera del Duomo, Florence). Our painting seems to have inspired several later versions of the subject, including the famous panel by Botticelli in the Berlin Museum (no. 1128), painted in 1473–1474, and one by Francesco Botticini in the Uffizi (no. 8476), in which even the motive of the angel bearing the crown is to be found. There are a number of pentimenti, the most conspicuous around the saint's head, visible through the top layers of paint.

Formerly attributed by the Museum to Andrea del Castagno.

Tempera and oil on wood. Over-all size (including molding), h. 56¾, w. 26¼ in. (144.1 × 66.7 cm.); painted surface, h. 53¾, w. 23 in. (136.5 × 58.4 cm.).

REFERENCES: B. Berenson (verbally, 1947) attributes this painting to Andrea del Castagno, dating it slightly earlier than the Sant'Apollonia frescoes of 1445–1450; and *Flor. School* (1963), p. 47, attributes it tentatively to Castagno // A. Morassi (unpublished opinion, n.d.) attributes it to Castagno and compares it with Botticelli's Saint Sebastian in Berlin // G. Fiocco, *Arte veneta*, II (1948), p. 29, note 1, attributes it to Castagno and observes Domenico Veneziano's influence in the landscape // T. Rousseau, *Met. Mus. Bull.*, n.s., VII (1949), pp. 125 ff., ill. (in color on cover), attributes it to Castagno, dates it about 1445, and compares the angel with that in Masaccio's Expulsion from Paradise // M. Salmi, *Boll. d'arte*, XXXV (1950), p. 307; and XXXIX (1954), pp. 28, 35, 40, note 18, figs. 16, 36, attributes it to Castagno, dates it about the time of the altarpiece formerly in the church of San Miniato and now in Berlin (1449–1450),

suggests that the figure of the angel is by a pupil, perhaps the same one who painted the tabernacle of Santa Cristina near Prato, and notes that the Larderel family, from which our painting came, is related to the Rucellai family, thus making it possible that our painting might be one of the works executed by Castagno for Giovanni Rucellai and mentioned in Rucellai's manuscript the "Zibaldone" (subjects not specified); and *Andrea del Castagno* (1961), pp. 21, 34, 48, figs 45., 46 (detail), observes that the motive of Saint Sebastian on a tree was later used by several Florentine artists and suggests that it may be of northern origin, comparing it with the Saint Sebastian in the Last Judgment altarpiece at Beaune by Rogier van der Weyden // *Art Treasures of the Metropolitan* (1952), no. 75, ill. (in color), as a work by Andrea del Castagno // F. Hartt, *Art Bull.*, XLI (1959), p. 159, note 1, rejects the attribution to Castagno and calls it a late, provincial, Pollaiuolesque work; in a letter (1969) calls it the work of a provincial South Tuscan artist, revealing possibly in the landscape the influence of Piero della Francesca, and dates it about 1475 // M. Modestini, in W. E. Suida, *The Samuel H. Kress Collection, Birmingham Museum of Art* (1959), p. 45, observes technical similarities between the Saint Sebastian and the Madonna adoring the Child in the Kress collection (K. 1722) // E. Fahy, *Burl. Mag.*, CIX (1967), p. 137, note 36, attributes it to Botticini // L. Bellosi, *Paragone*, XVIII (1967), no. 211, pp. 10 ff., 17, notes 16, 17, 19, rejects the attribution to Castagno, groups it with other works, ascribing them all to a Florentine painter working after Castagno's death, influenced by Pollaiuolo and especially by Verrocchio // J. Pope-Hennessy (in a letter, 1968), rejects the attribution to Castagno, ascribing it, along with the Crucifixion in the National Gallery, London, and other similar works, to Botticini.

EXHIBITED: Metropolitan Museum, New York, 1952–1953, *Art Treasures of the Metropolitan*, no. 75.

EX COLL.: the Counts Larderel, Florence and Leghorn (until about 1945); Count Giovanni Rasini, Milan (about 1945–1946); [M. Knoedler and Co., New York, 1948].

PURCHASE, ROGERS AND DICK FUNDS, 1948.

Giovanni di Francesco

Giovanni di Francesco del Cervelliera; possibly the same as the Giovanni da Rovezzano mentioned by Vasari among the pupils of Andrea del Castagno. The only documented work by Giovanni di Francesco is a frescoed lunette painted over the door of the church of the Innocenti in Florence in 1458–59. This painting was found to be so close in style to a homogeneous group of paintings formerly called the work of the Master of the Carrand Triptych, from a painting in the Carrand collection in the Museum of the Bargello in Florence, that the group has now been ascribed to him. His style shows a knowledge and understanding of the works of Domenico Veneziano, Andrea del Castagno, and Fra Filippo Lippi. His tones are luminous, but he defines form less with color than with linear design, an aesthetic approach that became common in Florentine painting in the third quarter of the fifteenth century.

Portrait of a Lady in Profile 32.100.98

This portrait shows clearly the influence of Fra Filippo Lippi in the treatment of line and that of Domenico Veneziano in the pale tones. The work by Giovanni di Francesco that this picture resembles most is the triptych in the Carrand collection in the Museum of the Bargello, and, like it, was probably painted in the late 1440's. The headdress of the lady and the careful rendering of the perspective of the architecture may be due to the influence of Paolo Uccello. Many years ago the surface of the painting was slightly abraded by overcleaning.

Formerly attributed tentatively by the Museum to Fra Diamante (Cat., 1940).

Tempera on wood. H. 16¼, w. 12¼ in. (41.3 × 31.1 cm.).

REFERENCES: L. Lelarge-Desar, *Revue de l'art ancien et moderne*, XXXIV (1913), p. 392, accepts the attribution of this painting to Fra Filippo Lippi given it in the Aynard sale catalogue // B. Beren-

son (in a letter, 1922) attributes it to Fra Diamante; in Cat. of Friedsam Coll. (unpublished, n.d.), p. 44, attributes it tentatively to Fra Diamante and dates it soon after 1450; *Ital. Pictures* (1932), p. 169, lists it as a work by Fra Diamante; and *Pitt. ital.* (1936), p. 279, attributes it hesitantly to the Master of the

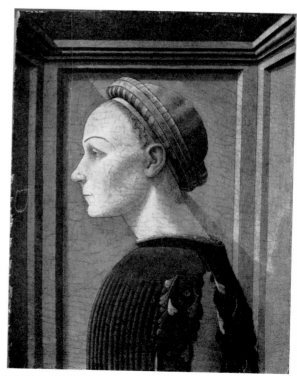

32.100.98

Carrand Triptych // B. Burroughs and H. B. Wehle, *Met. Mus. Bull.*, XXVII (1932), Nov., sect. II, p. 32, ill. // J. Lipman, *Art Bull.*, XVIII (1936), pp. 76, 101, fig. 32, lists it tentatively as a work by Fra Diamante and dates it between 1450 and 1475 // G. Pudelko, *Riv. d'arte*, XVIII (1936), p. 57, note, attributes it to the pupil of Lippi whom he calls "Scolaro di Prato" // R. Longhi (unpublished opinion, 1937) attributes it to Giovanni di Francesco; and *Paragone*, III (1952), no. 33, p. 43, attributes it to Giovanni di Francesco and dates it about 1450 // F. Mason Perkins (in a letter, 1938) attributes it to a close follower of Lippi, not necessarily Fra Diamante // C. L. Ragghianti, *La Critica d'arte*, III (1938), p. xxv, attributes it to Giovanni di Francesco // M. Pittaluga, *Filippo Lippi* (1949), p. 221, lists it among wrong attributions, works not directly connected with Fra Filippo Lippi.

EXHIBITED: Royal Academy, London, 1884, *Old Masters*, no. 225 (as Cosimo Tura, lent by Alexander Casella); Metropolitan Museum, New York, 1923, *Loan Exhibition of the Arts of the Italian Renaissance*, no. 2 (as Fra Diamante, lent by Michael Friedsam).

EX COLL.: Alexander Casella, London (in 1884); Édouard Aynard, Lyons (sale, Galerie Georges Petit, Paris, Dec. 1–4, 1913, no. 53, as attributed to Fra Filippo Lippi); Seymour de Ricci, Paris (1913); [F. Kleinberger, Paris and New York, 1922]; Michael Friedsam, New York (1923–1931).

THE MICHAEL FRIEDSAM COLLECTION. BEQUEST OF MICHAEL FRIEDSAM, 1931.

The Master of the Castello Nativity

The Master of the Castello Nativity is the name given by Berenson to the unknown painter of a Nativity at one time in the Villa Reale at Castello and now in the Accademia in Florence (no. Dep. 171). Other works apparently by him include paintings of the Madonna Adoring the Child in the Fitzwilliam Museum in Cambridge (Marlay Bequest, no. 14), the Huntington Art Gallery, San Marino, California, and the Museum in Leghorn. The style of the Master of the Castello Nativity, who seems to have been active in Florence from the late 1440's to the end of the third quarter of the fifteenth century, is essentially derivative, dependent on the styles of his major contemporaries. He took motives and forms from Fra Filippo Lippi and Fra Angelico; a number of his paintings also reveal a familiarity with Domenico Veneziano, thus expanding our knowledge of this painter's work, much of which is no longer extant. Although mannered and often conventional, the Master of the Castello Nativity, with his brilliant colors and his meticulous technique, is one of the most pleasing little masters of the Florentine fifteenth century. W. R. Valentiner tried, unconvincingly, to identify him with the sculptor Andrea dell'Aquila (*Art Bull.*, XIX, 1937, pp. 532 ff.).

Profile Portrait of a Lady 49.7.6

This portrait clearly shows the characteristics of the Master of the Castello Nativity, especially in the drawing of the face, the texture of the paint, and the peculiar pale shadow around the eye. The fashion of the costume and the coiffure, as well as the posi-

tion the picture takes in the sequence of works postulated for this artist, suggests that the portrait was done in the first half of the 1450's. A profile portrait in the collection of Robert Lehman, though often grouped by scholars with the Museum's painting, is by a different artist. One in the Isabella Stewart Gardner Museum in Boston, however, is

very close in style and composition to ours, and, like it, shows the luminous harmony of color and form that the artist adapted from the work of Domenico Veneziano, rather than the reflections of Paolo Uccello that some scholars claim to see in these two pictures. The identification of the sitter in our painting as Elisabetta da Montefeltro, wife of Roberto Malatesta of Rimini, is indefensible.

Formerly tentatively attributed by the Museum to Domenico Veneziano.

Tempera on canvas, transferred from wood. H. 15¾, w. 10¾ in. (40 × 27.3 cm.); with added strips all around, h. 17⅞, w. 12½ in. (44.2 × 31.8 cm.).

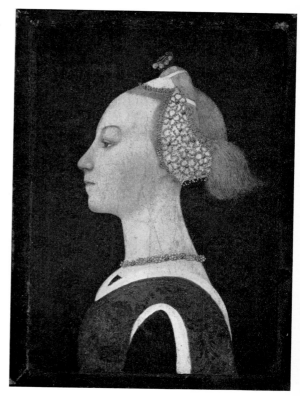

49.7.6

REFERENCES: R. Fry, *Burl. Mag.*, XVI (1910), p. 274, ill., suggests that this picture is Florentine or North Italian rather than Umbrian // O. Fischel, *Berliner Museen*, XLI (1920), col. 116 f., fig. 37, considers it an Umbro-Tuscan portrait, possibly coming from Urbino and suggests identifying the sitter as Elisabetta da Montefeltro // B. Berenson, *Art News*, XXVII (1929), Apr., p. 32, ill.; *Ital. Pictures* (1932), p. 172, lists it as a work by Domenico Veneziano; *Flor. School* (1963), p. 62 // L. Venturi, *L'Arte*, XXXIII (1930), p. 64, fig. 13, attributes it to Paolo Uccello; *Ital. Ptgs. in Amer.* (1933), pl. 195 // A. L. Mayer, *Pantheon*, VI (1930), pp. 537 f., ill. p. 539, attributes it to Domenico Veneziano // H. E. Wortham, *Apollo*, XI (May 1930), p. 353, fig. IV, attributes it to Domenico Veneziano // P. Hendy, *Gardner Mus. Cat. of Ptgs.* (1931), p. 388, mentions it in connection with the Gardner Museum portrait as a work by Paolo Uccello // R. Offner, *Burl. Mag.*, LXIII (1933), p. 178, note 36, attributes it to the Master of the Castello Nativity; and (verbally, 1944) repeats this attribution // G. Pudelko, *Art Bull.*, XVI (1934), p. 259, note 41, attributes it to a follower of Paolo Uccello whom he calls the Master of the Karlsruhe Adoration; *Mitt. des Ksthist. Inst. in Florenz*, IV (1934), pp. 176, note 1, 199; *Pantheon*, XV (1935), p. 95; and in Thieme-Becker, XXXIII (1939), p. 525, lists it among the works attributed to Paolo Uccello // J. Lipman, *Art Bull.*, XVIII (1936), pp. 72, 76, 79, 96, 98, 101, fig. 21, opp. p. 75, attributes it to the Master of the Castello Nativity and dates it between 1450 and 1475; *Art in Amer.*, XXIV (1936), pp. 110 ff.,

fig. 5, attributes it, along with the Lehman and Gardner profiles, to the Master of the Castello Nativity and dates the group in the middle period of his activity, around 1465 // M. Salmi, *Paolo Uccello, Andrea del Castagno, Domenico Veneziano* (1938), pp. 22 f., 107, pl. XXIX, attributes it to Paolo Uccello and dates it about 1440, observing that some elements suggest Domenico Veneziano; *Liburni Civitas*, XI (1938), pp. 250 f., fig. 30, rejects the attribution to the Master of the Castello Nativity and reaffirms his ascription to Uccello // R. W. Kennedy, *Alesso Baldovinetti* (1938), p. 131, and note 280, attributes it to the Master of the Castello Nativity; *Art Bull.*, XXI (1939), p. 298, rejects the attribution to Uccello, observing that the treatment is too summary and casual to be the product even of the workshops of Uccello or Domenico Veneziano // W. R. Valentiner, *Art Quarterly*, I (1938), pp. 283 ff., fig. 12, attributes it to the Master of the Castello Nativity, whom he tentatively identifies with Andrea dell' Aquila, dates it about 1465, and suggests that the sitter is Elisabetta da Montefeltro, basing the identification on a limestone bust of her in the Berlin Museum //

W. Cohn-Goerke, *Burl. Mag.*, LXXV (1939), p. 216, questions the attribution to Paolo Uccello // W. Arslan, *Zeitschr. für Kstgesch.*, VIII (1939), p. 315, accepts the attribution to Paolo Uccello, suggesting a date after 1440; in a letter (1952) reaffirms the attribution to Uccello, after 1440 // W. Boeck, *Paolo Uccello* (1939), p. 121, lists it among the paintings attributed to Paolo Uccello // *Duveen Pictures* (1941), no. 43, ill. as by Domenico Veneziano, painted about 1450 // M. Pittaluga, *Paolo Uccello* (1946), p. 14, pl. 14b, attributes it to Paolo Uccello // J. Pope-Hennessy, *Paolo Uccello* (1950), p. 150, fig. 12, rejects the attribution to Uccello, ascribing it to the Master of the Castello Nativity; *The Portrait in the Renaissance* (1966), pp. 41, 308, note 62, believes that it was not painted from life // E. Carli, *Tutta la pittura di Paolo Uccello* (1954), pp. 30 f., 55 f., pl. 23, attributes it to Paolo Uccello, dating it immediately after 1436.

EXHIBITED: Royal Academy, London, 1902, *Old Masters*, no. 45 (as Umbrian, lent by Capt. G. L. Holford); Burlington Fine Arts Club, London, 1909, *Umbrian Exhibition*, no. 5 (as Umbro-Florentine, 1460–1470, lent by G. L. Holford); Burlington Fine Arts Club, London, 1921–1922, *Pictures . . . from the Collection of Mr. Robert Holford*, no. 12 (as Florentine, about 1450, lent by Sir George Holford); Art Institute of Chicago, Chicago, 1934, *A Century of Progress, Exhibition of Paintings and Sculpture*, no. 58 (as Paolo Uccello, lent by Jules S. Bache); New York, World's Fair, 1939, *Masterpieces of Art*, no. 390 (as Paolo Uccello, lent by Jules S. Bache); Wildenstein, New York, 1943, *Fashion in Headdress, 1450–1943*, no. 2 (as Domenico Veneziano, lent by Jules S. Bache); Metropolitan Museum, New York, 1943, *The Bache Collection*, no. 6 (as Domenico Veneziano, lent by Jules S. Bache); Palazzo Strozzi, Florence, 1954, *Mostra di quattro maestri del primo rinascimento*, p. 47, no. 17 (as attributed to Paolo Uccello).

EX COLL.: Robert S. Holford, Westonbirt, Glos. (until 1892); Sir George Lindsay Holford, Westonbirt (1892–1926; Cat., 1924, no. 14, pl. xxii, as Florentine, about 1450; sale, Christie's, London, July 15, 1927, no. 121, as Umbro-Florentine); [R. Langton Douglas, London, 1927]; [Duveen Brothers, London and New York, 1927–1928]; Jules S. Bache, New York (1928–1944; Cat., 1929, no. 6).

THE JULES S. BACHE COLLECTION, 1949.

The Master of San Miniato

The Master of San Miniato is the name given by Bernard Berenson to the unknown Florentine artist who painted an altarpiece in the church of San Domenico in San Miniato al Tedesco, a small town between Florence and Pisa. The style of this painter, who seems to have been active during the 1460's and the two following decades, is heavily dependent upon that of the late work of Fra Filippo Lippi and that of Pesellino, but it also shows the successive influences of Benozzo Gozzoli, the young Botticelli, and possibly Domenico Ghirlandaio. The Master of San Miniato was a prolific painter, but a number of pictures still attributed to him are really by inferior Florentine contemporaries, such as the Madonna and Child with two Angels, a fresco in a tabernacle on the Via Romana in Florence.

The Madonna and Child 41.100.6

This painting, apparently a fragment of a larger composition, is surely one of the earliest surviving works by the Master of San Miniato. It is very close in style to some other early panels by him, such as a Madonna and Child published by Berenson (*Dedalo*, XII, 1932, ill. p. 822), a Madonna and Child enthroned formerly in the Ricasoli collection in Florence, a Madonna adoring the Child in the Louvre (no. 1694), and a

Madonna adoring the Child with an angel in a rocky landscape in the Acton collection in Florence. Our painting, probably the earliest of this group, shows the Master of San Miniato at his best, before he developed the stylistic formula used in his more mature period. He probably made this painting immediately after one by Fra Filippo Lippi, usually dated about the middle of the 1460's, a Madonna and Child in the Alte Pinakotek in Munich (no. 647), from which our composition, though varied and reversed, is derived.

Once called by the Museum a work by a follower of Fra Filippo Lippi and subsequently attributed to the Master of the Castello Nativity.

Tempera on wood. H. 17¾, w. 14¼ in. (45.1 × 36.2 cm.); with added strips, h. 19¾, w. 15 in. (50.2 × 38.1 cm.).

REFERENCES: U. Thieme, in W. Bode, *Cat. of O. Hainauer Coll.* (1897), p. 76, pl. 81, calls this painting a work close to Fra Filippo Lippi // B. Berenson, *Flor. Ptrs.* (1909), p. 169, lists it as a work by Pier Francesco Fiorentino; and *Ital. Pictures* (1932), p. 104, lists it as an early work by Botticelli // L. Venturi, *L'Arte*, XXXV (1932), p. 408, ill. p. 411, and *Ital. Ptgs. in Amer.* (1933), pl. 213, rejects the attribution to Botticelli and calls it a work by Fra Filippo Lippi // V. Daddi Giovannozzi, *Riv. d'arte*, XVI (1934), p. 342, calls it a fragment of an altarpiece from the school of Filippo Lippi, says it is derived from Lippi's Madonna in the Uffizi, notes its similarities to a panel representing the Madonna and Child with two saints in the Weisbach collection in Berlin, and excludes the possibility of an attribution to Giovanni di Francesco in his early period // G. Pudelko, *Riv. d'arte*, XVIII (1936), p. 51, note 4, notes that the composition is derived from Filippo Lippi's Madonna in Munich, rejects the attribution to Lippi, and calls it the work of a pupil, possibly the one who did the Madonna adoring the Child in a rocky landscape in the Acton collection in Florence // C. L. Ragghianti, *La Critica d'arte*, III (1938), p. xxv, fig. 6 (reprinted in *Miscellanea minore di critica d'arte*, 1946, p. 75, fig. 4), rejects the attribution to Fra Filippo Lippi and calls it a work by

Giovanni di Francesco, close to the predella in the Casa Buonarroti in Florence // M. Pittaluga, *L'Arte* XLIV (1941), p. 35, note 2, accepts very hesitantly the attribution to Giovanni di Francesco; and *Filippo Lippi* (1949), p. 222, fig. 206, calls it a fragment from a larger panel, says its composition is possibly derived from that of Lippi's Madonna and Child with Angels in the Uffizi (no. 1598), lists it among the works wrongly attributed to Lippi, and notes that an attribution to Giovanni di Francesco, though reasonable, seems to be excluded by chronology, since he died in 1459, some time before Lippi painted the Uffizi Madonna (about 1465) // R. Salvini, *Tutta la pittura del Botticelli* (1958), I, p. 72, rejects the attribution to Botticelli and to Giovanni di Francesco and observes that the composition is derived from Lippi's Madonna and Child in Munich.

EXHIBITED: Kleinberger Galleries, New York, 1917, *Italian Primitives*, no. 22 (as by a Follower of Fra Filippo Lippi, lent by George and Florence Blumenthal).

EX COLL.: Charles Butler, London (before 1894); Oscar Hainauer, Berlin (until 1894); Frau Julie Hainauer, Berlin (1894–1906); [Duveen Brothers, London, 1906]; George and Florence Blumenthal, New York (about 1906; until 1941; Cat., I, 1926, pl. XI).

GIFT OF GEORGE BLUMENTHAL, 1941.

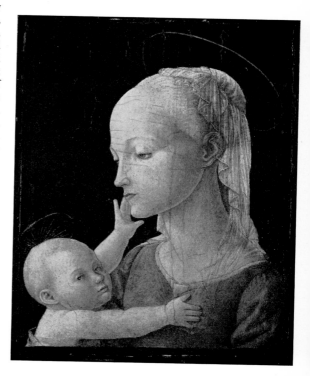

41.100.6

Benozzo Gozzoli

Real name Benozzo di Lese di Sandro. Born about 1420; died 1497. Gozzoli worked at first as a sculptor with Ghiberti on the second pair of doors for the Baptistry in Florence. He later assisted Fra Angelico in Saint Peter's in Rome (1447), in the cathedral of Orvieto (1447), and in the chapel of Pope Nicholas V in the Vatican (1449). During his busy life Gozzoli painted altarpieces and frescoes in many Italian towns—Montefalco, San Gimignano, and especially Pisa; his best-known works are the frescoes in the chapel of the Palazzo Medici-Riccardi in Florence (1459) showing the procession of the Magi, impersonated by the Medici family, progressing in gay cavalcade through a diversified landscape. Gozzoli's style closely follows Fra Angelico's, but it also reflects the styles of Domenico Veneziano, Filippo Lippi, and Pesellino. Although he popularized what he took from these great sources, his paintings have charm. He had a gift for clear and direct narration and shared the late Gothic love of minute detail, ornamental accessory, and fanciful interpretation of nature.

Saint Peter and Simon Magus 15.106.1

This picture and the three following were originally part of the predella of an altarpiece painted for the Alessandri family for their altar in the "Cappellone," or large chapel, in the church of San Pier Maggiore in Florence. A fifth panel, whose subject must have been an episode from the life of Christ or the Virgin, is now lost. Vasari described our four paintings when they were on the altar of the Alessandri family, but he mistakenly called them the work of Pesello and did not mention the main scenes in the altarpiece, which has been identified as the five-part polyptych signed "Lippus" now belonging to the Alessandri family in Florence. It is the work of Lippo di Benivieni, a Florentine painter of the first half of the fourteenth century, and our predella pictures by Gozzoli were added to it some time later. The main panels show in half length the Madonna and Child in the center and Saint Zenobius, Saint Peter, Saint Paul, and Saint Benedict at the sides. Since our predella scenes correspond to the side panels in width and represent episodes from the lives of the same saints, it seems certain that they were once together on the Alessandri altar. Three of the saints were connected with the church: Saint Zenobius, Bishop of Florence, preached at San Pier Maggiore, which was a church of the order of Saint Benedict. When the church was demolished in 1784 both the polyptych and the predella were taken to the Palazzo Alessandri, but it was not recognized until recently that they belonged together (see Offner, 1956, in Refs.).

This panel and Saint Zenobius Resuscitating a Dead Child are very similar in composition to panels in Buckingham Palace, London, and the Berlin Museum (no. 60c), which were part of the predella to an altarpiece by Gozzoli (National Gallery, London, no. 283) commissioned in 1461. Our panels,

15.106.1

however, seem to be somewhat earlier, possibly from the first half of the 1450's. In this picture Simon Magus, a magician who boasted that he could fly, is represented twice, at the top supported by devils and in the foreground lying crushed, his boast having proved vain. Nero is seated at the right, accompanied by his guard, and at the left Saint Paul is seen praying while Saint Peter calls to the evil spirits to let Simon Magus fall to earth.

Tempera on wood. H. 15¾, w. 18 in. (40 × 45.7 cm.).

REFERENCES: G. Vasari, *Vite* (1568), Milanesi ed., III (1878), p. 37, ascribes these panels to Pesello, and Milanesi notes that they were removed to the Palazzo Alessandri // F. Bocchi, *Le Bellezze della città di Fiorenza, ampliato da G. Cinelli* (1677), p. 357, records a painting by Pesello in the Alessandri chapel in San Pier Maggiore // G. Richa, *Notizie istoriche delle chiese fiorentine*, I (1754), p. 142, mentions them as works by Pesello Peselli in the Alessandri chapel of San Pier Maggiore // V. Follini and M. Rastrelli, *Firenze antica e moderna illustrata*, V (1794), p. 92, mentions them as works by Pesello formerly on the Alessandri altar in the Cappellone of San Pier Maggiore // Crowe and Cavalcaselle, *Ptg. in Italy*, II (1864), p. 365, note their resemblance to the work of Gozzoli // I. Lermolieff [G. Morelli], *Kstkrit. Stud.-Rom* (1890), pp. 335 f., attributes them to Pesellino // J. P. Richter, *Repert. für Kstwiss.*, XVII (1894), p. 240, rejects the attribution to Pesellino and calls them early works by Benozzo Gozzoli // C. J. Ffoulkes, *Arch. stor. dell'arte*, VII (1894), p. 158, agrees with the attribution to Gozzoli // B. Berenson, *Flor.*

Ptrs. (1896), p. 103, lists them as early works by Gozzoli; *Revue archéologique*, XL (1902), pp. 194 f., rejects the attribution to Pesellino and calls them early works by Gozzoli; *Flor. Ptrs.* (1909), p. 114; *Ital. Pictures* (1932), p. 264, lists them as early works by Gozzoli; *Drawings of the Florentine Painters* (1938), I, p. 87, note 4; and *Flor. School* (1963), p. 95 // H. Mackowsky, *Zeitschr. für bild. Kst.*, X (1898–1899), p. 83, identifies them with the pictures mentioned by Vasari and Richa but calls them copies after lost originals by Pesellino // W. Weisbach, *Francesco Pesellino und die Romantik der Renaissance* (1901), pp. 48 f., pl. VII, agrees with the attribution to Gozzoli, dates the panels about 1456, and considers Saint Zenobius Resuscitating a Dead Child a free replica of a panel now in Berlin, which he attributes to Pesellino // C. Ricci, *Riv. d'arte*, II (1904), pp. 3, 5, attributes the panels to Gozzoli // H. Horne, *Burl. Mag.*, VII (1905), p. 378, attributes them to Gozzoli and notes the close similarity of the Simon Magus panel to the Buckingham Palace one; (unpublished opinion, n.d.) attributes them to Gozzoli and dates them about 1462 // G. Gronau, in Thieme-Becker, III (1909), p. 344, lists them as works by Gozzoli // R. Langton Douglas, ed., in Crowe and Cavalcaselle, *Ptg. in Italy*, IV (1911), p. 194, note, attributes them to Gozzoli but notes the influence of Pesellino // B. B[urroughs], *Met. Mus. Bull.*, X (1915), pp. 224 ff., ill., dates them about 1461 // R. van Marle, *Ital. Schools*, XI (1929), pp. 172 ff., fig. 113, considers them predella panels by Gozzoli, dates them 1459–1463, and notes the similarity in composition of Saint Peter and Simon Magus and Saint Zenobius Resuscitating a Dead Child to two of the panels that formed the predella of the altarpiece in London // G. J. Hoogewerff, *Benozzo Gozzoli* (1930), p. 92, catalogues them as predella panels by Gozzoli // L. Venturi, *Ital. Ptgs. in Amer.* (1933), pls. 218, 219, considers Saint Peter and Simon Magus and Saint Zenobius Resuscitating a Dead Child free replicas by Gozzoli of the two panels from the predella of the altarpiece in London and dates them after 1461 // A. H. Mayor, *Met. Mus. Bull.*, n.s., VIII (1950), p. 265, ill. (detail) // M. Davies, *The Earlier Italian Schools* (*National Gallery Catalogues*) (1951), p. 59, note 13, attributes them to Gozzoli and notes their compositional connection with the predella panels from the altarpiece in London // W. and E. Paatz, *Die Kirchen von Florenz*, IV (1952), pp. 640, 655, note 63, calls them works by Gozzoli, from the Alessandri altar in the Cappellone in San Pier Maggiore, dating them about 1461 // H. van Dam van Isselt, *Boll. d'arte*, XXXVII (1952), p. 318, notes the iconographic similarity between the Conversion of Saint Paul and the fresco with the same subject painted by

Michelangelo in the Cappella Paolina in the Vatican // R. Offner, *Corpus*, sect. III, vol. VI (1956), p. 44, note 9, identifies the panels as the predella of the polyptych by "Lippus Benevieni" from the Alessandri altar in the Cappellone in the church of San Pier Maggiore in Florence, now in the possession of the Alessandri family, observing the correspondence of subject and size, attributes them to Gozzoli, and recalls that a similar instance of a predella painted several generations later than the main panels occurs in a triptych of the school of Daddi in the Berlin Museum, in which the predella panels are by Bicci di Lorenzo // C. de Tolnay, *Michelangelo*, V (1960), p. 71, fig. 295, discusses the iconography of the Conversion of Saint Paul, relating it to Florentine engravings of about 1460–1470, and attributes our panels to Gozzoli.

PROVENANCE: the Alessandri altar in the Cappellone, church of San Pier Maggiore, Florence (demolished 1784).

EX COLL.: the Alessandri family, Palazzo Alessandri, Borgo degli Albizzi, Florence (from 1784); Count Cosimo degli Alessandri, Palazzo Alessandri, Florence (until 1915); [Luigi Grassi, Florence, 1915].

PURCHASE, ROGERS FUND, 1915.

The Conversion of Saint Paul 15.106.2

The subject of this scene is drawn from the Acts of the Apostles, 22:6–10. See also comment above under Saint Peter and Simon Magus.

Tempera on wood. H. 15⅝, w. 18 in. (39.7 × 45.7 cm.).

REFERENCES: M. G. Ciardi Dupré Dal Poggetto, *Antichità viva*, VI (1967), no. 6, p. 67, fig. 5 (in color), ascribes this panel to Benozzo Gozzoli, observing in it the influence of Fra Angelico and Domenico Veneziano; finds in the composition and in the relation of figures to landscape enough similarity to Ghiberti's bronze relief of the Stories of David on the Paradise door of the Baptistry in Florence to suggest that Gozzoli assisted Ghiberti in the work. See also above under Saint Peter and Simon Magus.

PROVENANCE: the Alessandri altar in the

15.106.2

Cappellone, church of San Pier Maggiore, Florence (demolished 1784).

EX COLL.: the Alessandri family, Palazzo Alessandri, Borgo degli Albizzi, Florence (from 1784); Count Cosimo degli Alessandri, Palazzo Alessandri, Florence (until 1915); [Luigi Grassi, Florence, 1915].

PURCHASE, ROGERS FUND, 1915.

Saint Zenobius Resuscitating a Dead Child 15.106.3

In this panel Saint Zenobius is shown reviving a child who died while in his care. The mother, a noble French lady, had confided him to Saint Zenobius in Florence while she visited Rome. On her return she found the child dead and carried him to San Pier Maggiore, where Saint Zenobius was preaching, and the saint miraculously brought the child to life again. The composition of the scene is similar to that of the predella panel of the same subject painted slightly before 1450 by Domenico Veneziano for the altarpiece of Santa Lucia dei Magnoli, now in the Fitzwilliam Museum in Cambridge. See also comment above under Saint Peter and Simon Magus.

Tempera on wood. H. 15½, w. 18 in. (39.3 × 45.7 cm.).

REFERENCES: J. W. Goodison, *Italian Schools* (vol. II, 1967, of *Cat. of Ptgs.*, Fitzwilliam Museum,

Cambridge), p. 49, calls this painting a modified repetition of a predella panel in Berlin by Benozzo Gozzoli representing the same subject. See also above under Saint Peter and Simon Magus.

PROVENANCE: the Alessandri altar in the Cappellone, church of San Pier Maggiore, Florence (demolished 1784).

EX COLL.: the Alessandri family, Palazzo Alessandri, Borgo degli Albizzi, Florence (from 1784); Count Cosimo degli Alessandri, Palazzo Alessandri, Florence (until 1915); [Luigi Grassi, Florence, 1915].

PURCHASE, ROGERS FUND, 1915.

Totila before Saint Benedict 15.106.4

In this panel Totila, king of the Goths, is shown asking the blessing of Saint Benedict.

See also comment above under Saint Peter and Simon Magus.

Tempera on wood. H. 15½, w. 18 in. (39.3 × 45.7 cm.).

REFERENCES: See above under Saint Peter and Simon Magus.

PROVENANCE: the Alessandri altar in the Cappellone, church of San Pier Maggiore, Florence (demolished 1784).

EX COLL.: the Alessandri family, Palazzo Alessandri, Borgo degli Albizzi, Florence (from 1784); Count Cosimo degli Alessandri, Palazzo Alessandri, Florence (until 1915); [Luigi Grassi, Florence, 1915].

PURCHASE, ROGERS FUND, 1915.

15.106.3

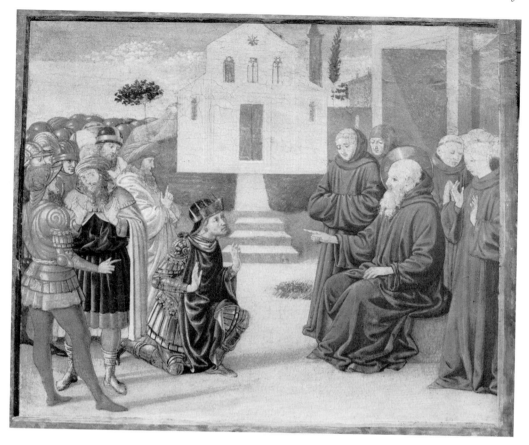

15.106.4

Piero del Pollaiuolo

Real name Piero di Jacopo Benci. Born about 1441; died not later than 1496. It is very probable that Piero studied with Alessio Baldovinetti, whose influence, like that of Piero's older brother Antonio, may sometimes be traced in his work. Both Antonio and Piero were sculptors as well as painters and probably collaborated. In any case, it is difficult to define their separate styles of painting, because, though Piero left several documented pictures, there are none by Antonio, who was known mostly for his goldsmith's work and his bronzes. Comparing Piero's work with the paintings reasonably ascribed to Antonio, and with his sculpture, it would appear that Piero was less imaginative and original than his brother, whom he often assisted and from whose powerful works he borrowed various pictorial elements.

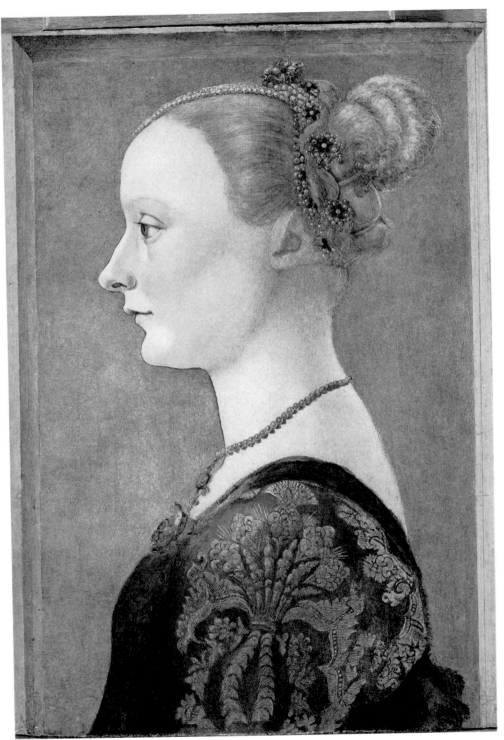

Portrait of a Young Lady 50.135.3

The attribution of this picture to Piero del Pollaiuolo is based on its similarity in style to three other profile portraits now generally ascribed to him. They are in the Poldi-Pezzoli Museum in Milan (no. 157), the Berlin Museum (no. 1614), and the Uffizi in Florence (no. 1491). The Uffizi portrait and ours are strikingly similar, both in style and in the way the hair is dressed, suggesting that the two pictures were painted at the same time, possibly around 1470. The woman represented here bears some resemblance to Marietta Strozzi, daughter of Lorenzo di Palla Strozzi, born in 1448, as she appears in a marble bust formerly in the Berlin Museum (no. 243), which is thought to be the one made by Desiderio da Settignano. Recent cleaning of this picture has revealed the original blue tempera background, which was covered over, possibly during the seventeenth century, with oil paint. The cleaning also shows that although the face and hair are fairly intact, very little remains of the original paint of the dress, and what is seen today is largely a reconstruction. The window frame is also carefully reconstructed on the basis of the remaining traces of the original.

Tempera on wood. H. 19¼, w. 13⅞ in (48.9 × 35.2 cm.).

REFERENCES: G. Gronau (verbally, 1927) attributes this painting to the artist who did the profile portraits in the Berlin Museum and the Poldi-Pezzoli Museum in Milan // L. Venturi (unpublished opinion, 1938) attributes it to either Antonio or Piero del Pollaiuolo // W. Suida (verbally, n.d.) attributes it to one of the Pollaiuolo brothers // A. Morassi (verbally, n.d.) attributes it to the same hand as the Poldi-Pezzoli profile portrait // A. Sabatini, *Antonio e Piero del Pollaiuolo* (1944), p. 78, calls it apparently a XIX century copy after the Poldi-Pezzoli portrait // *Met. Mus. Bull.*, n.s., X (1951), p. 61, ill. // *Art Treasures of the Metropolitan* (1952), p. 224, pl. 78 (in color) // T. Rousseau, *Met. Mus. Bull.*, n.s., XII (1954), p. 13, ill. // B. Berenson, *Flor. School* (1963), p. 179, attributes it to Piero del Pollaiuolo.

EXHIBITED: British Institution, London, 1863, *Loan Exhibition*, no. 52 (as an Italian Lady by Fra Filippo Lippi, lent by Lord Elcho); Royal Academy, London, 1886, *Old Masters*, no. 172 (as Portrait of a Lady, Italian School, lent by the Earl of Wemyss); Knoedler and Co., New York, 1940, *Exhibition of Renaissance Portraits*, no. 4 (lent anonymously); Metropolitan Museum, New York, 1951, *Harkness Exhibition*; Metropolitan Museum, New York, 1952–1953, *Art Treasures of the Metropolitan*, no. 78.

EX COLL.: Lord Elcho, later Earl of Wemyss and March, Gosford House, Longniddry, Haddingtonshire (by 1863; until 1914); Earl of Wemyss and March, Gosford House (1914–1938); [M. Knoedler and Co., New York, 1939]; Edward S. Harkness, New York (1939–1940).

BEQUEST OF EDWARD S. HARKNESS, 1940.

Francesco Botticini

Real name Francesco di Giovanni. Born about 1446; died 1497. In 1459 Botticini was an apprentice in the workshop of Neri di Bicci, with whom he studied less than a year. Our knowledge of his style is based upon the painted wings of a tabernacle now in the Museo della Collegiata at Empoli, which he was commissioned to paint in 1484. It was almost completed in 1491, but some further work on it was done after his death by his son Raffaello.

A fairly large group of works is now attributed to Botticini. Some of them had been previously grouped together by Bode under the name of the Master of the Rossi altarpiece, from a panel of 1475 now in the Berlin Museum. His paintings, executed with a solid and careful technique and a draughtsmanship that owes much to Andrea del Castagno, often show elements borrowed from others of his foremost contemporaries, such as the Pollaiuolo brothers, Verrocchio, and Botticelli.

The Madonna and Child Enthroned with Saints and Angels 61.235

This imposing altarpiece is among the best examples of Botticini's advanced period and clearly shows the rich and varied influences that formed him. The saints, from left to right, Benedict, Francis, Sylvester, and Anthony Abbot, recall the late works of Castagno. The marble throne, ornamented with polychrome encrustations and arched at the top over a coffered vault, is an adaptation of the thrones in the allegories of the Virtues painted about 1470 by the Pollaiuolos and Botticelli. The two angels holding the curtains were taken from Botticelli's so-called Barnaba altarpiece of 1483, now in the Uffizi in Florence (no. 8361), and Botticini's adoption of this motive, like the general style of the painting, suggests a date about the middle of the 1480's.

It has been traditionally assumed that this altarpiece was once in the church of the Santissima Annunziata in Florence, the Church of the order of the Servi, and was taken from there during the early nineteenth century to the Collegiata of Fucecchio, Tuscany, but this is not supported by any documentary evidence.

Inscribed (on border of the Virgin's robe, beginning at the upper left): AVE/MARIA/ GRAZIA PR[L]ENA DOM[INVS TECVM: BE]NED[IC]T[A TV] IN MVLIERIBVS / E[T] BENEDI[C]TVS / FRV[C]TVS [VEN- TRIS TVI]. ("Hail, Mary, full of grace, the Lord is with thee, blessed art thou among women, and blessed is the fruit of thy womb").

Tempera on wood. H. 110½, w. 69 in. (280.7×165.3 cm.); with added strips, h. 111½, w. 70 in. (283.3×177.8 cm.).

REFERENCES: Collection Toscanelli, Album contenant la reproduction des tableaux . . . [1883], pl. XVII b, attributes this painting to Domenico Ghirlandaio // W. Bode, Jahrb. der Preuss. Kstsamml., VII (1886), p. 235, attributes it to the Master of the Rossi altar-piece // R. van Marle, Ital. Schools, XIII (1931), p. 416, note 1, lists it among the works of Francesco Botticini // R. Offner (unpublished opinion, n.d.) attributes it to Botticini // G. M. Richter (in a letter, 1940) attributes it to Botticini and notes its connection with Botticelli's San Barnaba altarpiece of 1483 now in the Uffizi in Florence // B. Beren-son, Flor. School (1963), p. 41, pl. 1059, lists it among the works of Botticini and dates it about 1470–1475 // E. Fahy, Burl. Mag., CIX (1967), p. 137, note 36, calls it an authentic work by Fran-cesco Botticini // H. Friedmann, Met. Mus. Bull., n.s., XXVIII (1969), pp. 1 ff., ill., including details (cover detail in color), accepts the attribution to Botticini and discusses the iconography.

EXHIBITED: Westmoreland County Museum of Art, Greensburg, Pennsylvania, 1959, Christmas Exhibition, Madonna and Saints, from the George R. Hann Collection, no. 5.

EX COLL.: Cav. Giuseppe Toscanelli, Pisa (sale, Sambon's, Florence, April 9–23, 1883, no. 77, as Domenico Ghirlandaio); [Riblet, Florence, 1883– about 1886]; [private collection, London]; Carl W. Hamilton, New York (until 1938); George R. Hann, Sewickley, Pennsylvania (1938–1961).

GIFT OF GEORGE R. HANN, 1961, IN MEMORY OF HIS MOTHER, ANNIE SYKES HANN.

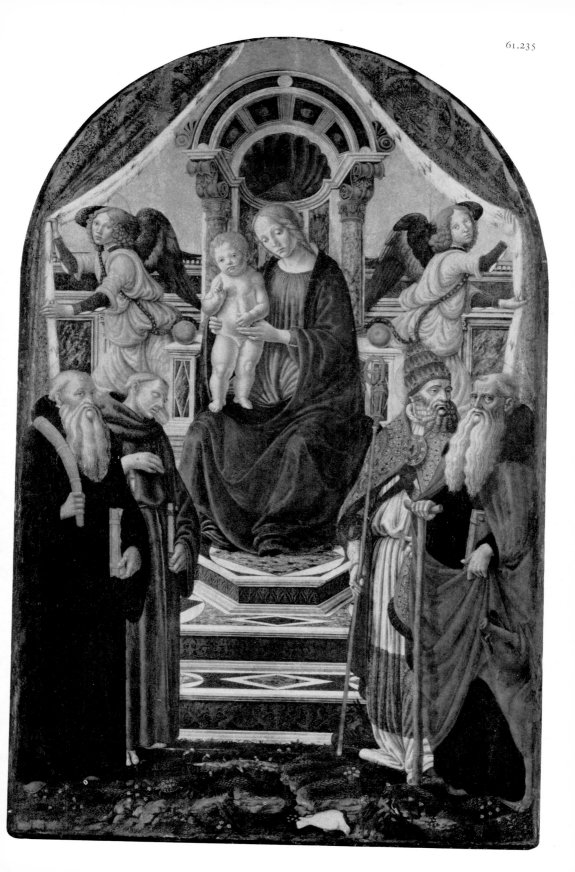

Domenico Ghirlandaio

Real name Domenico di Tommaso Curradi di Doffo Bigordi; also called, in the Florentine form, Grillandaio. Born about 1448; died 1494. Domenico Ghirlandaio, who is said to have studied under Alessio Baldovinetti, conducted a large workshop and employed numerous assistants, including his two brothers, Davide and Benedetto, and his brother-in-law, Sebastiano Mainardi. He was an artist much in demand in Florence, where he decorated chapels and painted altarpieces for many of the leading aristocratic families. He also worked several times in Rome, and in 1481 and 1482 he painted frescoes in the Sistine Chapel in the Vatican. There are also works by him in San Gimignano and in Pisa. Ghirlandaio's style is essentially derivative; he reworked in an academic manner the inventions of such artists as Baldovinetti, Verrocchio, and the Pollaiuolos. In the frescoes of the Sassetti chapel in Santa Trinità in Florence (1483–1486) and in those painted for Giovanni Tornabuoni in Santa Maria Novella (1486–1490), also in Florence, Ghirlandaio proved himself an able decorative painter. Essentially mundane, he related religious stories in terms of contemporary life.

Saint Christopher and the Infant Christ 80.3.674

Tradition has it that this fresco of about 1475 was cut from the walls of the chapel of the Michelozzi villa in Florence. It must have decorated a church façade in Florence or in the neighborhood, where such larger-than-life images of Saint Christopher in fresco near the entrances of churches were common. Vasari and other early writers state that Antonio del Pollaiuolo painted an image of Saint Christopher on the façade of San Miniato fra le Torri in Florence. Our fresco, which was long thought to be by Antonio del Pollaiuolo, may have taken its composition from this work, which is now destroyed. Many passages in it reveal the influence of Andrea del Castagno; the saint's left hand recalls that of Farinata degli Uberti in Castagno's portrait of him in the Museo di Sant'Apollonia in Florence.

Formerly attributed by the Museum to a follower of Antonio Pollaiuolo (Cat., 1940).

Inscribed (on the globe held by the Infant Christ): ASIA/AFRIHA/VROPA (Asia, Africa, Europe).

Fresco. Sight size: h. 112, w. 59 in. (284.4 × 149.9 cm.).

REFERENCES: G. Vasari, *Vite* (1568), Milanesi ed., III (1878), p. 293, mentions a Saint Christopher by Antonio del Pollaiuolo on the façade of San Miniato fra le Torri and gives its height as ten braccia (about 6 meters) // *Art Journal*, n.s. XIX (1880), pp. 351 f., attributes the Museum's fresco to Pollaiuolo (sic) and notes that it is said to have been taken from the wall of a chapel that belonged to the Michelozzi family at San Miniato fra le Torri // F. Harck, *Repert. für Kstwiss.*, XI (1888), p. 73, attributes it to Antonio del Pollaiuolo // B. Berenson, *Gaz. des B.-A.*, XV (1896), pp. 199 f., identifies it with the fresco on the façade of San Miniato and attributes the design to Antonio del Pollaiuolo, the execution to Piero; *Flor. Ptrs.* (1896), p. 125, lists it as a work by Piero; *The Drawings of the Florentine Painters* (1903), I, pp. 25 f., considers it a replica of

the San Miniato fresco, attributes the design to Antonio, the execution to Piero; *Ital. Pictures* (1932), p. 225, lists it as an early work by Domenico Ghirlandaio, painted in great part by him; and *Flor. School* (1963), p. 76 // M. Cruttwell, *Antonio Pollaiuolo* (1907), pp. 162 f., pl. xxxv, considers it a replica by Piero of Antonio's fresco on the façade of San Miniato and dates it about 1475 // W. Bode, *Burl. Mag.*, xi (1907), p. 181, attributes it to the Sienese or Umbrian school // W. Rankin, *Rass. d'arte*, viii (1908), cronaca no. 3, p. iv, accepts the attribution to Piero // R. L. Douglas, ed., in Crowe and Cavalcaselle, *Ptg. in Italy*, iv (1911), p. 234, note, calls it an early Umbrian picture, rejecting the attribution to the Pollaiuolo brothers, noting in it details that recall the work of Fiorenzo di Lorenzo // A. Venturi, *Storia*, vii, part i (1911), p. 570, mentions it as identical with Antonio's fresco on the façade of San Miniato // M. H. Bernath, *New York und Boston* (1912), p. 70, fig. 72, attributes it to Piero // R. van Marle, *Ital. Schools*, xi (1929), pp. 392 ff., fig. 241, identifies it with the San Miniato fresco, attributes the design tentatively to Antonio, the execution to Piero, and notes the influence of Verrocchio // F. Schottmüller, in Thieme-Becker, xxvii (1933), p. 215, suggests that it may be an Umbrian copy after the San Miniato fresco // R. Offner (verbally, 1935) attributes it to Domenico Ghirlandaio working under the influence of Castagno // C. L. Ragghianti, *L'Arte*, xxxviii (1935), pp. 360 ff., fig. 24, considers it an early work by Domenico Ghirlandaio (about 1473) // R. Longhi (unpublished opinion, 1937) attributes it to the workshop of Domenico Ghirlandaio and dates it about 1475–1480 // R. W. Kennedy, *Art. Bull.*, xxiv (1942), p. 195, attributes it to Domenico Ghirlandaio, and calls it a youthful adaptation of the famous figure by Antonio del Pollaiuolo on the façade of San Miniato // A. Sabatini, *Antonio e Piero del Pollaiolo* (1944), p. 95, observes the similarities to the work of Antonio Pollaiuolo and rejects the attribution to Domenico Ghirlandaio // S. Ortolani, *Il Pollaiuolo* (1948), p. 159, notes the opinions of various scholars in relating our fresco to the lost original by Antonio del Pollaiuolo on the façade of San Miniato // W. and E. Paatz, *Die Kirchen von Florenz*, iv (1952), pp. 298, 300, note 11, call it a smaller copy after the San Miniato fresco and question whether it is by Piero del Pollaiuolo.

PROVENANCE: possibly the chapel of the Michelozzi Villa, Florence.

EX COLL. Cornelius Vanderbilt, New York (1880).

GIFT OF CORNELIUS VANDERBILT, 1880.

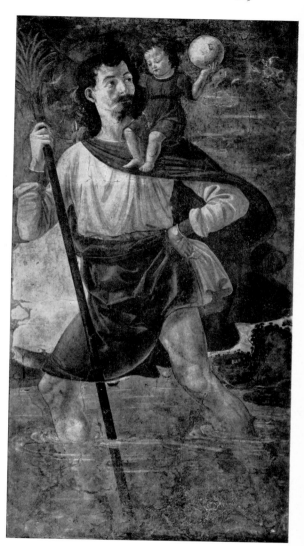

80.3.674

The Marriage of the Virgin (predella panel) 13.119.1

This painting and the two following, the Burial of Saint Zenobius and Tobias and the Angel, are part of the five-panel predella to an altarpiece by Domenico Ghirlandaio which was commissioned by the Gesuati, a

benevolent order established in the four-teenth century by Pope Urban V. It was installed on the high altar of their church on the outskirts of Florence, San Giusto alle Mura, by June 1486, when its frame was used as model for that of another Ghirlandaio altarpiece for the church of the Innocenti (see Refs., Küppers, 1916). In 1529, when the church and monastery were demolished in preparation for the siege of Florence, the altarpiece was moved and in 1531 was placed in San Giovannino, the new church given to the order, near the Porta Romana, which came to be called San Giusto "della Calza." The main panel, a Madonna enthroned with the archangel Michael, Saint Justus, Saint Zenobius, and the archangel Raphael, is now in the Uffizi in Florence (no. 881). The five predella panels were placed beneath the related figures in the main panel. Our Marriage of the Virgin must have been in the center, directly under the Madonna and Child, and next to it, on the right, the Burial of Saint Zenobius, with Tobias and the Angel at the right end. On the left were the other two predella panels, the Battle of Archangels and Devils (or the Fall of the Rebel Angels) now in the Detroit Institute of Arts (no. 25.205), and Saint Justus Distributing Bread to the Sol-diers in the National Gallery in London (no. 2902). The style of the main panel and the predella suggests a date between 1480 and 1485.

In judging predella panels from Ghir-landaio's workshop it is always difficult to distinguish his work from that of his assist-ants. Gronau and Berenson (see Refs., 1926, 1932) believed that only the panel in Detroit was painted by Ghirlandaio himself. The London panel has been unconvincingly ascribed by Francovich to Bartolomeo di Giovanni (*Boll. d'arte*, xx, 1926–1927, p. 82).

It is possible that in all five panels the master had assistance.

Once attributed by the Museum to Fran-cesco Botticini.

Tempera on wood. H. $6\frac{1}{4}$, w. $16\frac{1}{4}$ in. (15.9 × 41.3 cm.).

REFERENCES: G. Vasari, *Vite* (1568), Milanesi ed., III (1878), pp. 257, 570, describes the altarpiece painted by Domenico Ghirlandaio for the Gesuati and notes that it had been removed to the church of San Giovannino // F. Bocchi, *Le Bellezze della città di Fiorenza* (1591), p. 63, mentions the altarpiece as in the church of San Giovanni and attributes it to Domenico Ghirlandaio; *Le Bellezze . . ., ampliato da Giovanni Cinelli* (1677), p. 125, mentions the altarpiece as on the high altar of the church of San Giusto della Calza and attributes it to Ghirlandaio // G. Richa, *Notizie istoriche delle chiese fiorentine*, IX (1761), p. 103, mentions the altarpiece and its predella as in the church of San Giusto della Calza and attributes it to Ghirlandaio // C. F. von Rumohr, *Italienische Forschungen*, II (1827), pp. 285, 287, and in a letter of 1828 (published by F. Stock, *Jahrb. der Preuss. Kstsamml.*, XLVI, 1925, Beiheft, p. 7) mentions the predella, at that time owned by Metzger in Florence, and attributes it to Sebastiano Mainardi // B. B[urroughs], *Met. Mus. Bull.*, VIII (1913), p. 214, ill., attributes our panels to Botticini// O. Sirén, *Cat. of Jarves Coll.* (1916), p. 122, notes that the three scenes are similar in style to a panel of Saint Jerome and Saint Francis in the Jarves collec-tion at Yale University, New Haven, and attributes them all to Botticini // P. E. Küppers, *Die Tafel-bilder des Domenico Ghirlandaio* (1916), pp. 87 f., Doc. II // G. Gronau, *Apollo*, IV (1926), pp. 72 ff., identifies the London and Detroit panels as part of the predella of Ghirlandaio's altarpiece for San Giusto, attributing them to one of Ghirlandaio's assistants although noting that the Detroit panel might be by the master himself, and deduces the subjects of the other three predella panels; and *Art in Amer.*, XVI (1927), pp. 16 ff., figs. 2, 4–6, connects our panels with those in London and Detroit, iden-tifies them all as once composing the predella to Ghirlandaio's Madonna and Saints now in the Uffizi in Florence, considers them designed by Domenico but executed by his assistants, and illus-trates the reconstruction of the entire altarpiece // R. van Marle, *Ital. Schools*, XIII (1931), pp. 54 f., agrees with Gronau's theory that all five panels belonged to the predella of the Uffizi Madonna and Saints and calls them products of Ghirlandaio's

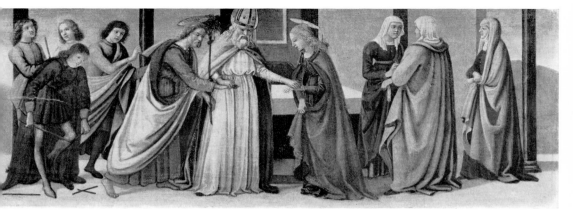

13.119.1

13.119.2

13.119.3

workshop // B. Berenson, *Ital. Pictures* (1932), p. 225, lists our three panels as products of Ghirlandaio's workshop; and *Flor. School* (1963), p. 76 // F. Mason Perkins (in a letter, 1938) considers our panels close in style to Ghirlandaio but not by him // J. Lauts, *Domenico Ghirlandaio* (1943), p. 50, calls them parts of the predella of the Uffizi Madonna and Saints and essentially workshop products // M. Davies, *The Earlier Italian Schools* (*National Gallery Catalogue*) (1951), pp. 169 ff., agrees that all five panels belonged to the predella of the Uffizi Madonna and Saints, gives a detailed account of the history of the altarpiece, and suggests that our panels and their companions were partly or wholly executed by Ghirlandaio's assistants // G. Kaftal, *Icon. of Saints in Tuscan Ptg.* (1952), col. 1041, attributes the Burial of Saint Zenobius to Ghirlandaio's shop // W. and E. Paatz, *Die Kirchen von Florenz*, II (1955), pp. 278, 282 f., attributes the predella panels to Ghirlandaio and his shop.

PROVENANCE: the churches of San Giusto alle Mura (until 1529) and San Giovannino, later called San Giusto della Calza (from 1531 to about 1827), Florence.

EX COLL.: Johann Metzger, Florence (by 1827; until 1828 or later); M. J. Rhodes, England; the Rt. Hon. Henry Labouchere, later Lord Taunton, Taunton, Somerset (until 1869); Mrs. Edward James Stanley, Quantock Lodge, Bridgewater, Somerset (1869–1913); [R. Langton Douglas and H. P. Horne, London, 1913].

PURCHASE, LELAND FUND, 1913.

The Burial of Saint Zenobius (predella panel) 13.119.2

This scene illustrates the legend of how a dead tree sprang to life and was covered with leaves and flowers when it was touched by the bier of Saint Zenobius during the translation of his body to the cathedral of Florence on January 26, 433. The building with encrusted decorations in the center background is the Baptistry of Florence, near which a marble column still marks the place the tree grew. On the left is shown the base of Giotto's campanile. See also com-

ment above, under the Marriage of the Virgin.

Once attributed by the Museum to Francesco Botticini.

Tempera on wood. H. 6¼, w. 16⅜ in. (15.9 × 41.6 cm.).

REFERENCES: See above under the Marriage of the Virgin.

PROVENANCE: the churches of San Giusto alle Mura (until 1529) and San Giovannino, later called San Giusto della Calza (from 1531 to about 1827), Florence.

EX COLL.: Johann Metzger, Florence (by 1827; until 1828 or later); M. J. Rhodes, England; the Rt. Hon. Henry Labouchere, later Lord Taunton, Taunton, Somerset (until 1869); Mrs. Edward James Stanley, Quantock Lodge, Bridgewater, Somerset (1869–1913); [R. Langton Douglas and H. P. Horne, London, 1913].

PURCHASE, LELAND FUND, 1913.

Tobias and the Angel (predella panel) 13.119.3

Tobias is shown taking from the fish the gall which the archangel Raphael told him to use to cure his father's blindness. The town in the background looks very much like Florence. See also comment above under the Marriage of the Virgin.

Once attributed by the Museum to Francesco Botticini.

Tempera on wood. H. 6¼, w. 16¼ in. (15.9 × 41.3 cm.).

REFERENCES: See above under the Marriage of the Virgin.

PROVENANCE: the churches of San Giusto alle Mura (until 1529) and San Giovannino, later called San Giusto della Calza (from 1531 to about 1827), Florence.

Francesco Sassetti and his Son Teodoro(?) 49.7.7

This painting has long been considered a portrait of Francesco Sassetti and his son Teodoro, as stated in the Latin inscription at the top. Recently, however, technical examination of the inscription indicates that it is not of the same period as the painting. The lettering, painted on the inside of the window recess at the top, transforms the embrasure to a flat band, completely nullifying the perspective. It could still, of course, record some old, reliable tradition about the people represented.

Francesco Sassetti was born in Florence in 1421 and died there in 1490. After entering the service of Cosimo de'Medici he was sent as a clerk or employee to the branch of the Medici bank at Avignon, where he soon rose to the rank of junior partner and branch manager. When he returned to Florence, in 1458, he became the close adviser in business affairs of Cosimo's son, Piero the Gouty, then the head of the Medici family, and eventually of Lorenzo the Magnificent. Among his friends were the humanist Angelo Poliziano, the poet Luigi Pulci, and the pamphleteer Matteo Franco. His burial chapel in the church of Santa Trinità was decorated with frescoes and with an altarpiece by Domenico Ghirlandaio, who received the commission in 1483. It is quite likely that Ghirlandaio painted a series of portraits for Francesco Sassetti, representing members of his family, as suggested by the Portrait of a Lady in the Museum (see p. 137), whose features appear again in the frescoes of the Sassetti chapel in the church of Santa Trinità. Francesco Sassetti had two sons named Teodoro; the first was born in 1460 and died in 1479, while the second, born in the year of his brother's death, lived on until 1546. Since the boy represented in the picture is obviously about six years old, it becomes a question whether the painting was executed by Ghirlandaio about 1466, when Francesco was forty-five and his first son six, or whether the man represented could be about sixty-four years old, when the second Teodoro was six, in 1485. Although Francesco Sassetti's general appearance is known to us through a marble bust by Antonio Rossellino in the Bargello and through a representation of him in the Santa Trinità frescoes, the age of the man in our double portrait cannot be judged by the present appearance of his face, which has been extensively repainted and is therefore useless as a means of dating the picture. This must be done on the basis of style. The boy's face and the man's hand, the best preserved parts of the painting, are executed with the fine quality of Domenico Ghirlandio's work around 1485–1489, and the picture accordingly probably represents Francesco Sassetti with his second son Teodoro.

The suggestion that the entire painting is a copy made in Ghirlandaio's workshop after an original by him dating from the 1460's (see Refs., De Roover, 1943) is not defensible and is based for the most part on the assumption that the sitters are Francesco and his first son Teodoro. We know from a photograph made when the picture belonged to the Benson collection in London (Cat., 1914, no. 27, ill. opp. p. 51) that the

man's appearance was slightly different at that time, resembling the image underneath the present surface, which is revealed by X-rays. This change probably came about with a restoration and subsequent repainting that took place about 1927. Figures once to be seen in the background have been lost except for a few traces. The landscape is so stereotyped that it must be assumed that pupils or assistants worked on it.

Inscribed (at top): FRANCISCVS SAXETTVS THEODORVSQUE. F[ILIVS] (Francesco Sassetti and [his] son Teodoro).

Tempera on wood. H. 29½, w. 20½ in. (74.9 × 52.1 cm.).

REFERENCES: The authorities cited below, with the exception of A. Venturi and F. E. de Roover, attribute this painting to Domenico Ghirlandaio. C. J. Ffoulkes, *Arch. stor. dell'arte*, VII (1894), p. 166, calls it an original work though it has been much overpainted // H. Ulmann, *Repert. für Kstwiss.*, XVII (1894), p. 493, considers it a genuine work and a counterpart to the picture of the Old Man and Boy in the Louvre in Paris // E. Steinmann, *Domenico Ghirlandaio* (1897), pp. 34, 80, includes it among the genuine works // E. Schaeffer, *Das Florentiner Bildnis* (1904), pp. 112 f., mentions it and judges it to be earlier than the Louvre Old Man and Boy // H. Hauvette, *Ghirlandaio* (1907), p. 134, calls it a work painted in 1485, compares the landscape with those in the frescoes of the Calling of Peter and Andrew in the Sistine Chapel and Saint Francis and his father in the Sassetti Chapel in the church of Santa Trinità in Florence but doubts whether the man is Francesco Sassetti and suggests that the picture may have been a first study for the Louvre Old Man and Boy // L. Cust, *Les Arts* (1907), October, p. 26, ill. p. 13, compares it with the Louvre picture // A. Warburg, *Kunstwissenschaftliche Beiträge August Schmarsow gewidmet* (1907), p. 146, note 11 (reprinted in *Gesammelte Schriften*, I, 1932, pp. 131 f.), mentions it as a portrait of the younger Teodoro with his father // B. Berenson, *Flor. Ptrs.* (1909), p. 138; *Ital. Pictures* (1932), p. 225; and *Flor. School* (1963), p. 76, lists it // A. Venturi, *Storia*, VII, part I (1911), pp. 769 f., refutes the attribution to Domenico Ghirlandaio, considering it and the Louvre panel workshop pieces // R. L. Douglas, ed., in Crowe and Caval-

caselle, *Ptg. in Italy*, IV (1911), p. 336, note 5, lists it and compares it with the Louvre picture // P. E. Küppers, *Die Tafelbilder des Domenico Ghirlandaio* (1916), p. 44, dates it soon after 1485; and in Thieme-Becker, XIII (1920), p. 558, lists it // W. E. Wortham, *Apollo*, XI (1930), p. 354, fig. 3, identifies the boy with the somewhat younger child in the Louvre painting // A. L. Mayer, *Pantheon*, VI (1930), p. 541 // R. van Marle, *Ital. Schools*, XIII (1931), p. 57, fig. 32, dates it about 1487; and *Boll. d'arte*, XXV (1931–1932), p. 10, identifies the figures as Francesco Sassetti and his son Teodoro // A. M. Frankfurter, *The Antiquarian*, XVII (1931), November, p. 58, ill. p. 25, compares it with the portrait of Matteo Sassettiano by Sebastiano Mainardi in the E. D. Levinson collection in New York and with other portraits from the Ghirlandaio-Mainardi circle // W. Suida, *Apollo*, XIII (1931), p. 40, remarks that opinions have been expressed connecting this painting with a pupil or another painter in the artist's immediate circle // L. Venturi, *Ital. Ptgs. in Amer.* (1933), pl. 268, dates it between 1487 and 1489 // L. Serra, *Boll. d'arte*, XXIX (1935), p. 30, ill. p. 34 // *Duveen Pictures* (1941), no. 113, ill., dates it about 1487–1489, and compares its composition with that of the Louvre Old Man and Boy // J. Lauts, *Domenico Ghirlandaio* (1943), pp. 42, 56, fig. 105, dates it about 1488 and suggests that, if the name of Francesco in the inscription is correct, the picture was executed after an earlier sketch or study // F. E. de Roover, *Bull. of the Business Historical Society*, XVII (1943), p. 77, note 8, and in a letter (1944) identifies the boy as the first Teodoro and dates the picture in the late 1460's; and *The Medici Bank* (1948), pp. 90 f., ill. opp. p. 62, identifies the boy as the first Teodoro and attributes the picture to the workshop of Domenico Ghirlandaio, after an early original by the master // F. M. Godfrey, *Connoisseur*, CXXVIII (1952), pp. 156 f., ill. p. 157, dates it 1488, comparing it with the Louvre picture, and tentatively suggests that Ghirlandaio may have painted it from a drawing made earlier in the life of Francesco Sassetti.

EXHIBITED: Royal Academy, London, 1875, *Old Masters*, no. 188 (lent by W. Graham); Royal Academy, London, 1893, *Old Masters*, no. 149 (lent by R. H. Benson); New Gallery, London, 1893–1894, *Early Italian Art*, no. 105 (lent by R. H. Benson); Grafton Galleries, London, 1909–1910, *National Loan Exhibition*, no. 67 (lent by R. H. Benson); Burlington Fine Arts Club, London, 1919, *Exhibition of Florentine Painting before 1500*, no. 23, (lent by R. H. Benson); City Art Gallery, Manchester, 1927, *Old Italian Masters*, no. 61 (lent by

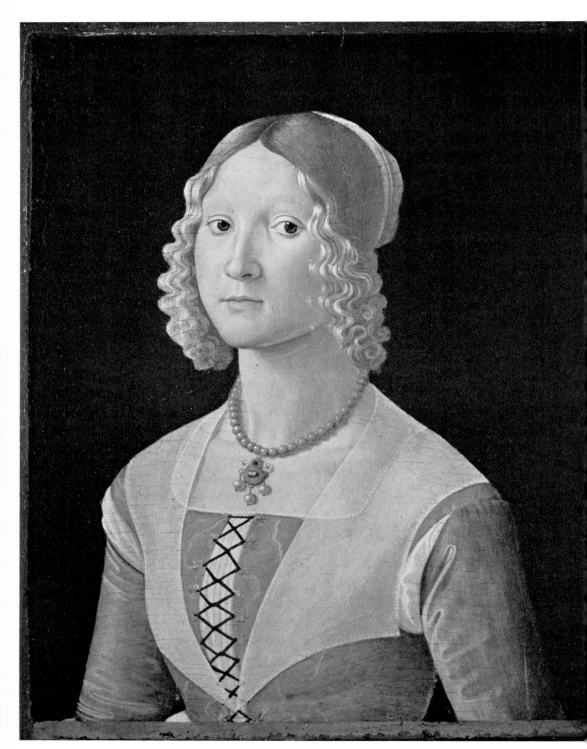

R. H. Benson); Petit Palais, Paris, 1935, *L'Art italien*, no. 184 (lent by Jules S. Bache); World's Fair, New York, 1939, *Masterpieces of Art*, no. 141 (lent by Jules S. Bache); Metropolitan Museum, New York, 1943, *The Bache Collection* (lent by Jules S. Bache); Metropolitan Museum, New York, 1952–1953, *Art Treasures of the Metropolitan*, no. 89.

EX COLL.: William Graham, London (by 1875; sale, Christie's, London, Apr. 8, 1886, no. 263); [Martin Colnaghi, London, 1886]; Robert H. and Evelyn Benson, London (by 1893; until 1927; Cat., 1914, no. 27, pp. 51 f., ill.); [Duveen Brothers, New York, 1927]; Jules S. Bache, New York (1927–1944).

THE JULES S. BACHE COLLECTION, 1949.

Portrait of a Lady 32.100.71

The woman represented in this portrait somewhat resembles a woman (possibly a daughter of Francesco Sassetti) appearing in Domenico Ghirlandaio's fresco (1483–1487) of Saint Francis Raising the Dead Child, in the chapel of the Sassetti family in the church of Santa Trinità in Florence, and may be the same person. The resemblance, however, is not close enough to be accepted without reservations, and, in any case, the sitter in our panel is apparently older. The style is that of Domenico Ghirlandaio during the last years of the 1480's, and it is not too far from that of the head of the boy in his portrait of Francesco Sassetti and his son of about 1485–1489, also in the Museum (see p. 134).

Tempera on wood. H. 22½, w. 17⅜ in. (57.1 × 44.1 cm.).

REFERENCES: The authorities cited below attribute this painting to Domenico Ghirlandaio. B. Berenson (unpublished opinion, 1924); in Cat. of Friedsam Coll. (unpublished, n.d.), p. 69, dates it 1486 at the latest; *Ital. Pictures* (1932), p. 225; and *Flor. School* (1963), p. 76 // R. van Marle, *Ital. Schools*, XIII (1931), pp. 95 f., figs. 59, 60, reproduces a drawing in the British Museum as a sketch for this portrait; and *Boll. d'arte*, XXV (1931), pp. 13 f., fig. 5, dates the portrait at the time of the frescoes in Santa Maria Novella in Florence, 1486–1490 // B. Burroughs and H. B. Wehle, *Met. Mus. Bull.*, XXVII (1932), Nov., sect. II, p. 36, ill. p. 41 // L. Venturi, *Ital. Ptgs. in Amer.* (1933), pl. 266, dates it 1483, at the time of the scenes in the Sassetti chapel // A. Hyatt Mayor, *Met. Mus. Bull.*, n.s., XVI (1957), p. 99, ill.

EX COLL.: Léopold Goldschmidt, Paris; Count André de Pastré, Paris (until 1924); [Kleinberger Galleries, New York, 1924]; Michael Friedsam, New York (1924–1931).

THE MICHAEL FRIEDSAM COLLECTION. BEQUEST OF MICHAEL FRIEDSAM, 1931.

Follower of Domenico Ghirlandaio

Portrait of a Lady 41.190.24

This fresco is painted on a large terra-cotta tile of the sort used in roofing. Considerable areas of the painted surface, especially in the background and the upper part of the body, are disfigured by heavy repainting. In spite of the damaged condition it is possible to reject the traditional attribution to Pinturicchio and to attribute this painting to the workshop of Domenico Ghirlandaio or to an immediate follower. This is suggested both by the character of the less damaged parts, especially the sleeve, as well as by the

41.190.24

though also extensively damaged in the upper part, is closer than ours to Ghirlandaio's style and is apparently derived from the first figure on the left of the large fresco of the Visitation from the cycle which Domenico Ghirlandaio, assisted by pupils, painted in the choir of Santa Maria Novella in Florence between 1486 and 1490. Our painting also vaguely recalls figures in this cycle, but its present condition precludes greater precision. The original purpose of these tiles is not clear. Probably not intended as real portraits, they were perhaps samples of the fresco technique or possibly exercises made by assistants following cartoons in the workshop.

Fresco on terra-cotta tile. H. (at left) $20\frac{3}{4}$ in. (52.7 cm.), (at right) $20\frac{5}{8}$ in. (52.3 cm.); w. (at top) $12\frac{5}{8}$ in. (31.4 cm.), (at bottom) $14\frac{1}{2}$ in. (36.8 cm.).

EX COLL.: Baron Maurice de Rothschild, Paris; George and Florence Blumenthal, Paris and New York (by 1926; until 1941; Cat., I, 1926, pl. XXXVI, as Pinturicchio).

BEQUEST OF GEORGE BLUMENTHAL, 1941.

close relationship to another tile, also a half-length portrait of a lady, in the Jarves collection in the Gallery of Fine Arts of Yale University (no. 1871.52). The Yale painting,

Mainardi

Sebastiano di Bartolo Mainardi. Active by 1493; died 1513. Mainardi was the pupil and assistant of his brother-in-law, Domenico Ghirlandaio, and collaborated with him in many works. A fresco of the Assumption of the Virgin in the church of Santa Croce in Florence was painted by Mainardi on Ghirlandaio's cartoon. The only documented works by Mainardi are some frescoes in the church of Sant'Agostino at San Gimignano that are said to have borne at one time Mainardi's initials and the date 1500, but they do not correspond very well with the paintings ascribed to him. The precise characteristics of Mainardi's style have not been well defined. At present his name is only a convenient label for a number of Ghirlandaio's shop pieces, many of which may have been painted by pupils after his designs or in collaboration with him.

The Madonna and Child with Angels (tondo) 14.40.635

In spite of extensive losses it is clear that this painting belongs to the group of works from Ghirlandaio's shop that are usually attributed to Mainardi. The same Ghirlandaiesque composition appears, with some slight variations, in a much smaller tondo of superior quality in the Cini collection in Venice (formerly in the Palazzo Caregiani; see *L'Arte*, VII, 1904, p. 76, ill.).

Tempera on canvas, transferred from wood. Diam. $38\frac{3}{4}$ in. (98.4 cm.).

REFERENCES: The authorities cited below attribute this painting to Mainardi. F. Monod, *Gaz. des B.-A.*, LXV (1923), p. 183 // G. de Francovich, *Cronache d'arte*, IV (1927), p. 174, fig. .4, dates it about 1490–1491 // R. van Marle, *Ital. Schools*, XIII (1931), p. 222, fig. 152, dates it early in the XVI century and notes the influence of Filippino Lippi // B. Berenson, *Ital. Pictures* (1932), p. 322; and *Flor. School* (1963), p. 127, lists it as a replica of the painting in the Cini collection // M. Hauptmann, *Der Tondo* (1936), p. 202, note 1, considers the Caregiani (now Cini) version a replica.

EX COLL.: Baron Michele Lazzaroni, Paris (1911); [Duveen Brothers, New York, 1911]; Benjamin Altman, New York (1911–1913).

In the Altman galleries.

BEQUEST OF BENJAMIN ALTMAN, 1913.

14.40.635

Portrait of a Cardinal 32.100.67

Recent cleaning reveals in the sitter's face
some sensitive brushstrokes worthy of
Ghirlandaio. However, until more is known
about the role Mainardi played in Ghir-
landaio's shop, the attribution cannot be
determined.

Tempera on wood. H. 21½, w. 17½ in.
(54.6 × 43.7 cm.).

REFERENCES: The authorities cited below attribute
this painting to Mainardi. B. Berenson, *Flor. Ptrs.*
(1909), p. 154; in a letter (1924); in Cat. of Fried-
sam Coll. (unpublished, n.d.), p. 38; *Ital. Pictures*
(1932), p. 322; and *Flor. School* (1963), p. 127 //
G. de Francovich, *Cronache d'arte*, IV (1927), p. 258,
fig. 49, dates it tentatively before 1490 // R. van
Marle, *Ital. Schools*, XIII (1931), p. 216, fig. 147 //
B. Burroughs and H. B. Wehle, *Met. Mus. Bull.*,
XXVII (1932), Nov., sect. II, p. 38 // L. Venturi,
Ital. Ptgs. in Amer. (1933), pl. 276.

EX COLL.: a private collection, Italy (before 1829);
Kaiser Friedrich Museum, Berlin (1829–1924;
bought through Rumohr; Bode, Cat., 1906,
no. 85); [F. Kleinberger Galleries, Paris and New
York, 1924–1925]; Michael Friedsam, New York
(1925–1931).

32.10(

THE MICHAEL FRIEDSAM COLLECTION. BE-
QUEST OF MICHAEL FRIEDSAM, 1931.

Bartolomeo di Giovanni

Active by 1486; died after 1493. Bartolomeo di Giovanni is recorded in a document as the
artist who painted in 1488 the seven-panel predella of Ghirlandaio's Adoration of the Magi
in the Spedale degli Innocenti in Florence. Before this document was known the predella
was one of a number of homogeneous paintings grouped together by H. Ulmann and
Berenson under the name of "Alunno di Domenico" (pupil of Domenico) because of the
obvious closeness of their style to that of Domenico Ghirlandaio. A large body of works has
since been attributed to Bartolomeo di Giovanni, enlarging the original group and including
some of the finest of the Florentine cassoni of the late fifteenth and early sixteenth centuries.
Little is known of his life, beyond the fact that he must have spent some time as a helper of
Domenico Ghirlandaio. About 1493 he was working in Rome decorating the Borgia apart-
ments in the Vatican, under the direction of Pinturicchio, whose style he closely imitated at
this time. Many of his paintings show the influence of Botticelli.

The Madonna and Child 41.100.1

Tempera on wood. H. 36¾, w. 19½ in. (93.4 × 49.5 cm.).

The simplified forms and the bright colors in this painting are derived chiefly from the work of Ghirlandaio; the type of the Madonna, her left hand, and the linear treatment of the draperies reveal the artist's knowledge of Botticelli. An approximate date for this painting, which is characteristic of Bartolomeo di Giovanni's mature period, would be about 1500. The band decorated with fruits and ribbons that frames the niche was a favorite motive in the workshop of the Della Robbias.

REFERENCES: The authorities cited below attribute this painting to Bartolomeo di Giovanni. G. de Francovich, *Boll. d'arte*, VI (1926), p. 71, fig. 3, compares it with a Madonna and Child ascribed to Bartolomeo di Giovanni in the Museum of Lille // R. van Marle, *Ital. Schools*, XIII (1931), p. 250, fig. 171, compares it with the Madonna and Child in the Museum of Lille // B. Berenson, *Ital. Pictures* (1932), p. 7; and *Flor. School* (1963), p. 26.

EX COLL.: [Arnoldo Corsi, Florence]; George and Florence Blumenthal, New York (about 1925; until 1941; Cat., I, 1926, pl. XIV).

GIFT OF GEORGE BLUMENTHAL, 1941.

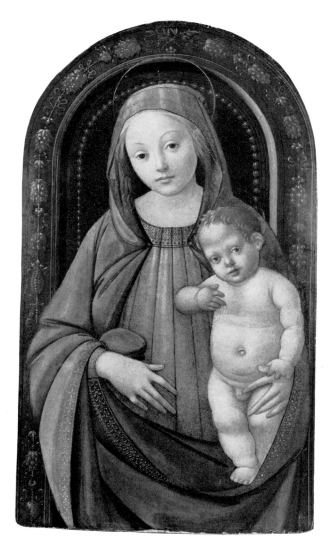

41.100.1

Unknown Florentine Painter, Fourth Quarter of the XV Century

Saint Anthony Abbot 80.3.679

Although this fragment of a fresco, apparently by a follower of Domenico Ghirlandaio, resembles the work of Bartolomeo di Giovanni, it cannot be ascribed to him with any certainty. The outline of the figure and the main details are incised in the plaster, probably following a cartoon. The fragment may have come from a street tabernacle.

Once attributed by the Museum to Domenico Ghirlandaio and later to an unknown Florentine painter of the third quarter of the XV century (Cat., 1940).

Fresco. H. 20¼, w. 14½ in. (51.4 × 36.8 cm.).

REFERENCES: B. Berenson, *Ital. Pictures* (1932), p. 37, lists this painting as a work by Baldovinetti; and *Flor. School* (1963), p. 22.

80.3.679

Biagio di Antonio

Known activity 1476–1504. Although Biagio di Antonio was a Florentine he worked repeatedly in the town of Faenza in the Romagna between 1476 and 1483 and again in 1504. In 1476 he painted an altarpiece now in the Philbrook Art Center of Tulsa, Oklahoma (Kress coll. no. 1088); in 1482 he was summoned to Rome to work in the Sistine Chapel in the Vatican with the most distinguished artists of his day. There he executed the fresco of the Crossing of the Red Sea and also assisted Cosimo Rosselli in his mural of the Last Supper. In 1483 he was again working in Faenza, where he must have headed an active workshop. No signed work by Biagio di Antonio has survived, but documentary evidence makes it

possible to attribute to him a large homogeneous group of paintings previously assigned to other artists, to Benedetto Ghirlandaio or, more often, to Giovanni Battista Utili (now identified as Giovanni Battista Bertucci). Biagio di Antonio's earliest works show the influence of Filippo Lippi and Pesellino and also the young Cosimo Rosselli. Later, about 1470–1480, he was deeply impressed by Verrocchio and, after his work in Rome, by Domenico Ghirlandaio and, to a lesser degree, by Perugino. From these influences he developed his characteristically meticulous style, which is evident in the paintings of his post-Roman period.

Scenes from the Story of the Argonauts (cassone panel) 09.136.2

This painting, apparently by an assistant in Biagio's shop, and the next, by the master himself, give a detailed account, in the continuous style, of Jason's conquest of the Golden Fleece and related incidents in the Greek legend. The story begins at the upper left of this picture, with Jason, in the golden armor that distinguishes him in each scene, bidding farewell to King Pelias. At the right of this scene, above, is the subsequent death of the king at the hands of his daughters, whom the vengeful Medea had craftily persuaded to destroy their father in an effort to restore his youth. Below this, Jason, with his horse, is about to set out to enlist companions, among them Orpheus, who may be seen on the island in the background. At the right, on a flat-topped rock (Mount Pelion), Jason, with Orpheus and Hercules, consults the centaur Chiron. Near by is the Argo, the ship that bore the heroes, and to the right Hylas, sent from the Argo to search for fresh water, is about to be carried off by the nymphs. In the right foreground is shown the hunt of the Calydonian boar, in which Jason took part. This panel, which is less finished than the following one, is of inferior quality and must be by an assistant working on the master's designs. Compared with those in the companion panel, the heads are weak in expression and the colors less bright.

Formerly attributed by the Museum to a follower of Pesellino (Cat., 1940).

Tempera on wood, gilt ornaments. Overall size, h. 24⅛, w. 60⅛ in. (61.3 × 152.7 cm.); painted surface, h. 19⅝, w. 56 in. (49.8 × 142.2 cm.).

REFERENCES: M. Logan, *Gaz. des B.-A.*, XLIII (1901), p. 334, tentatively ascribes the two paintings to Jacopo del Sellaio // W. Weisbach, *Francesco Pesellino und die Romantik der Renaissance* (1901), pp. 120 ff., ill., ascribes them to the follower of Pesellino who painted the Conquest of Pisa, the Battle of Anghiari, the Battle of the Romans, all from the Butler collection, and the battle piece in the Picture Gallery of Turin // B. B[urroughs], *Met. Mus. Bull.*, IV (1909), pp. 224 f., ill. pp. 222 f., calls our panels the work of a pupil of Pesellino // M. H. Bernath, *New York und Boston* (1912), pp. 71 f., figs. 70, 71, calls them good workshop pieces very close to Pesellino // P. Schubring, *Cassoni* (1915), pp. 116, 286, nos. 296, 297, pl. LXXI, and *Art in Amer.*, XI (1923), pp. 242 f., figs. 7, 8, ascribes them to a pupil of Pesellino and dates them about 1470 // O. Sirén, *Cat. of Jarves Coll.* (1916), pp. 126 ff., and *Burl. Mag.*, XXXVII (1920), pp. 300 ff., ascribes them to the immediate follower of Pesellino, working about 1460–1470, who painted two cassoni in the Fitzwilliam Museum in Cambridge, one in the Ashmolean Museum in Oxford, and probably also the Virgin adoring the Child in the Jarves collection at Yale University, New Haven // R. van Marle, *Ital. Schools*, X (1928), pp. 566 f., fig. 340, ascribes them to an artist of the school of Pesellino and agrees with Schubring's dating // B. Berenson, *Ital. Pictures* (1932), p. 585, lists them as works by Utili da Faenza; and *Flor. School* (1963), p. 211, pl. 1033 (09.136.1) // R. Longhi

09.136.2

09.136.1

(unpublished opinion, 1937) attributes them to Biagio di Antonio, whom he identifies with the painter wrongly called G. B. Utili da Faenza // *Met. Mus. Bull.*, n.s., II (1944), Feb., note opp. p. 177, ill., and color detail on cover (09.136.1) // H. W. Grohn, *Staatliche Museen zu Berlin, Forschungen und Berichte*, I (1957), pp. 94 f., figs. 3, 4, attributes them to a follower of Pesellino whom he calls the Master of the Argonaut Panels.

EX COLL.: [Stefano Bardini, Florence; sale, Christie's, London, June 5, 1899, no. 364]; [Colnaghi, London, 1899]; King Leopold II of Belgium, Brussels (1899–1909); [Kleinberger Galleries, New York, 1909]; J. Pierpont Morgan, New York (1909).

GIFT OF J. PIERPONT MORGAN, 1909.

Scenes from the Story of the Argonauts (cassone panel) 09.136.1

This painting is a continuation of the story of the Argonauts, which was begun on the preceding one. At the left Jason is shown being received by King Aeëtes and his two daughters, Medea and Chalciope. In the middle ground in a circular enclosure, representing the Grove of Ares, are seen the Golden Fleece hanging high on an oak tree, Orpheus standing near by, and Jason driving the fire-breathing oxen and killing the dragon and the knights sprung from the dragon's teeth, which he had sown in the ground. At the right Jason appears again before the king, then at the foot of the stairway mounting his horse, and finally galloping across the drawbridge. In the background at the left are Medea and Jason with a group of his companions. Beyond in a cauldron is Aeson, the father of Jason, being magically rejuvenated by Medea, and near the enchantress is Diana, whom she has summoned.

The pronounced influence of Pesellino and the similarity to the early works of Cosimo Rosselli suggest a date around 1465. Although this and the preceding panel were painted in the same workshop, as decoration for two companion marriage chests, their style is somewhat different. In this second half of the story of the Argonauts the hand of Biagio di Antonio himself is clearly recognizable. There are other sets of cassoni of which Biagio painted one panel and another painter did the companion piece. For instance, a panel in the Fitzwilliam Museum, Cambridge (Marlay bequest, no. 3) is apparently by him, while the companion piece in the same museum (Marlay bequest no. 4) is a typical work by Bartolomeo di Giovanni. A set of three panels, painted in 1487, and like ours devoted to the story of the Argonauts, includes the Marriage of Jason and Medea by Biagio di Antonio (Musée des Arts Décoratifs, Paris), Jason at the Banquet of Pelias by Bartolomeo di Giovanni, and Jason received by Aeëtes by an anonymous painter (both formerly in the Robinson collection, now collection of Princess Labia in Cape Town). See also comment above under the preceding entry.

Formerly attributed by the Museum to a follower of Pesellino (Cat., 1940).

Tempera on wood, gilt ornaments. Overall size, h. 24$\frac{1}{8}$, w. 60$\frac{3}{8}$ in. (61.3 × 153.4 cm.); painted surface, h. 19$\frac{5}{8}$, w. 56 in. (49.8 × 142.2 cm.).

REFERENCES: See above under the preceding entry.

EX COLL.: [Stefano Bardini, Florence; sale, Christie's, London, June 5, 1899, no. 360]; [Colnaghi, London, 1899]; King Leopold II of Belgium, Brussels (1899–1909); [Kleinberger Galleries, New York, 1909]; J. Pierpont Morgan, New York (1909).

GIFT OF J. PIERPONT MORGAN, 1909.

Portrait of a Young Man 32.100.68

This portrait is very much like the Portrait of a Boy in the National Gallery, Washington (Kress coll., K 326) and was probably painted at the same time in Biagio di Antonio's long career, about 1480. It shows the various influences that affected Biagio's style around this time. The composition harks back to earlier portraits by Florentine painters, such as Andrea del Castagno's Portrait of a Man in the National Gallery of Art in Washington; the modeling, however, resembles that in works by Verrocchio. In the quality of the drawing, indeed, and in the peculiar character of the landscape background our painting is one of a group by Biagio that show very clearly how much he was impressed by Verrocchio, a group that includes the altarpiece in the National Museum in Budapest (no. 1386) and the Madonnas in the Poldi-Pezzoli Museum in Milan (no. 581) and the Uffizi in Florence.

Formerly attributed by the Museum to an unknown Florentine painter, third quarter of the XV century (Cat., 1940).

Tempera on wood. H. 21½, w. 15⅜ in. (54.6 × 39 cm.).

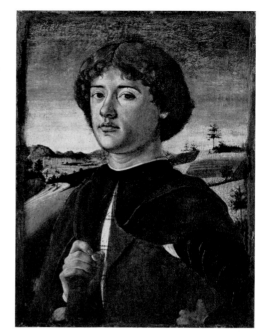

32.100.68

REFERENCES: B. Berenson (in a letter, 1925) calls this painting probably the earliest of Botticelli's known portraits; in Cat. of the Friedsam Coll. (unpublished, n.d.), pp. 73 f., attributes it to Botticelli and dates it about 1470 or before; *Ital. Pictures* (1932), p. 105, lists it as a work by Botticelli; and *Flor. School* (1963), p. 37 // G. Gronau (verbally, about 1925) calls it an authentic work by Botticelli // R. van Marle, *Ital. Schools*, XII (1931), p. 46, fig. 11, attributes it to Botticelli // B. Burroughs and H. B. Wehle, *Met. Mus. Bull.*, XXVII (1932), Nov. sect. II, pp. 35 f. // R. Offner (verbally, 1937) attributes it to the Verrocchiesque painter of a group of panels that includes a Madonna in Budapest (no. 1386) and one in the Poldi-Pezzoli Museum in Milan (no. 581) and notes its dependence on Castagno's Portrait of a Man in the National Gallery of Art in Washington // R. Longhi (unpublished opinion, 1937) attributes it to Biagio di Antonio, whom he identifies as the painter wrongly called G. B. Utili, and compares it with the Budapest Madonna // F. Mason Perkins (in a letter, 1938) attributes it to Botticelli // R. Salvini, *Tutta la pittura del Botticelli* (1958), II, p. 69, pl. 133 A, rejects the attribution to Botticelli and calls it a work by an imitator, whose style resembles that of Jacopo del Sellaio and Raffaellino del Garbo.

EX COLL.: Marchese Eugenio Niccolini, Florence (until about 1925); [Grassi, Florence, 1925]; [Frits Lugt, 1925]; [Kleinberger Galleries, New York, 1925]; Michael Friedsam, New York (1925–1931).

THE MICHAEL FRIEDSAM COLLECTION. BEQUEST OF MICHAEL FRIEDSAM, 1931.

The Story of Joseph (cassone panel)
32.100.69

This painting is a companion piece to a cassone panel once in the collection of Gregory Peck, Los Angeles. Both illustrate episodes

in the story of Joseph (Genesis 37, 39 ff.). In our panel the succession of episodes, marked with the names of the chief characters, begins in the background at the left, where Joseph, soon after reaching Egypt, is sold to Potiphar. Other scenes in the background show him fleeing from Potiphar's wife and later imprisoned. At the extreme right are shown Pharaoh dreaming and Joseph interpreting his dream. In the left foreground Joseph is greeting his father and kinsmen on their arrival in Egypt. The companion panel shows the earlier episodes in the story, before Joseph was sold into slavery in Egypt.

Biagio di Antonio's usual combination of forms derived from Verrocchio and Ghirlandaio shows here a slight Umbrian influence, apparently from Perugino. This suggests a dating about 1482, when Biagio worked in the Sistine Chapel in the company of Perugino and other Umbrian artists. The buildings in the background obviously reflect contemporary Florentine architecture.

Inscribed with the names of the persons represented.

Formerly attributed tentatively by the Museum to Utili da Faenza (Cat., 1940).

Tempera on wood. H. 27, w. 59 in. (68.5 × 149.9 cm.).

REFERENCES: P. Rosa, *Classificazione per epoca dei pittori di cui le opere nella Galleria Borghese* (manuscript in the archives of the Borghese Gallery, Rome, about 1837), attributes this painting and the Peck one to Pinturicchio // Crowe and Cavacaselle, *Ptg. in Italy*, III (1866), p. 295, lists the two pictures as works hastily painted in Pinturicchio's manner // I. Lermolieff [G. Morelli], *Kstkrit. Stud.-Rom* (1890), p. 142, attributes them to the workshop of Pinturicchio // A. Alexandre, *Les Arts*, III (1904), p. 8, ill., calls our painting a Florentine work of the XV century // H. Frantz, *L'Art décoratif*, I (1912), p. 291, ill. p. 289, mentions it as a Florentine work // B. Berenson, unpublished opinion (1914), and in Cat. of Friedsam Coll. (unpublished, n.d.), pp. 82 f., attributes it to Utili da Faenza, dates it soon after his work in the Sistine Chapel in the Vatican, and notes the influence of Perugino; *Ital. Pictures.* (1932), p. 585, lists it as a work by Utili; *Riv. d'arte*, XV (1933), p. 28, note, observes the close connection of the figure of the galloping horse with a drawing by the sculptor Francesco di Simone Ferrucci in the Stockholm print room, and suggests that Utili met Francesco, and that the two artists used the same material; and *Flor. School* (1963), p. 211, pl. 1027 (detail) // P. Schubring, *Cassoni* (1915), p. 302, no. 354,

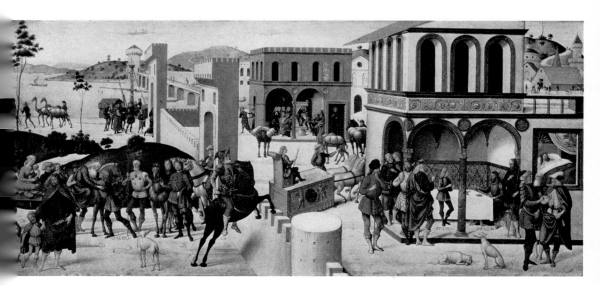

pl. LXXIX, considers it a Florentine-Umbrian work of about 1480 // R. van Marle, *Ital. Schools*, XIII (1931), p. 180, fig. 118, attributes it to Utili // B. Burroughs and H. B. Wehle, *Met. Mus. Bull.*, XXVII (1932), Nov., sect. II, pp. 36 f. // L. Venturi, *Ital. Ptgs. in Amer.* (1933), pl. 273, connects it with the Wildenstein painting (Peck) and attributes both to Benedetto Ghirlandaio // R. Offner (verbally, 1937) attributes it to Utili // W. Grohn, *Staatliche Museen zu Berlin, Forschungen und Berichte*, I (1957), p. 94, dates it in the 1480's, and ascribes it to the artist in the workshop of the Ghirlandaio brothers who painted the Marriage of Jason and Medea in the Musée des Arts Décoratifs and two cassone

frontals with the story of Lucretia in the Ca' d'Oro in Venice; rejects the attribution to Utili.

EX COLL.: Galleria Borghese, Palazzo Borghese, Rome (by 1837; Cat. 1859, no. 51, as Pinturicchio); Prince Borghese, Rome (sale, Galerie Georges Petit, Paris, June 30 and July 1, 1891, no. 126, as Pinturicchio); Jean Dollfus, Paris (sale, Galerie Georges Petit, Paris, April 1 and 2, 1912, no. 52, as Florentine School, XV century); [Wildenstein, New York, 1912–1919]; Michael Friedsam, New York (1919–1931).

THE MICHAEL FRIEDSAM COLLECTION. BEQUEST OF MICHAEL FRIEDSAM, 1931.

Cosimo Rosselli

Born 1439; died 1507. Cosimo Rosselli served an apprenticeship in the workshop of Neri di Bicci, learning the solid technique and good craftsmanship that distinguish his many extant pictures. Cosimo was an artist of little originality, and his style is essentially derivative, combining motives from the works of various contemporaries, especially Gozzoli, Baldovinetti, Verrocchio, and Ghirlandaio. His career extended over nearly half a century. Most of it was spent in Florence, though he was summoned in 1481 to Rome to work in the Sistine Chapel in the Vatican—an honor which he shared with some of the most distinguished artists of the day.

Portrait of a Man 50.135.1

The style of this painting indicates a date about the time of Rosselli's frescoes of 1481–1482 in the Sistine Chapel. The sitter bears a certain resemblance to a man who appears in his fresco of the Sermon on the Mount in the Sistine Chapel and also in the fresco of the Procession of the Miraculous Chalice in the church of Sant'Ambrogio in Florence, painted in 1486. All three of these representations may be self-portraits, though the red robe of our picture, trimmed with ermine, suggests that the subject is more likely a man of rank than a painter. This painting is a representative example of Florentine portraiture in the second half of the fifteenth

century, before it was modified and enriched during the 1480's under the influence of Flemish models, especially the work of Hans Memling.

Tempera on wood. H. 20⅜, w. 13 in. (51.8 × 33 cm.).

REFERENCES: The authorities cited below attribute this painting to Cosimo Rosselli. B. Berenson, *Rass. d'arte*, V (1905), p. 177, ill., calls it a portrait of a Florentine gentleman and dates it about the time of the fresco in the church of Sant'Ambrogio in Florence (1486); *Flor. Ptrs.* (1909), p. 179; and *Flor. School* (1963), p. 191, pl. 185 // A. Venturi, *Storia*, VII, part I (1911), p. 690, fig. 402, calls it a portrait of a man, dating it in the same period as the frescoes in the Sistine Chapel (1481–1482) // R. van Marle, *Ital. Schools*, XI (1929), p. 605, observes the influence of Botticelli and dates it between 1482

and 1486 // E. S. Siple, *Burl. Mag.*, LV (1929),
p. 331, ill. p. 327, calls it a self-portrait // R. Offner
(unpublished opinion, 1931) calls it a self-portrait,
dating it before the fresco in the church of Sant'
Ambrogio in Florence // G. Gronau, *Pantheon*, VII
(1931), p. 154, ill., rejects the hypothesis that it is a
self-portrait; and in Thieme-Becker, XXIX (1935),
p. 36 // W. R. Valentiner, *Pantheon*, XII (1933),
p. 238, ill. p. 237, calls it a self-portrait // *Met. Mus.
Bull.*, n.s., X (1951), p. 60, ill.

EXHIBITED: Knoedler and Co., New York, 1930,
Sixteen Masterpieces, no. 16 (lent anonymously);
Toronto Art Gallery, Toronto, 1931, *Exhibition of
Old Masters and German Primitives*, no. 15 (lent by
Knoedler and Co.); Institute of Art, Detroit, 1933,
*Loan Exhibition of Italian Paintings of the 14th to the
16th Century*, no. 22 (lent by Knoedler and Co.);
Century Association, New York, 1935, *Italian
Paintings of the Renaissance*, no. 14 (lent by Edward
S. Harkness); Knoedler and Co., New York, 1940,
Italian Renaissance Portraits, no. 7 (lent anony-
mously).

EX COLL.: Étienne Martin, Baron de Beurnonville,
Paris (until 1878); Joseph Spiridon, Paris (1878–
1929; sale, Cassirer and Helbing, Berlin, May
25–30, 1929, no. 63, as Self-Portrait of Cosimo
Rosselli); [Knoedler and Co., New York, 1929–
1934]; Edward S. Harkness, New York (1934–
1940).

BEQUEST OF EDWARD S. HARKNESS, 1940.

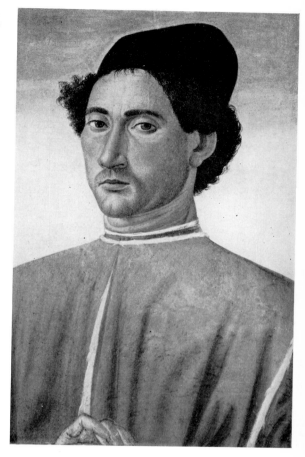

50.135.1

The Madonna and Child with Angels
32.100.84

The influence of Andrea del Verrocchio,
evident in the composition of the central
group and in the formal treatment of the
figure of the Child, may have come from
one of his sculptures rather than a painting.
A Madonna and Child with Angels, painted
in the workshop of Domenico Ghirlandaio
and usually attributed to Mainardi, which
was formerly in the Weber collection in
Hamburg and is now in the Huntington
Museum in San Marino, California, is very
similar in composition to this painting. It

cannot be determined which of the two
pictures was painted first; ours can be dated
in the first half of the 1480's.

Tempera on wood. H. 33½, w. 23 in.
(85.1 × 58.4 cm.).

REFERENCES: The authorities cited below attribute
this painting to Cosimo Rosselli. B. Berenson (un-
published opinion, 1910); in Cat. of Friedsam Coll.
(unpublished, n.d.), pp. 93 f., dates it about 1475
and notes that twenty years earlier the painting was
attributed to Botticelli; *Ital. Pictures* (1932), p. 492;
and *Flor. School* (1963), p. 191 // R. van Marle,
Ital. Schools, XI (1929), p. 608, dates it 1492–1505;
and *Burl. Mag.*, LVIII (1931), p. 45, ill. p. 47, calls it
an early work showing the influence of Gozzoli and
Verrocchio, dates it in the late 1470's, and

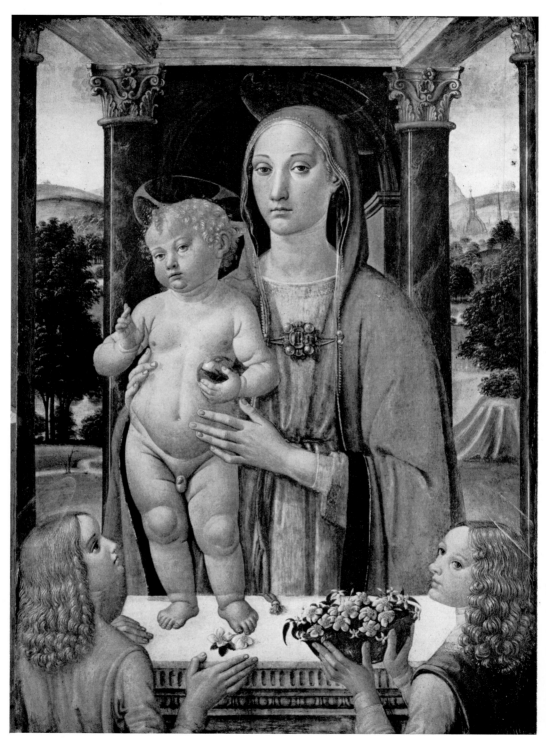

observes the similarity of the niche with columns in the background to the one in the Santa Barbara altarpiece in the Accademia in Florence // B. Burroughs and H. B. Wehle, *Met. Mus. Bull.*, XXVII (1932), Nov., sect. II, p. 35, ill. p. 39, date it before Rosselli's work in the Sistine Chapel // G. Gronau, in Thieme-Becker, XXIX (1935), p. 36 // F. Mason Perkins (in a letter, 1938) // R. Musatti, *Riv. d'arte*, XXVI (1950), p. 127, observes Verrocchio's influence and dates it about 1480–1482.

EXHIBITED: Kleinberger Galleries, New York, 1917, *Italian Primitives*, no. 31 (lent by Mrs.

Benjamin Thaw); Metropolitan Museum, New York, 1923, *Arts of the Italian Renaissance*, no. 4 (lent by Michael Friedsam).

EX COLL.: Valesi, Florence (until about 1910); [Wildenstein and Co., New York, 1910]; Mrs. Benjamin Thaw, New York (by 1917; sale, Galerie Georges Petit, Paris, May 15, 1922, no. 36); [Kleinberger Galleries, New York, 1922–1923]; Michael Friedsam, New York (1923–1931).

THE MICHAEL FRIEDSAM COLLECTION. BEQUEST OF MICHAEL FRIEDSAM, 1931.

Workshop of Verrocchio

Real name Andrea di Michele di Francesco Cioni. Born 1435; died 1488. Verrocchio, like so many of his contemporaries, was trained at first as a goldsmith, but he is chiefly known as a sculptor. Among his more important sculptures are the bronze group of Christ and Saint Thomas that fills one of the niches on the exterior of Or San Michele and works ordered by the Medici, including the bronze David (Bargello, Florence), the Boy with the Dolphin (Palazzo Vecchio), and the tomb of Giovanni and Piero de'Medici in the Old Sacristy of San Lorenzo. His greatest work is the equestrian monument of Bartolomeo Colleoni, commissioned by the Signoria of Venice. Verrocchio worked for several years on the model and finally sent it to Venice in 1481 but died before the statue was cast. Throughout his life he was employed also as a painter and kept a busy workshop, but there are only two pictures known with which he can certainly be connected—the Madonna Enthroned with Saints in the cathedral in Pistoia, commissioned in 1477, and the Baptism of Christ in the Uffizi in Florence. Leonardo was Verrocchio's apprentice in 1476, and, according to a tradition that arose in his lifetime, collaborated with his master on the Baptism, painting one of the angels. The figures of Christ and the Baptist are our best clues to Verrocchio's style as painter, which was incisive in drawing and, like his sculptures, modeled in a soft chiaroscuro. Out of it developed the vastly influential styles of Lorenzo di Credi, Perugino, and Leonardo.

The Madonna and Child 14.40.647

In composition and style this picture is closely related to reliefs by Verrocchio and his assistants, such as those in the Bargello in Florence representing the Madonna and Child, one in marble and one in terracotta. Only the conception of our painting, how-ever, is like Verrocchio; the handling seems to be by someone else, working under Verrocchio's supervision and deeply influenced by him. There is a small group of works that can be attributed on strong internal evidence to Domenico Ghirlandaio at the time when he was greatly influenced by Verrocchio. These paintings, which

include a Madonna and Child in the National Gallery in Washington (Kress coll., K 2076) and a Madonna and Child in the Louvre (no. 1367A), have in common with our painting precise and neat outlines, similar folds in the draperies, pigment and color treated in the same way, as well as the type of the Child, links so close that one might presume our picture too is by Ghirlandaio, perhaps at a slightly earlier date. The Museum's Madonna and Child, however, has at the same time certain dissimilarities to the paintings in Washington and the Louvre which make an attribution to Ghirlandaio not entirely convincing and suggest continuing to ascribe it to an anonymous helper in Verrocchio's workshop. On the basis of comparison with other paintings by Verrocchio's immediate followers our panel would seem to date about 1470.

Formerly attributed by the Museum to Verrocchio (Cat., 1940).

Tempera on canvas, transferred from wood. H. 26, w. 19 in. (66 × 48.2 cm.).

REFERENCES: H. Mackowsky, *Verrocchio* (1901), p. 84, notes that this painting was once attributed to Botticini and that it depends on Verrocchio's marble Madonna in the Bargello in Florence // B. Berenson, *The Drawings of the Florentine Painters* (1903), I, p. 38, considers it entirely executed by Verrocchio's assistants; in a letter (1912) calls it a genuine work by Verrocchio; *Ital. Pictures* (1932), p. 595, lists it as a work by Verrocchio; *Boll. d'arte*, XXVII (1933), pp. 196 ff., fig. 1, attributes it to Verrocchio and dates it 1467, soon after the Madonna in Berlin; and *Flor. School* (1963), p. 212 // E. Kühnel, *Francesco Botticini* (1906), p. 59, considers it Verrocchiesque, reminiscent of the Pollaiuolos // O. Sirén, *Leonardo* (1916), pl. opp. p. 28, hesitantly labels it a work by Verrocchio // T. Borenius, *Burl. Mag.*, XXX (1917), p. 129, calls it at least a work from Verrocchio's shop // Sir Claude Phillips, *Burl. Mag.*, XXXIV (1919), p. 216, attributes it tenta-

tively to Verrocchio // R. Fry, *Florentine Painting* (Burlington Fine Arts Club) (1919), p. 34, associates it closely with the Madonna with Angels (National Gallery, London, no. 296) and a fragmentary Virgin in Adoration lent to the Burlington Fine Arts Club Exhibition, no. 35, as School of Verrocchio // F. Monod, *Gaz. des B.-A.*, VIII (1923), pp. 180 f., ill., attributes it to the artist in Verrocchio's workshop who painted the Madonna in Berlin // R. van Marle, *Ital. Schools*, XI (1929), pp. 525 f., fig. 325, attributes it to Verrocchio and dates it later than the Madonnas in Frankfurt and Berlin // B. Degenhart, *Riv. d'arte*, XIV (1932), pp. 268, 294, 298, 442, ill. p. 265, fig. 2, attributes it to Verrocchio, dating it about 1475 // C. L. Ragghianti, *L'Arte*, XXXVIII (1935), p. 195, accepts the attribution to Verrocchio, dating it slightly before 1470 // A. Bertini, *L'Arte*, XXXVIII (1935), p. 467, note, attributes it to a painter of the school of Verrocchio // *Duveen Pictures* (1941), no. 72, ill., publishes it as by Verrocchio, about 1467 // R. C. Jebb, *Met. Mus. Bull.*, n.s., V (1946), ill. p. 85 // *Art Treasures of the Metropolitan* (1952), p. 224, pl. 77 (in color) // T. Rousseau, *Met. Mus. Bull.*, n.s., XII (1954), p. 13, ill. // G. Passavant, *Andrea Verrocchio als Maler* (1959), pp. 152, 211, note 373, fig. 96, attributes it to Verrocchio's workshop; *Verrocchio* (1969), p. 208, App. 32, ill., catalogues it as from the studio of Verrocchio, strongly related to Francesco Botticini.

EXHIBITED: Royal Academy, London, 1895, *Old Masters*, no. 147 (as Verrocchio, lent by Charles Butler); Metropolitan Museum, New York, 1952–1953, *Art Treasures of the Metropolitan*, no. 77.

EX COLL.: a private collection, Florence; Rev. Walter Davenport Bromley, Wootton Hall, Ashbourne, Derbyshire (sale, Christie's, London, June 12–13, 1863, no. 133, as Pesellino); Sir Walter R. Farquhar, London (1863–1894; sale, Christie's, London, June 2, 1894, no. 143, as Pesellino); Charles Butler, Warren Wood, Hatfield, Herts. (1894–1911; sale, Christie's, London, May 25–26, 1911, no. 108, as Verrocchio); [Harvey, 1911]; [Otto Gutekunst, London]; [Dowdeswell & Dowdeswell, London, 1912]; [Duveen Brothers, New York, 1912–1913]; Benjamin Altman, New York (1913).

In the Altman Galleries.

BEQUEST OF BENJAMIN ALTMAN, 1913.

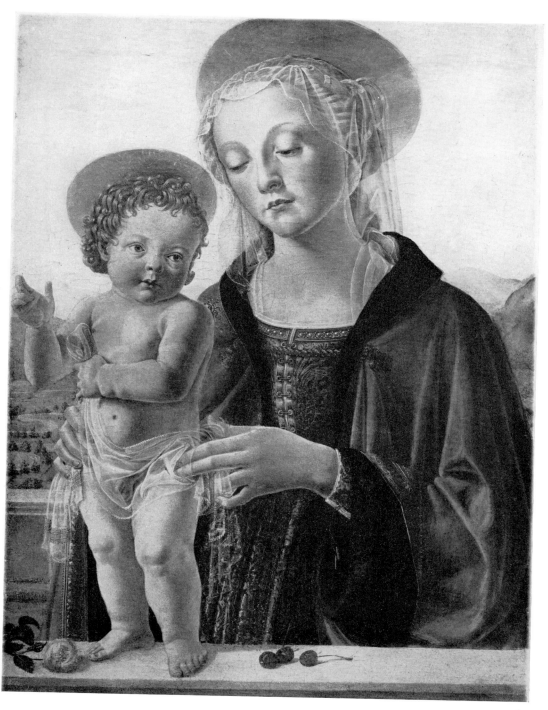

14.40.647

Lorenzo di Credi

Real name Lorenzo d'Andrea d'Oderigo. Born 1459 or 1460; died 1537. Lorenzo di Credi, who came from a family of goldsmiths and had some proficiency as a sculptor, was working as a painter in 1480 in the shop of Andrea del Verrocchio. There he was the fellow pupil of Leonardo da Vinci and, like so many of his contemporaries, fell under Leonardo's dominating influence. A few pictures dating from about 1510 show familiarity also with the work of younger artists, especially Fra Bartolomeo. Credi's works have consistently fine finish, and their execution shows an admirable perfection of technique, but their effectiveness is often lessened by a conventional repetition of types and facial expressions. Credi had a number of pupils who seem to have repeated his formulas.

Portrait of a Lady 43.86.5

This portrait shows all the characteristics of Lorenzo di Credi's style, but it is difficult to determine its date. The painted surface is in a poor state of preservation, the forms having been greatly altered, especially in the face. Furthermore, precise dating of paintings by Lorenzo di Credi is not possible, because between 1490 and the end of his long career there is very little change in his style. The lady is shown wearing a black dress, her head covered with a transparent white veil. This costume, along with the fact that she holds a wedding ring in her left hand and that there is behind her a juniper bush (in Italian, *ginepro*), has led to the hypothesis that the sitter was Ginevra di Giovanni di Niccolò. This Ginevra was a goldsmith's daughter who had married Lorenzo di Credi's elder brother Carlo. She appears among the beneficiaries in Lorenzo's will, and was very likely a widow at the time this portrait was painted. An old inscription on the back of the panel, possibly dating from the sixteenth century but reinforced in more

recent times, gives the name of the sitter as "Ginevra de' Amerigo Benci." It was this inscription which many years ago led to the identification of the picture with the portrait of this lady that Vasari says Leonardo da Vinci painted (*Vite*, 1568, Milanesi ed., IV, 1879, p. 39). Now, however, it is generally thought that the picture to which Vasari was referring is the one from the Liechtenstein collection in Vienna and Vaduz, now in the National Gallery of Art in Washington (no. 2326). Although in its present state the Museum's picture does not seem to show the same woman as the Washington portrait, in the underpainting revealed by X-ray the subject looks much more like the woman who posed for the Washington picture, especially in her features and the shape of her face. There is no doubt that in painting our picture Lorenzo di Credi was influenced by Leonardo's portrait, not only in placing the figure against the juniper bush, in allusion to the sitter's name, but also in the general composition, which he used in reverse. There is still another connection between the two panels. Leonardo's picture, which

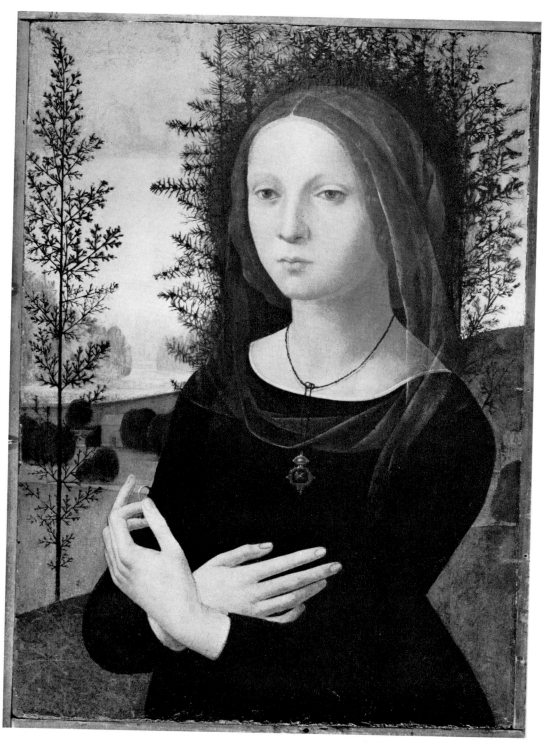

43.86.5

now lacks its original lower portion, very probably showed the hands of the sitter. A drawing by Leonardo in the Royal Library at Windsor Castle (no. 12558) of a pair of hands, one of them raised and holding what is possibly the stem of a flower, is thought to be a preparatory study for the hands of Ginevra de' Benci. Although in reverse, this raised hand of the drawing bears a close resemblance to the hand of our sitter holding the ring.

In the lower left corner of the Museum's picture, against the grass, there is a device of four lines resembling arrows, crossed symmetrically to form a star; it appears again, but only in part, along the edge of the painted surface at the lower right. It is not clear whether this device is an emblem or just a stylized and rather crude representation of a plant form, as the pigment with which it was painted is now very thin.

It is possible that this panel had a companion piece, either a pendant portrait or a religious representation, but there is no evidence for this assumption. The picture was enlarged, possibly in the seventeenth century, with an added strip of wood almost two inches wide at the right side. This addition and the repainting that concealed the joining were removed in 1957.

When the portrait was exhibited in New York in 1924 Valentiner asserted (see Refs., below) that it had come from the convent of the Annunziata in Florence. Elizabeth Gardner has suggested that it may not have been a possession of the convent but was perhaps shown there at one of the exhibitions frequently held during the XVIII century to honor Saint Luke.

Tempera on wood. H. 23⅛, w. 15¾ in. (59 × 40 cm.).

REFERENCES: G. B. Benigni, C. Coltellini, G. Fabbroni, G. Ferri, and G. Magni, in an un-published document (1795), attribute this painting to Leonardo da Vinci, identifying it with the portrait of Ginevra di Amerigo Benci mentioned by Vasari // B. Berenson, Flor. Ptrs. (1898), p. 109, lists it as a work by Lorenzo di Credi; in a letter (1920), rejects the attribution to Leonardo, ascribes it to Lorenzo di Credi, notes the juniper in the background and the traditional identification as Ginevra de' Benci; Ital. Pictures (1932), p. 297, lists it as a Portrait of a Young Woman by Lorenzo di Credi; and Flor. School (1963), p. 116 // W. Bode, Zeitschr. für bild Kst., n.f., XIV (1903), p. 276, ill. p. 275, calls it a free school copy after Leonardo's portrait of a girl in the Liechtenstein collection, which he observes has been cut down about 25 or 30 cm., reports the inscription on the back, and states that the painting was first noted by F. Knapp when it was in the Pucci collection; and Studien über Leonardo da Vinci (1921), pp. 34 f., fig. 18, hesitantly attributes it to G. A. Sogliani // C. Carnesecchi, Riv. d'arte, VI (1909), p. 292, quotes Bode's opinion that this is an old free copy of the Liechtenstein portrait but notes that there is no similarity between the two sitters and that some scholars, because of the inscription, believe it is a copy of the original painting of Ginevra di Amerigo Benci by Leonardo // A. Venturi, Storia, VII, part I (1911), pp. 817 f., note, attributes it to Lorenzo di Credi // J. Thiis, Leonardo da Vinci; the Florentine Years of Leonardo and Verrocchio (n.d., about 1913?), pp. 109 f., ill., doubtfully attributes it to Lorenzo di Credi, calls it the portrait of a widow, rejects Bode's opinion concerning the identification of the sitter as Ginevra de' Benci // O. Sirén, Leonardo da Vinci (1916), p. 24, ill., calls it a Florentine work, rejects the identification of the sitter of the Liechtenstein painting as Ginevra de' Benci, suggesting that our portrait is a copy of an older work, now lost, which may have been the original portrait by Leonardo; and Léonard de Vinci (1928), I, p. 18, II, pl. 14 A // R. Offner, The Arts, V (1924), ill. p. 254, as Lorenzo di Credi // J. Alazard, Le Portrait florentin de Botticelli à Bronzino (1924), pp. 58 f., 86, rejects Bode's hypothesis and the identification of our painting as a copy of the portrait of Ginevra de' Benci by Leonardo in the Liechtenstein collection, attributing our painting to a clumsy imitator of Lorenzo di Credi or a poor pupil of Leonardo, wrongly stating that on the reverse is the painted device which is on the Liechtenstein painting // W. R. Valentiner, Catalogue of Early Italian Paintings (Duveen Gallery) (1926), no. 16, ill., attributes it to Lorenzo di Credi and calls it a portrait of a Florentine Lady // W. Suida, Leonardo und sein Kreis (1929), p. 26, calls it a later variant of the Liechtenstein portrait, painted not before the beginning of

the XVI century // C. Gamba, *Dedalo*, XI (1930–1931), p. 598, ill. p. 591, attributes it to Lorenzo di Credi, dates it tentatively in the XVI century, suggesting that it might be a partial replica of the unknown original by Leonardo da Vinci representing Ginevra de' Benci // B. Degenhart, *Pantheon*, VIII (1931), p. 463, attributes it to Lorenzo di Credi, dates it between 1501 and 1505; and *Münchner Jahrb. der bild. Kst.*, n.f., IX (1932), pp. 122, 160 // R. van Marle, *Ital. Schools*, XIII (1931), p. 276, fig. 184, attributes it to Lorenzo di Credi, notes the resemblance between the backgrounds in it and the Liechtenstein painting, and rejects the identification of the sitter as Ginevra de' Benci // L. Venturi, *Ital. Ptgs. in Amer.* (1933), pl. 282, calls it a Portrait of a Lady by Lorenzo di Credi // E. Möller, *Münchner Jahrb. der bild. Kst.*, n.f., XII (1937–1938), p. 205, fig. 10, attributes it to G. A. Sogliani, rejects the identification of the sitter as Ginevra di Amerigo Benci, postulating a daughter of a younger generation of the Benci who might have been the subject of this portrait, observes the close relationship to Leonardo's portrait of Ginevra in the Liechtenstein collection and to his drawing of hands at Windsor Castle // G. Dalli Regoli, *Lorenzo di Credi* (1966), pp. 44 f., 145, no. 89, fig. 111, includes it among Lorenzo di Credi's sure works, calls it a portrait of a widow, suggests identifying the sitter with Lorenzo's sister-in-law, Ginevra di Giovanni di Niccolò, notes the Leonardesque influence, and dates it in Credi's mature period, either in the early XVI century or in the period between 1490 and 1495 // J. Walker, *Report and Studies in the History of Art* (1967) (National Gallery of Art), pp. 13 ff., figs. 12, 13, 15, considers it and Leonardo's painting in Washington, which he dates about 1480, representations of the same person, comments on the relationship that the Museum's painting and a portrait of a young man in Turin bear to the Washington picture, explaining it by the suggestion that they were inspired by a vanished engraving of Leonardo's portrait; raises the possibility that the Museum's picture was ordered from Lorenzo di Credi by Ginevra's family because Bembo had taken the original portrait of her to Venice, and interprets her black costume as a symbol of her devotion to religion and the addition of the ring as an emphasis of her fidelity to her marriage vows.

EXHIBITED: Cincinnati Art Museum, Cincinnati, *Special Exhibition of Italian Paintings*, 1921 (as Lorenzo di Credi, lent by Duveen Brothers); Duveen Gallery, New York, 1924, *Early Italian Paintings*, no. 1 (as Lorenzo di Credi, lent by A. W. Mellon); Knoedler Gallery, New York,

1929, *Loan Exhibition of Primitives*, no. 10 (as Lorenzo di Credi, lent by Richard de Wolfe Brixey); Royal Academy, London, 1930, *Italian Art*, no. 237 (as Lorenzo di Credi, lent by Mr. and Mrs. Richard de Wolfe Brixey); Knoedler Gallery, New York, 1935, *Fifteenth Century Portraits*, no. 14 (as Portrait of Ginevra de' Benci by Lorenzo di Credi, lent anonymously).

EX COLL.: The Marchesi Pucci, Palazzo Pucci, Florence (by 1795?); Marchese Emilio Pucci, Florence (until about 1912); [A. S. Drey, Munich, about 1912]; [Arthur Ruck, London, 1920]; [Duveen Brothers, New York, about 1920–1921]; Andrew W. Mellon, Washington (1922–1924); [Duveen Brothers, New York, 1924–1925]; Richard de Wolfe Brixey, New York (by 1926–1943).

BEQUEST OF RICHARD DE WOLFE BRIXEY, 1943.

The Madonna Adoring the Child, with the Infant Saint John the Baptist and an Angel (tondo) 09.197

The theme of this picture was often repeated by Lorenzo di Credi and his workshop. From one of the versions Albrecht Dürer in 1495 made a drawing of the Child. Certain elements reappear, more or less varied, in several paintings: one in the Berlin Museum (no. 100), another, the Nativity, in the Accademia in Florence (no. 8661), and a third, the Adoration of the Shepherds, in the Uffizi (no. 8399). Our panel seems to be in great part the work of Lorenzo himself, although some details, especially in the figure of the angel and in the left background, may be by helpers.

Tempera on wood. Diam., 36 in. (91.4 cm.).

REFERENCES: R. E. F[ry], *Met. Mus. Bull.*, IV (1909), pp. 186 ff., ill., dates this painting between similar versions in Karlsruhe and Berlin and considers it the original by Lorenzo di Credi, from which a version in the Pinakothek in Munich was copied // M. H. Bernath, *New York und Boston* (1912), pp. 72, 75, fig. 73, attributes it to Credi // R. van Marle, *Ital. Schools*, XIII (1931), pp. 294 f.,

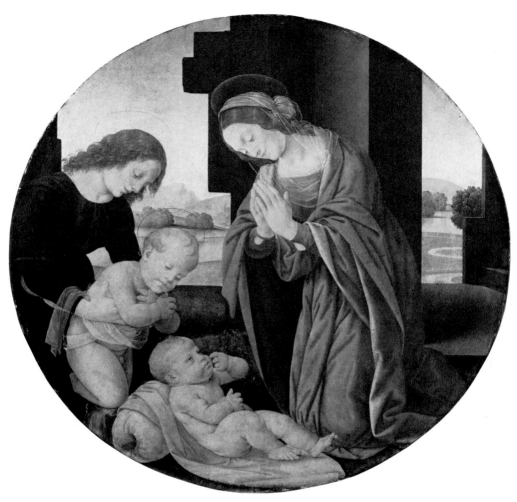

09.197

fig. 203, attributes it to Credi and dates it before 1510 // B. Degenhart, *Münchner Jahrb. der bild. Kst.*, n.f., IX (1932), pp. 131, 160, lists it and refers to it as a genuine late work by Credi // B. Berenson, *Ital. Pictures* (1932), p. 297, lists it as a work painted in great part by Credi; and *Flor. School* (1963), p. 116 // M. Hauptmann, *Der Tondo* (1936), p. 206, notes 2 and 3, dates it about 1490, calling it a later variation of Credi's tondo in Karlsruhe, compares it to the version in the Casati collection, Soncino, believes it might be by Credi's own hand except for the oversimplified background, and refers to a drawing by Dürer of 1495 that shows the Child in the same pose as in our picture // G. Dalli

Regoli, *Lorenzo di Credi* (1967), pp. 62 f., 159 f., no. 127, fig. 167, attributes it to Lorenzo di Credi, suggesting that it may be the earliest of the versions // E. Fahy, *Art Bull.*, LI (1969), p. 144, note 9, notes that the same composition appears in reverse in a tondo in the Pinakothek in Munich that he attributes to the early period of Fra Bartolomeo, suggesting that our painting might be the prototype.

EX COLL.: Frédéric Reiset, Paris; Mme de Ségur-Lamoignon, Paris; Viscountess Amelot de Roussilhe, Paris (1909); [Robert Dell, Paris, 1909].

PURCHASE, ROGERS FUND, 1909.

Botticelli

Real name Alessandro Filipepi. Born 1444 or 1445; died 1510. Botticelli was perhaps trained as a goldsmith, but according to an old tradition, confirmed by the style of his earliest works, he was a pupil of Fra Filippo Lippi. The greater part of his work was done in Florence, where the Medici were his principal patrons. In 1481, however, he went to Rome, and remained there about a year, painting three large frescoes for the Sistine Chapel in the Vatican. Botticelli's style shows the influence of Antonio Pollaiuolo and, to a lesser degree, of Andrea del Verrocchio, but its foundation rests mainly upon Filippo Lippi's linear treatment of forms. Filippo's son Filippino in turn studied with Botticelli, who late in his life was somewhat affected by his pupil's style. Although Botticelli's works display perhaps more than any others a highly personal and unique quality, they nevertheless are typical of a change in the character of Florentine painting as a whole that took place under the rule of the Medici. The strongly realistic tendencies of the early Renaissance gave way to an interest in the expression of emotion and poetry, especially in the many representations of the classical and Neoplatonic themes that preoccupied the Humanists in the circle of Lorenzo the Magnificent. In painting such subjects for them as the Primavera, the Birth of Venus, and Pallas Subduing the Centaur, Botticelli devised a sophisticated language and a sensitive use of calligraphic line. After the death of Lorenzo de' Medici in 1492 and the ensuing fall of the Medici family, he was profoundly moved by the preaching and martyrdom of the fanatic Girolamo Savonarola. His late works, which almost all had religious themes, reflect in their strained and nervous movement both the emotional climate of the times and his own heightened intensity.

The Last Communion of Saint Jerome
14.40.642

Botticelli painted this picture for Francesco di Filippo del Pugliese, a wool stapler, a patron of artists, and, like Botticelli, an ardent disciple of Savonarola. It has been identified with a small panel showing the death of Saint Jerome listed in Pugliese's first will in 1502 and also with a Saint Jerome mentioned in the Anonimo Gaddiano, a book compiled about the middle of the sixteenth century and one of Vasari's sources. Antonio Billi, another sixteenth century source, refers to a small painting of Saint Jerome by Botticelli. Our panel in illustrating the death of the saint follows the account quoted in Buonacorsi's *Life of Saint Jerome*, published in Florence in 1490. Although this work was painted by Botticelli for a private patron it must have been well known, since a number of more or less contemporary copies and versions exist. There is one in the Palazzo Balbi in Genoa, a second, very accurate one was formerly in the Abdy and Benson collections in London, and a third in 1953 on the art market of Paris (formerly in the Kay collection, Edinburgh).

A fourth, in the Pallavicini Gallery in Rome (no. 18), by Bartolomeo di Giovanni, is a free interpretation of our painting with considerable changes, particularly in the background. A pen drawing in the Robert Lehman collection in New York (no. G 104) is a faithful copy of the central group and was certainly made in Botticelli's shop.

Tempera on wood. H. 13½, w. 10 in. (34.3 × 25.4 cm.).

REFERENCES: The will of Francesco del Pugliese (Feb. 28, 1502), published by H. Horne, *Burl. Mag.*, XXVIII (1915), pp. 45 f., ill., lists this painting // Anonimo Gaddiano (about 1542–1556), fol. 85 recto, published in *Archivio storico italiano*, XII (1893), p. 84, mentions it // F. Fantozzi, *Nuova Guida* (1841), p. 399, mentions it as a work by Castagno // O. Mündler, *Zeitschr. für bild. Kst.*, II (1867), p. 279, recognizes it as probably the original of the Balbi copy but ascribes it to Filippino Lippi // J. Burckhardt, *Der Cicerone* (1874), III, p. 878, calls it probably the original of the copy in the Balbi collection, there ascribed to Filippino Lippi // G. B. Cavalcaselle (unpublished opinion, 1883?) attributes it to Filippino Lippi, notes that in the Capponi collection it was called a work by Castagno; and, with J. A. Crowe, *Ptg. in Italy*, IV (1911), p. 290, calls it a replica of the Balbi version, attributed to Filippino Lippi // I. Lermolieff [G. Morelli], *Kstkrit. Stud.-Rom* (1890), p. 146, note, calls it the original of the Balbi copy and ascribes it to Botticelli; and in a letter (1891) published in *Italianische Malerei der Renaissance im Briefwechsel* (1960), p. 580, attributes it to Botticelli // H. Ulmann, *Sandro Botticelli* (1893), p. 72, attributes it to Botticelli and dates it at the time of the Uffizi Saint Augustine (1485–1495) // Count Plunkett, *Sandro Botticelli* (1900), pp. 59 f., 116, calls it a work from the school of Botticelli // A. Streeter, *Botticelli* (1903), p. 157, lists it as a work by Botticelli // B. Berenson, *Drawings of Florentine Painters* (1903), I, p. 62, attributes it to Botticelli; *Flor. Ptrs.* (1909), p. 117; in a letter (1912), attributes it to Botticelli; *Ital. Pictures* (1932), p. 104, lists it as a work by Botticelli: *I Disegni de' pittori fiorentini* (1961), II, p. 111, no. 580 A, fig. 200, considers the Lehman drawing a contemporary copy after our picture; and *Flor. School* (1963), p. 37, pl. 1087 // J. Cartwright [Ady], *Botticelli* (1904), pp. 136 f., 190, lists it as a work by Botticelli and notes that critics have identified it with the painting mentioned by Antonio Billi and the Anonimo Gaddiano // M. C. Diehl, *Botticelli* [1906?], p. 165, lists it as a work by Botticelli // H. P. Horne, *Sandro Botticelli* (1908), pp. 174 ff., ill., attributes it to Botticelli, dates it about 1490, and refers to an apocryphal letter by Eusebius as the source of the subject; *Met. Mus. Bull.*, X (1915), pp. 52 ff., 72 ff., 101 ff., ill. pp. 39, 73, 103, gives an extensive account of the Pugliese family, identifying the patron for whom Botticelli painted this picture as Francesco del Pugliese; and *Burl. Mag.*, XXVIII (1915), pp. 45 f., ill., publishes Pugliese's will // C. Gamba, in Thieme-Becker, IV (1910), p. 419, lists it as a late work by Botticelli; and *Botticelli* [1937], pp. 177 f., fig. 148, dates it in the first half of the 1490's and hesitantly accepts it as the one mentioned in Pugliese's will; refers to another small Saint Jerome by Botticelli mentioned by the Anonimo Gaddiano and to a Communion of Saint Jerome by an unknown painter that was in the collection of Lorenzo the Magnificent and notes that there were several replicas // R. L. Douglas, ed., in Crowe and Cavalcaselle, *Ptg. in Italy*, IV (1911), p. 270, note, attributes it to Botticelli and calls it the original of the Balbi and Abdy copies // A. Venturi, *Storia*, VII, part I (1911), p. 642, note, assigns it to the latest period of Botticelli; and *Botticelli* (1926), pp. 55, 98, pl. CXXVII, dates it about the time of the portrait of Lorenzano in the Johnson collection in the Philadelphia Museum // W. von Bode, *Sandro Botticelli* (1921), pp. 157 f., ill., and *Botticelli* (*Kl. der Kst.*) (1926), ill. p. 73, attributes it to Botticelli and dates it about 1490 // F. Monod, *Gaz. des B.-A.*, VIII (1923), pp. 183 f., ill., attributes it to Botticelli and dates it between 1490 and 1502 // Y. Yashiro, *Sandro Botticelli* (1925), I, pp. 186, 210 f., 230, 243, III, pl. CCXXXIX, calls it a very late work by Botticelli, dating it 1498, and notes a fourth version (a free copy) in the collection of Mr. A. Kay // R. van Marle, *Ital. Schools*, XII (1931), p. 160, fig. 98, ascribes it to Botticelli, dates it slightly later than the Uffizi Saint Augustine, and notes analogies to the Calumny in the Uffizi // L. Venturi, *Ital. Ptgs. in Amer.* (1933), pl. 254, ascribes it to Botticelli and dates it about 1500; and *Botticelli* (1937), p. 22, ill., dates it about 1490 // R. Offner (verbally, 1935) attributes it to Botticelli // H. Tietze, *Meisterwerke europäischer Malerei in Amerika* (1935), p. 327, pl. 52, attributes it to Botticelli // A. Scharf, *Filippino Lippi* (1935), p. 117, no. 142, calls it a replica of the Balbi painting, which he lists as a work by Filippino Lippi // J. Mesnil, *Botticelli* (1938), pp. 157 ff., pl. 87, accepts it as the one mentioned in Pugliese's will // *Duveen Pictures* (1941), no. 104, ill. // S. Bettini, *Botticelli*

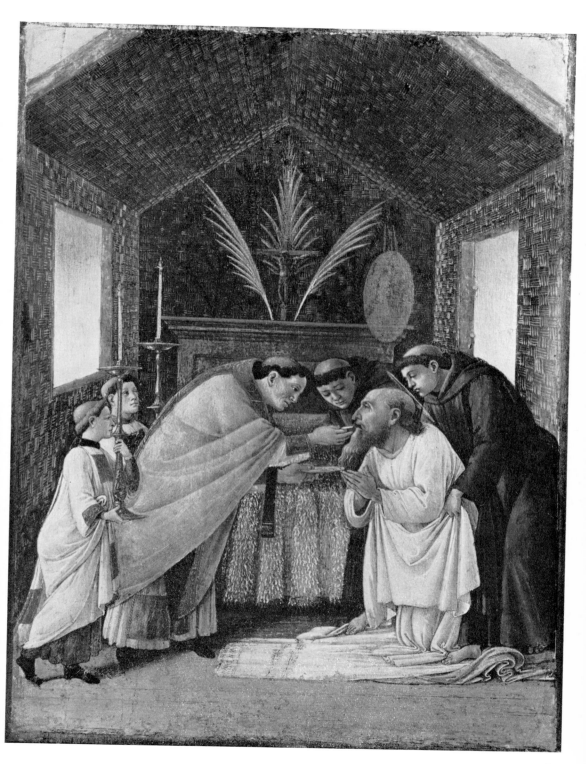

(1942), pp. 40, 45, pl. 142 A, attributes it to Botticelli and tentatively dates it about 1503 // *Art Treasures of the Metropolitan* (1952), p. 225, pl. 88 (in color) // G. Kaftal, *Iconography of Saints in Tuscan Painting* (1952), col. 529, fig. 607, attributes it to Botticelli // G. C. Argan, *Botticelli* (1957), p. 124, ill. p. 118 (in color), attributes it to Botticelli, dating it about 1490 // R. Salvini, *Tutta la pittura del Botticelli* (1958), II, p. 53, pl. 69, attributes it to Botticelli, dating it shortly after 1490 // F. Zeri, *La Galleria Pallavicini in Roma* (1959), pp. 33 f., publishes the copy by Bartolomeo di Giovanni, identifying our painting with the one painted by Botticelli for Francesco del Pugliese.

EXHIBITED: Metropolitan Museum, New York, 1952–1953, *Art Treasures of the Metropolitan*, no. 80.

EX COLL.: Francesco di Filippo del Pugliese, Florence (by 1502–1519); Niccolò di Piero del Pugliese, Florence (1519–before 1553); Marchese Gino Capponi, Palazzo Capponi, Florence (by 1841; until 1876; as Castagno); Marchese Farinola, Palazzo Capponi, Florence (1876–1912); [Duveen Brothers, New York, 1912]; Benjamin Altman, New York (1912–1913).

In the Altman galleries.

BEQUEST OF BENJAMIN ALTMAN, 1913.

Three Miracles of Saint Zenobius 11.98

This painting is related to three similar pictures also illustrating the life and miracles of Saint Zenobius, one in the picture gallery in Dresden and two in the National Gallery in London (Mond collection). Although there is some variation in size (Dresden, no. 9, 26×71⅝ in.; National Gallery, nos. 3918, 3919, 26×58¾ in. and 25×55 in.) the common provenance of the four panels is unquestionable, and it is known that they were still together in the nineteenth century in the Rondinelli collection in Florence. It has been suggested that the series had some connec-

tion with Botticelli's project for mosaics, commissioned by Lorenzo de' Medici in 1491 for the chapel of Saint Zenobius in the cathedral of Florence but never executed. The style of the panels, however, clearly indicates a later date, possibly towards the beginning of the 1500's. Saint Zenobius, who died during the first quarter of the fifth century, was bishop of Florence and one of her patron saints. The paintings follow Tolosani's version of his legend, written in 1487. Our panel shows him at the left restoring to life a dead youth whose funeral procession he had met. In the center he is reviving a messenger, killed while journeying to him with gifts of relics from Saint Ambrose. At the right, in the background, he is handing to Saint Eugenius a cup of holy water with which to bless a relative who had died without receiving the sacrament; Saint Eugenius is then shown hastening across the piazza and, in the foreground, sprinkling the water on his relative and reviving him. The coffin in the center had been overpainted to cover the two skeletons in it; it was uncovered during a cleaning in the Museum in 1946.

Tempera on wood. H. 26½, w. 59¼ in. (67.3×150.5 cm.).

REFERENCES: The authorities cited below, with the exception of Bode and Offner, attribute this painting to Botticelli. C. F. von Rumohr, *Italienische Forschungen*, II (1827), p. 273, publishes the Dresden panel as a fairly late work by Botticelli and says that it came from the Compagnia di San Zanobi in Florence // Crowe and Cavalcaselle, *Painting in Italy*, II (1864), p. 430, call the Dresden panel an early work // I. Lermolieff [G. Morelli], *Kstkrit. Stud.-München und Dresden* (1891), p. 336 // H. Ulmann, *Sandro Botticelli* (1893), p. 139, connects our panel with those in London and Dresden and dates them in the artist's late period but doubts whether they, especially the Dresden panel, were executed by Botticelli himself // Count Plunkett, *Sandro Botticelli* (1900), pp. 23, 31, 73 f., assigns the

four panels to the artist's late period // M. C. Diehl, *Botticelli* [1906?], p. 162, dates the Dresden and London panels in 1491 // H. P. Horne, *Sandro Botticelli* (1908), pp. 308 ff.; and *Met. Mus. Bull.*, X (1915), pp. 238 f., tentatively dates the Mond pair as late as 1505 and suggests that the four panels were intended as decoration for a private house and that one, if not both, of the Mond panels has been cut down // J. P. Richter, *The Mond Collection* (1910), II, pp. 401 ff., dates the Mond pair 1470–1480; and *Art in Amer.*, III (1915), pp. 192 ff., calls them early works and suggests that the series may have included a fifth panel showing the death of the saint // B. B[urroughs], *Met. Mus. Bull.*, VI (1911), pp. 185 ff., ill., dates them about 1490–1495 and suggests that they were painted for furniture decoration // C. J. Ff[oulkes], *L'Arte*, XV (1912), pp. 269 f., discusses the Mond panels, especially their subject matter // L. M. Richter, *Zeitschr. für bild. Kst.*, n.f., XXIV (1913), pp. 94 ff., fig. 1 // P. Schubring, *Cassoni* (1915), pp. 119, 290, no. 308, pl. LXXIV, dates the series about 1480 and presumes that it decorated the walls or the closet doors of the Archbishop's Palace in Florence // G. Poggi, *Riv. d'arte*, IX (1916), pp. 62 ff., dates the series 1490–1495 // W. von Bode, *Sandro Botticelli* (1921), pp. 164 ff., and *Botticelli* (*Kl. der Kst.*) (1926), p. XL, ill. p. 99, dates the series 1493–1500, presumes that it was executed by Botticelli's pupils after his designs for mosaics and that the panels were to be inserted in wainscoting // R. Fry, *Burl. Mag.*, XLIV (1924), pp. 234, 239, 312, calls the series a late work // A. Venturi, *L'Arte*, XXVII (1924), pp. 204 f., and *Botticelli* (1926), pp. 75 f., suggests a date in the artist's last period // Y. Yashiro, *Botticelli* (1925), I, pp. 196, 214, 230, III, pl. CCXLII, dates the series 1498 // R. van Marle, *Ital. Schools*, XII (1931), p. 188, fig. 111, suggests a dating slightly later than 1500 // B. Berenson, *Ital. Pictures* (1932), p. 104, lists our panel as a late work; and *Flor. School* (1963), p. 37, pl. 1090 // L. Venturi, *Ital. Ptgs. in Amer.* (1933), pl. 259, dates it about 1505; and *Botticelli* (1937), pp. 13, 24 f., ill. p. 15 // R. Offner (verbally, 1935) rejects the attribution of our panel

to Botticelli // C. Gamba, *Botticelli* [1937], pp. 195 f., pl. 181, calls it a late work and hesitantly connects the series with the payments that Botticelli received from 1503 to 1505 from the Compagnia di San Luca in Florence (for documents, see H. P. Horne, *Sandro Botticelli*, 1908) // J. Mesnil, *Botticelli* (1938), pp. 183 f., 215, 225, pl. CV, dates the series in Botticelli's late period and suggests that the four panels were the decoration of a large chest for a religious brotherhood // S. Bettini, *Botticelli* (1942), pp. 40, 45, pl. 143 B, tentatively dates the series 1505, suggesting a connection with the documents of 1503 published by Horne // G. Kaftal, *Iconography of Saints in Tuscan Ptg.* (1952), col. 1036, fig. 1166 // W. and E. Paatz, *Die Kirchen von Florenz*, III (1952), pp. 424 f., 612, note 746, accept the idea that the series came from the Compagnia di San Zanobi and date the panels around 1503–1504, call them possibly part of a chest, attributing them to Botticelli // G. C. Argan, *Botticelli* (1957), p. 131, ill. pp. 132 (in color), 134 (detail in color), dates them after 1500 // R. Salvini, *Tutta la pittura del Botticelli* (1958), II, pp. 34, 68, pls. 124, 126 (detail), considers the series as decorative paneling from a room of one of the Florentine confraternities dedicated to Saint Zenobius, dating it about 1500–1505 // M. Davies, *The Earlier Italian Schools* (*National Gallery Catalogue*) (1961), p. 109, rejects the idea that the panels belonged to the Compagnia di San Zanobi attached to the cathedral of Florence and does not accept Richter's dating in the artist's early period.

EXHIBITED: Louvre, Paris, 1885, *Tableaux . . . Orphelins d'Alsace-Lorrains*, no. 37 (lent by Sir William Abdy).

EX COLL.: Marchese Rondinelli, Florence; [Giuseppe Baslini, Milan]; Sir William N. Abdy, London (by 1885; sale, Christie's, London, May 5, 1911, no. 87); [R. Langton Douglas, London, 1911].

PURCHASE, KENNEDY FUND, 1911.

Follower of Botticelli

The Coronation of the Virgin 49.7.4

This picture shows the Coronation of the Virgin in an unusually stark and simple

setting. The Virgin is being crowned by Christ wearing the triple tiara, representing the Holy Trinity, in the presence of Saints Anthony Abbot, John the Baptist, Julian the

49.7.4

Hospitaller, and Francis of Assisi. The figure of the Virgin recalls the Virgin in the large Coronation painted by Botticelli in 1490, now in the Uffizi in Florence (no. 8362), and the four saints, in their facial types and gestures, reflect the forms and figures painted by him a little later, towards the end of the century. There is, however, a lack of energy, both in the drawing and in the psychological expression, which indicates that the picture is not by Botticelli but by a follower, someone perhaps familiar with the work of Raffaellino del Garbo. The painting is in an extremely poor state of preservation, and many areas, especially in the Virgin's robe and in the face of Saint Anthony Abbot have suffered losses of pigment and repeated restorations. But even so, it is clear that, painted near the turn of the century, it cannot have been made in Botticelli's workshop since its academic, dry quality is far removed from the emotional character of Botticelli's late works.

Tempera on canvas, transferred from wood; gold haloes. H. 39½, w. 60¼ in. (100.3 × 153 cm.).

REFERENCES: The authorities cited below attribute this painting to Alessandro Botticelli. B. Berenson (unpublished opinion, 1927) calls it close to the Pietà in Munich; *Ital. Pictures* (1932), p. 104, dates it not later than 1486; and *Flor. School* (1963), p. 37 // H. E. Wortham, *Apollo*, XI (1930), p. 352, calls it a work of Botticelli's later period // A. L. Mayer, *Pantheon*, VI (1930), p. 541, ill. p. 537, dates it about 1495–1500 // R. van Marle, *Ital. Schools*, XII (1931), p. 172, fig. 104, dates it immediately before 1500 // C. Gamba, *Botticelli* (1936), p. 163, pl. 135, calls the saint beside Saint Francis Minias and dates the painting after 1490 // *Duveen Pictures* (1941), no. 103, ill., dates it about 1486 // S. Bettini, *Botticelli* (1942), p. 36, pl. 115 C, compares it with the large Coronation in the Uffizi // R. Salvini, *Tutta la pittura del Botticelli* (1958), II, p. 48, pl. 49, dates it about the time of the Coronation in the Uffizi.

Follower of Botticelli

The Madonna and Child 41.116.1

This picture combines motives from some of Botticelli's most famous works. The head of the Madonna and certain details recall the San Barnaba altarpiece, now in the Uffizi in Florence (no. 8361), while the figure of the Christ Child seems to be a version of the Child in the so-called Convertite altarpiece, also in the Uffizi (no. 8657). The weakness of the drawing and modeling, as well as the rather dull and empty expressions, suggests that it is by a follower of Botticelli who was perhaps not even a helper in his shop. The picture seems to have been painted towards the end of the fifteenth century or in the first decade of the sixteenth. At the bottom, concealed by the frame, there is an unfinished section of about $2\frac{1}{4}$ inches.

Tempera on wood. H. $29\frac{1}{4}$, w. 16 in. (74.3×40.6 cm.).

41.116.1

REFERENCES: The authorities cited below, with the exception of R. van Marle, attribute this painting to Botticelli. G. Gronau (unpublished opinion, 1926) // D. von Hadeln (unpublished opinion, 1926) // R. Longhi (in a letter, 1926) dates it about 1483–1485 // A. L. Mayer (unpublished opinion, 1926) // W. Suida (unpublished opinion, 1926) dates it about 1485 // G. Swarzenski (unpublished opinion, 1927) // R. van Marle, *Ital. Schools*, XII (1931), p. 241, fig. 148, attributes it to the school of Botticelli.

Filippino Lippi

Born probably in 1457; died 1504. Filippino, the son of the painter Fra Filippo Lippi and the nun Lucrezia Buti, was doubtless trained first by his father and afterwards by his father's assistant Fra Diamante. Later he became the pupil of Botticelli, who profoundly influenced the development of his style. About 1483 or 1484 Filippino was chosen to complete Masolino's and Masaccio's great series of frescoes in the Brancacci chapel in the church of the Carmine in Florence, and in his work there he altered his own style to harmonize with the breadth and solidity of Masaccio's. He also worked in Rome, in the church of Santa Maria sopra Minerva, in the Villa at Poggio a Caiano near Florence, and in the Strozzi chapel in Santa Maria Novella in Florence. Filippino's style is the culmination of the linear treatment of forms that characterized the works of his predecessors Filippo Lippi and Botticelli. His figures are outlined with nervous and sensitive drawing, and the agitated movement typical of his compositions often reaches a point of extreme tension. Filippino Lippi is indeed one of the first Florentines to express fully the deep unrest in art and thought that eventually led to Mannerism.

The Madonna and Child 49.7.10

On the capital of the nearer column seen through the window is the coat of arms of the Strozzi family, consisting of an escutcheon with three crescents on a fess. Crescents also appear on the spandrel above it. This picture was therefore probably commissioned by a member of the Strozzi family, for whom Filippino Lippi decorated the family chapel in the church of Santa Maria Novella between 1487 and 1502. This picture appears from stylistic evidence to have been painted around 1485. In several details it is closely related to the tondo of the Madonna and Child in the Corsini Gallery and to the Tanai de' Nerli altarpiece in Santo Spirito in Florence, which are generally regarded as works of the 1480's. Furthermore the motive of the Christ Child playing with the leaves of the book also occurs in the

Uffizi Sacra Conversazione, which is signed and dated 1485. The influence of fifteenth-century Flemish painting is to be observed in the view of the city seen through the loggia at the left, as well as in the book and candlestick at the right of the Madonna. The composition of this picture was copied, with a number of variations, by Piero di Cosimo in a panel now in the Royal Palace in Stockholm; there is also a copy by an early sixteenth-century Florentine artist who was a follower of Filippino Lippi or Raffaellino del Garbo in the City Gallery of Mainz, Germany (no. 215).

Tempera and oil on wood. H. 32, w. $23\frac{1}{2}$ in. (81.3 × 59.7 cm.).

REFERENCES: The authorities cited below attribute this painting to Filippino Lippi. G. Frizzoni, *Rass. d'arte*, v (1905), p. 6, fig. 7, observes that it was certainly painted for the Strozzi family and dates it

49.7.10

close to 1478 // P. Schubring, *Zeitschr. für christliche Kst.*, XVIII (1905), cols. 97 ff., pl. 3, dates it about 1485, points out that its color and light and its use of genre details are derived from the Portinari altarpiece by Hugo van der Goes, and suggests that this picture was perhaps a bridal gift for the second wedding of Filippo, the eldest son of Filippo Strozzi, who remarried in Florence after returning from his exile in Naples in 1479 // B. Berenson, *Flor. Ptrs.* (1909), p. 148; *Ital. Pictures* (1932), p. 286; and *Flor. School* (1963), p. 110 // A. Venturi, *Storia*, VII, part I (1911), p. 674, note 1 // R. L. Douglas, ed., in Crowe and Cavalcaselle, *Ptg. in Italy*, IV (1911), p. 292, note 4 // G. Gronau, in Thieme-Becker, XXIII (1929), p. 270; and *Pantheon*, VI (1930), pp. 512 f., ill., dates it about 1487 and points out that it was the model for Piero di Cosimo's panel in Stockholm // H. E. Wortham, *Apollo*, XI (1930), p. 352, notes the influence of Botticelli // R. van Marle, *Ital. Schools*, XII (1931), p. 318 // A. Scharf, *Art in Amer.*, XIX (1931), pp. 59 ff., fig. 2 (erroneously captioned as by Piero di Cosimo), dates it about 1487 and mentions the copies in Stockholm and in the City Gallery of Mainz; and *Filippino Lippi* (1935), pp. 26, 31 f., 108, no. 33, pl. 19, dates it about 1485, regarding it as a trial piece for the contract of 1487 to decorate the walls of the Strozzi chapel in Santa Maria Novella, and suggests that the flat architectural background was influenced by contemporary relief sculpture // L. Venturi, *Ital. Ptgs. in Amer.* (1933), pl. 263 // O. Sirén, *Italienska Tavlor och Techningar* (1933), pp. 64 ff., ill., mentions it in connection with Piero di Cosimo's panel in the Royal Palace of Stockholm // K. B. Neilson, *Filippino Lippi* (1938), pp. 27, 68 ff., 72, 114, 116, 119 f., 123, fig. 26, dates it about 1487 and suggests that it may have been derived from Botticelli's Madonna in the Poldi-Pezzoli Museum in Milan, which, though undated, appears to belong to the 1480's // *Duveen Pictures* (1941), no. 112, ill. // F. Zeri, *Paragone*, X (1959), no. 115, p. 45, mentions it in connection with Piero di Cosimo's panel in Stockholm and dates it about 1485 // L. Grassi, *Piero di Cosimo* (1963), p. 38, observes that it was imitated by Piero di Cosimo in the Stockholm panel // M. Bacci, *Piero di Cosimo* (1966), pp. 66 f., quotes R. Longhi as calling this picture a replica, not entirely by Filippino's own hand, of a postulated original by Filippino (1475–1480) that inspired Piero di Cosimo's Stockholm painting.

EXHIBITED: Düsseldorf, 1904, *Kunsthistorische Ausstellung*, no. 244 (lent by Prof. Götz Martius); World's Fair, New York, 1939, *Masterpieces of Art*, no. 216 (lent by Jules S. Bache); Metropolitan Museum, New York, 1943, *The Bache Collection*, no. 10 (lent by Jules S. Bache).

EX COLL.: possibly Strozzi, Florence; Don Marcello Massarenti, Rome (before 1900); [Nikolaus Steinmeyer, Cologne, about 1900]; Dr. Götz Martius, Kiel (about 1900–1920); [Van Diemen, Berlin, about 1920–1923]; [Duveen Brothers, New York, 1923–1928]; Jules S. Bache, New York (1928–1944; Cat., 1929, no. 10).

THE JULES S. BACHE COLLECTION, 1949.

Workshop of Filippino Lippi

The Descent from the Cross 12.168

The composition of this painting is related to that of the large altarpiece, now in the Uffizi in Florence (no. 8370), for which Filippino Lippi received a commission in 1503 and which was still unfinished in 1505 at his death. The completion of the work was entrusted to Pietro Perugino, who finished it by January, 1506, altering the lower part of the composition and in the upper part, which had been almost completed by Filippino, transforming the figures to resemble his own work. Our painting shows no connection at all with Pietro Perugino, and its lower part is quite different from that section of the Uffizi altarpiece. It clearly depends on Filippino and was probably painted in his workshop, directly from a small-size model or from sketches that the painter had prepared for the altarpiece. It is one of several versions, none of them good

enough to be considered Filippino's original model. Others belonged to the Bellini collection in Florence, to Viscount Rothermere in London, and to J. Böhler of Munich (see G. Gronau, *Zeitschr. für bild. Kst.*, LX, 1926, pp. 22 f.).

Formerly attributed by the Museum to an unknown Florentine painter of the early XV (*sic* for XVI) Century (Cat., 1940).

Tempera on wood. H. 22, w. 16 in. (55.9 × 40.6 cm.).

REFERENCES: B. B[urroughs], *Met. Mus. Bull.*, VII (1912), pp. 216 f., ill., attributes this painting to a close follower of Filippino Lippi, working from his sketches // P. G. Konody, *Apollo*, II (1925), pp. 190 f., ill., calls it a work of the school of Filippino and considers Lord Rothermere's version Filippino's original sketch // R. van Marle, *Ital. Schools*, XII (1931), p. 356, fig. 232, describes it as at least a product of Filippino's workshop // A. Scharf, *Filippino Lippi* (1935), p. 108, no. 28 A, pl. 91, calls it one of four copies after Filippino's original composition // K. B. Neilson, *Filippino Lippi* (1938), pp. 179 ff., fig. 91, considers it a work of Filippino's shop, derived directly from a sketch by him.

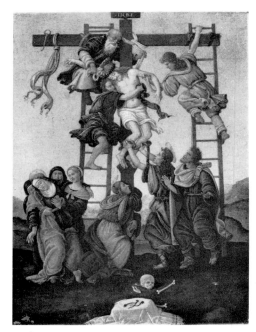

12.168

EX COLL. [Elia Volpi, Florence, 1912].

PURCHASE, KENNEDY FUND, 1912.

Jacopo del Sellaio

Real name Jacopo di Arcangelo. Born 1441 or 1442; died 1493. This painter takes his name from the trade of his father, a saddler, *sellaio* in Italian. Jacopo's first authenticated work is the Annunciation of about 1473 in the church of Santa Lucia dei Magnoli in Florence. In 1483 or 1484 he was working on a Pietà once in the church of San Frediano in Florence and now in the Berlin Museum (no. 1055); a Crucifixion, still in San Frediano, is traditionally assigned to him. Jacopo del Sellaio worked with Filippo di Giuliano as a partner in 1473 and again in 1480–1481, but there is no basis on which we may establish a distinction between the two painters, since no signed or authenticated work of Filippo exists. The panels of the fairly large and homogeneous group ascribed to Jacopo del Sellaio are often unequal in quality, suggesting that he conducted an active workshop. He was an essentially modest and derivative artist. Vasari says that he was a pupil of Filippo Lippi, but the work that goes under his name reflects all the major painters of the contemporary Florentine school, chiefly Botticelli, Filippino Lippi, and, less markedly, Domenico Ghirlandaio. Jacopo's best works are his fine and delicately drawn cassone panels, in which narratives are unfolded against rich and imaginative landscapes.

The Madonna Adoring the Child, with the Infant Saint John the Baptist

41.100.10

The composition of this painting is often repeated with variations in works from Jacopo del Sellaio's shop. It appears in tondos in the Pitti Gallery in Florence (no. 364) and the Ca' d'Oro in Venice and in panels with arched tops in the Walters Art Gallery in Baltimore (no. 754) and the Johnson collection in the Philadelphia Museum (no. 52). In the Johnson panel, as in many others, the figure of the little Saint John is omitted. Although the chronology of Jacopo del Sellaio's works is unclear, the fact that the influences of Botticelli and Filippino Lippi are combined in our picture suggests that it was painted in the late 1480's. In the background high at the right a small figure of an angel once shown in the sky, part of the Annunciation to the Shepherds, was removed by cleaning before the picture came to the Museum.

Tempera on wood. H. 41, w. 27 in. (104.2 × 68.6 cm.).

REFERENCES: R. van Marle, *Ital. Schools*, XII (1931), p. 381, attributes this painting to Jacopo del Sellaio // B. Berenson, *Ital. Pictures* (1932), p. 527, lists it as a work by Jacopo del Sellaio; and *Flor. School* (1963), p. 198 // John G. Johnson Collection, *Catalogue of Italian Paintings* (1966), p. 70, no. 52, calls it one of the versions closest to the Johnson example.

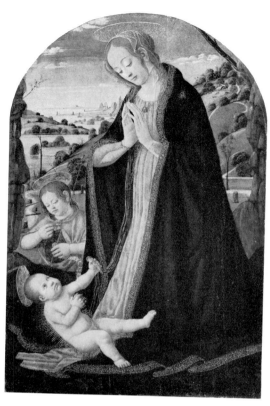

41.100.10

EX COLL.: Count Bellini delle Stelle, Florence, Cav. Marcello Galli-Dunn, Castello di Badia, Poggibonsi, Tuscany; [Dowdeswell and Dowdeswell, London and New York; sale, American Art Galleries, New York, Apr. 7, 1904, no. 116]; George and Florence Blumenthal, New York (Cat. I, 1926, pl. XIII).

GIFT OF GEORGE BLUMENTHAL, 1941.

Unknown Florentine Painter, End of the XV Century

The Annunciation 53.115

This tondo is the work of an anonymous Florentine artist who was painting toward the end of the fifteenth century in a style that stems from the immediate following of Botticelli and Jacopo del Sellaio. The Madonna's face and hands are clearly derived from Botticelli's types of the early 1480's, and it is possible that the painter began his

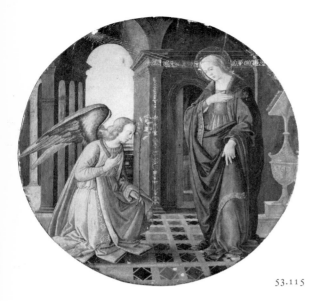

53.115

career in Botticelli's workshop around that time. There is also in the style a strong influence from Domenico Ghirlandaio, which probably came through Bartolomeo di Giovanni. A number of paintings now attributed to the school of Botticelli or of Ghirlandaio seem rather to be by the painter of this picture. Among these are four panels from the Kress collection, now ascribed to the Master of the Apollo and Daphne

Legend, two representing the story of Apollo and Daphne (Kress Foundation, K 1721A and B), two representing episodes from the life of Saint John the Baptist (Howard University, Washington, D.C., K 1152 A and B), and three cassone panels in the Walters Gallery in Baltimore (nos. 37.480, 485, 490) showing the history of Susanna.

Formerly attributed by the Museum to a follower of Filippino Lippi.

Tempera on wood. Diam. $32\frac{3}{8}$ in. (82.3 cm.).

REFERENCES: F. R. Shapley, *Paintings from the Samuel H. Kress Collection* (1966), pp. 129 f., agrees with F. Zeri's attribution of this picture to the painter of four panels in the Kress collection, whom she calls the Master of the Apollo and Daphne Legend // E. Fahy, *Museum Studies*, 3 (1968), pp. 31, 39, no. 19, agrees in calling it a work by the Master of Apollo and Daphne and notes strong similarities to works by Bartolomeo di Giovanni.

EX COLL.: a private collection, St. Petersburg (until 1911); [Victor G. Fischer, Washington, D.C., 1911]; Mr. and Mrs. George B. McClellan, Washington, D.C. (by 1917; until 1952).

BEQUEST OF GEORGIANA MCCLELLAN, 1952.

Raffaellino del Garbo(?)

Raffaellino del Garbo. Real name Raffaelle di Bartolomeo di Giovanni di Carlo. Probably born before 1479; died 1524 or a few years later. Raffaelle, also called Raffaellino Capponi after the family that protected him when he became an orphan, is assumed to be the Raffaellino del Garbo mentioned by Vasari and the earlier Anonimo Magliabechiano as the painter of works that closely resemble paintings by Filippino Lippi, with some suggestions of Ghirlandaio and Perugino. A document of matriculation in the painters' guild in 1499 naming a Raphael Bartolomei Nicolai Capponi "pictor nel Garbo" (apparently his Florentine street address) may confirm this assumption. There are two paintings with Carli as part of the signature and one with a signature that includes the name Capponi. These three paintings are somewhat different in style from those attributed to Raffaellino by Vasari, and some critics believe them to be by another hand.

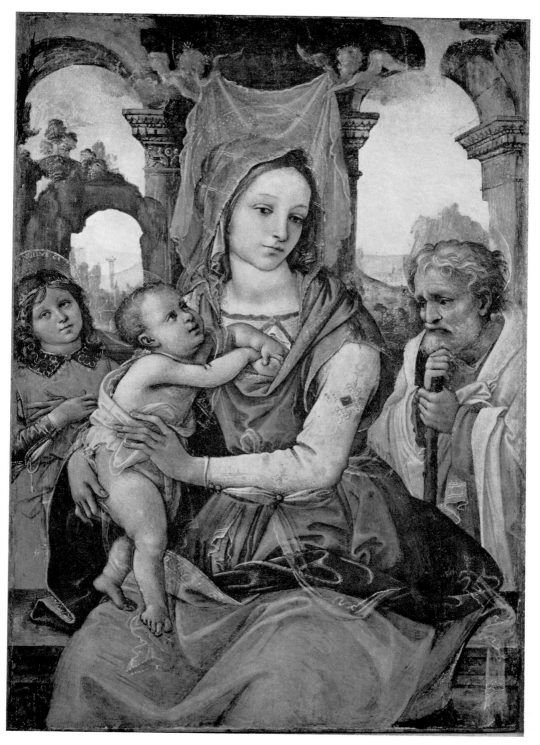

The Madonna and Child with Saint Joseph and an Angel 14.40.641

This painting closely follows the elaborate style of Filippino Lippi's late period, but the execution is not his, nor are the range of color, the facial expressions, or the treatment of landscape and draperies characteristic of him. The same relationship to the style of Filippino is found in certain works usually ascribed to Raffaellino del Garbo, as, for instance, the Madonna and Child with Two Female Saints in the National Gallery in London (no. 5903). The London picture, however, must be of a slightly different period from ours, since the borrowings from Filippino are less pronounced in it and there are also some reflections of Domenico Ghirlandaio. It is quite possible that our panel was executed in Filippino's workshop, probably based on his cartoon.

Inscribed (on halo of angel): ANGELVS GRAD . . . SR.

Formerly attributed by the Museum to the workshop of Filippino Lippi (Cat., 1940).

Tempera on canvas, transferred from wood. H. 22, w. 15 in. (55.8 × 38.1 cm.).

REFERENCES: F. Monod, *Gaz. des B.-A.*, LXV (1923), II, p. 183, attributes this painting to Filippino Lippi // R. van Marle, *Ital. Schools*, XII (1931), p. 352, fig. 229, attributes it to Filippino and dates it tentatively at the time of the Strozzi frescoes (1500–1502) // B. Berenson, *Ital. Pictures* (1932), p. 286, lists it as a late work by Filippino; and *Flor. School* (1963), p. 110 // A. Scharf, *Jahrb. der Preuss. Kstmlgn.*, LIV (1933), p. 159, and *Filippino Lippi* (1935), p. 119, no. 165, pl. 127, fig. 215, attributes it to Raffaellino del Garbo // R. Offner (verbally, 1937) attributes it to a follower of Filippino // R. Longhi (unpublished opinion, 1937) attributes it to Filippino, not to a pupil // F. Mason Perkins (in a letter, 1938) suggests calling it a late work by Filippino // K. B. Neilson, *Filippino Lippi* (1938), p. 217, fig. 213, attributes it to a workshop assistant of Filippino, using his design, and dates it about 1500.

EX COLL.: Mme. A. de Couriss, Dresden (until 1911); [Duveen Brothers, New York, 1911–1912]; Benjamin Altman, New York (1912–1913).

In the Altman galleries.

BEQUEST OF BENJAMIN ALTMAN, 1913.

Piero di Cosimo

Real name Piero di Lorenzo. Born 1462; died 1521(?). The eccentricities of Piero di Cosimo's character and a number of anecdotes about his life are described in detail by Vasari, but little is known about the development of his art. In 1480 he is mentioned as a pupil in the studio of Cosimo Rosselli, and in the following year, when Rosselli went to Rome to work in the Sistine chapel in the Vatican, Piero is said to have been with him as his assistant. Because there are no signed or documented pictures by Piero di Cosimo, those mentioned as his in Vasari's biography are the only basis for our idea of his work. His early paintings show that he was deeply affected by the work of Filippino Lippi, but his more advanced style reveals also the influence of Leonardo and Signorelli and Hugo van der Goes's Portinari altarpiece. The

delicate lyricism of his style, which combines a knowledge of Flemish art with his Florentine inheritance, gives Piero di Cosimo a very special position among his contemporaries, as one of the last great figures of the early Renaissance in Florence.

The Young Saint John the Baptist

22.60.52

This painting, depending heavily on Filippino Lippi, must be considered one of Piero's earliest works. The sharply silhouetted profile and the facial expression call to mind Piero's famous portrait of Simonetta Vespucci in the Musée Condé at Chantilly, which was painted, however, at a much later date.

Tempera on wood. H. 11½, w. 9¼ in. (28.5 × 23.5 cm.).

REFERENCES: The authorities cited below, with the exception of G. F. Waagen, attribute this painting to Piero di Cosimo. G. F. Waagen, *Treasures – Gt. Brit.* (1854), II, p. 330, attributes it to Antonio Pollaiuolo // T. Borenius, ed., in Crowe and Cavalcaselle, *Ptg. in Italy*, VI (1914), p. 48, note // E. Bertaux, Aynard Sale Cat. (1913), p. 75, no. 60, compares it with the profile portrait attributed to Pollaiuolo in the Poldi-Pezzoli collection // H. B. W[ehle], *Met. Mus. Bull.*, XVII (1922), p. 102, ill. p. 106 // R. van Marle, *Ital. Schools*, XIII (1931), p. 350, notes the influence of Filippino Lippi // B. Berenson, *Ital. Pictures* (1932), p. 454; and *Flor. School* (1963), p. 176 // K. B. Neilson, *Filippino Lippi* (1938), p. 129, fig. 58, observes that it was painted under the influence of Filippino, noting its similarity to an angel by him in San Gimignano // R. L. Douglas, *Piero di Cosimo* (1946), p. 114, pl. 49 // B. Nicolson, *Burl. Mag.*, XCVII (1955), pp. 208, 213, no. 34, quotes the Sanford collection catalogues, stating that it was acquired in Florence as a work by Pollaiuolo // P. Morselli, *L'Arte*, LVI (1957), ill. p. 171, fig. 20, and LVII (1958), p. 82 // F. Zeri, *Paragone*, X (1959), no. 115, p. 48, observes the influence of Filippino and dates it about 1482–1484 // L. Grassi, *Piero di Cosimo* (1963), pp. 37 f., dates it about 1490, noting a strong influence of Filippino // M. Bacci, *Piero di Cosimo* (1966), pp. 24, 65 f., pl. 2, dates it before Piero di Cosimo's trip to Rome (1481–1482) with Cosimo Rosselli, among the youthful works strongly inspired by Filippino Lippi, closely related to Filippino's Sto-

ries of Esther at Chantilly // F. Abbate, *Paragone*, XIX (1968), no. 215, p. 75, includes it among the artist's early works.

EXHIBITED: British Institution, London, 1849, no. 106 (as Pollaiuolo, lent by C. S. Bale).

EX COLL.: Bentivoglio, Florence (before 1833); Rev. John Sanford, Casino Torrigiani, Florence, and London (by 1833; sale, London, Christie's, March 9, 1839, no. 63, as Pollaiuolo); Charles Sackville Bale, London (by 1849; sale, London, Christie's, May 14, 1881, no. 297, as Pollaiuolo; [Martin Colnaghi, London, 1881]; Édouard Aynard, Lyons (1881; sale, Paris, Galerie Georges Petit, Dec. 1–4, 1913, no. 60, as Piero di Cosimo); [Trotti and Co., Paris, 1913]; Michael Dreicer, New York (until 1921).

BEQUEST OF MICHAEL DREICER, 1921.

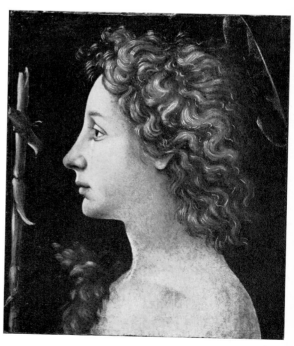

A Hunting Scene 75.7.2

Vasari describes two series of decorations painted by Piero di Cosimo in Florence, consisting of various *storie* arranged around a room, one series for Francesco del Pugliese and the other for Giovanni Vespucci; several pictures by Piero have been tentatively identified with these decorations. This panel and the following and a panel in the Ashmolean Museum in Oxford, belong apparently to the same cycle – according to Panofsky, the one made for Francesco del Pugliese. Although our paintings, with their scenes of primitive life, correspond with certain passages in Ovid (cf. *Metamorphoses* XII), the interpretation offered by Panofsky is much more convincing; according to it the series symbolizes the growth of civilization through the control of fire. The theme of the series was very likely derived from the writings of the Roman architect Vitruvius (*De architectura* II, 1), transmitted to the Renaissance through Boccaccio (*Genealogie deorum*, XII). Our two hunting scenes and the scene in the Ashmolean Museum, representing a forest fire, illustrate the age before Vulcan, when man's knowledge was primitive and forest fires raged unchecked. In the Return from the Hunt may be seen an advance in culture; man has partially controlled the violence of fire and has learned to build rude boats. According to Panofsky, this set included also two other pictures, of a different shape and on canvas instead of wood, which now belong to the Wadsworth Atheneum in Hartford and to the National Gallery of Canada in Ottawa; he suggests that they show the arrival of Vulcan on the isle of Lemnos and Vulcan teaching mankind the arts and crafts. The inclusion of the Hartford and Ottawa paintings in the series seems questionable, if not impossible. A panel in the John and Mable Ringling Museum in Sarasota, Florida, however, may well be the final episode following the Ashmolean Forest Fire and our scenes; it is about the same size as the Oxford panel and represents the construction of an elaborate building in marble, with various craftsmen and sculptors, thus symbolizing civilization reaching its full maturity. The style of our paintings and those at Oxford and Sarasota indicates a date about 1505–1507; many passages of the Hunting Scene clearly show the influence of Leonardo's Battle of Anghiari. Paintings by Piero di Cosimo in the National Gallery in London (no. 4890), the Worcester Art Museum in Worcester, and the Fogg Art Museum in Cambridge (Mass.), belong apparently to another series, possibly the one painted for Giovanni Vespucci.

Tempera and oil on wood. H. $27\frac{3}{4}$, w. $66\frac{3}{4}$ in. (70.5×169.5 cm.).

REFERENCES: G. Vasari, *Vite* (1568), Milanesi ed., IV (1879), pp. 139, 141 f. // W. Rankin, *Rass. d'arte*, V (1905), pp. 25 f., ill., attributes these paintings to Piero di Cosimo // W. Rankin and F. J. M[ather, Jr.], *Burl. Mag.*, X (1907), pp. 332 ff., ill., attribute them to Piero di Cosimo, Rankin calling them early works and Mather dating them soon after 1490, calling the Ricketts panel (now in the National Gallery, London) a companion piece, and suggesting that the three formed part of the decoration of a small room // A. Schiaparelli, *La Casa fiorentina e i suoi arredi* (1908), p. 165, fig. 117, attributes our panels to Piero and suggests that they and the Ricketts panel are parts of the decorations painted for Giovanni Vespucci // E. Hutton in Crowe and Cavalcaselle, *New History of Painting in Italy*, III (1909), p. 395, mentions them as by Piero // B. Berenson, *Flor. Ptrs.* (1909), p. 165, and *Ital. Pictures* (1932), p. 454, lists them as works by Piero; and *Flor. School* (1963), p. 176, pl. 1196

(detail, 75.7.2) // A. Venturi, *Storia*, VII, part I (1911), p. 713, note, lists them among the paintings attributed to Piero // M. H. Bernath, *New York und Boston* (1912), p. 72, attributes them to Piero // T. Borenius, ed., in Crowe and Cavalcaselle, *Ptg. in Italy*, VI (1914), p. 48, note, lists them as works by Piero // P. Schubring, *Cassoni* (1915), p. 310, nos. 383, 384, pl. XC, attributes them to Bartolomeo di Giovanni and calls them cassone panels connected with the Ricketts and Meyer pictures (now National Gallery, London, and collection of Francis Howard); and *Belvedere*, IX (1930), part II, p. 3, connects them only with the Forest Fire in the collection of Prince Paul of Yugoslavia (now Ashmolean Museum) and thinks their subjects symbolize the elements earth and water // M. Armstrong, *Day before Yesterday* (1920), p. 191 // R. Fry, *Burl. Mag.*, XXXVIII (1921), pp. 132 ff., attributes them to Piero, assigns them to his middle period, and doubts whether they and the panels owned by Ricketts and Prince Paul originally belonged to the same decoration // K. D. McNight, *Art Bull.*, VI (1924), pp. 100 ff., attributes them to Piero di Cosimo // G. Camille, *Documents* (1930), no. 6, pp. 330 f., ill. p. 329 // R. van Marle, *Ital. Schools*, XIII (1931), p. 248, fig. 169, attributes them to Bartolomeo di Giovanni and connects them with the Ricketts and Meyer panels // B. Degenhart, in Thieme-Becker, XXVII (1933), p. 16, lists them hesitantly as works from the school of Piero // C. Gamba, *Boll. d'arte*, XXX (1936), p. 51, figs. 7, 8, assigns them to Piero's youthful period, suggests that they, with the Ricketts, Meyer, and Ashmolean panels and with the larger ones in Hartford and Ottawa, may have formed the decoration painted by Piero for Guido Antonio (sic) Vespucci // E. Panofsky, *Journal of the Warburg Institute*, I (1937), pp. 24 ff., pls. 5 A, 5 B, attributes them to Piero, identifies them as the Pugliese decorations, and interprets their subjects as the growth of civilization; and *Worcester Art Museum Annual*, II (1936–1937), p. 35 (both reprinted in *Studies in Iconology*, 1939, pp. 33 ff.); and *Art Bull.*, XXVIII (1946), pp. 286 ff., XXIX (1947), p. 284 // T. Bodkin, *Dismembered Masterpieces* (1945), p. 19, pl. 16, attributes them to Piero di Cosimo, quoting Panofsky's grouping of them with the other panels of the series // R. Langton Douglas, *Piero di Cosimo* (1946), pp. 4, 6, 13, 16 f., 31, 33 f., 64, 113, pls. 11, 12 (detail), 13, 14 (detail), rejects the attribution to Bartolomeo di Giovanni, calls them works by Piero di Cosimo painted about 1487–1488 for Francesco del Pugliese, along with the London, Oxford, Hartford, and Ottawa pictures, suggesting that their literary source

may have been Boccaccio's *Genealogie deorum*, quoting Vitruvius's *De Architectura*; and *Art Bull.*, XXIX (1947), pp. 143 ff., 222 f. // E. K. Waterhouse, *Burl. Mag.*, LXXXIX (1947), p. 230 // D. von Bothmer, *Met. Mus. Bull.*, n.s., VII (1949), p. 219, ill. // M. Davies, *The Earlier Italian Schools (National Gallery Catalogue)* (1951), p. 329 // P. Morselli, *L'Arte*, LVI (1957), pp. 134 ff., figs. 1, 2, calls them works by Piero di Cosimo painted for Francesco del Pugliese, and LVII (1958), pp. 81 f. // F. Zeri, *Paragone*, X (1959), no. 115, p. 44, attributes them to Piero di Cosimo and dates them about 1505–1507, notes the influence of Leonardo, and accepts their connection with the Ashmolean panel, adding tentatively to the series the painting in the Ringling Museum in Sarasota // L. Grassi, *Piero di Cosimo* (1963), pp. 34, 41, 43 f., rejects Zeri's suggested dating of around 1505–1507, placing the Hunting Scene about 1485–1490, noting the influence of Uccello and Pollaiuolo // M. Bacci, *Piero di Cosimo* (1966), pp. 16, 18, 29, 36, 74 ff., 88, 104, 115, 120, pls. 13, 13 A, 14, relates them to the painting of the Forest Fire at Oxford and observes that they are probably the decorations made for the Pugliese palace and dates them before the end of the XV century // B. N. O'Doherty, *Art Quarterly*, XXIX (1966), pp. 20 f., 25, publishes the sale catalogue of Hotchkiss's collection, discovered among John Durand's papers in the New York Public Library, identifying our paintings with nos. 29 and 30 in the sale // F. Abbate, *Paragone*, XIX (1968), no. 215, pp. 76 f., dates them at the beginning of the XVI century, noting the influence of Filippino Lippi and suggesting that the series was originally more extensive.

EXHIBITED: Metropolitan Museum, New York, December 1874, *Loan Exhibition of Paintings and Statuary*, no. 127 or 128 (as Satyrs by an Unknown Artist, lent by Robert Gordon); Petit Palais, Paris, 1935, *L'Art Italien*, no. 365; Metropolitan Museum, New York, 1952, *Art Treasures of the Metropolitan*, no. 82.

EX COLL.: Thomas H. Hotchkiss, Rome (until 1869; sale, New York, Johnston and Van Tassel, December 9, 1871, nos. 29 and 30, as "Satyrs, Sacrifice, etc."); Robert Gordon, New York (1871–1875).

GIFT OF ROBERT GORDON, 1875.

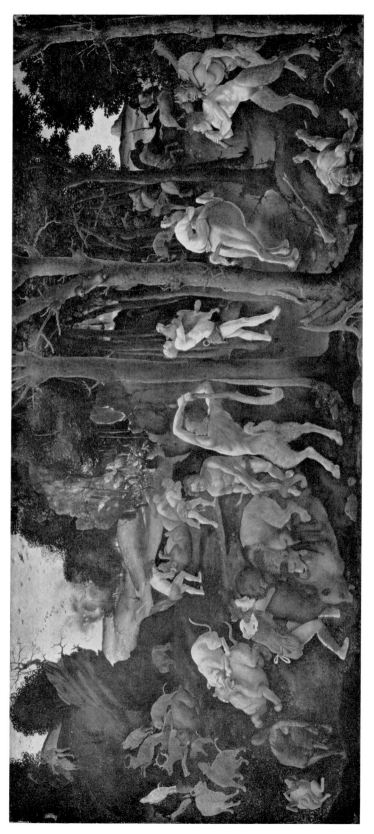

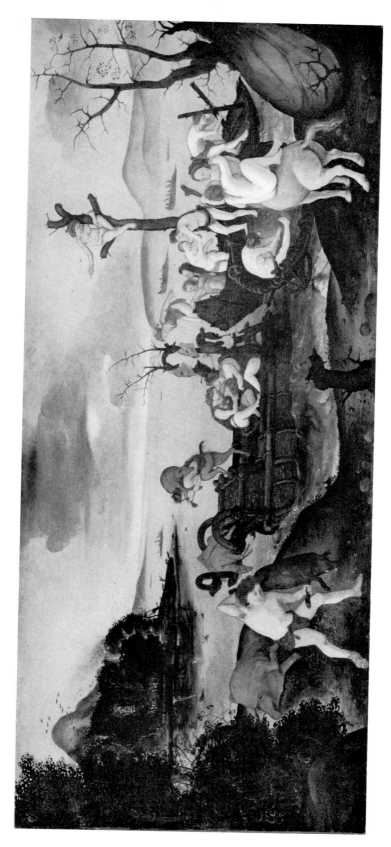

The Return from the Hunt 75.7.1

See comment above under A Hunting
Scene.

Tempera and oil on wood. H. 27¾, w. 66½ in.
(70.5 × 168.9 cm.).

REFERENCES: See above under A Hunting Scene.

EXHIBITED: Metropolitan Museum, New York,
December, 1874, *Loan Exhibition of Paintings and
Statuary*, no. 128 or 127 as Satyrs by an Unknown
Artist, lent by Robert Gordon); Petit Palais, Paris,
1935, *L'Art Italien*, no. 366.

EX COLL. See above under a Hunting Scene.

GIFT OF ROBERT GORDON, 1875.

Granacci

Francesco Granacci. Real name Francesco di Andrea di Marco. Born 1469; died 1543.
Granacci was a pupil of Domenico Ghirlandaio, and assisted him in several works, including
the decoration of the Duomo in Pisa, and the main altarpiece in the church of Santa Maria
Novella in Florence. In his youth, Granacci worked alongside Michelangelo and Fra
Bartolomeo; the latter's hand can be identified in works of Ghirlandaio's shop, in which
Francesco had probably some part also. There are many works from Granacci's mature
period. At the beginning of this time his style shows a sort of monumental grandeur due
possibly to the influence of Michelangelo. Afterward the highly stylized forms can be re-
lated to the birth of Mannerism. Among Granacci's most famous productions are his con-
tributions to the cycle of panels depicting the story of Joseph that was executed by several
artists, including Andrea del Sarto, Pontormo, and Bacchiacca for a room in the house of
Pierfrancesco Borgherini. Granacci was assisted there by the so-called Master of the Spiridon
Story of Joseph, an anonymous painter who did two of the panels in this room. This master
was a prolific painter whose vast output has often been confused with Granacci's. Judging
from his later works Granacci was unimpressed by contemporary developments in Florentine
art, adhering to outdated and archaic formulae.

*Scenes from the Life of Saint John the
Baptist* 1970.134.1

Three episodes from the story of Saint John
the Baptist are depicted here: the Annun-
ciation, the Visitation, and the Birth of
Saint John. At the left, inside a richly

decorated tabernacle, an angel announces to
Zacharias the birth of his son. The other
scenes are set within a large building with
an arched portico that occupies the fore-
ground of the picture. Under the first arch
at the left, we see the Visitation of Mary to
Elizabeth; behind them, a group of young

women stand in a doorway. The second and third arches open into the bedroom of Elizabeth, who watches from her bed as two women care for the newborn John. Another woman coming through a doorway carries food and refreshments on a tray for the new mother, and Zacharias sits before a roaring fire where a woman is drying clothing.

The tabernacle and the spandrels above the arches of the main building are richly decorated with sculpture. At the top of the tabernacle is a statue of Abraham and Isaac; two of the statues at the corners of the tabernacle's entablature can be identified as Judith with the head of Holophernes and David trampling over the head of Goliath. The spandrels above the arches of the portico are decorated with reliefs in monochrome representing ancient Roman subjects, from left to right: a warrior on horseback; a general or emperor addressing his troops; a standing Victory writing on a shield; a pagan divinity, almost certainly Jupiter; a Victory arranging a trophy; and a seated figure personifying Rome. These reliefs are apparently derived from classical prototypes, more probably from Roman coins than from marbles, although the scene of the general or emperor addressing his troops bears a certain resemblance to a famous relief on the Arch of Constantine, and the Victory writing on a shield is a motif that occurs at a very conspicuous point on Trajan's column.[1] The idea that these scenes come from Roman coins is

supported by the letters "S" and "C" that appear on either side of each of the three arches and are the usual abbreviation meaning "Ex Senatu Consulto," to be found as a rule on the verso of Roman imperial coinage. Other classical reminiscences, although less conspicuous and direct, are to be seen in the ornaments on the altar within the tabernacle—a head of Medusa, a garland, acanthus leaves, lions' paws, and rams' heads at the corners—all elements that usually appear in the decoration of Roman altars or funerary stones (cippi).

This painting and its companion piece in the Museum, The Preaching of Saint John the Baptist (see below, no. 1970.134.2), belonged to a series of panels depicting scenes from the story of Saint John that originally must have decorated the walls of a chapel or oratory in a private dwelling in Florence. The series includes a panel in the Walker Art Gallery in Liverpool (no. 2783, $30\frac{1}{2} \times 90$ in.), showing five scenes from the legend of Saint John: the naming of the infant saint, his departure from his parents, his journey into the wilderness, his meeting with the young Jesus, and his taking water from a spring. Between this painting and ours, there must have been another scene, probably the fragment now in the Cleveland Museum of Art (no. 44.91, $30\frac{11}{16} \times 13\frac{1}{4}$ in.), showing the newborn John being carried to Zacharias. The unusual two-stepped pedestal that forms the base for the arched building on our painting is continued and completed on the Cleveland fragment. Moreover, the four women represented on that fragment are nearly identical with the women in the doorways on our panel, and these figures appear a third time in the naming of John on the Liverpool panel. Although our painting was very likely cut along its right edge, where the

[1] For a similar representation of an "Adlocutio" painted in fresco by the workshop of Domenico Ghirlandaio in the church of Santa Trinità in Florence, and derived from a coin of Emperor Gordian III, see E. Panofsky, *Problems in Titian* (1969), figs. 85, 86.

final pilaster of the third arcade ends
abruptly, and although the perspective
arrangement of the composition seems to
call for an area of open landscape on the
right to correspond with that on the left, it
is hard to believe that the Cleveland frag-
ment was originally directly attached to our
painting because its quality is so inferior.
Obviously based upon a drawing by

depicting the Baptism of Christ in an open
landscape with a large number of figures,
similar in shape and size to our two panels
and the one in Liverpool, formerly belonged
to the collection of the Marchese Gerini in
Florence, as did the Cleveland fragment.
The style of this Baptism was that of Granac-
ci, to whom it was traditionally attributed,
but its connection with the series is difficult

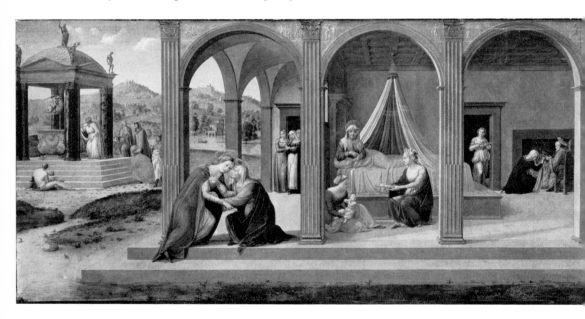

1970.134

Granacci, it must have been carried out by a
pupil or assistant, very likely the Master of
the Spiridon Story of Joseph. Should
further research prove conclusively that the
Cleveland fragment was once attached to
our painting, it would follow that Granacci
was assisted here too by partners and pupils.

The series originally must have also in-
cluded the Baptism of Christ and John's im-
prisonment and beheading, the two most
important episodes in the whole story,
which, judging from other cycles devoted to
John, could not have been left out. A panel

to substantiate because the painting itself
was completely destroyed by damp in 1944,
and the photographs of it have been lost.

The stylistic evidence supplied by our two
paintings and those in Cleveland and Liver-
pool shows that Granacci was responsible for
the conception of the cycle, supervising it
and providing drawings, possibly sketching
in roughly on the panels themselves the
designs of the various scenes. Different
hands, however, carried out the painting:
the Cleveland painting is almost certainly
by the Master of the Spiridon Story of

Joseph, while the identity of the different assistants who painted the Liverpool panel and the companion piece in this Museum remains puzzling. Granacci himself appears to be responsible for only our Scenes from the Life of Saint John, which is in the style of his early period, after he had left Ghirlandaio's shop and had started his career as an independent painter. Probably both it and its companion piece in the Museum can be roughly dated around 1510, if not some time earlier.

Inscribed (in spandrels of center arch): VICTORIA (Victory), PACOS (Peace); (in spandrels of third arch): ROMA (Rome), FIDES (Faith).

Oil on wood. H. 31½, w. 60 in. (80×152 cm.).

REFERENCES: J. P. Richter (verbally, before 1878) rejects the traditional attribution of this panel to Domenico Ghirlandaio, and calls it a work by Francesco Granacci, noting that it is not by the same hand that executed the companion piece // C. J. Ffoulkes, *Arch. stor. dell'arte*, VII (1894), p. 166, fig. 8a, accepts the attribution to Granacci // B. Berenson, *Flor. Ptrs.* (1896), p. 115, and *Ital. Pictures* (1932), p. 266, lists it and its companion as early works by Granacci; *Flor. School* (1963), p. 98, fig. 1265, calls it and its companion part of the same series as the Liverpool panel, listing them all as early works by Granacci // A. Scharf, *Burl. Mag.*, C (1958), p. 300, fig. 2, tentatively accepts the attribution to Granacci for the companion piece representing Saint John Preaching, but rejects it for this panel, which he gives to the artist who painted the one in Liverpool, noting in the monochrome above the arches a close connection with the drawings attributed to Davide Ghirlandaio // H. Shipp, *Apollo*, LXVIII (1958), p. 40, ill. p. 39, accepts the attribution to Francesco Granacci, but doubts whether the companion piece is by the same artist // [M. Compton], *Foreign Schools Catalogue, Walker Art Gallery* (1963), pp. 83 f., calls this painting and its companion piece part of the

same set as the panel in Liverpool, suggests that the series included at least two more pictures, and that probably it formed part of the decoration of a private room, accepts the attribution to Granacci, and thinks that slight stylistic differences between the panels are probably due to the employment of different assistants // C. von Holst, Doctoral Thesis (unpublished), Kunsthistorisches Institut der Freien Institut Berlin-West (1968), accepts the attribution to Granacci, and includes in the series the panel in the Cleveland Museum.

EXHIBITED: New Gallery, London, 1893–1894, *Early Italian Art*, no. 150 (as Ghirlandaio, lent by the Earl of Ashburnham); Royal Academy, London, 1958, *The Robinson Collection*, no. 21 (as Granacci, lent by Princess Labia); National Gallery of South Africa, Cape Town, 1959, *The Sir Joseph Robinson Collection*, no. 6 (as Granacci, lent by Princess Labia); Kunsthaus, Zürich, 1962, *Sammlung Sir Joseph Robinson*, no. 4 (as Granacci, lent by Count Giuseppe Labia and Count Natale Antonio Labia); Metropolitan Museum, New York, 1970–1971, *Masterpieces of Fifty Centuries*, no. 188a.

EX COLL.: the Tornabuoni family, Florence; [Samuel Woodburn, London, before 1850]; Earl of Ashburnham, Ashburnham Place, Battle, Sussex (after 1850; Ashburnham House catalogue, 1878, as by Ghirlandaio); Sir George Donaldson, London (shortly after 1894); Sir Joseph B. Robinson, Cape Town, South Africa (shortly after 1894–1929; sale, Christie's, London, July 6, 1923, no. 39, bought in); Ida Louise Robinson, Princess Labia, Cape Town (1929–1961); Prince and Count don Giuseppe Labia and Count don Natale Antonio Labia (1961–1970; sale, Sotheby's, London, June 24, 1970, no. 39).

PURCHASE, ANDREWS, DICK, DODGE, FLETCHER AND ROGERS FUNDS, FUNDS FROM VARIOUS DONORS, DEPEYSTER GIFT, OENSLAGER GIFT AND GIFTS IN MEMORY OF ROBERT LEHMAN, 1970.

The Preaching of Saint John the Baptist 1970.134.2

Saint John is shown preaching in a wooded, rocky landscape. A few rustic houses are

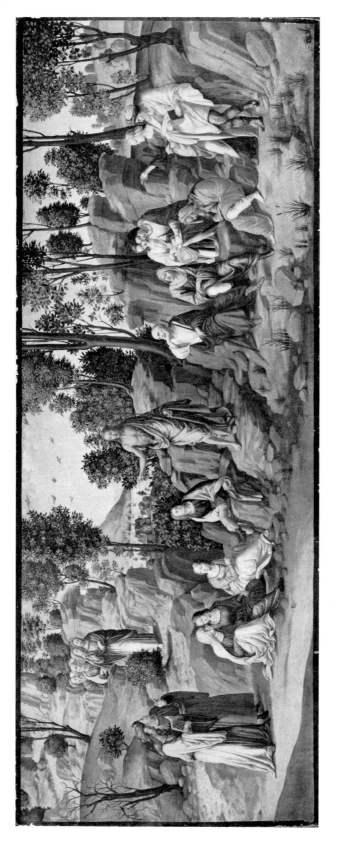

seen in the middle ground, and in the far distance a town is visible, with towers, churches, and a castle at its left. In the foreground, groups of people listen to John; some hold the open Bible, a passage of which apparently forms the subject of the saint's preaching. Christ, followed by his apostles, approaches along a rough path at the left, and blesses John.

This panel belongs to the same series as no. 1970.134.1 (see above). Its composition clearly shows that it has not been cut along the lateral edges, and that almost certainly it has come to us in its entirety. Many of the figures are like Granacci's in type, particularly the standing man near the right edge, the three seated men at the right, and the two standing men, probably Pharisees, at the left. However, only the conception of these figures and of the entire composition relates to Granacci's style. The actual execution is obviously due to a hand quite different from that of the companion pieces, both ours and the ones at Liverpool and Cleveland.

The Preaching of Saint John shows very close similarities to the works of the early period of Raffaello Botticini (1477; still active by 1520). This is evident in the classicizing type of some of the heads, and in the smooth rendering of the faces, especially those of the women, as well as in the academic rendering of certain reflections of Perugino and Ghirlandaio, such as the group of Christ and the apostles. The rocks in our panel are rendered in a strikingly similar way to the ones in the background of a Saint Jerome in the Pinacoteca della Collegiata at Empoli, a work signed by Raffaello Botticini and dated 1500.[1] Numer-

[1] See *Gaz. des B.-A.*, CX (1968), p. 160, fig. 1a.

ous other likenesses could be pointed out between the figures of our painting and sure works by the younger Botticini, and would seem to lead toward a possible attribution. In any case, the painter was affected by the personality of Granacci, and by the drawings and the layout that he provided.

Oil on wood. H. 29¾, w. 82½ in. (75.5 × 210 cm.).

REFERENCES: A. Venturi (in manuscript opinion in the private Ashburnham House catalogue, before 1878) rejects the attribution of this painting to Domenico Ghirlandaio and calls it a work by Raffaellino del Garbo // J. P. Richter (verbally, before 1878), observes that it is not by the same hand that executed the companion piece, which he attributes to Francesco Granacci // B. Berenson, *Flor. Ptrs.* (1896), p. 115, and *Ital. Pictures* (1932), p. 266, lists it and its companion as early works by Granacci; *Flor. School* (1963), p. 98, calls it and its companion part of the same series as the Liverpool panel, listing them all as early works by Granacci // A. Scharf, *Burl. Mag.*, C (1958), p. 300, fig. 3, tentatively accepts the attribution to Granacci // H. Shipp, *Apollo*, LXVIII (1958), p. 40, doubts whether it is by the same artist who executed the companion piece, for which he accepts the attribution to Granacci // [M. Compton], *Foreign Schools Catalogue*, *Walker Art Gallery* (1963), pp. 83 f., accepts the attribution to Granacci, suggesting that slight stylistic differences between the various panels of the series are due to the employment of various assistants // C. von Holst, Doctoral Thesis (unpublished), Kunsthistoriches Institut der Freien Institut Berlin-West (1968), calls it a work by an unknown contemporary of Granacci.

EXHIBITED: Royal Academy, London, 1958, *The Robinson Collection*, no. 20 (as Granacci, lent by Princess Labia); National Gallery of South Africa, Cape Town, 1959, *The Sir Joseph Robinson Collection*, no. 5 (as Granacci, lent by Princess Labia); Kunsthaus, Zürich, 1962, *Sammlung Sir Joseph Robinson*, no. 3 (as Granacci, lent by Count Giuseppe Labia and Count Natale Antonio Labia); Metropolitan Museum, New York, 1970–1971, *Masterpieces of Fifty Centuries*, no. 188 b.

Fra Bartolomeo

Real name Bartolomeo di Paolo del Fattorino; called also Baccio della Porta. Born 1472; died 1517. Bartolomeo was a pupil of Cosimo Rosselli, in whose shop he was working as an apprentice in 1485. He was deeply impressed by the teaching of Savonarola, who was executed in 1498. Two years later he became a novice at the Dominican monastery at Prato and after taking his vows returned to Florence to the monastery of San Marco. In 1504, after several years of interruption, he began to paint again. At least twice in his career Fra Bartolomeo worked in partnership with Mariotto Albertinelli, providing ideas and even cartoons that were widely imitated in their common workshop, especially by Fra Paolino da Pistoia. The few sure works by Fra Bartolomeo known to have been painted before his resumption of his painter's career in 1504 reveal that he was formed by the example of his master, Cosimo Rosselli, but was soon impressed and influenced by his study of the works of Domenico Ghirlandaio and Piero di Cosimo. Later he became aware of the powerful styles of Michelangelo and Leonardo da Vinci. In 1508 he took a trip to Venice, which is reflected in his paintings in certain minor borrowings from Giorgione. The major characteristic that dominates the large body of works done in the later part of Fra Bartolomeo's life is an extraordinary purity of form. This quality, so antithetical to the sophistication and stylishness of the painting that had found favor during the time of Lorenzo the Magnificent, is basically related to the style of his great predecessor at the convent of San Marco, Fra Angelico.

The Madonna and Child with the Young Saint John the Baptist 06.171

Although the high quality of this painting proclaims that it was made by a strongly individual artist, uncertainty about his identity has persisted for many years. There is good reason for supposing that it is an early work by Fra Bartolomeo, from the beginning of the 1490's. Another painting, a tondo of the Holy Family in the Borghese Gallery in Rome (Inv. no. 439), is surely by the same hand as this Madonna and has likewise been attributed on stylistic grounds to the youthful period of Fra Bartolomeo. The forms in the Museum's painting reflect the

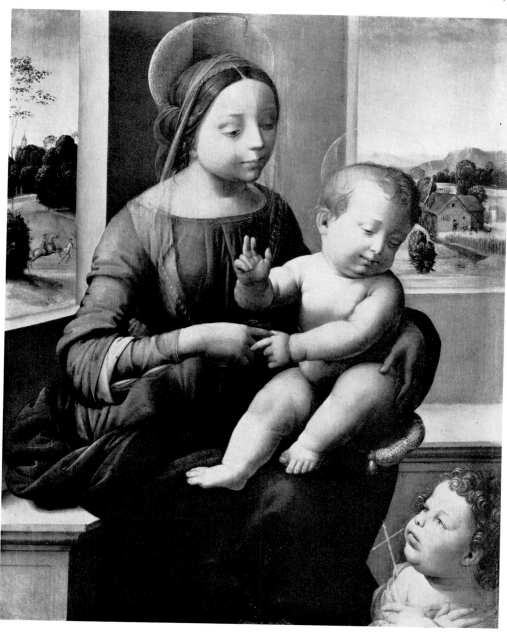

style of Domenico Ghirlandaio and Piero di Cosimo; the composition of the main group and the arrangement of the drapery recall Leonardo da Vinci's early "Benois" Madonna in the Hermitage in Leningrad. The landscape seen through the window at the right has been borrowed from Memling; a Madonna and Child enthroned with two Angels by Memling, now in the Uffizi (no. 703), which had already reached Florence in the

late fifteenth century, has a very similar glimpse of landscape. There is a sixteenth-century copy of our picture in the Stross-mayer Gallery at Agram in Yugoslavia (no. 30, panel, 64×48 cm.), which has been attributed by Frizzoni and Gamba to Ridolfo Ghirlandaio and is also listed by Berenson as possibly one of Ridolfo's early works (see *L'Arte*, VII, 1904, pp. 431 ff., ill.; *Dedalo*, IX, 1929, pp. 464 f., ill., 481; *Ital. Pictures*, 1932, p. 226).

Formerly attributed by the Museum to Bugiardini (?) (Cat., 1940).

Tempera on wood. H. 23, w. 17¼ in. (58.4×43.8 cm.).

REFERENCES: B. Berenson, *Flor. Ptrs.* (1909), p. 125, lists our painting hesitantly as a work of Bugiardini; and *Ital. Pictures* (1932), p. 227, lists it hesitantly as a work of Ridolfo Ghirlandaio's early period; and *Flor. School* (1963), p. 78 / / A. Venturi, *Storia*, IX, part I (1925), p. 426, lists it as a work by Bugiardini / / R. Offner (verbally, 1937) rejects the attribution to Bugiardini and notes the influence of Credi and Leonardo / / R. Longhi (unpublished opinion, 1937) attributes it to the Master of the Czartoryski Tondo, a Florentine artist close to Bartolomeo di Giovanni and later to Lorenzo di Credi / / F. Mason Perkins (in a letter, 1938) rejects the attribution to Bugiardini / / S. J. Freedberg, *Painting of the High Renaissance in Rome and Florence* (1961), p. 76, pl. 71, attributes it to Bugiardini and dates it about 1500, observing the influences of Domenico Ghirlandaio, Lorenzo di Credi, and Piero di Cosimo / / E. Fahy (in a letter, 1966) calls it an early work by Fra Bartolomeo, dating from about 1490; *Burl. Mag.*, CVIII (1966), p. 463, note 22, and *Art Bull.*, LI (1969), pp. 145 ff., figs. 8, 13 (detail), attributes it to Fra Bartolomeo, identifies two preparatory sketches for it in the Uffizi, notes the influence of Leonardo's Benois Madonna, and borrowings from Memling.

EX COLL.: Sandleford Priory, Newbury, Berkshire; [Dowdeswell and Dowdeswell, London, 1900]; [Sedelmeyer Gallery, Paris, Cat. 1902, p. 70, no. 55, as Bugiardini]; [Eugène Fischof, New York, 1906].

PURCHASE, ROGERS FUND, 1906.

Albertinelli

Mariotto di Bigio di Bindo Albertinelli. Born 1474; died 1515. Albertinelli studied in the workshop of Cosimo Rosselli, where he was the fellow pupil of Fra Bartolomeo, and was also influenced by Piero di Cosimo and Lorenzo di Credi. He worked in partnership with Fra Bartolomeo and became so dependent on his style that in 1512, when they separated, he was unable to continue alone and therefore abandoned painting. In spite of this dependence, however, Albertinelli's style remained old-fashioned in comparison with that of his partner, and though he was one of the earlier representatives in Florence of the High Renaissance, his paintings always retained something of the character of late fifteenth-century work.

The Madonna and Child with the Infant Saint John the Baptist and an Angel 30.95.270

The ample forms and the composition of this painting betray Fra Bartolomeo's influ-ence; silhouetted profiles like that of the young Baptist are found in the works of Piero di Cosimo. The variegated color is Albertinelli's own. A certain quality that vaguely recalls Raphael suggests a date around 1506. The initials F F A (Franciscus

Francia Aurifex) which at one time could be
seen on Saint John's cross were a later addi-
tion made to establish Francesco Francia as
the painter. They were removed more than
a century ago. This is the type of painting by
Albertinelli that strongly influenced his
assistant Giuliano Bugiardini.

Until 1931 exhibited by the Museum as a
work by Francia.

Oil and tempera on wood. H. 38½, w. 30¼ in.
(97.7 × 76.8 cm.).

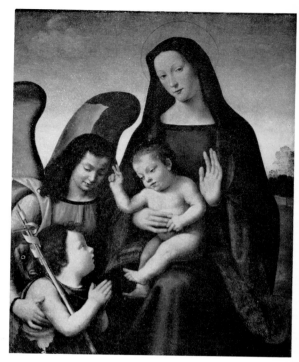

30.95.270

REFERENCES: *Monumenti di pittura e scultura trascelti
in Mantova e nel suo territorio* (1827), I, pl. 1, illus-
trates an engraving of this painting by D'Arco and
Brustaffi, attributes it to Francesco Francia, and
relates that on Saint John's cross the initials F F A
were seen at one time but disappeared during a
restoration // O. Mündler, *Diary* (unpublished), I
(1857), p. 88 v., attributes it to Giovanni Antonio
Sogliani // Crowe and Cavalcaselle, *Ptg. in Italy*, III
(1866), p. 498, attribute it to Bugiardini and note a
resemblance to Raphael in the composition //
B. Berenson (verbally, 1897) attributes it to Bugiar-
dini; *Ital. Pictures* (1932), p. 119, lists it as a work by
Bugiardini; and *Flor. School* (1963), p. 45 // J.
Breck, *Rass. d'arte*, XI (1911), pp. 114 f., attributes
it to Bugiardini and tentatively identifies it with a
painting formerly in the Susani collection //
T. Borenius, ed., in Crowe and Cavalcaselle, *Ptg.
in Italy*, VI (1914), p. 120, note 1, quotes Breck's
identification of this painting with the one from
the Susani collection // A. Venturi, *Storia*, IX,
part I (1925), p. 426, lists it as a work by Bugiar-
dini // B. Burroughs, *Met. Mus. Bull.*, XXVI (1931),
March, sect. II, p. 14, attributes it to Albertinelli //
R. Offner (verbally, 1937) accepts the attribution to
Albertinelli // F. Mason Perkins (in a letter, 1938)
attributes it to Bugiardini // P. Pouncey (verbally,

1958) considers it closer to Bugiardini than to
Albertinelli.

EXHIBITED: Royal Academy, London, 1891, *Old
Masters*, no. 109 (as Francia, lent by Mme Baude).

EX COLL.: the Gonzaga family, Dukes of Mantua,
Mantua; Gaetano Susani, Mantua (by 1827; sale,
Paris, Hotel Drouot, Feb. 28, 1868, no. 37, as
Francia); Alfredo Omfray, Naples (1871); Mme
Baude, Paris (by 1891–1894); [T. Lawrie and Co.,
London, 1894–1896]; Theodore M. Davis, New-
port (1896–1915).

THE THEODORE M. DAVIS COLLECTION.
BEQUEST OF THEODORE M. DAVIS, 1915.

Bugiardini

Giuliano di Piero di Simone Bugiardini. Born 1475; died 1554. Bugiardini was a pupil of
Domenico Ghirlandaio and in his workshop came to know Michelangelo, who some years
afterwards in Rome, while at work on the Sistine ceiling, sought his services but later
rejected them. He was at one time the helper of Mariotto Albertinelli and is known to have

completed for him certain works left unfinished by Albertinelli's former partner, Fra Bartolomeo. Bugiardini's paintings reflect not only the influence of his masters but also that of the artists who shaped the style of the early sixteenth century in Florence, including Raphael, Perugino, Leonardo, and Michelangelo. His attempt to express himself in their magnificent classical way was, however, futile, because he did not understand the formal principles according to which they worked and in many of his paintings awkwardly translated High Renaissance motives into his own archaic, outdated terms. His style is often thin and dry, characterized by outline drawing.

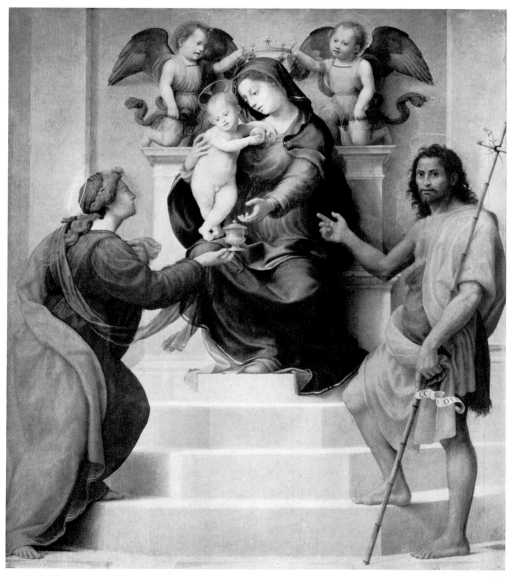

30.83

The Madonna and Child Enthroned with Saint Mary Magdalen and Saint John the Baptist 30.83

Tempera on wood. H. 76¼, w. 65¼ in. (194.3 × 165.6 cm.).

This altarpiece is known to have come from a church at Incisa in Valdarno. It is one of the very few works in which Bugiardini, in spite of his inadequacies, realized his ambitious intentions. In the composition he was deeply influenced by Fra Bartolomeo, and the figures have something of Raphael. Several pentimenti are visible through the very thin layer of color. The most conspicuous are the ones around the Magdalen's profile and the Baptist's right arm, which is now placed in a lower position. The types, architecture, and draperies in this painting, which are much like those in Bugiardini's Marriage of Saint Catherine in the Gallery in Bologna, suggest a date of about 1510–1515. On the frame, apparently the original one, at the base of the lateral pilasters, are the arms of the Altoviti family of Florence (sable, a wolf rampant argent, armed and langued gules).

Formerly attributed by the Museum to Fra Bartolomeo.

Inscribed (on Saint John's scroll): ECCE AN . . . S [AGNUS] DEI.

REFERENCES: W. Biehl, *Monats. für Kstwiss.*, IX (1916), pp. 237 ff., pl. 58, considers that this painting is from the workshop of Fra Bartolomeo, dates it about 1509–1512, tentatively suggesting that Mariotto Albertinelli collaborated on the figures and Fra Paolino on the background, and identifies the arms in the frame with those of the Altoviti family // H. Tietze, *Meisterwerke Europäische Malerei in Amerika* (1935), p. 327, pl. 58, attributes it to Fra Bartolomeo, suggesting the collaboration of Albertinelli // F. Mason Perkins (in a letter, 1938) attributes it to a Florentine painter strongly influenced by Fra Bartolomeo // R. Offner (verbally, 1939) agrees with the Museum's attribution to Bugiardini // R. G. Mather (in a letter, 1947) identifies the coat of arms as that of the Del Nero family of Florence // B. Berenson, *Flor. School* (1963), p. 45, attributes it to Bugiardini // F. Sricchia, *Paragone*, XIV (1963), no. 163, p. 22, note 26, attributes it to Bugiardini and notes Franciabigio's influence, dating it after 1512.

PROVENANCE: the church of Santa Maria Maddalena all'Isola, Incisa Valdarno, Tuscany.

EX COLL.: the Altoviti family, Florence; Colonel Sacchetti, Villa Isola, near Incisa Valdarno (until about 1910); the Sacchetti heirs, Incisa Valdarno, Prato, and Milan (1910–1930; in 1912 the altarpiece was shown in a dealer's gallery in the Palazzo Strozzi in Florence).

PURCHASE, FLETCHER FUND, 1930.

Ridolfo Ghirlandaio

Born 1483; died 1561. At the death of his father, Domenico Ghirlandaio, Ridolfo became the assistant of his uncle, Davide. Later he had a workshop of his own. He was official painter to the Signoria of Florence and to the court of the Medici and was responsible for some of the ceremonial decorations for the weddings of Giuliano and Lorenzo de' Medici and for the entry of Charles V into Florence in 1536. Ridolfo's painting shows a combination of the realistic tradition of the Ghirlandaios with the classical style of some of his greatest

contemporaries, particularly Fra Bartolomeo, Albertinelli, Raphael, and Leonardo. His early works were influenced by Piero di Cosimo and his Northern treatment of form, and in his portraits this influence continued throughout his career.

The Nativity with Saints (triptych)

32.100.80

Central panel: the Nativity, Saint Maurus (or Placidus)
Left wing: Saints Peter, Benedict, and Christine
Right wing: Saints Paul, John the Evangelist, and Dorothy

This triptych is closely related to Ridolfo's decorations in the Cappella dei Priori in the Palazzo Vecchio in Florence, painted in 1514, and the composition of its central panel is very similar to that of an Adoration of the Shepherds attributed to him which was formerly in the collection of Henry Harris in London (on wood, $22 \times 17\frac{1}{2}$ in., in sale at Sotheby's, Oct. 25, 1950, no. 195). The influences of Fra Bartolomeo and Mariotto Albertinelli are most pronounced in the central panel, while the wings show a close similarity to the work of Francesco Granacci. The original tops of the wings

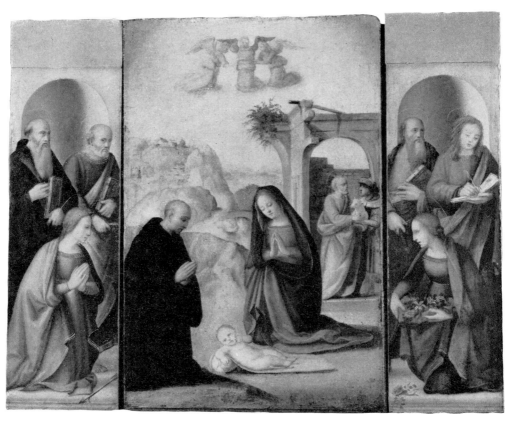

32.100.80

now replaced with added strips, may possibly have borne the arms of the donors.

Tempera on wood. Central panel, h. 14, w. 9 in. (35.4×20.8 cm.); left and right wings, each, h. 14, w. 4 in. (35.4×10.1 cm.).

REFERENCES: The authorities cited below attribute this painting to Ridolfo Ghirlandaio. B. Berenson, *Flor. Ptrs.* (1909), p. 139; in Cat. of Friedsam Coll. (unpublished, n.d.), pp. 75 f., dates it soon after 1514; *Ital. Pictures* (1932), p. 227; and *Flor. School* (1963), p. 78, pl. 1286, identifies the female saints as Ursula and Dorothy // A. Venturi, *Storia*, IX, part 1 (1925), p. 512 // B. Burroughs and H. B. Wehle, *Met. Mus. Bull.*, XXVII (1932), Nov., sect. II, p. 38 // S. J. Freedberg, *Painting of The High Renaissance in Rome and Florence* (1961), p. 210, ill. pl. 280, dates it between 1512 and 1515 and notes the influence of Fra Bartolomeo and Mariotto Albertinelli.

EXHIBITED: Kleinberger Galleries, New York, 1917, *Italian Primitives*, no. 38 (lent by Michael Friedsam).

EX COLL.: Genolini, Milan; Cristoforo Benigno Crespi, Milan (as Mariotto Albertinelli; sale, Galerie Georges Petit, Paris, June 4, 1914, no. 24, as Ridolfo Ghirlandaio); [Thomas Agnew and Sons, London, 1914]; [Oswald Sirén, Stockholm, 1914]; [F. Kleinberger & Co., New York, 1914–1916]; Michael Friedsam, New York (1916–1931).

THE MICHAEL FRIEDSAM COLLECTION. BEQUEST OF MICHAEL FRIEDSAM, 1931.

Bacchiacca

Real name Francesco d'Ubertino. Born 1494; died 1557. Bacchiacca, an early Mannerist, reflects the spiritual and artistic upheaval in Florence during the first half of the sixteenth century. According to Vasari, from whom we draw most of our knowledge of his life, he was a friend of Andrea del Sarto, who advised him on questions of art. He is often called an eclectic, because he frequently borrowed and adapted compositions from various artists, such as Franciabigio, Perugino, Michelangelo, and Leonardo. He also seems to have been influenced by the group of painters working under Fra Bartolomeo and Albertinelli in the convent of San Marco. Under the rule of the Medici and during the Republic his contemporaries had developed an aristocratic and sophisticated way of painting. Bacchiacca translated some of their most successful motives into a more popular, old-fashioned form, using a brilliant range of color, simplified shapes, and an accurate rendering of landscape, animals, and small details. He seems to have specialized in making furniture panels; he also provided designs, including a series of months, for Duke Cosimo de' Medici's tapestry factory in Florence.

Eve with Cain and Abel 38.178

It is clear that this panel is a fragment of a larger composition since the right edge shows the original finish but the left one has been cut. A strip of new wood, which was added on the right to center the figure, has now been removed. The figure of Eve with two children, which was once interpreted as Charity, is very much like the Eve in Bacchiacca's Adam and Eve with Cain and Abel in the Johnson collection in Philadelphia (no. 80). This suggests that our painting also once included a seated figure

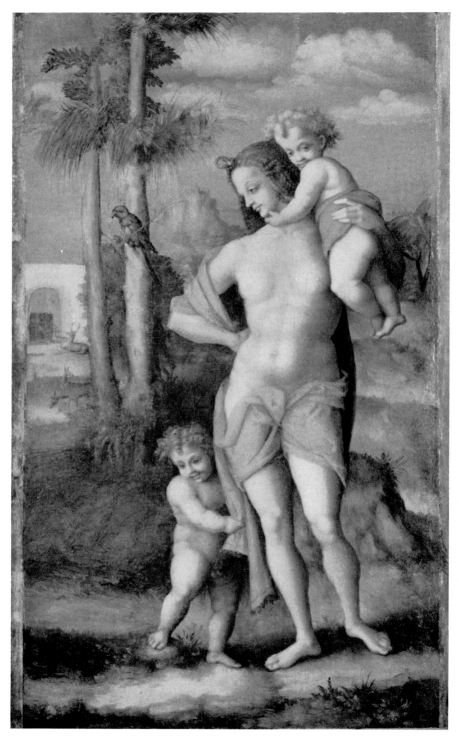

38.178

of Adam, but no traces of it are visible. Both pictures are adaptations of Perugino's Apollo and Marsyas in the Louvre (no. 1509). Our picture was probably painted in the 1520's.

Formerly called Charity.

Tempera and oil on wood. H. 15¾, w. 9¼ in. (40 × 23.6 cm.).

REFERENCES: The authorities cited below attribute this painting to Bacchiacca. A. Scharf, *Burl. Mag.*, LXX (1937), p. 65, pl. II D, notes that the composition of this picture evolved from Bacchiacca's Adam and Eve in the Johnson collection in the Philadelphia Museum and from Perugino's Apollo and Marsyas in the Louvre // L. Burroughs, *Met. Mus. Bull.*, XXXIV (1939), pp. 97 f., ill. // R. Salvini, in Thieme-Becker, XXXIII (1939), p. 522 // [L. Marcucci], in *Mostra di Disegni dei primi Manieristi*

Italiani, Catalogo (1954; Gabinetto Disegni e Stampe degli Uffizi), pp. 55 f., observes that the group of trees in the background is apparently borrowed from Albrecht Dürer's engravings, and dates the painting before 1527, calling it a figure of Eve // B. Berenson, *Flor. School* (1963), p. 20 // L. Nikolenko, *Francesco Ubertini, called Il Bacchiacca* (1966), pp. 12, 43, fig. 25, calls it Caritas, dates it 1520–1525, notes its relationship to the painting of Adam and Eve in the Johnson collection and the dependence of both pictures on Perugino's Apollo and Marsyas in the Louvre.

EXHIBITED: Baltimore Museum of Art, Baltimore, 1961, *Bacchiacca and His Friends*, no. 2.

EX COLL.: James Hope, Edinburgh; [Larsen, London]; Godfrey Locker-Lampson, London (*Italian Pictures Collected by Godfrey Locker Lampson*, n.d., no. II, ill.); [Durlacher, London, 1937–1938].

PURCHASE, GWYNNE M. ANDREWS FUND, 1938.

Tommaso Fiorentino

Real name Tommaso di Stefano Lunetti. The Tommaso Fiorentino who signed the portrait below is assumed to be the Tommaso di Stefano who, according to Vasari, was born around 1495 and died in 1564, the son of the architect, painter, and illuminator Stefano di Tommaso, none of whose works survive. Vasari further states that Tommaso was a pupil of Lorenzo di Credi and that he painted a Nativity for a villa in Arcetri, near Florence. This picture, owned in the nineteenth century by the Capponi family and now in a private collection in Florence, and our portrait provide our only knowledge of Tommaso di Stefano's work. In both works his style shows a strong link with such Florentine painters as Mariotto Albertinelli, Franciabigio, Bacchiacca, and Pierfrancesco Foschi. It is still uncertain whether our Tommaso Fiorentino, probably the Tommaso di Stefano mentioned by Vasari, is the same artist who according to Lanzi and other early writers, was summoned from Florence to Spain by the Duke of Alba to paint grotesques in fresco for his castle at Alba de Tormes (now destroyed) and also painted a portrait at one time in the Royal Palace in Madrid.

Portrait of a Man 17.190.8

In its type this portrait betrays the strong influence of Franciabigio and Ridolfo Ghirlandaio, and in its execution it recalls the style of Pierfrancesco Foschi. The gesture of the left hand may perhaps indicate that the painting originally had a companion piece, perhaps a portrait of the sitter's wife.

Signed and dated (on paper at left): [O]PVS

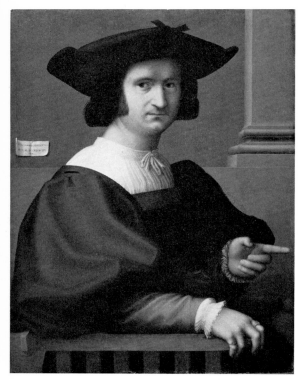

17.190.8

THOME FLORĒTINI/.A[NNO].S[ALVTIS]:
MDXXI MAII ("the work of Tommaso
Fiorentino, in May of the year of salvation
1521").

Tempera on wood. H. 32¼, w. 23⅞ in.
(81.9×60.6 cm.).

REFERENCES: P. Zani, *Enciclopedia Metodica*, part I,
9 (1822), pp. 44, 221, mentions, without giving its
subject, a painting by Tommaso Fiorentino bearing
the same signature and date as ours, probably this
portrait // W. Stechow, *Pinacotheca*, I (1928),
pp. 135 ff., fig. 2, identifies the Tommaso Fioren-
tino who signed this portrait with Tommaso di
Stefano // B. Berenson, *Flor. School* (1963), p. 208,
pl. 1356, lists it as a work by Tommaso di Stefano
Lunetti // F. Zeri, *Boll. d'arte*, XLVIII (1963),
p. 253.

EXHIBITED: Vassar College, Poughkeepsie, 1956,
Humanism North and South, no. 6.

EX COLL. J. P. Morgan, New York.

GIFT OF J. P. MORGAN, 1917.

Andrea del Sarto

Real name Andrea d'Agnolo. Born 1486; died 1530. Andrea del Sarto received his training
in the workshop of Piero di Cosimo. His painting shows also his study of Leonardo da Vinci,
Fra Bartolomeo, and later, Michelangelo. Vasari states that at the beginning of his career
Andrea had Franciabigio as his partner in Florence. In 1518 and 1519 he was employed by
Francis I in France; after he returned to Florence in 1523 he completed a famous cycle of
frescoes in the Chiostro dello Scalzo. Andrea del Sarto was one of the leading exponents of
the high renaissance style, and his perfectly balanced compositions, although excellent
expressions of the classical ideal, foreshadow in certain details of their formal treatment the
work of some of the most important Mannerists of the next generation, such as Pontormo,
Il Rosso, and Vasari, who were all trained in his workshop.

Head of the Madonna (fragment)

32.100.89

Obviously a fragment cut out of a much larger picture, this painting shows, especially in the upper right corner, some areas which have been repainted to conceal losses in the original surface. The complete picture, known through an engraving by Cornelis Bloemaert, belonged in the seventeenth century to the Marchese Vincenzo Giustiniani in Rome. It showed the full-length figure of the Madonna seated in a landscape with the Infant Christ and the young Saint John the Baptist standing near her. It is not known when the picture was altered, and no other fragments of it are known. This fragment is clearly from Andrea's early period, since it is reminiscent of Piero di Cosimo's work and shows, too, a similarity to Franciabigio's. It must have been painted about 1510, or possibly slightly earlier.

Formerly attributed by the Museum to Franciabigio and called Head of a Saint (Cat., 1940).

Tempera on wood. H. 15, w. 11½ in. (38.1 × 29.2 cm.).

REFERENCES: *Galleria Giustiniani del Marchese Vincenzo Giustiniani* (1631), II, supplement, pl. 8, engraving by Cornelis Bloemaert of the Madonna and Child with Saint John the Baptist; inventory of this collection, 1638, published by L. Salerno, *Burl. Mag.*, CII (1960), p. 136, no. 23 // B. Berenson, in a letter (1924) and in Cat. of Friedsam Coll. (unpublished, n.d.), p. 41, attributes this painting to Franciabigio and notes a similarity in style to the work of Domenico Puligo; *Ital. Pictures* (1932), p. 210, lists it as a Head of a Madonna by Franciabigio; and *Flor. School* (1963), p. 65 // A. Venturi, *Storia*, IX, part I (1925), pp. 430, 432, fig. 315, attributes it to Franciabigio // R. Offner (verbally, 1935) agrees with the attribution to Franciabigio // R. Longhi (verbally, 1948) rejects the attribution to

Franciabigio and calls it an early work by Andrea del Sarto // S. J. Freedberg (verbally, 1961) attributes it to Andrea del Sarto; and *Andrea del Sarto* (1963), *Text and Illustrations*, fig. 8, *Catalogue Raisonné*, p. 7, no. 5, attributes it to Andrea del Sarto and dates it about 1508 // J. Shearman (verbally, 1961; in a letter, 1964); and *Andrea del Sarto* (1965), pp. 28, 35 f., 42, 202, cat. no. 12, pl. 17 A (engraving), pl. 17 B (painting), attributes it to Andrea del Sarto, dates it about 1510, and identifies it as a fragment of the painting formerly in the collection of Marchese Vincenzo Giustiniani and known through the engraving by Bloemaert; observes a strong influence of Raphael in the entire composition, apparently recalling Raphael's Madonna del Cardellino, and notes that a Madonna and Child with Saint John attributed to Michel Coxcie (sale, Paris, Hotel Drouot, May 23, 1903, no. 10) appears to be derived from this picture // F. Sricchia, *Paragone*, XIV (1963), no. 163, p. 22,

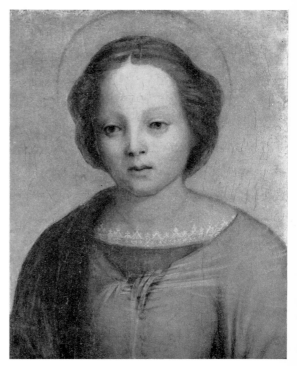

32.100.89

note 25, attributes it to the early period of Andrea del Sarto, rejecting the attribution to Franciabigio // R. Monti, *Andrea del Sarto* (1965), p. 120, fig. 329, considers it a fragment of Andrea's early picture once in the Giustiniani collection and observes similarities to Raphael's work // E. Fahy (in a letter, 1966) notes that a drawing attributed to Sassoferrato in the Royal Library at Windsor is a copy of the complete painting and that there is a painted copy in the British Institute in Florence.

EX COLL.: Marchese Vincenzo Giustiniani, Rome (by 1631–1638); Andrea Giustiniani, Rome (1638); the Giustiniani family, Rome; Morisey, Paris; [F. Kleinberger, New York]; Michael Friedsam, New York (by 1924–1931).

THE MICHAEL FRIEDSAM COLLECTION. BEQUEST OF MICHAEL FRIEDSAM, 1931.

The Holy Family with the Infant Saint John 22.75

According to Vasari, this picture was painted for Giovanni Borgherini, a Florentine nobleman, one of whose relatives, Pier Francesco Borgherini, was a patron of Andrea del Sarto and other renowned Florentine painters around 1515–1518. It has recently been suggested that the motive of the handing of the globe by Saint John the Baptist to the Infant Christ symbolizes a doctrine promulgated by Savonarola to the effect that Florence transferred its allegiance from John the Baptist to Christ himself (see O'Gorman, 1965, in Refs. below). The picture shows the characteristics of Andrea's mature phase and was possibly painted about 1530. Preparatory drawings for it are in the Uffizi in Florence (nos. 631 E, 635 E, 6444 F) and the Louvre in Paris (no. 1714, 1). This painting, sometimes called the Borgherini Madonna, was one of the most successful compositions by Andrea del Sarto and was widely imitated. In many private collections there are copies, derivations and variations, dating mostly from the last

decades of the sixteenth century. None of these, however, could have been painted in Andrea's workshop.

Oil on wood. H. 53½, w. 39⅝ in. (135.8 × 100.6 cm.).

REFERENCES: G. Vasari, *Vite* (1568), Milanesi ed., V (1880), p. 52, describes the painting executed by Andrea del Sarto for Giovanni Borgherini; Milanesi notes that he saw this painting for sale in Florence in 1852 // Crowe and Cavalcaselle, *Painting in Italy* (1866), III, p. 578, mention Vasari's description of the Borgherini Holy Family and call a painting in their time in the Corsini collection a copy by a pupil // H. Guinness, *Andrea del Sarto* (1899), p. 93, lists a painting in the Corsini Gallery as an old copy of the Borgherini Holy Family described by Vasari // O. von Schleinitz, *Kunstchronik*, n.f., XVIII (1907), p. 242, calls it a work from the school of Andrea del Sarto // F. di Pietro, *I Disegni di Andrea del Sarto negli Uffizi* (1910), pp. 18, 74 f., and note, mentions two old copies in the Museo di San Marco and in the Uffizi, Florence, publishes drawings for it in the Uffizi, mentions this painting when in the Murray collection, known to him only from a photograph // F. Mason Perkins (in a letter, 1920) attributes it to Andrea del Sarto // B. B[urroughs], *Met. Mus. Bull.*, XVII (1922), pp. 123 f., ill. p. 121, identifies this painting with the one painted for Borgherini and described by Vasari // B. Berenson, *Ital. Pictures* (1932), p. 19, lists it as a work by Andrea; and *I Disegni dei pittori fiorentini* (1961), I, p. 428, calls it a work by Andrea and dates it in his late but not final period; II, nos. 90, 98, 127 recto and verso, lists the drawings for it in the Uffizi, and, no. 154, the drawing in the Louvre; III, fig. 849; and *Flor. School* (1963), p. 10 // W. S. Spanton, *An Art Student and His Teachers* (1927), p. 114, notes that Murray lent the painting to Dulwich // I. Fraenckel, *Andrea del Sarto* (1935), pp. 86 ff., 159, 182 f., 233, pl. XI, dates it about 1526, thinks it was designed and begun by Andrea, and publishes drawings for it in the Louvre (no. 1714, recto and verso); and in Thieme-Becker, XXIX (1935), p. 474, lists it as a painting by Andrea, presumably worked over by another artist // J. Shearman, *Burl. Mag.*, CI (1959), p. 127, note 4, identifies as a self-portrait the head of Saint Joseph, comparing it with the self-portraits in the Passerini and Panciatichi Assumptions in the Pitti Palace, Florence; and *Andrea del Sarto* (1965), I, p. 109, pls. 164 a, 163 a (detail, head of Joseph) notes its close relationship

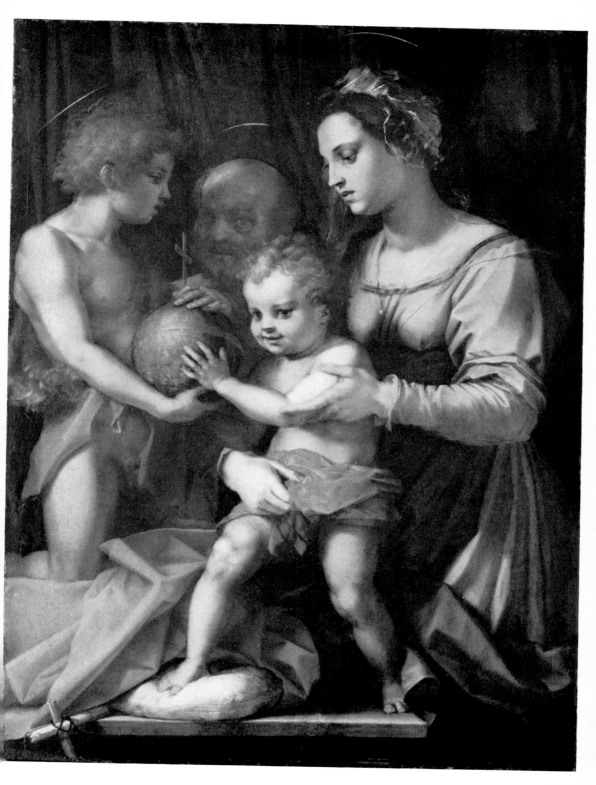

22.75

to a painting of Charity in the Kress collection in Washington; II, pp. 276 ff., no. 90, catalogues it among the authentic paintings by Andrea del Sarto, identifying it with the one painted for Giovanni Borgherini, agrees with Vasari's dating (about 1529), mentions an engraving by H. Cock, and rejects the identification with the painting sold by Vincenzo Borgherini to Cardinal Ferdinando de' Medici in 1579 (see Sanchez and Freedberg, below), and lists a number of copies // E. Sanchez (in a letter, 1960) connects this painting with one sold by Vincenzo Borgherini to Cardinal Ferdinando de' Medici in 1579, mentioned in documents in the State Archive of Florence // S. J. Freedberg, *Andrea del Sarto* (1963), *Text and Illustrations*, fig. 194, pp. 79 ff., 84 f., 88 f., 92, *Catalogue Raisonné*, pp. 153 ff., no. 68, dates it about 1527, identifies it with the painting described by Vasari as painted for Giovanni Borgherini, quotes the Medici documents regarding the purchase in 1579 from Vincenzo Borgherini by Cardinal Ferdinando de' Medici, lists preparatory drawings in the Uffizi and the Louvre, and lists copies // R. Monti, *Andrea del Sarto* (1965), pp. 108 f., 178, note 176, ill. p. 109 (in color) and fig. 267, accepts the attribution to Andrea del Sarto, dates it in the painter's late period, about 1528, identifies it with the one described by Vasari as executed for Borgherini, considers that Andrea painted the Charity in the Kress collection in Washington later, using the same model and changing it in some areas, and lists

preparatory drawings in Paris and Florence // J. F. O'Gorman, *Art Bull.*, XLVII (1965), pp. 502 ff., fig. 2, interprets the iconographic theme as the transfer of Florentine allegiance from Saint John the Baptist to Christ as King of Florence and dates the painting between 1526 and 1530.

EXHIBITED: Royal Academy, London, 1907, *Old Masters*, no. 31 (lent by C. Fairfax Murray); Dulwich College, 1918–1920 (lent by C. Fairfax Murray).

EX COLL.: Giovanni Borgherini, Florence (about 1528–1559); Vincenzio Borgherini, Florence (1559–1597?); possibly the Rinuccini and Corsini families (1845–1901): Marchese Pier Francesco Rinuccini, Florence (cat., 1845, p. 13, room 4, no. 34, and sales, Florence, May 1 ff., 1852, and Paris, Dec. 6–8, 1852, no. 1, as School of Andrea del Sarto); Vignier, 1852 (as agent for Rinuccini family?); Princess Corsini (Eleonora Rinuccini), Palazzo Corsini, Florence (1852–1886); Prince Tommaso Corsini, Florence (1886–1901); [Haskards and Co., Ltd., Palazzo Antinori, Florence, 1901]; [Thos. Agnew and Sons, London, 1901–1905]; C. Fairfax Murray, London (1905–1919; sale, Christie's, London, July 5, 1920, no. 62); [Durlacher Bros., New York, 1920–1922].

PURCHASE, MARIA DE WITT JESUP FUND, 1922.

Bronzino

Real name Agnolo di Cosimo di Mariano. Born 1503; died 1572. Bronzino, one of the foremost representatives of the Florentine Mannerist style, was the pupil and assistant of Jacopo Pontormo. During the years from 1530 to 1532 he worked at the court of Urbino, but the greater part of his life was spent in Florence, where Cosimo I de' Medici, Duke and later Grand Duke of Tuscany, was his chief patron. Bronzino painted for Cosimo's wife, the Duchess Eleonora di Toledo, the frescoes for her chapel in the Palazzo Vecchio in Florence. He also painted a number of altarpieces and mythological and allegorical scenes and made cartoons for tapestries, but his best work was in portraiture. Although his style shows the influence of Michelangelo and Pontormo it is unique. With precision and purity he molded natural objects into ideal forms, rendering their surfaces cold and marble-like. His effects are unreal but impressive and superbly aristocratic.

Portrait of a Young Man 29.100.16

An engraving of this portrait by Pietro Fontana (1762–1837), published in 1812, bears the title A Duke of Urbino by Sebastiano del Piombo. The painting, however, is surely by Bronzino, and the sitter does not at all resemble authenticated portraits of Guidobaldo II, who was then Duke of Urbino. This picture is one of Bronzino's best. It was certainly painted in Florence, possibly in the late 1530's, and reflects the restoration of the aristocracy in Florentine society after the failure of the republic and the reinstatement of the Medici.

Oil on wood. H. 37$\frac{5}{8}$, w. 29$\frac{1}{2}$ in. (95.5 × 74.9 cm.).

REFERENCES: Abate Guattani, *Galleria del Senatore Luciano Bonaparte, Roma* (1808), I, p. 73, no. 40, calls this picture a Portrait of a Young Duke of Urbino by Sebastiano del Piombo // *Choix de gravures . . . d'après les peintures . . . de la galerie de Lucien Bonaparte* (1812), stanza IV, no. 37, reproduces the engraving by Fontana after the painting // W. Buchanan, *Memoirs* (1824), II, pp. 270 f., no. 25, p. 289, no. 30, calls it a portrait of a Florentine gentleman by Sebastiano del Piombo // E. Galichon, *Gaz. des B.-A.*, XVIII (1865), pp. 10 f., ill. opp. p. 6 (engraving by Deveaux), attributes it to Bronzino // B. Berenson, *Flor. Ptrs.* (1909), p. 123; *Ital. Pictures* (1932), p. 115, lists it as a Portrait of a Youth by Bronzino; and *Flor. School* (1963), p. 43 // H. Schulze, *Die Werke Angelo Bronzinos* (1911), pp. 8, xxvi, pl. VIII, calls it a portrait of an unidentified young man by Bronzino and dates it about 1535–1540 // M. Tinti, *Bronzino* (1920), pl. 28, attributes it to Bronzino // H. Voss, *Die Malerei der Spätrenaissance in Rom und Florenz* (1920), I, p. 230, attributes it to Bronzino, comparing it with Pontormo's Halberdier, formerly in the collection of Princess Mathilde Bonaparte in Paris (now in the collection of Chauncey Stillman, New York) // J. Alazard, *Portraits florentins de Botticelli à Bronzino* (1924), pp. 233 f., attributes it to Bronzino, dates it slightly later than the portrait of Ugolino Martelli,

which he dates about 1535 or 1536, and calls it a young nobleman // A. McComb, *Agnolo Bronzino* (1928), pp. 8, 73, pl. 9, calls it a portrait of an unidentified young man by Bronzino and dates it about 1535–1540 // G. Gronau (in a letter, 1930) attributes it to Bronzino, considers it the portrait of a Florentine nobleman, not the Duke of Urbino // L. Venturi, *Ital. Ptgs. in Amer.* (1933), pl. 462, calls it a portrait of a young man by Bronzino // L. Becherucci, *Manieristi toscani* (1944), p. 44, fig. 123, attributes it to Bronzino, dating it about the time of the portrait of Ugolino Martelli in the Berlin Museum, that is, about 1537–1538 // *Met. Mus. Bull.*, n.s., V (1946), Summer, ill. on cover (detail in color), ill. p. 76 // A. H. Mayor, *Met. Mus. Bull.*, n.s., VIII (1950), ill. p. 264 // *Art Treasures of the Metropolitan* (1952), p. 108, ill. (in color) // T. Rousseau, *Met. Mus. Bull.*, n.s., XII (1954), p. 20, ill. // C. H. Smyth (unpublished opinion, 1955), suggests that it may be a self-portrait, begun perhaps in 1530 and reworked about 1531–1532 // A. Emiliani, *Il Bronzino* (1960), p. 21 (in color) and opp. pl. 72, attributes it to Bronzino, does not consider it the Duke of Urbino, Guidobaldo II, and dates it between 1535 and 1540 // K. F. Forster, *Pantheon*, XXII (1964), p. 378, fig. 6, p. 380, dates it about 1545, attributing it to Bronzino // E. Sanchez (verbally, 1964) suggests that the subject might be Vincenzo Borghini, painted before he took holy orders and before Bronzino went to Urbino.

EXHIBITED: Palais de la Présidence du Corps Législatif, Paris, 1874, *Ouvrages de peinture exposés au profit de la colonisation de l'Algérie par les Alsaciens-Lorrains*, no. 19 (as Bronzino, lent by the Princess de Sagan); M. Knoedler and Co., New York, 1915, *Loan Exhibition of Masterpieces by Old and Modern Painters*, no. 1 (as Portrait of the Duke of Urbino by Bronzino, lent anonymously); Metropolitan Museum, New York, 1930, *The H. O. Havemeyer Collection*, no. 1; Metropolitan Museum, New York, 1952–1953, *Art Treasures of the Metropolitan*, no. 108.

EX COLL.: Lucien Bonaparte, Prince of Canino, Rome (by 1808; sale, London, Stanley, May 14 ff., 1816, no. 163, as A Florentine Gentleman by Sebastiano del Piombo); [Charles J. Nieuwenhuys, London, 1816]; Alexandre, Count of Pourtalès Gorgier, Paris (by 1841; cat., 1841, no. 49, as "Sebastiano del Piombo, or, more likely, Andrea del Sarto"; sale, Paris, March 27–April 1, 1865, no. 114, as the figure of a young man believed to be a Duke of Urbino, by Sebastiano del Piombo);

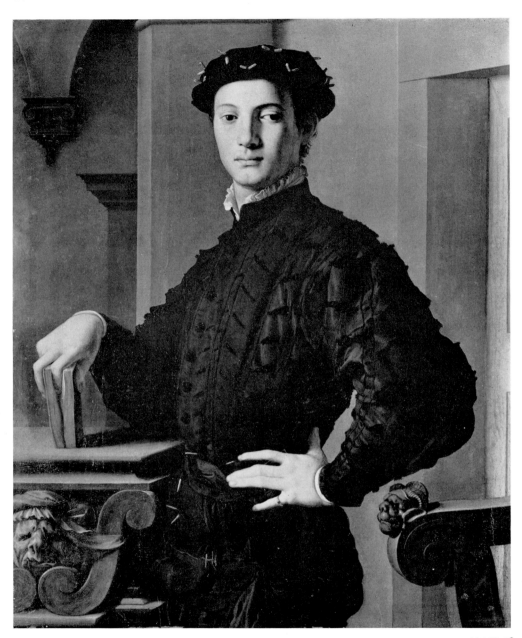

29.100.16

Baron Achille Seillière, Paris and Château de Mello (1865–1873); Jeanne Marguérite Seillière, Princess de Sagan, later Duchess de Talleyrand-Périgord, Paris (1873–1903); [Durand-Ruel, Paris, 1903]; H. O. Havemeyer, New York (by 1903–1907);

Mrs. H. O. Havemeyer, New York (1907–1929; Cat., 1931, p. 5).

THE H. O. HAVEMEYER COLLECTION. BEQUEST OF MRS. H. O. HAVEMEYER, 1929.

Workshop of Bronzino

Cosimo I de' Medici 08.262

Bronzino was at work in 1545 on a portrait of Cosimo I de' Medici (1519–1574), first Duke of Tuscany, as he stated in a letter (published by G. Gaye, *Carteggio*, II, 1840, pp. 330 ff.). It is not certain whether this portrait still exists, but several scholars consider it to be a panel in the Uffizi in Florence (no. 28). There are portraits of Cosimo in the style of Bronzino in many other museums and collections, all of them more or less contemporary copies or workshop products. Most of these pictures show Cosimo wearing the badge of the order of the Golden Fleece, which was conferred upon him in 1546. As our picture has no badge, it was probably derived from Bronzino's portrait of 1545. It is the only one of the versions of this composition showing in the background a fringed curtain and ornamental border, details which are probably taken from Salviati's Portrait of a Gentleman (see p. 205).

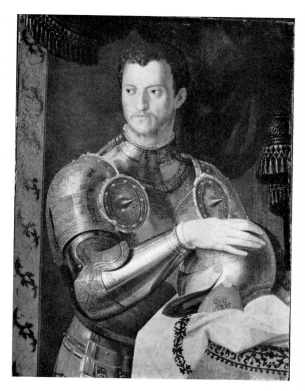

08.262

Inscribed (on armor of right elbow): CM.

Oil on wood. H. 37¾, w. 27¾ in. (95.9 × 70.5 cm.).

REFERENCES: B. B[urroughs], *Met. Mus. Bull.*, IV (1909), p. 69, ill., attributes this painting to Bronzino // J. Breck, *Cicerone*, I (1909), p. 292, attributes it to Bronzino // H. Schulze, *Die Werke Angelo Bronzinos* (1911), p. xxiv, considers it a replica by Bronzino similar to the version in the Accademia in Florence // C. Gamba, *Boll. d'arte*, V (1925–1926), p. 145, considers the portrait in the Uffizi in Florence the original portrait of 1545 and attributes all the other versions to followers of Bronzino // A. McComb, *Agnolo Bronzino* (1928), pp. 13, 72 f., pl. 17, calls our portrait probably the original and

dates it about 1542–1545 // C. Brandi (verbally, 1940) tentatively suggests that it was painted by Bronzino's pupil Alessandro Allori // L. Becherucci, *Manieristi toscani* (1944), p. 46, mentions it as one of the replicas of the Uffizi portrait and agrees with Gamba in considering the Uffizi picture the original // A. Emiliani, *Il Bronzino* (1960), pl. 90, calls it a replica of the Uffizi portrait.

EXHIBITED: Museum of Fine Arts, Boston, 1908.

EX COLL.: Strozzi, Florence; Rev. John Sanford, Florence and London (sale, Christie's, London, March 9, 1839, no. 123, as Bronzino); Charles Callahan Perkins, Boston (until 1886); Charles Bruen Perkins, Boston (1886–1908).

PURCHASE, ROGERS FUND, 1908.

Jacopino del Conte

Born 1515; died 1598. Jacopino del Conte was a pupil of Andrea del Sarto in Florence, but about 1535–1537 he went to Rome, where he remained for the rest of his life. His earliest works show an intelligent interpretation of motives taken from Andrea del Sarto and Michelangelo; he was also closely connected with Perino del Vaga. Later, about the middle of the century, there is a complete change in his style, possibly reflecting a spiritual crisis resulting from the influence of his friend Ignatius Loyola. The sadness and the dry mechanical quality seen in Jacopino's advanced style are typical peculiarities seen in painting of the Counter Reformation. Jacopino was famous as a painter of portraits, but only a few of the many that he did have been discovered, among them likenesses of Michelangelo and Loyola. His portraits are similar to those by Salviati and show, too, his knowledge of the older artist Sebastiano del Piombo.

Portrait of a Prelate 30.95.236

30.95.236

This picture, a fine example of the few remaining early portraits by Jacopino del Conte, is very eclectic in character. Long considered a work by Sebastiano del Piombo, it is also similar to early works by Giorgio Vasari and even more to those by Francesco Salviati. The dignity of the portrait and the similarity to the donor in Jacopino's large Deposition in the Oratory of San Giovanni Decollato in Rome, painted about 1540, serve to date it about that time. The subject of this portrait has been thought to be a member of the Sicilian family of Ventimiglia, who once owned it. Cleaning in 1946 removed the overpaint on the added strips, now concealed by the frame.

Formerly attributed by the Museum to Sebastiano del Piombo and called Portrait of a Man (Cat., 1940).

Oil on canvas. H. 43¼, w. 36¾ in. (110× 93.4 cm.); with added strips at top and sides, h. 47½, w. 38¼ in. (120.5×97.2 cm.).

REFERENCES: G. B. Cavalcaselle (unpublished opinion, 1865?) hesitantly ascribes this portrait to Moroni or Sebastiano del Piombo // *Boston Mus. Bull.*, 1 (1903), p. 30, ascribes it to Sebastiano del Piombo and notes Florentine influence // J. Breck, *Rass. d'arte*, XI (1911), p. 112, ill. p. 111, attributes it to the Roman period of Sebastiano del Piombo // L. Campi, *Rass. d'arte*, XI (1911), pp. 173 f., attributes it to Sebastiano and notes its similarity to a portrait of about 1530 in the Wawra sale, Vienna // B. Burroughs, *Met. Mus. Bull.*, XXVI (1931), Mar., sect. II, p. 15 // B. Berenson, *Ital. Pictures* (1932), p. 522; and *Ven. School* (1957), p. 163, lists it as a work by Sebastiano // A. Venturi, *Storia*, IX, part V (1932), p. 82, lists it as a work by Sebastiano // G. Gombosi, in Thieme-Becker, XXVII (1933), p. 74, lists it among works doubtfully attributed to Sebastiano // L. Dussler, *Sebastiano del Piombo* (1942), p. 154, rejects the attribution to Sebastiano, suggesting Francesco Salviati as the painter // R. Pallucchini, *Sebastian Viniziano* (1944), pp. 105, 186, rejects the attribution to Sebastiano, suggesting that it is by Salviati, strongly under Sebastiano's influence // J. Shearman (verbally, 1964) attributes it to Salviati.

EXHIBITED: Museum of Fine Arts, Boston, 1903 (lent by Theodore M. Davis).

EX COLL.: the Ventimiglia family, Palermo; Prince Belmonte, Palermo; Prince Pandolfini, Palermo (about 1865); [T. Lawrie & Co., London, 1902]; Theodore M. Davis, Newport (1902–1915).

THE THEODORE M. DAVIS COLLECTION. BEQUEST OF THEODORE M. DAVIS, 1915.

Francesco Salviati

Real name Francesco de' Rossi; called Francesco (or Cecchino) Salviati after his early patron, Cardinal Salviati. Born 1510; died 1563. Salviati studied with Giuliano Bugiardini, Andrea del Sarto, and the sculptor Baccio Bandinelli, in whose studio he met and became the friend of Vasari. Salviati traveled frequently and extensively, visiting and working in Bologna, Venice, Parma, Mantua, Verona, Florence, and Rome, as well as in France. He was mostly in Florence and Rome, however, carrying out commissions received from the Duke of Tuscany, the papal court, and the most important families in both cities. His very early works are lost, but a great number of paintings dating from about 1533 on are known. There are frescoes by him in the Palazzo Vecchio in Florence, in the Vatican, and in the Cancelleria, Sacchetti, and Farnese palaces in Rome and paintings in several Roman churches. He also made cartoons for tapestries. His portraits, which were much in demand, are among his best works. His mature painting shows a synthesis of influences received from the painters whose works he encountered in his travels, the Florentine Mannerists of the 1520's, the two pupils of Raphael, Perino del Vaga and Polidoro da Caravaggio, the painters Parmigianino and Mazzola-Bedoli in Parma. The style that he evolved, with its exquisite decorative quality, its wit, and its refined elegance, was of great importance for the later development of Roman and Florentine Mannerism, as well as for the widespread influence of the Italian style on North European painting in the second half of the sixteenth century.

Portrait of a Gentleman 55.14

This portrait, one of Salviati's richest and most finished, is in his style of about 1540.

Costumes like this and beards cut in this way were fashionable about that time in Mantua and Salviati may have painted it when he was there in 1541. It was probably he who

55.14

originated the curtain and border ornament, which are repeated in a portrait of Cosimo de' Medici from Bronzino's workshop (see p. 203).

Oil on canvas. H. 48¼, w. 36¾ in. (122.5 × 93.3 cm.).

REFERENCE: P. Pouncey (verbally, 1958) questions the attribution of this painting to Salviati, tentatively suggesting that it may be by Girolamo Sicciolante di Sermoneta.

EXHIBITED: M. Knoedler and Co., London, 1935, *Twenty Masterpieces* (1400–1800), no. 25 (lent anonymously); John Herron Art Museum, Indianapolis, 1954, *Pontormo to Greco, the Age of Mannerism*, no. 18 (lent by Mr. and Mrs. N. B. Spingold); University of Notre Dame, Art Gallery, and State University of New York, Binghamton, University Art Gallery, 1970, *The Age of Vasari*, no. P14.

EX COLL.: John Edward Taylor, London (until 1905); Mrs. John Edward Taylor, London (1905–1912; sale, Christie's, London, July 5–8, 1912, no. 28); [Colnaghi and Co., London, 1912]; [M. Knoedler and Co., New York, 1913]; J. Horace Harding, New York (1913–1939/40); [James St. L. O'Toole Gallery, New York, 1940; *Cat. of the Collection of the late J. Horace Harding*, p. 10, ill.]; Mr. and Mrs. Nate B. Spingold, New York (after 1940–1955).

GIFT OF MR. AND MRS. NATE B. SPINGOLD, 1955.

Portrait of a Man 45.128.11

This painting is a minor but interesting example of Salviati's mature work. Its composition, along with the subject's stylized

45.128.11

hands and their pose, shows the influence of the schools of Parma and Florence. The costume of the sitter and the drawing, which is less incisive than in Salviati's early paintings, together suggest a date in the early 1540's.

Oil on canvas. H. 37¾, w. 29½ in. (95.9 × 74.9 cm.).

EX COLL. Mrs. Payne Whitney, New York.

BEQUEST OF HELEN HAY WHITNEY, 1944.

Zacchia

Zacchia di Antonio da Vezzano or Zacchia il Vecchio; called Paolo Zacchia by the eighteenth-century art historian Luigi Lanzi. School of Lucca, born at the end of the fifteenth century; still active in 1561. Zacchia seems to have been the pupil of Ridolfo Ghirlandaio in Florence and his earliest known work, an Adoration of the Shepherds in the church of

Sant'Agostino at Pietrasanta, dated 1519, reflects Ridolfo's influence. Zacchia is thought to have settled in Lucca soon after 1520, and he worked there and in the neighboring region. His mature works show a knowledge of Raphael and his circle, modified, however, by his awareness of the early Florentine mannerists, especially Pontormo. A few portraits have been attributed to Zacchia on the basis of a signed one in the Louvre in Paris (no. 1608). Our knowledge of his career and of his works is still very inexact and limited.

Portrait of a Young Gentleman 56.51

The sharp outlines in this panel, the hard contrasts of light and shadow, and the simplification of forms, relate it strikingly to Zacchia's signed Portrait of a Musician in the Louvre. The costume of this young gentleman represented with a page suggests a date about 1530. The two groups of still life in the background, which include a bagpipe, a lute, and books of music, are painted with great care for detail.

Oil on wood. H. 46¼, w. 30¾ in. (117.5 × 78.1 cm.).

EX COLL.: Sir Francis Sharp Powell, Horton Old Hall, West Riding, Yorkshire (until 1911; sale, Sotheby's, London, November 27, 1929, no. 33, as by Lotto); [Leger, London]; [Norton Gallery, Palm Beach, until 1934]; [Karl Freund, Arts Incorporated, New York, by 1938); Mr. and Mrs. Graham F. Blandy, New York (until 1939); Mrs. Orme Wilson, New York (1939–1956).

GIFT OF ALICE BORLAND WILSON, 1956.

56.51

Unknown Florentine Painter, Middle of the XVI Century

The Madonna and Child with Saint John 53.45.1

This painting, by an artist working about the middle of the sixteenth century or

slightly earlier, is closely related in style to Agnolo Bronzino's early works. This is especially evident in the figure of the Infant Christ. Other elements in the composition reveal the artist's knowledge of Francesco

Salviati's pictures. Both in conception and in quality this painting is similar to the works of such minor Florentine Mannerists as Girolamo Macchietti and Mirabello Cavalori.

Inscribed (on Saint John's scroll): ECCE AGN[US DEI].

Oil on wood. H. 26⅞, w. 22¼ in. (68.3 × 56.5 cm.).

REFERENCES: P. Pouncey (verbally, 1958) attributes this painting to a provincial and primitive follower of Bronzino // J. Shearman (in a letter, 1965) calls it an early work by Bronzino based on a drawing in the Uffizi, which he dates about 1529–1530 // E. E. Gardner (verbally, 1966) identifies a painting in the Museo Diocesano di San Miniato Tedesco (no. 29, attributed to Il Cigoli) as an old copy of our painting by two different artists.

BEQUEST OF KATHERINE S. DREIER, 1952.

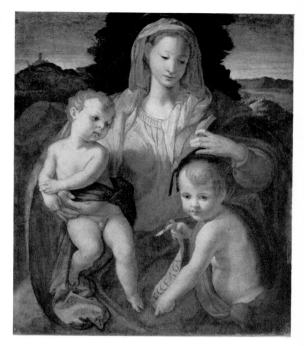

53.45.1

Unknown Florentine Painter, Middle of the XVI Century

Portrait of a Lady 32.100.66

This portrait can be dated by the costume in the late 1550's. It is a characteristic example of the type of portraiture favored by the Florentine nobility during the late years of the reign of Cosimo I de' Medici (1519–1574). In style it is chiefly dependent upon Bronzino and Salviati, but it is less intense than their works and very much conventionalized. Its closest analogies are the works of Michele di Ridolfo Ghirlandaio and Francesco Brina.

Once attributed by the Museum to Salviati and later to an unknown Florentine painter of the middle of the XVI century (Cat., 1940).

Oil on wood. H. 38½, w. 30 in. (97.7 × 76.1 cm.).

REFERENCES: B. Berenson, in Cat. of Friedsam Coll. (unpublished, n.d.), pp. 90 ff., attributes this portrait to Salviati, rejects the identification of the sitter as Maria di Cosimo, and considers the costume Venetian of about 1550 // A. McComb, *Agnolo Bronzino* (1928), pp. 115 f., calls it a portrait of Maria di Cosimo, rejects the attribution to Bronzino, and suggests ascribing it to Salviati, about 1554–1557 // B. Burroughs and H. B. Wehle *Met. Mus. Bull.*, XXVII (1932), Nov., sect. II, p. 40 // H. Voss (in a letter, 1935) notes its similarity to the work of Salviati but suggests attributing it to

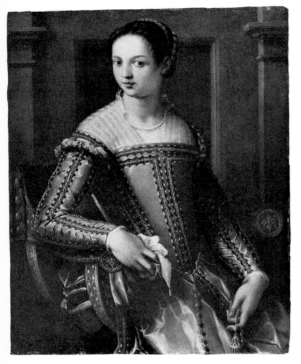

32.100.66

Michele Ghirlandaio or Francesco Brina // R. Longhi (unpublished opinion, 1937) calls it a work of the Florentine school of the middle of the sixteenth century, close to Michele Ghirlandaio and Brina // I. Kühnel-Kunze, *Pantheon*, xx (1962), p. 92, fig. 16, attributes it to Lucia Anguissola, comparing it with her Portrait of Three Children of the Gaddi Family in the collection of Lord Methuen at Corsham Court // P. C. Brooks, *Burl. Mag.*, cviii (1966), p. 564, fig. 27, attributes it to Maso da San Friano.

EXHIBITED: Kleinberger Galleries, New York, 1917, *Italian Primitives*, no. 39 (as Maria di Cosimo by Bronzino, lent by Michael Friedsam.)

EX COLL.: a private collection, Florence (until about 1840); Richard, second Marquess of Westminster (from about 1840); Lady Theodora Guest, Templecombe, Somerset; [R. Langton Douglas, London, 1917]; [Kleinberger Galleries, New York, 1917]; Michael Friedsam, New York (1917–1931).

THE MICHAEL FRIEDSAM COLLECTION. BEQUEST OF MICHAEL FRIEDSAM, 1931.

Aurelio Lomi

Born 1556; died 1622. Aurelio Lomi was born in Pisa, but was trained in Florence under Cigoli. He returned frequently to work in Pisa, and he worked also in Genoa. Although Lomi has not been extensively studied, his work shows that he was familiar with paintings by Correggio as well as those of the Florentine Mannerists of the late sixteenth century. He is chiefly known as the first teacher of his half-brother Orazio Gentileschi.

The Gathering of Manna 80.3.245

This picture, painted in monochrome in a sketchy technique, is very likely the model for a much larger mural decoration intended for the side wall of a church or chapel. The style is characteristic of Aurelio Lomi around 1600, bearing striking similarity to the predella to the altarpiece of the Adoration of the Magi that he executed for the church of Santo Spirito in Florence.

Once attributed by the Museum to Domenico Beccafumi, and later to an unknown Florentine painter of the third quarter of the XVI century (Cat., 1940).

Oil on canvas; monochrome. H. 41½, w. 42¾ in. (105.4 × 108.6 cm.).

REFERENCES: P. Pouncey (verbally, 1958) tentatively attributes this picture to a Sienese painter of the early XVII century, perhaps Rutilio Manetti // M. Gregori (verbally, 1961) tentatively attributes it to Pietro Sorri or to Aurelio Lomi // J. Shearman (in a letter, 1965) suggests tentatively that it is Florentine about 1580–1590, resembling the work of Poccetti.

GIFT OF CORNELIUS VANDERBILT, 1880.

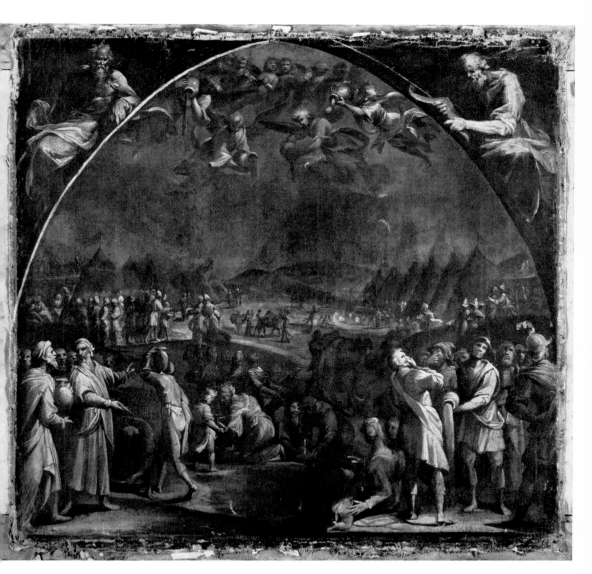

Cesare Dandini

Born 1596; died 1656. After studying for three years under Francesco Curradi, Cesare Dandini became a pupil of Cristofano Allori. He eventually completed his apprenticeship in the studio of Domenico Creti, called Passignano. Some paintings that he executed with Passignano for the cathedral of Pisa have been lost. There are several documented works by Dandini, the finest of which is the Glory of Saint Charles Borromeo, an altarpiece in the Chiesa del Sacramento at Ancona. Many other minor paintings can be attributed to him on stylistic evidence, mainly allegories and other secular subjects. Dandini's strongly individualized paintings show the influence of Cristofano Allori, especially in technique and in the female faces. Some of his earlier compositions and his range of color reflect the influence of Passignano, who had studied the great Venetian artists of the sixteenth century.

Charity 69.283

This painting follows the iconography of Cesare Ripa (*Iconologia* . . ., 1603, pp. 63 f.) in showing Charity as a woman feeding a child whom she holds in her left arm. Here, however, the flames described by Ripa as a crown on Charity's head or coming from a heart held in her hand rise from a richly decorated urn, which includes among its ornaments a putto holding a flame, another allusion to the same theme. This urn symbolizes the love of God, while a child at the left with a silver ewer and another holding up a silver shell symbolize the love of one's neighbor. Judging from its style this painting clearly belongs to Dandini's middle period, and such a dating is confirmed by the facial type of Charity as well as by the color, with its brilliant reds and blues. According to Filippo Baldinucci (*Notizie dei professori del disegno* . . . , 1846 ed., IV, p. 559), Cesare Dandini painted a Charity with three putti for Cardinal Carlo de' Medici, and made two other representations of the same subject that were left unfinished at his death and were completed by his brother Vincenzo.

The Medici Charity was later set into the vaulted ceiling of a room in the Casino Mediceo near San Marco in Florence, and as Baldinucci notes, it was painted with a perspective "di sotto in sù," that is, to be seen from below, just as ours is. A version of the same theme, with a similar figure of Charity, is in the collection of Mr. and Mrs. Paul H. Ganz in New York. This picture apparently belongs to a much later date in Dandini's career, and the composition is quite different. A replica of our painting, of much inferior quality, is reported in the Villa Santini at Camigliano, near Lucca (see Refs., Gregori, 1965). A painting showing the Holy Family and the young Saint John the Baptist that was for sale in London in 1962 (Appleby) repeats, in the figures of the Madonna and Child, our Charity and the child in her arm. The quality of this picture, however, suggests that it is an old copy after a missing work and not an original by Dandini.

Oil on canvas. H. 47$\frac{1}{8}$, w. 41$\frac{1}{2}$ in. (119.7× 105.4 cm.).

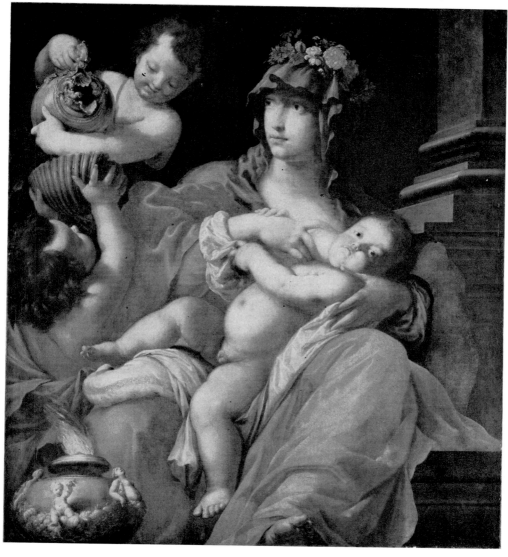

69.283

REFERENCES: F. Zeri (verbally, 1962) rejects the attribution of this painting (then in the Wildenstein Gallery, New York) to the French school of the XVII century and calls it a work by Cesare Dandini // M. Gregori, in *70 Pitture del '600 e '700 Fiorentino* (Cat. of exhibition, 1965), pp. 45 f., accepts the attribution to Dandini, mentions versions in a private collection in Milan and in the Villa Santini at Camigliano, near Lucca, and notes connections with Domenico Feti and Sigismondo Coccapani; and *Comma*, v (1969), p. 10, ill. p. 9 (in color, reversed).

EXHIBITED: Winnipeg Art Gallery, 1967, *Mother and Child*, no. 41; Metropolitan Museum, *Florentine Baroque Art from American Collections*, 1969, no. 30 (lent anonymously).

EX COLL.: [Wengraf Old Master Gallery, London, 1954]; [Wildenstein and Co., New York, 1954–1968]; Mr. and Mrs. Ralph Friedman, New York (1968–1969).

GIFT OF MR. AND MRS. RALPH FRIEDMAN, 1969.

Unknown Florentine Painter, Second Quarter of the XVII Century

Scenes and Allegories of the Virgin
(Ceiling) 68.162

This small ceiling came to the Museum as the decoration of the underside of a tester, or bed canopy, but its subject matter suggests that originally it was intended to ornament the ceiling over an altar. The surface is divided by an elaborate, symmetrical pattern: painted compartments, of various sizes and shapes, are framed by embossed and gilt moldings, not unlike a church ceiling. It is probable that the painted scenes are no longer placed in their original arrangement. The central space shows the Coronation of the Virgin (17). Scenes from her life are

represented in the corners of the outer row: the Annunciation (33), the Visitation (29), the Nativity (1), and the Death of the Virgin (5). At the corners of the Coronation are four small square compartments with symbols alluding to the Virgin and the Immaculate Conception, deriving from the Litanies of the Virgin. These include a mirror (26, speculum sine macula), a rosebush (23, plantatio rosae), a lily plant (8, lilium inter spinas), and the sun and moon (11, electa ut sol; pulchra ut luna). The symbol of the sun and moon is borrowed from the Song of Songs (VI, 10).

The ceiling includes four octagons, each with a representation of an archangel: Michael (28), holding a sword alluding to his fight against the rebel angels; Gabriel (12), holding the lily of the Annunciation; Raphael (6), holding the medicine vase for Tobias; and Uriel (22), holding a flaming circle, as the archangel whose name is interpreted as the light or flame of God. Though representations of Uriel are rare in Western art, his inclusion with the archangels, in order to form a group of four, is typical of Byzantine iconography. It is not clear why an eagle is placed near Saint Michael, but this may suggest a parallel between Michael as chief of the archangels and the eagle as symbol of supreme power, in connection with the Roman emperors. The rest of the compartments, numbering twenty, depict flowers, and angels singing, playing music, and carrying garlands.

The ceiling, clearly Florentine in style,

68.162

archangels and the scenes from the life of the Virgin, there is a pronounced similarity, in style and technique, to the work of Francesco Montelatici, called Cecco Bravo (1607–1661). If he painted this ceiling, he could only have done so very early, about 1625, but the likeness to his work is not great enough to permit so definite an attribution.

Oil on canvas. H. 95, w. 70½ in. (241.1 × 179 cm.).

REFERENCES: W. M. Odom, *A History of Italian Furniture* (1918), I, pp. 218, 220, figs. 205, 206, pp. 279 f., attributes the ceiling to Giovanni Ricciarelli, whom he identifies with the nephew of Daniele da Volterra // P. Pouncey (in a letter, 1969), tentatively suggests an attribution to Cecco Bravo.

EX COLL.: [Stefano Bardini, Florence; sale, American Art Association, New York, April 23–27, 1918, no. 780]; [Otto Bernet, agent, New York, 1918]; [French & Co., New York, by 1966]; Mr. and Mrs. Alan S. Hartman, New York (until 1968).

GIFT OF MR. AND MRS. ALAN S. HARTMAN, 1968.

shows the influence of Giovanni Mannozzi, called Giovanni da San Giovanni, and of other Florentine artists. In the more elaborate compartments, such as those with the

Pietro Annigoni

Born 1910 in Milan; active in Florence. Annigoni is one of the best-known representatives of the traditional and classical trend in contemporary painting, and his pictures show that he knows and studies the old masters. Although many of his paintings are highly elaborate treatments of landscape, allegory, and religious themes, Annigoni is especially famous for his portraits of aristocrats and intellectuals, mostly of English and Italian society. His exact reproduction of reality is executed with very careful and minute brushwork.

Gulliver (Portrait of the Artist) 58.50

This painting, in which the artist has represented himself as Gulliver, the hero of Jonathan Swift's satire, shows how closely Annigoni is linked to the great European tradition and its figurative and literary themes.

Inscribed (on fold of collar and on back of panel) with the artist's monogram. Dated (on collar and on back of panel): LAMA LVI (Lama, [19]56). Inscribed (on back of panel): *Nel mezzo del tuo cuor commosso | Minimo e immenso | Si disgiungono | E se, per la | virtù d'un tutto solo, | poli opposti all'Infinito amor, | Si congiungono, | A te non vien sollievo, | A te, solo | Il solitario tuo cammino resta, | pellegrino Gulliver.*

Oil and tempera on presswood. H. $25\frac{3}{8}$, w. $19\frac{1}{2}$ in. (64.5 × 49.5 cm.).

REFERENCE: N. Rasmo, *Pietro Annigoni* (1961), pl. 92.

EXHIBITED: Royal Society of Portrait Painters, London, 1956, *Annual Exhibition*, no. 103; Wildenstein and Co., New York, 1958, *Paintings by Pietro Annigoni*, no. 26.

GIFT OF THE ARTIST, 1958. 58.50

Books and Periodicals Abbreviated

Arch. stor. dell'arte
 Archivio storico dell'arte

Art Bull.
 The Bulletin of the College Art Association

Art in Amer.
 Art in America

Boll. d'arte
 Bolletino d'arte

Burl. Mag.
 The Burlington Magazine

The Christ Child
 The Christ Child in Devotional Images in Italy during the XIV Century

Corpus
 A Critical and Historical Corpus of Florentine Painting

Flor. Ptrs.
 The Florentine Painters of the Renaissance

Flor. School
 Italian Pictures of the Renaissance, Florentine School

Gaz. des B.-A.
 Gazette des Beaux-Arts

Hist. of Ital. Ptg.
 A History of Italian Painting

Ital. Pictures
 Italian Pictures of the Renaissance

Ital. Ptgs. in Amer.
 Italian Paintings in America

Ital. Schools
 Italian Schools of Painting

Jahr. der Preuss. Kst.
 Jahrbuch der Preussischen Kunstsammlungen (Jahrbuch der Königlich Preussischen Sammlungen)

Kstkrit. Stud.-Rom
 Kunstkritische Studien über Italienische Malerei: Die Galerien Borghese und Doria Panfili in Rom

Kstkrit. Stud.-München und Dresden
 Kunstkritische Studien über Italienische Malerei: Die Galerien zu München und Dresden

Met. Mus. Bull.
 Bulletin of The Metropolitan Museum of Art

Mitteil. des Ksthist. Inst. in Florenz
 Mitteilungen des Kunsthistorisches Institut in Florenz

Monats. für Kstwiss.
 Monatsheft für Kunstwissenschaft

Pitt. ital.
 Pitture italiane del Rinascimento

Ptg. in Italy
 A History of Painting in Italy, Umbria, Florence and Siena from the Second to the Sixteenth Century

Ptg. of High Ren.
 Painting of the High Renaissance in Rome and Florence

Rass. d'arte
 Rassegna d'arte antica e moderna

Repert. für Kstwiss.
 Repertorium für Kunstwissenschaft

Riv. d'arte
 Rivista d'arte

Storia
 Storia dell'arte Italiana

Thieme-Becker
 U. Thieme and F. Becker, *Allgemeines Lexikon der Bildende Kunst*

Treasures—Gr. Brit.
 Treasures of Art in Great Britain

Verzeichn. der Gemäldesmlg. des Königl. Museum zu Berlin
 Verzeichnis der Gemälde-Sammlung des Königliches Museum zu Berlin

Vite
 Le Vite de' più eccellenti Pittori, Scultori ed Architettori

Zeitschr. für bild. Kst.
 Zeitschrift für bildende Kunst

Zeitschr. für christliche Kst.
 Zeitschrift für christliche Kunst

Zeitschr. für Kstgesch.
 Zeitschrift für Kunstgeschichte

Index of former Owners

Crane, Mrs. W. Murray
 Unknown Florentine, 69.280.4

Crawford and Balcarres, Earls of
 Unknown Florentine, 53.37

Crespi, Cristoforo Benigno
 R. Ghirlandaio, 32.100.80

Crews, Charles T. D.
 Lippi-Pesellino Imitators, 65.181.4

Daniell
 Giotto, 11.126.1

Davis, Theodore M.
 Albertinelli, 30.95.270
 Jacopino del Conte, 30.95.236
 Unknown Florentine, 30.95.254

Dell, Robert
 Lorenzo di Credi, 09.197

Dollfus, Jean
 Biagio di Antonio, 32.100.69
 Marco del Buono and Apollonio di Giovanni,
 18.117.2
 Master of the Magdalen, 64.189.1

Donaldson, Sir George
 Granacci, 1970.134.1,2
 Lippi-Pesellino Imitators, 32.100.79

Douglas, R. Langton
 Botticelli, 11.98
 Domenico di Michelino, 19.87
 D. Ghirlandaio, 13.119.1-3
 Giotto, 11.126.1
 Lippi-Pesellino Imitators, 65.181.4
 Master of the Castello Nativity, 49.7.6
 Unknown Florentine, 06.1048; 32.100.66

Dowdeswell & Dowdeswell
 Fra Bartolomeo, 06.171
 Bicci di Lorenzo, 16.121
 Sellaio, 41.100.10
 Verrocchio workshop, 14.40.647

Dreicer, Michael
 Piero di Cosimo, 22.60.52

Dreier, Katherine S.
 Unknown Florentine, 53.45.1

Drey, A. S.
 Lorenzo di Credi, 43.86.5
 Lorenzo Monaco, 65.14.4

Drey, Paul
 Unknown Florentine,
 41.190.129, 130

Durand-Ruel
 Bronzino, 29.100.16

Durlacher Brothers
 Bacchiacca, 38.178
 Andrea del Sarto, 22.75

Duveen Brothers
 Botticelli, 14.40.642
 Botticelli follower, 49.7.4
 D. Ghirlandaio, 49.7.7
 Filippo Lippi, 35.31.3; 49.7.9
 Filippino Lippi, 49.7.10
 Lippi-Pesellino Imitators, 32.100.79
 Lorenzo di Credi, 43.86.5
 Mainardi, 14.40.635
 Master of the Castello Nativity, 49.7.6
 Master of San Miniato, 41.100.6
 Raffaellino del Garbo (?), 14.40.641
 Verrocchio workshop, 14.40.647

Elcho, Lord Francis Richard
 Pollaiuolo, 50.135.3

Farinola, Marchese
 Botticelli, 14.40.642

Farquhar, Sir Walter R.
 Verrocchio workshop, 14.40.647

Fenouil, Rudolph
 Lorenzo di Niccolò, 58.135

Fischer, Victor G.
 Lorenzo Monaco workshop, 09.91
 Unknown Florentine, 53.115

Fischof, Eugène
 Fra Bartolomeo, 06.171

Foresse, de
 Bicci di Lorenzo, 88.3.89

Fossi, Countess
 Unknown Florentine, 30.95.254

Fox, Gen. Charles Richard
 Giotto, 11.126.1
 Giovanni da Milano, 07.200

French & Co.
 Unknown Florentine, 68.162

Freund, Karl
 Zacchia, 56.51

Friedman, Mr. and Mrs. Ralph
 Dandini, 69.283

Friedrich Wilhelm II, King of Prussia
 Daddi workshop, 32.100.70

Index

5